Saint Peter's University Library
Withdrawn

The Wrightsman Lectures II

The Wrightsman Lectures
Rembrandt and the Italian Renaissance
by Kenneth Clark
Titian Problems, Mostly Iconographic
by Erwin Panofsky

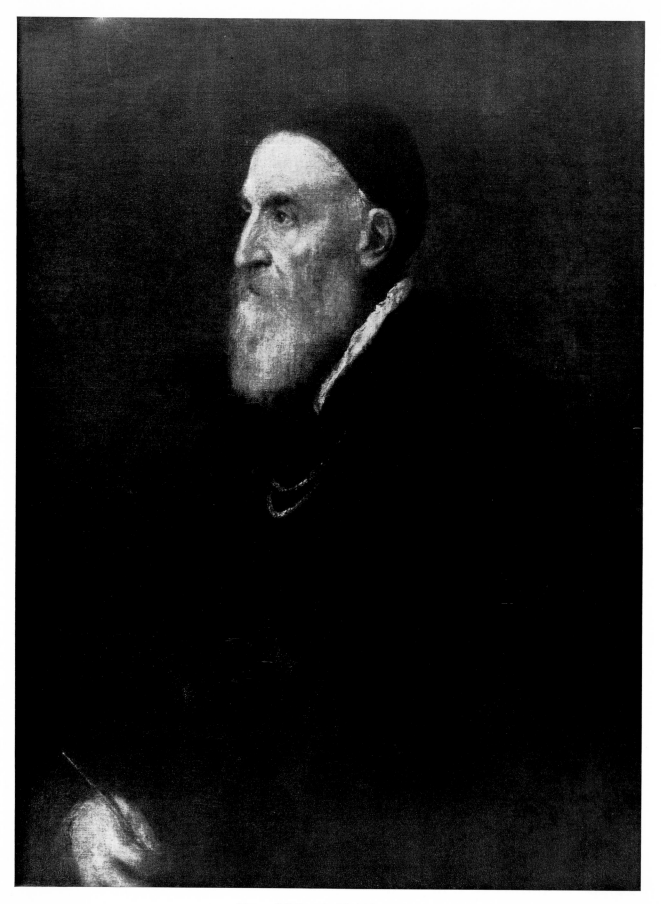

Titian, *Self-Portrait*. Madrid, Prado

ERWIN PANOFSKY

PROBLEMS IN TITIAN
MOSTLY ICONOGRAPHIC

THE WRIGHTSMAN LECTURES

UNDER THE AUSPICES
OF THE NEW YORK UNIVERSITY
INSTITUTE OF FINE ARTS

DELIVERED AT
THE METROPOLITAN MUSEUM OF ART
NEW YORK, N.Y.

NEW YORK UNIVERSITY PRESS

Copyright © 1969 by New York University
Published for the Institute of Fine Arts, New York University
by New York University Press, New York, N. Y.

*This is the second volume
of the Wrightsman Lectures,
which are delivered annually
under the auspices of the
New York University Institute of Fine Arts*

Library of Congress Catalog Card No. 66–13550
SBN 7148 1325 7
Published in England by Phaidon Press Limited
Composed and printed by J. J. Augustin, Glückstadt, West Germany
First impression

ND
623
.T7
P32
1969

Preface

It was known to his friends that Erwin Panofsky loved Titian more than any other artist, although he had published only marginal studies on Titian's work. When he was casting about for the subject of his next annual course at the Institute of Fine Arts several years ago, it was suggested to him that he give the course on Titian. Reluctant at first, in a week or two he sent word that Titian would indeed be the subject and that he was already hard at work in preparation. The following year Pan was asked to give the second series of Wrightsman Lectures, and this time he chose Titian of his own accord. He insisted, however, that he would only discuss some problems that aroused his curiosity when studying Titian's work, mostly connected with content rather than with style, questions of authenticity, or date. Later, as he prepared the lectures for publication, he wrote that they would "not pretend to give an overall picture of Titian's development and importance but may enable the reader to draw his own conclusions with the aid of fairly copious footnotes and excurses." He added something also about the illustrations: they "were made from the best available originals and are all in black and white, not in spite but because of the fact that Titian was the greatest 'colorist' who ever lived."

The text of these lectures on Titian proved to be Pan's last major work. When he died in March 1968, the book had reached the stage of page proofs.

We should like to thank the friends and colleagues of Erwin Panofsky whose help he would have acknowledged in his preface. Only he himself could have named them all. Unable to reconstruct the list, we ask them to accept our thanks on his behalf. But we do know that he would have wanted to express his appreciation to Mr. and Mrs. Charles B. Wrightsman, who have made the Wrightsman Lectures and their publication

v

possible. He greatly enjoyed being Wrightsman Lecturer, and his sojourn in New York for the lectures themselves was a very happy time.

The final correcting of the proofs was the work of Mrs. Gerda Panofsky, who also prepared the index, and Professor H. W. Janson. All concerned with the publication of this book are profoundly grateful to them for their devotion to this task.

The Institute of Fine Arts

Contents

I Introduction 1

II Some Biblical and Hagiological Problems 27

III Counterpoint: Mediaeval and Classical Formulae in Disguise 58

IV Reflections on Time 88

V Reflections on Love and Beauty 109

VI Titian and Ovid 139

Excursuses

1 Some Bibliographical Notes 172

2 The Problem of Titian's Birth Date 176

3 The *Battle of Cadore* 179

4 Titian and Seisenegger 182

5 The Portraits of Empress Isabella 184

6 The *Allegory of Religion* 186

7 The "*Pardo Venus*" in the Louvre 190

List of Illustrations

Frontispiece. Titian, *Self-Portrait*. Madrid, Prado

1. Titian, *Portrait of His Father* (?). Milan, Pinacoteca Ambrosiana
2. Giovanni Bellini and Titian, *The Feast of the Gods*. Washington, National Gallery of Art (Widener Collection)
3. Jacopo Bassano, *The Purification of the Temple*, detail showing Titian as a Money-Lender. London, National Gallery
4. Orlando Flacco (Fiacco), *Portrait of Titian*. Stockholm, Nationalmuseum
5. Titian, *Portrait of Federico Gonzaga, Duke of Mantua*. Madrid, Prado
6. Titian, *Portrait of Charles V*. Madrid, Prado
7. Titian, *Self-Portrait*. Berlin, Staatliche Museen, Gemäldegalerie
8. Titian, *Portrait of Isabella of Portugal, Wife of Charles V*. Madrid, Prado
9. Titian, *Portrait of Pietro Aretino*. Florence, Palazzo Pitti
10. Wrongly ascribed to Titian, *Portrait of a Girl ("Violante")*. Vienna, Kunsthistorisches Museum
11. Titian, *Portrait of Pietro Aretino*. New York, Frick Collection
12. Titian, *Crowning with Thorns*. Munich, Alte Pinakothek
13. Detail of Figure 12
14. Titian, *Assumption of the Virgin ("Assunta")*. Venice, S. Maria Gloriosa de'Frari
15. Titian, *Polyptych*. Brescia, SS. Nazzaro e Celso
16. Titian, *First Altarpiece of Jacopo Pesaro*. Antwerp, Musée Royal des Beaux-Arts
17. Titian, *The Venus of Urbino*. Florence, Uffizi
18. Titian, *Transfiguration*, Venice, S. Salvatore
19. Raphael, *Sistine Madonna*. Dresden, Gemäldegalerie
20. Titian, *Crowning with Thorns*. Paris, Louvre
21. Titian, *Annunciation*. Venice, S. Salvatore
22. Marcello Venusti after Michelangelo, *Annunciation*. Rome, Galleria Nazionale d'Arte Antica
23. Titian, *Pietà*. Venice, Galleria dell'Accademia
24. *Adonis Sarcophagus* (detail). Mantua, Palazzo Ducale
25. Michelangelo, *Moses*. Rome, S. Pietro in Vincoli
26. Donatello, *Abraham*. Florence, formerly Campanile (as shown here), now Museo dell'Opera di S. Maria del Fiore
27. Michelangelo, *The Risen Christ*. Rome, S. Maria sopra Minerva
28. Michelangelo, *Pietà*. Rome, St. Peter's
29. Titian, *The Fall of Man*. Madrid, Prado
30. Raphael (School), *The Fall of Man*. Fresco. Rome, Vatican, Loggie
31. Dürer, *The Fall of Man*. Engraving B. 1 (first state). New York, Metropolitan Museum of Art (Fletcher Fund, 1919)

32. Rubens after Titian, *The Fall of Man*. Madrid, Prado

33. Titian, *Annunciation*. Venice, Scuola di S. Rocco

34. Detail of Figure 33

35. Titian, Three Ceiling Paintings, proposed original arrangement. Venice, S. Maria della Salute

36. Titian, *Cain Slaying Abel*. Venice, S. Maria della Salute

37. Titian, *Sacrifice of Isaac*. Venice, S. Maria della Salute

38. Titian, *David's Triumph over Goliath*. Venice, S. Maria della Salute

39. Altichiero, *Martyrdom of St. George*. Fresco (detail). Padua, Oratorio di S. Giorgio

40. Titian, *St. John on Patmos*. Washington, National Gallery of Art (Samuel H. Kress Collection)

41. Titian, *Presentation of the Virgin*. Venice, Galleria dell'Accademia

42. Detail of Figure 41

43. Cima da Conegliano, *Presentation of the Virgin*. Dresden, Gemäldegalerie

44. Sebastiano Serlio, *Tragic Scene*. Woodcut from *Il Libro primo dell' architettura*, Venice, 1551, fol. 29v

45. Dürer, *Presentation of the Virgin*. Woodcut B. 81. New York, Metropolitan Museum of Art (Rogers Fund, 1918)

46. Giovanni Domenico Tiepolo, *Flight into Egypt*. Etching from *Idee pittoresche sopra la Fugga in Egitto*. Washington, National Gallery of Art (Rosenwald Collection)

47. Titian, *The Perpetual Intercession of the Virgin Mary*. Medole, Collegiata

48. Miguel Esteve (?), *Christ and the Redeemed Patriarchs Appearing to the Virgin Mary*. Williamstown, Williams College Museum of Art

49. Guido Reni, *Intercession of the Virgin Mary in Limbo*. Dresden, Gemäldegalerie (destroyed?)

50. Titian, *Salome*. Rome, Galleria Doria-Pamphili

51. Pieter Cornelisz van Rijck, *Salome*. New York, art market

52. Guercino, *Salome Visiting John the Baptist in Prison*. London, Collection Denis Mahon

53. Titian, *The Miracle of the Newborn Infant*. Fresco. Padua, Scuola del Santo

54. Donatello, *The Miracle of the Newborn Infant*. Padua, S. Antonio

55. Titian, *St. Margaret*. Escorial

56. Titian, *St. Margaret*. Madrid, Prado

57. *Orestes Sarcophagus* (detail). Rome, Lateran

58. Opicinus de Canistris, *St. Martha, the Tarasque and St. Margaret*. Rome, Vatican Library, Cod. Vat.Lat. 6435, fol. 52v

59. Titian, *Martyrdom of St. Lawrence*. Venice, Gesuiti Church

60. Titian, *Martyrdom of St. Lawrence*. Escorial

61. Marcantonio Raimondi after Bandinelli, *Martyrdom of St. Lawrence*. Engraving B. 104. New York, Metropolitan Museum of Art (Dick Fund, 1917)

62. Marcantonio Raimondi after Raphael (?), *The Standard Bearer*. Engraving B. 481. New York, Metropolitan Museum of Art (Dick Fund, 1944)

63. *Fallen Gaul*. Venice, Museo Archeologico

64. Detail of Figure 59

65. Cornelis Cort after Titian, *Martyrdom of St. Lawrence*. Engraving. Rome, Gabinetto Nazionale delle Stampe

66. Titian, *Triumph of Faith*. Woodcut (details). New York, Metropolitan Museum of Art (Whittelsey Fund, 1949)

67. Titian, *Triumph of Faith*. Woodcut (details). New York, Metropolitan Museum of Art (Whittelsey Fund, 1949)

68. Titian, *Triumph of Faith*. Woodcut (detail). New York, Metropolitan Museum of Art (Whittelsey Fund, 1949)

69. *Triumph of Divinity* (originally *Eternity*). North French tapestry. Vienna, Kunsthistorisches Museum

70. *The Shulamite Woman on the "Quadriga Christi"*. Vienna, Nationalbibliothek, Cod. 942, fol. 79v

71. *Crucifixion*. Copy after a miniature in Herrade of Landsberg's *Hortus Deliciarum* (destroyed)

72. *Triumph of Chastity*. North French tapestry. Vienna, Kunsthistorisches Museum

73. Titian, *"La Gloria"*. Madrid, Prado

74. Dürer, *All Saints Altarpiece* (the *"Landauer Altarpiece"*). Vienna, Kunsthistorisches Museum

75. Michelangelo. *Last Judgment*. Fresco (detail). Rome, Sistine Chapel

76. *The Trinity*. Paris, Bibliothèque Nationale, MS. Lat. 18014, fol. 137v

77. *"La Cour Céleste"*. Paris, Bibliothèque Ste.-Geneviève, MS. 246, fol. 406

78. Jacob Cornelisz van Oostsanen, *All Saints Altarpiece*. Kassel, Gemäldegalerie

79. Enguerrand Quarton, *Coronation of the Virgin* (detail). Villeneuve-lès-Avignon, Carthusian Church

80. Titian, *Allegory of the Battle of Lepanto*. Madrid, Prado

81. *"Ad te levavi" Initial*. Paris, Bibliothèque Nationale, MS. Lat. 17318, fol. 18

82. Titian, *Portrait of Alfonso d'Avalos, Marchese del Vasto*. Paris, Collection Marquis de Ganay

83. Titian, *Allocution of Alfonso d'Avalos, Marchese del Vasto*. Madrid, Prado

84. Jan Stevensz of Calcar, *"Secunda Musculorum Tabula"*. Woodcut from Andreas Vesalius, *Fabrica Corporis Humani*

85. *"Adlocutio Augusti"*. Coin of Gordian III

86. Domenico Ghirlandaio (Workshop), *"Adlocutio"*. Fresco. Florence, S. Trinita

87. Giulio Romano, *Allocution of Constantine*. Fresco. Rome, Vatican

88. Giovanni Battista Tiepolo, *Allocution of Queen Zenobia*. Washington, National Gallery of Art (Samuel H. Kress Collection)

89. Titian, *Portrait of Pope Paul III and His Grandsons, Alessandro Cardinal Farnese and Ottavio Farnese*. Naples, Galleria Nazionale di Capodimonte

90. Raphael, *Portrait of Pope Leo X and His Nephews, Giulio Cardinal de' Medici and Lodovico Cardinal de' Rossi*. Florence, Uffizi

91. *Mercury Receiving the Newborn Bacchus*. Roman relief (left-hand section). Rome, Musei Vaticani

92. Titian, *Portrait of Jacopo Strada*. Vienna, Kunsthistorisches Museum

93. Hans Holbein the Younger, *Portrait of Georg Gisze*. Berlin, Staatliche Museen, Gemäldegalerie

94. Lorenzo Lotto, *Portrait of Andrea Odoni*. London, Hampton Court

95. *Mother and Child*. Attic Stele. Avignon, Musée Calvet

96. Titian, *Portrait of Charles V*. Munich, Alte Pinakothek

97. Titian, *Portrait of Charles V on Horseback*. Madrid, Prado

98. Detail of Figure 97

99. Dürer, *The Christian Knight*. Engraving B. 98. New York, Metropolitan Museum of Art (Dick Fund, 1943)

100. *"Profectio Augusti"*. Coin of Trajan

101. *"Profectio Augusti"*. Coin of Marcus Aurelius

102. Velázquez, *Portrait of Philip IV of Spain on Horseback*. Madrid, Prado

103. Rubens (copy), *Portrait of Philip IV of Spain on Horseback*. Florence, Uffizi

104. Titian, *Portrait of Eleonora, Duchess of Urbino*. Florence, Uffizi
105. Michel Colombe and Girolamo da Fiesole, *Tomb of Francis II of Brittany and Marguérite de Foix*. Nantes, Cathedral
106. Rubens(?) after Titian, *Double Portrait of Charles V and Isabella of Portugal*. Madrid, The Duchess of Alba
107. Titian, *"La Vecchia"*. Venice, Galleria dell'Accademia
108. Titian, *Young Woman Doing Her Hair*. Paris, Louvre
109. Titian, *Vanitas*. Munich, Alte Pinakothek
110. Titian, *The Three Ages of Man*. Edinburgh, National Gallery of Scotland (on loan from the Duke of Sutherland Collection)
111. Fra Bartolommeo, *"The Feast of Venus"*. Drawing. Florence, Uffizi
112. Giulio Romano, *"The Feast of Venus"*. Drawing. Chatsworth, Devonshire Collection
113. Titian, *"The Feast of Venus"*. Madrid, Prado
114. Titian, *The Bacchanal of the Andrians*. Madrid, Prado
115. Titian, *Bacchus and Ariadne*. London, National Gallery
116. Domenico Beccafumi, *Two Nudes*. Drawing. Private Collection
117. Titian, *Allegory of Prudence*. London, National Gallery
118. *Personification of Prudence*. Niello Pavement (detail). Siena, Cathedral
119. Antonio Rossellino (School), *Personification of Prudence*. London, Victoria and Albert Museum
120. Baccio Bandinelli, *The Three Forms of Time*. Drawing. New York, Metropolitan Museum of Art (Rogers Fund, 1963)
121. *Serapis*. Coin of Caracalla
122. *The Companion of Serapis ("Signum triceps" or "Tricipitium")*. Graeco-Egyptian statuette. Engraving from L. Begerus, *Lucernae . . . iconicae*, Berlin, 1702
123. *Apollo Enthroned on the "Signum Triceps"*. Rome, Vatican Library, Cod. Reg. Lat. 1290, fol. 1 v
124. Jan Collaert after Giovanni Stradano, *Sol-Apollo Accompanied by the "Signum Triceps"*. Engraving
125. *"Simulachro di Serapi"*. Woodcut from Francesco Colonna, *Hypnerotomachia Polyphili*, Venice, 1499, fol. Y 1
126. *Good Counsel ("Consiglio")*. Woodcut from Cesare Ripa, *Iconologia*, Venice, 1643
127. Artus Quellinus the Elder, *Allegory of Good Counsel*. Amsterdam, Paleis. Engraving from J. van Campen, *Afbeelding van't Stad-Huys van Amsterdam*, 1664-68, Pl. Q
128. Titian, *"Sacred and Profane Love"*. Rome, Galleria Borghese
129. *Nereid Sarcophagus*. Pisa, Camposanto
130. *St. Basil between "Worldly Happiness" and "Heavenly Life"*. Paris, Bibliothèque Nationale, MS. Grec 923, fol. 272
131. *Nature and Divine Grace (?) at the Fountain of Life*. Medal of Constantine the Great, formerly in the collection of Jean Duc de Berry (from plaster cast). Paris, Bibliothèque Nationale
132. Giovanni Dentone, *Venus Urania*. Padua, Loggia Cornaro
133. Detail of Figure 128
134. Titian, *Venus*. Florence, Uffizi
135. Titian, *Venus with an Organ Player*. Berlin, Staatliche Museen, Gemäldegalerie
136. Titian, *Venus with an Organ Player*. Madrid, Prado
137. Titian, *Venus (?) with an Organ Player*. Madrid, Prado
138. Titian, *Venus with a Lute Player*. Cambridge, Fitzwilliam Museum
139. Ascribed to Titian, *Venus with a Lute Player*. New York, Metropolitan Museum of Art (Munsey Fund, 1936)

140. Titian, *"Allegory of Alfonso d'Avalos, Marchese del Vasto"*. Paris, Louvre

140a. Titian, *"Allegory of Alfonso d'Avalos, Marchese del Vasto"*. Underdrawing discovered and salvaged when the picture was recanvased. Paris, Louvre

141. Detail of Figure 140

142. *Roman Couple (Commodus and Crispina?) in the Guise of Mars and Venus.* Rome, Museo Capitolino

143. Paris Bordone, *Married Couple in the Guise of Mars and Venus.* Vienna, Kunsthistorisches Museum

144. Titian, *"Education of Cupid"*. Rome, Galleria Borghese

145. *Eros and Anteros.* Woodcut from Andrea Alciati, *Emblemata*, Paris (Wechel), 1534, p. 76

146. Guido Reni, *Eros and Anteros.* Pisa, Museo Nazionale di S. Matteo

147. Niccolò Fiorentino (?), *The Three Graces.* Medal of Pico della Mirandola. London British Museum

148. Niccolò Fiorentino (?), *The Three Graces.* Medal of Giovanna degli Albizzi, Wife of Lorenzo Tornabuoni

149. Bartolomeo Veneto, *Bridal Portrait of a Lady.* Frankfurt, Städelsches Kunstinstitut

150. Titian, *Danaë.* Naples, Galleria Nazionale di Capodimonte

151. Rembrandt, *Danaë.* Leningrad, Hermitage

152. After Primaticcio, *Danaë.* Tapestry. Vienna, Kunsthistorisches Museum

153. Rosso Fiorentino after Michelangelo, *Leda.* London, National Gallery

154. *Leda.* Drawing after a classical relief. Veste Coburg, Kunstsammlungen. MS. HZ II (*Codex Coburgensis*)

155. Titian, *Tityus.* Madrid, Prado

156. Giulio Sanuto after Titian, *Tantalus.* Engraving. London, British Museum

157. Titian, *Sisyphus.* Madrid, Prado

158. Titian, *Danaë.* Madrid, Prado

159. Titian, *Adonis Taking Leave from Venus.* Madrid, Prado

160. *"Bed of Polyclitus"*. Ashford, Kent, Collection K. J. Hewett

161. Raphael (School), *The Marriage Feast of Psyche*, Fresco (detail). Rome, Villa Farnesina

162. Hans Bol (or after Hans Bol), *Venus Taking Leave from Adonis.* Etching. Amsterdam, Rijksmuseum

163. Titian, *Diana Surprised by Actaeon.* Edinburgh, National Gallery of Scotland (on loan from the Duke of Sutherland Collection)

164. Titian, *Diana Discovering the Pregnancy of Callisto.* Edinburgh, National Gallery of Scotland (on loan from the Duke of Sutherland Collection)

165. Ugo da Carpi(?) after Parmigianino, *The Bath of Diana.* Chiaroscuro Woodcut. London, British Museum

166. *Diana Surprised by Actaeon.* Woodcut in *P. Ovidii Metamorphosis*, Venice (J. Thacuinus), 1513, p. xix, reversed copy after the corresponding woodcut in the first illustrated edition, Venice (Z. Rosso), 1497

167. *Diana Surprised by Actaeon.* Woodcut in Lodovico Dolce, *Le Trasformationi*, Venice (G. Giolito), 1553, p. 63

168. Bernard Salomon, *Diana Surprised by Actaeon.* Woodcut in *La Métamorphose d'Ovide figurée*, Lyons (J. de Tournes), 1557, No. 42

169. *The Story of Callisto.* Woodcut in *P. Ovidii Metamorphosis*, Venice (J. Thacuinus), 1513, p. xxii, reversed copy after the corresponding woodcut in the first illustrated edition, Venice (Z. Rosso), 1497

170. *The Story of Callisto.* Woodcut in Lodovico Dolce, *Le Trasformationi*, Venice (G. Giolito), 1553, p. 44

171. Rembrandt, *Diana Surprised by Actaeon; Diana Discovering the Pregnancy of Callisto.* Anholt, Wasserburg, Prince Salm-Salm

172. Titian, *Diana Discovering the Pregnancy of Callisto.* Vienna, Kunsthistorisches Museum

173. Titian, *Death of Actaeon.* London, Earl of Harewood (on deposit in the National Gallery, London)

174. Bernard Salomon, *Death of Actaeon.* Woodcut from *La Métamorphose d'Ovide figurée,* Lyons (J. de Tournes), 1557, No. 43

175. Titian, *Abduction of Europa.* Boston, Isabella Stewart Gardner Museum

176. Titian, *Perseus Liberating Andromeda.* London, Wallace Collection

177. Dürer, *Abduction of Europa.* Drawing L. 456 (left-hand section). Vienna, Albertina

178. Bernard Salomon, *Abduction of Europa.* Woodcut from *La Métamorphose d'Ovide figurée,* Lyons (J. de Tournes), 1557, No. 38

179. Bernard Salomon, *Perseus Liberating Andromeda.* Woodcut from *La Métamorphose d'Ovide figurée,* Lyons (J. de Tournes), 1557, No. 6

180. X-Ray Photograph of Figure 176

181. *Perseus Liberating Andromeda.* Woodcut from *Ovidio Metamorphoseos vulgare,* Venice (A. di Bandoni), 1508, IV, 48, printed from the same block as the corresponding woodcut in the first illustrated edition, Venice (Z. Rosso), 1497

182. Titian, *"Nymph and Shepherd".* Vienna, Kunsthistorisches Museum

183. Giulio Campagnola after Giorgione, *Reclining Nude.* Engraving. Cleveland Museum of Art (gift of the Print Club of Cleveland)

184. *Paris as a Shepherd.* Drawing after the end of a Roman sarcophagus at Ince Hall. Veste Coburg, Kunstsammlungen, MS. HZ II (*Codex Coburgensis*)

185. Titian, *Portrait of Jacopo Pesaro,* detail of Figure 16

186. Titian, *Portrait of Jacopo Pesaro,* detail of the *"Pala Pesaro".* Venice, S. Maria Gloriosa de'Frari

187. Giulio Fontana after Titian, *The Battle of Cadore.* Engraving. London, British Museum

188. Titian (copy), *The Battle of Cadore.* Florence, Uffizi

189. Titian, *The Battle of Cadore.* Drawing. Paris, Louvre

190. Jakob Seisenegger, *Portrait of Charles V.* Vienna, Kunsthistorisches Museum

191. Hans Burgkmair, *Maximilian I Visiting Hans Burgkmair in His Studio.* Woodcut destined for the *Weiss-Kunig*

192. Pieter de Jode after Titian, *Portrait of Isabella of Portugal, Wife of Charles V.* Engraving. Rome, Gabinetto Nazionale delle Stampe

193. Titian, *"La Religione".* Madrid, Prado

194. Giulio Fontana after Titian, *"La Religione".* Engraving. London, British Museum

195. Titian and Assistants, *"La Religione".* Rome, Galleria Doria-Pamphili

196. François Boitard, *Bellona.* Engraving from L. G. Gyraldus, *Opera omnia,* Leyden, 1696, I, Plate following cols. 75, 76

197. Titian, *Pardo Venus,* Paris, Louvre, Infra-red Photograph

198. Detail of Figure 197

199. After Titian, *Pan and Silvanus* (?). Drawing. New York, Collection Curtis O. Baer

Abbreviations

B.: A. Bartsch, *Le Peintre graveur*, Vienna, 1803-21.

C.-C.: J. A. Crowe and G. B. Cavalcaselle, *Titian: His Life and Times*, first ed., London, 1877.

L.: F. Lippmann, *Zeichnungen von Albrecht Dürer in Nachbildungen*, Berlin, 1883-1929.

P.-C.: *Lettere sull'arte di Pietro Aretino, commentate da F. Pertile, a cura di E. Camesasca*, Milan, 1957-60.

T.: H. Tietze, *Titian: The Paintings and Drawings*, New York, 1950.

V.: F. Valcanover, *Tutta la pittura di Tiziano*, Milan, 1960.

I

Introduction

According to legend St. Augustine, while meditating upon the Trinity, tried to clear his thoughts by a walk on the seashore. Here he observed a little boy busily scooping up water with a spoon or scallop shell and pouring it upon the sands. When asked what he was doing the boy replied that he was emptying the ocean; it then dawned upon the Saint that any human mind attempting to penetrate the mystery of the Trinity was acting as the child was acting.

The moral of this charming tale — a product of the fourteenth century — applies to the art historian who tries to speak about Titian. He cannot empty the ocean either. And when restricted to a few lectures, he will find it advisable to leave the water alone and to limit himself to collecting quaintly shaped pebbles, sea urchins, conchs, and starfish which the tide has left on the beach and which have happened to attract his attention. In non-metaphorical language: I shall confine my discussion to a few special problems, mostly iconographic, which have aroused my curiosity and which I present to this gentle audience in the fond hope that this curiosity may be shared.

This discussion must start, however, with a few introductory remarks enabling us to "place," as Henry James would say, the works to be considered later. And these introductory remarks cannot, unfortunately, begin with the classic formula: "N.N. was born on such-and-such a day in such-and-such a year."

We know a good deal about Titian's birthplace, Pieve di Cadore. The chief borough of a mountainous borderline district between the Alps and the North Italian plain, this area was rich in lumber, ore and dairy products, but so poor in grain that three-quarters of the annual supply had to be imported, stored away and distributed under official supervision. Cadore had once formed part of the German Empire; but in 1420 it had

accepted the rule of Venice while retaining a considerable degree of independence. We also know a good deal about Titian's family, the Vecelli (originally spelled Guecelli), who can be traced back to the end of the thirteenth century. Unfailingly loyal to the "Serenissima" (as the municipal government of Venice is called to this day), Titian's fifteenth-century forbears, though not rich, were prominent and respected as businessmen, lawyers, public servants, and officers of the regional militia. Titian's own father, Gregorio di Conte Vecelli (died 1534), held such honorable offices as overseer of the grain stores just mentioned, inspector of mines and captain of the militia of Pieve di Cadore. Titian is said to have portrayed him "in armor," and I see no reason to doubt the old tradition which identifies this portrait with a small painting now in the Ambrosian Library at Milan (Fig. 1).[1]

The date of Titian's birth, however, has been — and still is — a subject of agitated debate. It is certain that he died on August 27, 1576 during a plague (but probably not of it, since he was solemnly buried in S.M. Gloriosa dei Frari on the following day); and certain it is that he lived to a very old age. But the evidence regarding the exact number of years allotted to him is so contradictory that it defies evaluation. The contemporary sources place the date of his birth in 1477, so that he would have died at ninety-nine; in 1473, so that he would have lived to a hundred and three; and in the years between 1488 and 1490, so that he would have reached an age of only between eighty-six and eighty-eight. My personal opinion, which I shall attempt to substantiate in an Excursus (pp. 176 ff.), is that he was born in the first half of the 'eighties (c. 1482) and thus was in his early nineties when he died.

Be that as it may, Titian and his probably older brother, Francesco, appear to have been the first painters produced by a family previously not remarkable for artistic talent (though both of them inherited the more practical abilities of their ancestors). Francesco retired to Pieve di di Cadore in 1527 to become a professional lumber and grain merchant while Titian practiced both these trades — occasionally even that of money lender — as an amateur but no less efficiently.

1. *V.*, ɪ, Pl. 134. The Ambrosian Library received the picture from its founder, Federigo Cardinal Borromeo (1564-1631), and as early as 1618 it is listed as a portrait of Titian's father. We know from a trustworthy source — the funeral oration on Titian's brother, Francesco, delivered in 1559 by a relative, Vincenzo Vecelli (S. Ticozzi, *Vite dei pittori Vecelli di Cadore*, Milan, 1817, p. 321) — that Titian, complying with his father's wish, had portrayed him "in armor"; and the style of the Milan picture is quite compatible with a date slightly earlier than 1534 when Gregorio di Conte Vecelli died.

Titian's gift for painting seems to have manifested itself at an early date: tradition has it that he was sent to Venice at the tender age of nine or ten, to be apprenticed to a painter and mosaicist named Sebastiano Zuccato. From this workshop, where he had little to learn, he seems to have wandered into that of Gentile Bellini and from here into that of the latter's probably younger brother, Giovanni, where he made friends with Palma Vecchio, his senior by a few years. There is reason to believe, however, that he was already on his own by c. 1503 (according to my calculation, at the age of about twenty); and five years later, in 1508, he joined forces — as a junior partner rather than as a mere assistant — with Giorgione. They shared in the exterior decoration of the Fondaco dei Tedeschi, the commercial and social center for German merchants operating in Venice. After a conflagration in 1505, the Serenissima had authorized its speedy reconstruction with the significant proviso that neither marble nor tracery be used. Thus the exterior had to be decorated with murals, which have fared so badly in the Venetian climate that most of them can be studied only in prints of the seventeenth and eighteenth centuries.[2]

The desolation visited upon the Republic by the wars against Maximilian I and the League of Cambrai (the latter beginning in 1508), and by a plague (of which Giorgione died in 1510), seems to have caused Titian to move to Padua where he stayed from the end of 1510 to the end of 1511 or the beginning of 1512. And it was here that he produced the earliest authenticated and firmly dated work preserved in reasonably good condition: a series of three frescoes from the life of St. Anthony of Padua in the Scuola del Santo, one of which (Fig. 53) will be discussed later (pp. 48f.).

2. Of the frescoes on the Fondaco only two pale and shadowy figures, mentioned but not illustrated in *V.*, i, p. 78f., have been detached and removed to other locations: a *Female Nude* by Giorgione, now preserved in the Accademia, and Titian's "*Compagno della Calza*" (viz., a member of a club of young patricians exempt from the sumptuary laws and expected to provide splendid parades and spectacles at carnival time), now preserved in the Palazzo Ducale; for a reproduction of Giorgione's *Nude*, see M. Muraro et al., *Pitture murali nel Veneto e tecnica dell'affresco* (Fondazione Cini, *Cataloghi di Mostre*, xii), Venice, 1960, p. 98f., Fig. 65. I learned recently from my friend Dr. Carl Nordenfalk that the frescoes still *in situ* are not so hopelessly ruined as is generally assumed and that attempts are being made to salvage what remains of them; but for the time being we have to rely on the prints by Giacomo Piccini and Antonio Maria Zanetti (*V.*, ii, Pls. 186, 187). For the iconography of the Fondaco frescoes, see C. Nordenfalk, "Titian's Allegories on the Fondaco de'Tedeschi," *Gazette des Beaux-Arts*, series 6, xl, 1952, pp. 101 ff.

After his return from Padua (via Vicenza, where he is said to have adorned the Loggia of the Palazzo della Ragione with a fresco, appropriately showing the Judgment of Solomon, which was destroyed when the Palazzo was rebuilt by Palladio) Titian's rise to fame and fortune was rapid and uninterrupted though rather stormy at times. In 1513 — I limit myself to a few salient facts — he was renowned enough to be called to Rome (apparently at the instigation of Pietro Bembo); but he used this invitation only as a lever to obtain an official position in Venice: on May 31, 1513, he offered to replace a ruined Trecento mural in the Sala del Maggior Consiglio with a battle scene in oils — a task which, to quote his application *ad verbum*, "no other painter has ever dared undertake." He did not ask for money but only for a studio, two assistants and an assurance of receiving the first broker's patent (*senseria*) which would fall vacant at the Fondaco. This was a kind of sinecure which elevated the incumbent to the rank of official painter to the Serenissima and brought him an annual salary of three-hundred *scudi* or one-hundred ducats (tax-exempt!) in return for providing a portrait and a votive image, as well as a shield to be affixed to the "Bucentoro," for every Doge elected during the painter's tenure.

Titian's proposal — not very tactful since the "first broker's patent which would fall vacant" was obviously that of his old teacher, Giovanni Bellini (then about eighty) — was accepted in June 1513 and Titian was installed in a workshop near S. Samuele. But very soon afterward (March 24, 1514) the appointment was rescinded — only to be reconfirmed on November 29th of the same year. The reason for this curious vacillation is, it would seem, that Giovanni Bellini, angered by Titian's lack of consideration and possibly favoring a different successor, had first obtained the revocation of the original appointment but had come to terms with Titian shortly afterward, agreeing to withdraw his objections while Titian on his side agreed to drop, temporarily at least, his claim to the "next vacant *senseria*" and, more importantly, to finish Bellini's *Feast of the Gods* (Washington) which the old master had always considered a burden (Fig. 2).[3] It is hardly an accident that this much-debated picture

3. For Bellini's *Feast of the Gods*, see E. Wind, *Bellini's Feast of the Gods*, Cambridge, Mass., 1948; J. Walker, *Bellini and Titian at Ferrara*, London, 1956; H. Bardon, *Le Festin des dieux; Essai sur l'humanisme dans les arts plastiques*, Paris, 1960, pp. 1 ff.

In 1505, after long negotiations conducted through Pietro Bembo, Bellini consented to paint a *poesia* — subject as yet undetermined — for the "Studiolo" of Isabella d'Este in the Castello di Corte at Mantua, reserving for himself more freedom than this authoritarian lady accorded to the other painters involved in her

was completed (according to Vasari with Titian's help) and signed by Bellini in precisely the year, even the month (November 14, 1514, as we happen to know), of the Serenissima's second reversal.

In 1517, after Giovanni Bellini's death on November 29th of the preceding year, Titian actually received the latter's broker's patent and kept it — with a brief interruption from June 23, 1537 to August 28, 1539 — for more than half a century. The interruption was caused by Titian's failure to produce the battle piece which he had offered to supply more than twenty years before. He could be persuaded to deliver it only by the most stringent measures.

This delay in delivering what is normally — and, I believe, correctly — referred to as *The Battle of Cadore* (destroyed by a disastrous fire on

enterprise. Since both parties seem to have lost patience with each other after a while, Isabella's brother, Alfonso d'Este, seems to have secured the picture for his own Studio in the Castello at Ferrara, where it formed the nucleus of a decoration to which Titian was soon to contribute the "*Feast of Venus*," the *Bacchanal of the Andrians* and the *Bacchus and Ariadne* (see pp. 98 ff. and 141 ff., Figs. 113, 114, 115). There is, however, no evidence that Bellini went to Ferrara in person and finished the picture there. The remark in the record of payment of November 14, 1514, according to which it had been completed "instante domino nostro" means not that this happened "in the very presence of Alfonso" (*C.-C.*, I, p. 174) but "at Alfonso's insistence."

As far as the painting itself is concerned, the X-ray photographs analyzed in Walker's book (with which I agree despite some recent objections) strongly suggest that Titian intervened twice: first, in 1514, when the picture was still unfinished and when he largely limited himself to minor changes and additions, particularly to covering areas not as yet touched by Bellini's brush (I find it difficult to interpret even these minor changes as *pentimenti* effected by Bellini himself because they transcend, it seems to me, the possibilities of even his latest phase); second, after the picture had been put in place and had to be harmonized with Titian's independent

and somewhat later contributions (Figs. 113, 114, 115). This second intervention, therefore, amounted to an actual superimposition of Titian's work upon Bellini's, from which resulted a profound change in style and tone: the landscape was entirely revised (so much so that in this area the thickness of the coat of paint measurably and visibly exceeds that in the lower zone of the picture); attributes were added to several figures; and the postures and gestures of many prominent characters, originally calm and dignified, were changed in favor of the more licentious spirit which pervades the "*Feast of Venus*" and the *Bacchanal of the Andrians*. This second transformation may have taken place during any of Titian's numerous visits to Ferrara in the third decade of the century: 1523-1524, 1525, 1528, 1529. The hypothesis of a double intervention not only fits in with the wording of Vasari's statement (VII, p. 433), which — presumably reflecting Titian's own recollection — assures us of the fact that *la quale opera* (i.e., the *Feast of the Gods* discussed at length in the preceding lines) was "not entirely finished by Bellini because of his great age," but also explains the curious goings-on in 1513 and 1514 (see text) which, far from testifying to an irreversible enmity between old Bellini and young Titian, suggest a kind of final accommodation advantageous to both.

December 20, 1577; cf. Figs. 187-189)[4] was excessive even for Titian. Battle pieces, it is true, were not his forte; but in other cases, too, procrastination was almost the rule with him — resulting, as nearly everything in human affairs, from the interaction of inclination and circumstance.

Titian, it must be admitted, loved money. He charged high prices and collected benifices and pensions, one of which (exceptionally payable in cash instead of in wood or grain) was so difficult to come by that he referred to it as a "passion rather than a pension" (*passione piuttosto che pensione*). He dealt in lumber and grain. He invested his money in real estate, gold or jewels and occasionally lent it out on proper security. Nearly all his letters are concerned with business matters, and not for nothing did Jacopo Bassano cast Titian — clearly recognizable by his hawk-like features and his inevitable skull-cap — in the role of chief money changer in a *Purification of the Temple* (Fig. 3).[5] Yet he was neither a Balzacian miser nor an unmitigated egotist. He could be more than liberal when the occasion demanded it. He lived in a seignorial style, entertaining as royally as he was being entertained (in 1531 he had moved to a big house, surrounded by a beautiful garden, whence he could see on a clear day the contours of his native mountains). He was a loyal friend, a loyal son of Cadore and a loyal servant of the Serenissima; he was also a brilliant conversationalist, and deeply musical. In 1540 he acquired an organ (significantly not for cash but in exchange for a portrait of the builder, Alessandro degli Organi); and while Jacopo Bassano portrayed him as a money changer, Paolo Veronese showed him playing the bass viol in the famous *Wedding of Cana* now in the Louvre.

Living as he did, Titian was constitutionally unable to refuse a good commission even if it interfered with obligations already incurred. And from as early as c. 1510 such commissions were showered upon him not

4. See pp. 179 ff., *Excursus* 3.

5. London, National Gallery, the pertinent group reproduced in L. Foscari, *Iconografia di Tiziano*, Venice, 1935, Pl. 31. I cannot see any reason to doubt Titian's identity as does C. Gould, *National Gallery Catalogues*; *The Sixteenth-Century Venetian School*, London, 1959, pp. 11 f. Bassano's "Money Lender" bears a perfectly striking resemblance to Titian as he appears in the unflattering but for this very reason compellingly convincing portrait by a professional portraitist, Orlando Flacco (or Fiacco) da Verona (Fig. 4). In this painting, preserved in the Nationalmuseum at Stockholm (cf. Thieme-Becker, *Allgemeines Künstlerlexikon*, xii, p. 61) but, so far as I know, published only in O. Sirén, "Italian Pictures in Sweden, II", *Burlington Magazine*, VI, 1904, pp. 59 ff., Plate facing p. 64, the great painter looks as one would imagine Shakespeare's Shylock to have looked.

only from Venice itself but also by municipal and ecclesiastical com-
munities ranging from Brescia and Ancona to Naples and, even more
importantly, by countless princes and their entourages. To mention only
the most prominent of his aristocratic patrons: his first connection of this
kind was that with Alfonso d'Este, Duke of Ferrara, the brother of Isabella
d'Este; it is to this connection — formed as early as 1515-16 — that we
owe, e.g., the *Bacchanal* and the "*Feast of Venus*" in the Prado as well as the
Bacchus and Ariadne in the National Gallery at London (Figs. 113, 114,
115) and the *Tribute Money* in Dresden. From 1523 he began to work for
Isabella's son, Federico Gonzaga, Duke of Mantua (Fig. 5), whose court,
rich in art treasures ancient and modern and from 1524 graced by the
presence of Giulio Romano, he visited with some regularity for almost
twenty years. From the 'thirties on he was frequently employed by the
court of Urbino, ruled by Isabella's son-in-law, Francesco Maria della
Rovere, up to his death in 1538 and thereafter by the latter's son,
Guidobaldo II. And in 1542 he made his first contact with the Farnese
family (Fig. 89) whose head, Pope Paul III, sat for him for the first time
in the following year and invited him to Rome in 1545. It was Titian's
only visit to the Eternal City, with two stop-overs (at Urbino and Pesaro)
on his way out and two others (at Florence and Piacenza) on his way
home in 1546.

The most important and most faithful of Titian's princely patrons,
however, was Charles V, the greatest monarch of his time, whom even his
arch enemies, the French, still honor by calling him "Charles-Quint"
rather than "Charles Cinq," much as they honor the formidable Pope
Sixtus V by calling him "Sixte-Quint." Titian seems to have been in-
troduced to the Emperor (by Federico Gonzaga) on the occasion of the
Emperor's coronation in Bologna on February 24, 1530. And from this
first encounter — which produced a portrait of His Majesty in armor,
unfortunately lost — there resulted an artist-and-patron relationship,
extending to the Emperor's whole family and entourage, which is almost
unique in the annals of art.

Charles V — a ruler of men from his sixteenth year, indomitably
courageous in spite of his weak health, aloof and moody to the point of
melancholy (it is characteristic that he renounced his crown and sought
refuge in the Monastery of S. Jeronimo at San Yuste three years before his
death in 1558), yet not without a wry sense of humor — seems to have
been immensely attracted to Titian from the outset. He invited the artist
to join him, again in Bologna, late in 1532 or early in 1533, when a second

portrait was produced (Fig. 6)[6] and when the Emperor conferred upon the painter the rank of Count Palatine as well as the Order of the Golden Spur. The golden chain which went with this distinction is Titian's only ornament in the two self-portraits which have come down to us in the original: the Berlin *Self-Portrait* of c. 1555-60 (Fig. 7), and the unforgettable *Self-Portrait* in the Prado, probably as late as toward 1570, where the old master represented himself in almost pure profile as though he had wished to perpetuate his appearance after the fashion of a classical marble relief or medal, and where his eyes, red-rimmed and more tired than in the earlier picture, yet as penetrating as ever, are no longer focused upon any definite object but seem to be lost in the contemplation of a universe of his own making (*Frontispiece*). In 1548 and again in 1550 Titian was asked to wait upon the Emperor on the occasion of the Diet of Augsburg — with the intent, of course, of using his talents as a portraitist. No less than nine of Titian's pictures accompanied the Emperor into the seclusion of San Yuste.

In Titian's patent of nobility his relationship with Charles V is compared to that between Apelles and Alexander the Great[7] (no other painter would ever be asked to portray His Majesty!) and this is exceptionally more than an empty phrase. It is certainly not true that Charles V, to the pained surprise of his courtiers, picked up a brush which had slipped from Titian's hand. But it is true that the Emperor treated him as an equal in spirit, if not in rank, and that their correspondence occasionally reads like that between two great and equal powers. Not in form, of course. Titian always writes with becoming humility and flattery, never forgetting to kiss His Majesty's "invincible and Catholic hand." In content, however, his letters are no less self-assured than they are obliging. To adduce one characteristic example which also throws light upon Charles

6. Madrid, Prado, *V.*, i, Pl. 132; see pp. 182ff., *Excursus* 4.

7. This time-honored comparison (recently discussed by R. W. Kennedy, "Apelles Redivivus," *Essays in Memory of Karl Lehmann*, New York, 1964, pp. 160ff., and, more circumstantially, by M. Winner, *Die Quellen der Pictura-Allegorien in gemalten Bildergalerien des 17. Jahrhunderts zu Antwerpen*, Diss. Cologne, 1957, pp. 3-40) became hereditary; see Titian's letter to Philip II in *C.-C.*, ii, pp. 278ff. (here dated September 22, 1559) and pp. 515ff. (here dated September 27, 1559). For an

excellent summary of the unique relationship between Titian and Charles V, see H. von Einem, *Karl V. und Tizian* (Arbeitsgemeinschaft für Forschung des Landes Nordrhein-Westfalen, Geisteswissenschaften, Heft 92), Köln-Opladen, 1960; cf. also J. Müller Hofstede "Rubens und Tizian: Das Bild Karls V," *Neue Zürcher Zeitung*, October 2, 1966 (*Literatur und Kunst*, p. 4f.); published in expanded form in *Münchner Jahrbuch der Bildenden Kunst*, xviii, 1967, pp. 33ff. A list of the pictures by Titian which Charles V took with him to San Yuste is found in *C.-C.*, ii, p. 236.

V's real sophistication in artistic matters: four years after the death of his beautiful and dearly-beloved wife, Isabella of Portugal (died 1539), the Emperor provides Titian with a portrait of her, which is described as a very good likeness (*molto simile al vero*) though from a "trivial brush" (*di triviale pennello*), and asks the master, who had never seen the Empress, to use this unambitious piece as the basis for a really good portrait. On October 5, 1545, Titian, having dispatched the portrait, excuses himself for not having delivered it in person (he was too old, he says) and professes his willingness to correct all "faults and failings" (*li falli et mancamenti*) which his Imperial patron might point out to him; but then he adds: "Your Majesty should not, however, permit anyone else to lay hands on my work." This picture, alas, is known to us only through copies (Fig. 192); but a slightly later version, probably executed at Augsburg, is preserved in the Prado (Fig. 8).[8]

In conducting what may be called his official correspondence, particularly in addressing illustrious personages, Titian enjoyed the help of the most controversial of all controversial characters: Pietro Aretino. He had appeared in Venice in 1527, the year of the Sack of Rome, at the same time as Jacopo Tatti (better known as Jacopo Sansovino), the great architect and sculptor to whom the Piazza and Piazzetta of S. Marco owe their final shape. With these two Titian contracted, almost immediately, a life-long friendship. A formidable alliance of the "Three Arts of Design" with literature, this "Triumvirate" wielded an enormous influence and its members were united by genuine affection as well as self-interest. They thoroughly enjoyed each other's company while helping each other in countless practical ways. Sansovino immortalized the features of Aretino and Titian, together with his own, in the medallions on the doors of the Sacristy of St. Mark's. Titian in turn designed silverware for Sansovino and when the Great Hall of the Libreria di San Marco, then in the course of erection, had collapsed, he helped him out of jail and back to favor. Aretino, on the other hand, was not only Titian's best friend — Titian portrayed him four times, apparently without remuneration (Figs. 9, 11) — but also his mentor and, as it were, his public relations man. Always knowing the right form of salutation and the appropriate dosage of flattery, he edited or even "ghost-wrote" Titian's more formal letters (as other literate friends of the painter had done before Aretino's arrival). He

8. Madrid, Prado, *V.*, ii, Pl. 25; see pp. 184 ff., *Excursus* 5.

would write directly to clients who became impatient with Titian's proverbial delays. He composed innumerable descriptions and sonnets in praise of Titian's paintings, and he never tired to inform and entertain him *in literis* when they were separated. Everyone knows his description of a sunset over the Canal Grande — a description in terms of nuances rather than colors — to which only Titian's brush could have done justice. But Aretino's published correspondence includes no less than forty-three other letters addressed to Titian, and in no less than 225 he is mentioned.

This friendship lasted until Aretino's death in 1556.[9] Allegedly he died

9. In addition to incorporating Aretino into one or more of his narrative compositions — notably, in the guise of Pilate, in the Vienna *Ostentatio Christi* of 1543 (*V.*, ɪ, Pls. 174, 175) — Titian is known to have represented him in four independent portraits (see Note 1 in *Le opere di Giorgio Vasari*, ed. G. Milanesi, Florence, 1878-1885, vɪɪ, p. 442). The earliest portrait, executed almost immediately upon Aretino's arrival in Venice and presented to Federico Gonzaga (*C.-C.*, ɪ, pp. 317ff.; *V.*, ɪ, p. 82), is lost; and so is the second, produced for Ippolito Cardinal de'Medici (Vasari, vɪɪ, p. 442). The third is the celebrated portrait in the Palazzo Pitti at Florence, painted for Aretino himself in the spring of 1545 and presented by him to Duke Cosimo I of Tuscany in the autumn of the same year (our Fig. 9; *V.*, ɪ, Pls. 193, 194; cf. *C.-C.*, ɪɪ, pp. 108ff.). The fourth, finally, was made for the Venetian publisher and print maker, Francesco Marcolini (Vasari, vɪɪ, p. 445); it may well be identical with the picture which passed from the Palazzo Chigi in Rome to the Frick collection in New York (*V.*, ɪɪ, Pl. 11, our Fig. 11), and I see no reason to doubt the latter. Admittedly less spectacular than the Pitti portrait (as already pointed out by Vasari) and said to have been executed in three days (Marcolini's letter of September 15, 1551, cited in Vasari, vɪɪ, p. 442, Note 1), it shows Aretino at a more advanced age, his beard no longer dyed (a practice which, as we happen to know, he abandoned in 1548),

his posture less aggressive and his expression a little disillusioned. The multicolored splendor of silk, velvet and brocade has given way to a quiet harmony of brown, black and grey; and the violent contrapposto between the thick-lipped face, turned to three-quarter profile, and the torso, seen in front view, has been abandoned. I cannot help feeling that the fiery Aretino of the Pitti portrait was styled after the fashion of Michelangelo's *Moses* (our Fig. 25) which could have become known to Titian through any number of two- or three-dimensional copies. When Aretino described the Pitti portrait as "una si terribile meraviglia" (*P.-C.*, ɪɪ, p. 61) he may have chosen this epithet — here used in a laudatory sense since Aretino goes on to say that Titian had exalted his "natural appearance" in a manner which made him too embarrassed to say more — under the unconscious influence of the fact that the words *terribile* and *terribiltà* were commonly applied to Michelangelo; they anticipated the later fashionable term "sublime" which John Dennis was to define as "a delightful Horrour, a terrible Joy."

For a summary of Aretino's life and character, see *P.-C.*, ɪɪɪ, pp. 21ff. The letter describing the sunset over the Canal Grande is found ibidem, ɪɪ, pp. 16ff.; the final version of Feuerbach's *Death of Aretino* (Basel, Oeffentliche Kunstsammlung) is reproduced ibidem, ɪɪɪ, Pl. 12. The source of the scurrilous story of Aretino's end is Antonio Lorenzini (Antonius

at a dinner party in his own house: when one of the guests had told a particularly funny and indecent story, it was said, Aretino roared with laughter and threw himself back in his chair with such violence that the chair tipped over and he broke his head. There is no shred of evidence for this story (which gave rise to an unintentionally humorous composition by the German painter, Anselm Feuerbach); but it throws light on Aretino's reputation — a reputation summarized in a famous "epitaph" which exists in Latin as well as Italian and had the honor of being translated into German by Eduard Mörike:

"Questo è Pietro Aretino, poeta Tosco,
Che d'ogni un disse male, eccetto che di Dio;
Scusandosi con dir 'non lo conosco'"

("Here Aretino lies, a Tuscan poet; Evil he spoke of all, except of God; When questioned why, he said 'Him I don't know'").

In many ways this reputation was well deserved. Aretino was perhaps the first publicist to make a living by misrepresentation and extortion; and — in return for praise or, no less often, for silence — he received honors, presents and huge sums of money from nearly all the princes of his time — including the two eternal adversaries, Charles V and Francis I of France. He led a loose life. He wrote indecent sonnets and equally indecent, often extremely amusing comedies while posing as a fervent believer and even aspiring to a Cardinal's hat. He was forward in giving advice to great artists and he could wheedle as well as threaten in a fairly nauseating way. But he was boundlessly generous, utterly loyal to those whom he really liked, an admirable stylist, extraordinarily witty, and truly responsive to the values which he saw in Titian's paintings: the color, the light, the atmosphere, the splendor, and the very spirit of Venice, "la ville la plus triomphante du monde," as Philippe de Comminges had written in 1494.

It was indeed only in Venice, governed with an extraordinary combination of discipline and permissiveness (characteristic, it would seem, of cosmopolitan, seafaring communities ruled by a hereditary oligarchy), where life was strictly regulated in theory but very free in practice, and where political action was rigorously controlled while the liberty of thought, the liberty of speech and the liberty of the press were protected even against the Inquisition, that a man like Aretino could flourish.

Laurentius Politianus), *De risu...libri duo*, printed in N. Jossius, *Tractatus novus...de* *voluptate et dolore, de risu et fletu, somno et* *vigilia*, Frankfurt, 1603.

After his return from the second trip to Augsburg (in the summer of 1551) Titian became less mobile. Apart from regular sojourns in his native Pieve di Cadore (where he owned property, played the role of public benefactor and habitually sought refuge from the treacherous Venetian summers) and an occasional business trip, he did not do much traveling anymore. But he worked as furiously as ever, developing that grandiose late style which reflects both the fervor and the loneliness concomitant to great age.

A darling of the gods in so many other respects, Titian was not very fortunate in his family. In 1525 he had married his common-law wife, Cecilia, who had already borne him two sons, Orazio and Pomponio. She died as early as 1530, the same year which saw one of Titian's greatest triumphs, the completion of the famous *Martyrdom of St. Peter Martyr* for SS. Giovanni e Paolo, the commission for which he had obtained in competition with his only serious rival, Giovanni Antonio Pordenone. He never remarried and his children were not "blessed after him." Orazio, the most dutiful of sons, was but an indifferent painter. Pomponio, destined for the clergy, turned out to be a drifter and a wastrel. And Titian's beloved daughter Lavinia, born shortly after her parents' formal wedding and married, in 1555, to Cornelio Sarcinelli of Serravalle,[10] died in the prime of life, presumably predeceasing her father by about fourteen years. Titian had no grandchildren, and the only younger members of his family to follow his profession during his lifetime were, in addition to Orazio, two distant relatives, Cesare and Marco.

In 1556, we recall, Titian had lost Aretino; in 1559 he lost his brother Francesco; and in 1570 the other member of the "Triumvirate," Jacopo Sansovino. Orazio, faithful to the end, died shortly after his father, certainly before October 23, 1576. Breathing his last in a hospital, the Lazzaretto Vecchio, and buried in a place unknown, he probably did die

10. An elusive "second daughter" of Titian has been recalled to public attention by a reference in O. Bock von Wülfingen's remarkable little monograph, *Tiziano Vecellio, Danaë*, Stuttgart, 1958, p. 26. But her existence is more than doubtful. The "sorella Cornelia" mentioned in the testament of Orazio Vecelli allegedly of June 24, 1577 (read 1576, since Orazio died in that year?) is clearly identical with Lavinia since she is explicitly identified as the wife of Cornelio Sarcinelli (Ticozzi, *Vite dei pittori Vecelli*, p. 267). And a portrait said to have borne the absurd inscription "Joannina Vecella pictoressa filia prima Titiani," which is referred to in A. Maier, *Della imitazione pittorica e della vita di Tiziano scritta da S. Ticozzi*, Venice, 1818, p. 375 (a passage kindly brought to my attention by my friend Michelangelo Muraro), is clearly fictitious. Aretino (*P.-C.*, II, pp. 302f. and 448), speaks of Titian's daughter only in the singular, *figliola*.

of the plague. The deserted house was broken into and plundered before
Pomponio, the black sheep, could reach Venice. And he, Titian's only
surviving descendant, managed to squander his inheritance within a few
years and perished in misery.

One of the many things which make Titian great is that his horizon was
not limited to Venice or even North Italy. He learned what could be
learned not only from the antique (as Jacopo Bellini and Mantegna had
done before him), but also from Dürer, from Raphael, from Michelangelo
(with whom his relation was one of complementarity resulting from op-
position as well as admiration), and even from the Mannerists. But all
these "influences" served only to nourish his originality. No other great
artist appropriated so much while making so few concessions; no other
great artist was more pliable while remaining so utterly himself. When
Charles V wanted a big religious picture based on late mediaeval and in
part distinctly non-Italian concepts, Titian complied by producing one of
his most personal and modern compositions (Fig. 73).[11] When the Papal
Legate to Venice, Altobello Averoldi, Bishop of Brescia, wanted a polyp-
tych (a form then somewhat out of fashion in Venice) for SS. Nazzaro
e Celso, Titian, normally the champion and, in a sense, the originator
of the colossal but unified altarpiece (see, e.g., Fig. 16) delivered a
polyptych which even in the choice of color adapts itself to the tradition
of the *terra ferma*; yet every square inch of this polyptych is purest
Titian (Fig. 15).[12]

Ever since Paolo Pino in his *Dialogo della Pittura* of 1548 had equated
the names of Michelangelo and Titian with the categories of "design" and
"color," Titian has been considered the colorist *par excellence*; "disegno di
Michelangelo e colorito di Tiziano" was said to have been the device of
Tintoretto. But what precisely do we mean by this characterization?[13]

Our "uninterpreted" retina picture — if there were such a thing —
would consist of patches of color and nothing else. But modern psychology
— anticipated, incidentally, by Thomas Aquinas when he said that
"sensory perception, too, is a kind of reason" (*nam et sensus ratio
quaedam est*)[14] — as well as everyday experience has taught us that our

11. I am referring to the "*Gloria*" in the
Prado (*V.*, ii, Pl. 53), for the iconography
of which see below, pp. 63 ff.
12. *V.*, i, Pls. 101-105 (ensemble view, e.g.,
in *T.*, Pl. 54); cf. below, p. 20 f., Note 27.
13. See T. Hetzer, *Tizian, Geschichte seiner*

Farbe, 2nd edition, Frankfurt, 1948,
particularly pp. 61 ff.
14. *Summa Theologiae*, I, qu. 5, art. 4, ad. 1.
Cf. E. Panofsky, *Gothic Architecture and
Scholasticism*, Latrobe, Pa., 1951, and New
York, 1957, p. 38.

sense of sight, not so much "interpreting" our visual image *ex post facto* as shaping it in the very act of perception, provides us with *gestalten*: solid shapes delimited by surfaces (which are in turn delimited by contours) and surrounded by what we refer to as "space." A color, therefore, is perceived as something adhering to the surface of an object but, while constant in itself, is capable of being modified by the effect of adjacent colors as well as of direct or reflected light. A billiard ball, "objectively" white, may display all kinds of colors, depending on the play of light and shade and on whether it is placed on the green billiard table or a red carpet. Moreover, light itself is colored, and its effect is varied by the greater or lesser density of the medium through which it passes on its road from its source to the object and from the object to the eye.

The painter who — according to a definition not challenged before our own century — endeavors to produce a recognizable two-dimensional image of the three-dimensional world, has no choice and no problem as long as he thinks in terms of isolated *gestalten*, and not in terms of a space enveloping them; in other words, as long as he ignores or disregards perspective. An Egyptian painter — or, for that matter, a Polygnotus — projects what he considers to be the "objective" color of figures and things upon the painting surface — unchanged by any accident of illumination or atmosphere. But as soon as the interaction between "objective" color and light-in-space is recognized and calls for expression, the pure polychromy of pre-perspective painting is bound to give way to a variety of possibilities chiefly determined by three factors: the color of the object; the changes of color effected by light and atmosphere; and the color materially appearing on the painting surface, viz., the pigments.

The world of Titian may be described, very briefly, as follows.

First, he conceived of pigments as inducing an aesthetic effect *sui generis* and *sui iuris*; he interpreted color neither as a mere reference to reality (we should not forget that Titian's personal *impresa* was a she-bear licking her cub into shape and thus exemplifying the proud motto: NATURA POTENTIOR ARS, "Art is more powerful than nature")[15] nor, if I may say so, as undigested paint. We can enjoy his colors, singly

15. G. de Tervarent, *Attributs et symboles dans l'art profane, 1450-1600*, Geneva, 1958-59, II, col. 293; F. Picinelli, *Mundus Symbolicus* (first Italian edition, Milan, 1653; first Latin edition, Cologne, 1687), V, 48, No. 663, with references to classical sources. Cf. J. Białostocki, "The Renaissance Concept of Nature and Antiquity," *Studies in Western Art (Acts of the Twentieth International Congress of the History of Art)*, Princeton, 1963, II, pp. 19 ff., particularly p. 27.

and in relation to each other, just as we may enjoy precious stones; yet we do not think of them as material substances applied to an equally material surface.

Second, Titian always respected — and this seems very important to me — what may be called the autonomy or integrity of color values as opposed to such textural values as the specific qualities of glass, metal, velvet, silk, or hair. When the "hairiness" of hair becomes as obtrusive as in the so-called *Violante* in Vienna (Fig. 10),[16] the chances are that the painting is not by Titian.

Third, while Titian never sacrificed plastic, spatial and luminary values at the altar of color, he did conceive of all these values as functions of color, and not the other way around. Even in his rare and late nocturnes, the flames of torches, candles or lamps are not so much sources of illumination controlling a complicated machinery of light and shade (unlike Leonardo, Titian was not interested in chiaroscuro effects for their own sake but only as a means to an end) as spots of color. In a quite late picture such as the Munich *Crowning with Thorns* (Figs. 12, 13) the very flames of the chandelier look like the petals of beautiful, white-and-rose colored flowers.[17]

Fourth, Titian's space constitutes itself by a sequential arrangement of colored shapes rather than by means of geometrical construction. He builds it *from* objects instead of distributing objects *within* it: the scenery operates as a fluid accompaniment of the figures rather than as a set stage defined by a perspective system of coordinates. He therefore tended — for reasons diametrically opposite to those of the "classicist" — to keep the action, if any, within a limited area parallel to the picture plane and to avoid protracted vanishing lines. In contrast to Tintoretto, he was, as a rule, averse to violent foreshortenings and (barring a few well-motivated exceptions) such *di sotto in sù* effects as we find in the ceiling decorations of Mantegna, Correggio or Giulio Romano; and he had an almost claustrophobic dislike of boxed interiors closed on all sides. He normally staged his scenes — even his portraits, unless the figure is set out against a neutral background — either in the open air or, preferably, in a "semi-interior," often a kind of loggia, where the indoors osmotically interpenetrates with the outdoors. The Munich *Portrait of Charles V* (Fig. 96)

16. *V.*, I, Pl. 55.
17. *V.*, II, Pl. 134. Cf. Hetzer, *Tizian*, p. 175. For the possible destination of the picture (left in Titian's house when he died and acquired by Jacopo Tintoretto), see E. Tietze-Conrat, "Titian's Workshop in His Late Years," *Art Bulletin*, XXVIII, 1946, pp. 76 ff., particularly p. 84 f.

or the many versions of the *Venus with a Musician* (Figs. 135-139) are cases in point.[18]

This kind of colorism dominated Titian's style throughout his life; but no painter in history traveled so long and tortuous a road in a predetermined direction. Titian's earlier pictures are, to quote Vasari, "carried out with incredible finesse and diligence so that they can be observed at close range as well as at a distance." "His latest works, however," Vasari continues, "are painted with broad strokes, dashed off in a rough manner and in patches (*condotte di colpi, tirate via di grosso e con macchie*) so that they cannot be enjoyed at close range and appear perfect only from afar." In these late works, of which the Munich *Crowning with Thorns* (Figs. 12, 13) is a particularly magnificent example, Titian reportedly used brushes "big as broomsticks" or even his fingers — "like God when he created man," as he used to say himself. And the same author who transmits this *bon mot* (Marco Boschini, who received much of his information from Palma Giovane, one of the last and most faithful of Titian's pupils) has left us a marvelously vivid description of the old master's procedure: how he would take out an unfinished painting set aside many years ago, look at it "as though it were a mortal enemy," and then attack it with a few vigorous strokes.[19]

To reach this final stage of his development Titian needed more than half a century. At the beginning, he still thinks of color as something adhering to the objects shown; in his middle period, he thinks of color as something primarily determined by the coloristic pattern as it appears on the panel or canvas, so that we may speak of "picture color" as opposed to "object color." In his last period, finally, he comes to think of color as something diffused in space (we may call it "space color"), and, as it were, merely concentrated and diversified in individual areas; and his basic disinclination to overemphasize textural qualities sharpens into a tendency to underemphasize them. Goethe is reported to have observed,

18. For the Munich portrait of Charles V (*V.*, II, Pl. 21), see p. 82 ff. The iconographical problem of "Venus with a Musician" (*V.*, II, Pls. 32-34, 72, 73) will be discussed below, pp. 121 ff.

19. M. Boschini, *Le Minere della pittura... di Venezia*, Venice, 1664; in the enlarged edition of 1674 (entitled *Le ricche Minere della pittura Veneziana*), fols. b 4 v. ff.,

quoted in *C.-C.*, I, pp. 218 ff., and G. Gronau, *Titian*, London and New York, 1904, p. 248 (both omitting Titian's reference to God's creation of Adam): "perchè [Tiziano], volendo imitare l'operazione del Sommo Creatore, faceva di bisogno osservare, che egli pure nel formar questo corpo humano lo formò di terra con le mani."

with reference to his own conviction that all art should proceed from the specific to the generic, that "Titian, the great colorist, painted in his old age those materials which he had imitated so concretely at an earlier stage, for instance, velvet, *only in the abstract*, as a mere idea thereof."[20] In the same sense, the colors themselves assume an "abstract" quality, and in such very late pictures as the *St. Sebastian* in the Hermitage or the "*Nymph and Shepherd*" in Vienna (Fig. 182)[21] the beholder receives an impression of colorful tonality without being struck by any particular hue.

On the whole, the mature and late Titian had a certain aversion to green, even in landscapes; it is only at the beginning of his career (or when he deliberately resumed earlier tendencies) that he based the whole color scheme on the Giorgionesque contrast between the complementaries, red and green. Usually he preferred, as already stressed by Carlo Ridolfi, the subtler contrast between red and blue;[22] and a subdued moss green which appears in his latest works is normally limited to the draperies of female saints. Yellow mostly occurs in a warm, golden shade, and it is only in a handful of instances that we encounter that lemon-colored variety known as "chrome yellow." Titian himself is said to have stated, only half-facetiously, that a good painter needed only three colors (one less than Apelles but just as many as Watteau in his "*trois-crayons*"): white, black and red.[23]

20. Conversation with F. W. Riemer, quoted in E. R. Curtius, "Goethe als Kritiker," *Kritische Essays zur Europäischen Literatur*, Bern, 1950, pp. 28 ff., particularly p. 37: "Tizian, der große Kolorist, malte im hohen Alter diejenigen Stoffe, die er früher so konkret nachzuahmen gewusst hatte, auch nur *in abstracto*, z. B. den Sammet, nur als Idee davon."

21. *V.*, II, Pl. 141; cf. Hetzer, *Tizian*, pp. 172 ff. For the iconography of this picture, see below, pp. 168 ff.

22. See C. Ridolfi, *Le Maraviglie dell' arte o vero le vite degl'illustri pittori Veneti...*, Venice, 1648 (ed. D. von Hadeln, Berlin, 1914 - 1924), I, p. 209: "...poneva volontieri ne'panni il rosso e l'azzurro, che giamai sconciano le figure."

23. Boschini in *Le ricche Minere* as quoted, e.g., in Gronau, *Titian*, p. 249. Titian's statement, eliminating the yellow from Apelles' and his contemporaries' "four-color system" (Pliny, *Nat. hist.*, XXXV, 32;

cf. R. W. Kennedy, "Apelles redivivus," p. 167 f.), was made, of course, in a spirit of paradox, even bravado; it may, however, have an interesting historical background. As suggested to me by Dr. Leo Steinberg, it is strangely reminiscent of a passage in some of the "Chaldaean" commentaries on the Old Testament, the so-called *Targumim*, upon *Genesis*, 2:7. In creating Adam, we are told, God "took red, black and white dust from the place of the Temple and the four regions of the world, and kneaded it with the water of the whole world"; for this passage (recently mentioned by U. Schlegel, "Masaccio's Trinity Fresco in Santa Maria Novella," *Art Bulletin*, XLV, 1963, pp. 19 ff., particularly Note 74, but with references which make it difficult to locate its source), see M. Grünbaum, *Neue Beiträge zur semitischen Sagenkunde*, Leiden, 1893, p. 55; M. Altschueler, *Die aramaeischen Bibel-Versionen*, Vienna and Leipzig, 1909, pp. 21 ff. As I

In speaking of "early," "middle" and "late," I have tacitly implied the customary division of a great artist's activity into three periods: that in which he defines his attitude toward tradition; that in which he originates a tradition of his own; and that in which he outgrows the tradition established by himself and thus attains a sphere no longer accessible to others.

It is indeed quite possible to divide Titian's work according to this scheme, his "first period" extending from his enigmatical beginnings to the completion of the *Martyrdom of St. Peter Martyr* (1530); the second, from c. 1530 to his second trip to Augsburg in 1551; the third, from c. 1551 to the end.

But Titian lived and worked so long, and reached out in so many different directions, that it is advisable to subdivide each of these periods of nearly equal length into two sub-periods or "phases." This six-phase system, proposed by Theodor Hetzer,[24] takes into account not only Titian's handling of color but also other significant criteria: the preference for certain kinds of subject matter; a curious alternation between a severely schematized and a more fluid mode of composition; a similar

learn from Professor Moshe Barasch, the passage is absent from the best-known *Targum*, the "*Targum Onkelos*," but does occur in the so-called "*Targum Jonathan*" and in the "*Targum Jerushalmi*," both printed in Venice in 1591 but apparently available in earlier editions and manuscripts. Another rabbinical source, the *Pirkê Rabbi Eliezer* (ed. J. Friedländer, 1916, quoted by Grünbaum, *loc. cit.*), asserts that God employed four kinds of dust: red, black, white, and of a color variously described as yellow or pale green. Both versions obviously express the pervasive notion that the four basic colors represent the four elements (for this parallel, see, e.g., Leone Battista Alberti's *Della Pittura*, ed. H. Janitschek, in *Leone Battista Alberti's Kleinere kunsttheoretische Schriften* [*Quellenschriften für Kunstgeschichte*, XI], Vienna, 1877, p. 65, discussed by M. Barasch, "The Colour Scale in Renaissance Thought," *Romanica et Occidentalia, Etudes dédiées à la mémoire de Hiram Peri* [Pflaum], Jerusalem, 1963, pp. 74ff., particularly p. 78); and that the body of

Adam, *qua* microcosm, is composed of the same four elements as the macrocosm — red standing for fire, black for earth and white for air. The only difference is that water is directly referred to as a binding medium in the two *Targumim* whereas it is symbolized by light-colored dust in the *Pirkê*. Since, we recall, the same Boschini who transmits Titian's statement about the three colors also likens Titian's practice of occasionally painting with his fingers to the procedure of God in creating Adam (for a selection of texts likening the artist to God, see J. Schlosser, "Der Weltenmaler Zeus," *Präludien*, Berlin, 1927, pp. 296ff.), a connection between the statement attributed by him to Titian and a rabbinical source is not excluded, especially since Venice was an important center of Hebrew publications and Judaistic scholarship which in the Renaissance was cultivated by Christian humanists and learned Jews alike.

24. Hetzer, *Tizian*, pp. 80ff., and in Thieme-Becker, *Allgemeines Künstlerlexikon*, XXXIV, 1940, pp. 158ff.

alternation between an emphasis on expressive action and a calmer, more reflective attitude; the higher or lesser degree of responsiveness to the art of classical antiquity. But it goes without saying that every system of periodization is to historical reality as the geographer's system of degrees of longitude and latitude is to the actual aspect of the earth.

In the first of these six phases — from the beginning to 1516/18, when the *Assunta* was being carried out — Titian slowly disengages himself from the tradition of Leonardo, Bellini and Giorgione and makes his first, preliminary contacts with the classical world as well as with Dürer and the Tuscan and Roman tradition, including Raphael and Titian's great antipode, Michelangelo. In this phase color is still conceived as "object color" (with particular emphasis on draperies and garments) and the Giorgionesque contrast between red and green is normally preferred to that between red and blue. The shadows, like Leonardo's, are still occasionally grey rather than tinted. The general mood is calm and lyrical. Classical influence tends to be limited to incidental accessories instead of determining the posture and behavior of the *dramatis personae*. And motifs borrowed from Central Italian art are not as yet completely assimilated.

In the Antwerp Altarpiece of Jacopo Pesaro (Fig. 16) — in my opinion the earliest unquestionable picture from Titian's hand — there is hardly any trace of blue: St. Peter is clad in a red mantle (Titian did not as yet know, or chose to disregard, the tradition according to which St. Peter should wear a yellow mantle over a blue coat); the Pope is dressed in a gold-brocaded pluvial; and the pseudo-classical relief on the base of St. Peter's throne, its iconographical importance notwithstanding,[25] remains a mere prop. In the *Salome* in the Galleria Doria-Pamphili (Fig. 50), datable between c. 1512 and c. 1515, the dark crimson robe of the princess (her posture still vaguely reminiscent of Leonardo's *Leda*) is balanced, *à la* Giorgione, with the olive-green dress of her handmaiden. It should be noted, however, that even this relatively early painting — and the same is true of the still earlier frescoes at the Fondaco dei Tedeschi — already exploits what was to remain a leitmotif in Titian's art: the motif of the "space-traversing glance." Here, as in many other paintings, a devoted attendant (occasionally even a pet animal) looks up at her mistress. In the "*Sacred and Profane Love*" (Fig. 128, not very much

25. *V.*, I, Pls. 10-12. For the interpretation of this relief, see R. Wittkower, "Transformations of Minerva in Renaissance Imagery," *Journal of the Warburg Institute*, II, 1939, pp. 194 ff., particularly p. 202 f.

later than the *Salome*) a celestial divinity looks down, almost compassionately, at a terrestrial one. In the late *Danaë* (Fig. 158) a mortal virgin looks up, in ecstasy, at an approaching god.[26]

In contrast to the first, still somewhat tentative phase, the second is an age of impassioned freedom and self-realization. In the *Assunta* (Fig. 14) the tension between light and color is resolved in favor of color. The grey shadows have disappeared. The chromatic harmony begins to be dominated by the chord of red and blue on the terrestrial plane from which emerges, to quote Balzac, "cette auréole chaude et dorée" surrounding the Virgin Mary. And the whole composition throbs with a movement which transcends individual action. Now Titian really comes to grips with Pordenone, with Central Italian art and with classical antiquity, the influence of which begins to extend not only from accessories to essentials but also from form to content. Suffice it to mention first, the Brescia polyptych of 1520-22 (Fig. 15), where the resurrected Christ is patterned after the *Laocoön* while the St. Sebastian presupposes Michelangelo's "*Rebellious Slave*"; second, the *Bacchanal of the Andrians* in the Prado (Fig. 114; 1518-19). Here the subject is taken from Philostratus; the sleeping nymph and the little boy passing water are derived from classical sarcophagi; the reclining youth in the center comes from Michelangelo's *Battle of Cascina*; and the magnificent nude pouring wine from Domenico Beccafumi (Fig. 116).[27] The whole composition is unified as well as

26. For a fuller discussion of the *Salome* (*V.*, I, Pl. 61), see pp. 42 ff.; of the "*Sacred and Profane Love*" (*V.*, I, Pls. 64-69 and color plate), pp. 110 ff.; of the Madrid *Danaë* (*V.*, II, Pl. 58), p. 149 f. For the importance of the glance in Titian's art, see C. Nordenfalk, "Tizians Darstellung des Schauens," *Nationalmusei Årsbok*, 1947-48 (published 1950), pp. 39 ff., where attention is called to the fact that in the relationship between master and servant or master and a pet animal the animal can acquire an almost human quality (as does the dog in the Madrid portrait of Charles V, our Fig. 6) while the servant may bear the expression of a faithful dog (as does the handmaiden of Salome in our Fig. 50). *Mutatis mutandis*, this applies to the secretary (Guillaume Philandrier) of Georges d'Armagnac, Bishop of Rodez, in the recently discovered double portrait in the collection of the Duke of Northumberland at Alnwick Castle: M. Jaffé, "The Picture of the Secretary of Titian," *Burlington Magazine*, CVIII, 1966, pp. 114 ff., Figs. 1, 4.

27. The influence of the *Laocoön* and Michelangelo's "*Rebellious Slave*" on the Risen Christ and the St. Sebastian in the Brescia polyptych has frequently been noted (see, e.g., O. J. Brendel, "Borrowings from Ancient Art in Titian," *Art Bulletin*, XXXVII, 1955, pp. 113 ff., particularly p. 118). The old question whether the *St. Sebastian* now forming part of the polyptych is the original or a *propria manu* replica substituted for the original which Alfonso d'Este had tried to acquire in 1520, could probably be decided by a technical examination of the Brescia panel. The front surface of the broken column on which the Saint places his right foot bears the final inscription of the polyptych:

dynamized by a pervasive rhythm which anticipates Rubens and Poussin (both of whom copied the picture and its counterpart) as well as Watteau.

By contrast, the third phase, viz., the decade from c. 1530 to c. 1540, amounts to what the French call a *détente*. With one or two exceptions — particularly the *Battle of Cadore*, the conception of which may substantially antedate its long-delayed execution — this decade is dominated by a spirit of quiet observation and impassive order. That it produced an unusual number of portraits may be an accident. But even the narrative pictures tend to register and to systematize impressions rather than to realize visions and to express dramatic passion. Reminiscences of Titian's "untried years" tend to emerge and — again, with one or two well-motivated exceptions — the influence of classical as well as Tusco-Roman art tends to recede.[28] A characteristic example of this phase is the famous *Venus of Urbino* in the Uffizi (Fig. 17), completed in 1538.[29] In posture it almost literally repeats Giorgione's *Venus* in Dresden, and in color it revives the Giorgionesque contrast between red (the pillows and the dress of one of the attendants) and green (the curtain). The composition is determined by a system of regularly spaced coordinates. Vertically, the field is symmetrically divided by the edge of the curtain; horizontally, the right-hand

"TITIANVS FACIEBAT MDXXII." If the Brescia panel is the original this inscription should show distinct traces of being superimposed upon a painting demonstrably completed and privately exhibited as early as the end of 1520 (*C.-C.*, I, pp. 237 ff.) and therefore quite dry in 1522; whereas in a replica substituted *ex post facto* the inscription would probably have grown more or less homogeneous with the substance of the painting itself. In addition, we know from a report of Alfonso's envoy, Jacopo Tebaldi, dated December 1, 1520 (G. Campori, "Tiziano e gli Estensi," *Nuova Antologia*, XXVII, 1874, pp. 581 ff., particularly p. 591, Note), that the original showed the Saint tied to a column (*attachato cum un brazo alto et uno basso ad una colonna*) rather than a tree; if the panel now forming part of the polyptych is the original, this column should be discoverable beneath the present coat of paint. For the *Bacchanal of the Andrians* (*V.*, I, Pls. 80-82), cf. below, pp. 99 ff., particularly p. 100, Note 26.

28. Exceptions: the torso in the *Presentation of the Virgin* in the Accademia at Venice (*V.*, I, Pl. 149, for which see below, pp. 36 ff.) and the *Roman Caesars*, undertaken at the request of Federico Gonzaga but transmitted only through prints and painted copies (*V.*, I, p. 86; *V.*, II, Pl. 191), which reveal a characteristic tension between the classical and the modern. It is to be hoped that the thus far unsolved problems surrounding this series (see E. Verheyen, "Correggio's *Amori di Giove*," *Journal of the Warburg and Courtauld Institutes*, XXIX, 1966, pp. 160 ff., particularly pp. 170 ff., Pls. 40 and 41 c - e; idem, "Jacopo Strada's Mantuan Drawings of 1567 - 1568", *Art Bulletin*, XLIX, 1967, pp. 62 ff., particularly p. 66, Figs. 13 - 25).
29. *V.*, I, Pls. 155, 156. See T. Reff, "The Meaning of Titian's *Venus of Urbino*," *Pantheon*, XXI, 1963, pp. 359 ff. (convincing on most if not all points); idem, "The Meaning of Manet's *Olympia*," *Gazette des Beaux-Arts*, series 6, LXIII, 1964, pp. 111 ff.

SAINT PETER'S COLLEGE LIBRARY
JERSEY CITY. NEW JERSEY 07306

section is symmetrically divided by the edge of the tiled floor, and within the upper half of this section minor verticals and horizontals predominate. The whole arrangement can be described, in Frankl's terms, as "additive": we have the impression that certain sections — such as the window with its prospect into the open, the little myrtle tree on its sill or the charming group of the two attendants — could be cut out as independent still-lifes or genre scenes.

That this is not an isolated case is demonstrated by the famous *Presentation of the Virgin* in the Accademia at Venice (Fig. 41; 1534-38)[30] where the huge surface is similarly organized by verticals and horizontals and where such details as the horrid egg woman sitting in front of the stairs or the onlookers enframed by windows strike the beholder as selfcontained genre pictures while the dignitaries approaching from the left form a detachable, isocephalous group portrait.

From about 1540, we find Titian in a kind of crisis, punctuated by the journey to Rome in 1545/46 and sharpened by an incisive recrudescence of those influences which were, so to speak, complementary to his innate tendencies and, for this very reason, indispensable for their fulfillment: the Tusco-Roman tradition, especially Michelangelo; Pordenone; perhaps Correggio; and the art of the ancients. So strong were these impulses that they resulted in the abandonment of, to quote Vasari, "incredible finesse and delicacy"in favor of "broad strokes and patches," in a new emphasis on forceful, occasionally almost brutal action and in the replacement of clear and harmonious colors by an often dissonant chromaticism. But just this change was necessary as a prelude to that indescribable glow or shimmer (first the glow, then the shimmer) which is the signature of Titian's *ultima maniera*.

Let me adduce a few instances. First, there is the Prado *Allocution of Alfonso d'Avalos, Marchese del Vasto* (Fig. 83) of 1540-41.[31] Derived, as we shall see, from a Roman coin, it almost shocks us by an unaccustomed tension between foreground and background, individuals and anonymous mass; and it exhibits a curious concord of discordant hues: blue, white and two disharmonious reds, the cinnabar of the General's mantle, sounding, so to speak, a diminished second with the somber crimson coat of the gigantic soldier seen from the back. As a second instance, we may use the *Slaying of Abel*, one of three ceiling pictures executed in 1543/44 for Santo Spirito in Isola but transferred, in or shortly after 1656, to the large

30. *V.*, I, Pls. 148-152; for a more detailed discussion, see pp. 36 ff.

31. *V.*, I, Pl. 158; for a more detailed discussion, see pp. 74 ff.

sacristy of S.M. della Salute[32] — pictures impressive not in spite but because of the absence of coloristic allurements and making their effect by the brute force of bold foreshortenings and almost overexpressive action (Figs. 35-38). A third example is the *Crowning with Thorns* in the Louvre (Fig. 20), datable about 1540/42, stressing physical rather than mental cruelty and suffering and clearly evincing the renewed influence of the *Laocoön* — that *exemplum doloris* par excellence which had interested Titian about twenty years before and, after the estrangement from classical pathos in the 'thirties, now asserted its power with redoubled force.[33] Fourth, and finally, we may cite the Naples *Danaë* of 1545/46 (Fig. 150).[34] Chiefly based on Michelangelo and the antique, this painting captures as much of non-pictorial, dynamic and plastic values — down to the overpowering bulk of the column and the sweeping curves of the drapery — as was possible within the framework of Titian's essentially coloristic style.

A juxtaposition of the Naples *Danaë* with a later version of the same composition, despatched to Philip II in 1554 and still preserved in the Prado (Fig. 158), may give a preliminary idea of Titian's fifth phase which, we recall, begins about 1551 and ushers in Titian's last style. In the later picture the figure of the heroine is smaller in relation to its surroundings, less heroically proportioned and far less muscular. The powerful column has disappeared; the Lysippian Cupid has been replaced by a terrifying old nurse who tries to collect as much as she can of the golden shower; the magnificent sweep of the drapery has given way to a ripple of small folds; and the whole composition is dominated by a contrast between big areas of colored light (Danaë and the draperies of her couch) and colored darkness (to which even the sky belongs).

This fifth phase is characterized by an unprecedented increase in mythological subject matter of which the second *Danaë* is only one example. That this tendency was nourished, if not induced, by the accession of Philip II (as fond of *erotica* as he was devout) in 1555 can hardly be questioned; but neither can it be questioned that Titian himself experienced, at this time, a kind of second youth. In 1559, at about the same age at which Goethe wrote the *Marienbader Elegie*, he could refer to a young woman whose portrait he sent to Philip II — the still mysterious *"Girl in Yellow"* — as the "absolute mistress of my soul" ("patrona as-

32. *V.*, ɪ, Pls. 179-181; for a more detailed discussion, see pp. 30 ff.
33. *V.*, ɪ, Pls. 170, 171.
34. *V.*, ɪɪ, Pls. 4-5 (Naples) and 58 (Madrid). For a more detailed discussion, see below, pp. 144 ff., 149 f.

soluta dell' anima mia");[35] and a last encounter with the Mannerism of Parmigianino and Cellini, produced (*par antiphrase*, as the French say) the final efflorescence of Titian's colorism.

The two *Diana* pictures of 1559 (Figs. 163 and 164; formerly at Bridgewater House and now on deposit in the National Gallery at Edinburgh)[36] show features commonly associated with this Mannerism: a — for Titian — rather crowded and compressed composition and an — again for Titian — remarkable contortion of pose and elongation of proportion. But the pictorial treatment, particularly the coloring, blooms forth with a new euphony and a new vigor. It is in these years that the colors begin to glow like jewels and to be matched like jewels in a piece of ornament; and that they begin to exercise their power within the narrow limitations of the nocturne.

Titian's very last phase, after about 1560, is marked by a curious bifurcation. On the one hand, we have numerous, in part repetitious workshop productions only superficially revised by the old master himself or not even touched by him at all; on the other, we have those authentic creations which show the ultimate in "lateness," particularly the final triumph of spatial over local color resulting in what may be called a colorful monochrome.

The now familiar *Crowning with Thorns* in Munich (Figs. 12, 13), probably produced as late as about 1570, is based on the equally familiar *Crowning with Thorns* in the Louvre (Fig. 20), produced just about thirty years before. But in the later version — characteristically, a nocturne, which the earlier was not — physical violence and pain are suppressed in favor of inward emotion. The soldier spitting in the face of the Lord has been eliminated. Christ Himself no longer seems to suffer physical pain; rather He seems to experience an all-embracing compassion with the "sins of the whole world" (I *John* 2:2). The pigments are applied, quite literally, *di colpi* (Fig. 13), and the sharpest coloristic accents are placed where the narrative accents are not. In the Louvre picture the strongest coloristic stimulus had been provided by the red robe of Christ. In the Munich version, the robe of Christ is white (a white, however, which is broken up into a million shades of color) and the main coloristic stimulus — apart from the white and red flames of the chandelier — is provided by the costume of the henchman in the foreground, with his dark red hose, blue doublet, and golden-yellow sleeves.

35. Letter of September 27 (?), 1559, referred to above, p. 8, Note 7.

36. *V.*, II, Pls. 84, 85. For a more detailed discussion, see pp. 154 ff.

The rest is a sea of browns, greys, occasional whites (the hair and collar of the old man), with only a spot of red above the sword of the soldier on the extreme left.

Titian's latest style — like the latest style of most great masters — amounts to a coincidence of opposites: intense emotion and outward stillness, color and non-color, the broadest and apparently almost chaotic technique of execution and the most rigid order and density of composition.

The so-called "*Nymph and Shepherd*" in Vienna (Fig. 182) is one of the most "pictorial" pictures ever produced by Titian.[37] Yet the nude gives the impression of faultlessly molded solidity, and her face has an intriguing family likeness with certain faces in Picasso's *Ingriste* works such as the Museum of Modern Art's *Woman in White* of 1923. In both cases the modeling is extremely simplified, almost stereographical, and in both cases the eyes show no distinction between iris and pupil: we feel as if we were looking into a well the depth of which remains unfathomable.

As far as the influence of classical art is concerned, Titian began, from c. 1551, to pay more attention to objects accessible in Venice itself. And in his very latest works, from c. 1560, when the second "Mannerist crisis" of the 'fifties had passed, he responded once more to the challenge of Michelangelo and Raphael. The figure of Christ in the *Transfiguration* in San Salvatore at Venice (Fig. 18; about 1560),[38] that grandiose variation on Raphael's last work, presupposes, I believe, not only the *Apollo Belvedere* but also another work of Raphael's: the *Sistine Madonna*, then in San Sisto at Piacenza, where Titian could have seen it on his way back from Rome (Fig. 19); the rhythm of the drapery and the position of the feet are nearly identical. Titian's even later *Annunciation*, also in San Salvatore (Fig. 21; c. 1565),[39] would hardly have been possible without the influence of a late composition of Michelangelo, accessible to us — and to Titian — not only in painted copies (Fig. 22) but also in engravings. And his very last work, the *Pietà* which had been destined for his own tomb and, left unfinished when he died, was faithfully completed by Palma Giovane (Fig. 23),[40] epitomizes, as it were, those influences which the aged master still recognized as determining forces.

The Magdalen storming out of the picture reflects — but with what change in spirit and expression! — the lamenting Venus in an Adonis sarcophagus at Mantua (Fig. 24), familiar to Titian since 1523.[41] The

37. *V.*, II, Pls. 141, 142. For a discussion of the iconography, see pp. 168 ff.
38. *V.*, II, Pl. 103.
39. *V.*, II, Pls. 108, 109.

40. *V.*, II, Pls. 144-146.
41. See F. Saxl, *Lectures*, London, 1957, I, p. 173; II, Pl. 114.

Moses recalls not only his great namesake in S. Pietro in Vincoli (Fig. 25)
but also Donatello's *Abraham* from the Campanile at Florence (Fig. 26),
probably inspected by Titian on his return trip from Rome. The posture
of the Hellespontian Sibyl evokes, for the last time, the memory of
Michelangelo's *"Risen Christ"* — in reality a *Man of Sorrows* — in S.M.
sopra Minerva (Fig. 27), a plaster cast of which was in Titian's personal
possession.[42] And the principal group — the nucleus of the composition
not only in a spiritual but even in a purely technical sense — recalls
Michelangelo's *Pietà* in St. Peter's (Fig. 28).[43] A lifelong rivalry, com-
pounded of mutual respect as well as opposition, ended in a tribute paid
by the survivor to his defunct antagonist — and doing honor to both.

42. See E. Tietze-Conrat, "Titian as a
Letter-Writer," *Art Bulletin*, xxvi, 1944,
pp. 117 ff. For the iconography of Michel-
angelo's statue, see H. Thode, *Michelangelo,
Kritische Untersuchungen*, Berlin, 1908, ii,
p. 269; E. Panofsky, "'Imago Pietatis';
Ein Beitrag zur Typengeschichte des
'Schmerzensmanns' und der 'Maria Me-
diatrix'," *Festschrift für Max J. Friedländer*,
Leipzig, 1927, pp. 261 ff., particularly
p. 294; C. de Tolnay, *Michelangelo*, iii,
Princeton, 1948, pp. 90 ff., 179; and, most
particularly, W. Lotz, "Zu Michelangelos
Christus in S. Maria sopra Minerva,"
*Festschrift für Herbert von Einem zum 16. Fe-
bruar 1965*, Berlin, 1965, pp. 143 ff.

43. The painting is composed of several
pieces "d'imprimatura diversa," and much
can be said for Johannes Wilde's con-
jecture that the *Pietà* group proper was
originally intended to form an independent
picture; see A. H. R. Martindale's review
of S. M. Marconi's *Galleria dell' Accademia
di Venezia*, ii, in *Burlington Magazine*, cvi,
1964, p. 578 f. Titian's indebtedness to
Michelangelo's *Pietà* and *Moses* has often
been noticed; for a recent statement, see
R. W. Kennedy, *Novelty and Tradition in
Titian's Art* (The Katharine Asher Engel
Lectures), Northampton, Mass., 1963,
p. 14.

II

Some Biblical and Hagiological Problems

It seems appropriate to begin a discussion of assorted Titian problems with his interpretation of that event which is the root of all problems and, at the same time, the source of our ability to cope with them: *The Fall of Man*.

This fateful moment, when Adam and Eve forfeited their innocence and immortality because they wanted to "know," is represented in a picture, now in the Prado, which was so much damaged by the notorious fire at the Alcazar in 1734, and so thoroughly repainted (by Juan de Miranda), that it is no more than a magnificent ruin (Fig. 29).[1] Completed quite late in Titian's career (probably between 1560 and 1570), it is generally believed to have been composed at a considerably earlier date; and certain it is that its sources can be traced back to the first quarter of the century.

One of these sources appears to be Raphael's — or, rather, Giulio Romano's — *Fall of Man* in the Loggie of the Vatican (Fig. 30). From it, it would seem, Titian took over the idea of representing Adam seated while Eve is shown standing — a motif foreshadowed in the ceiling of the Camera della Segnatura, and apparently intended to emphasize the more passive role of the male in the act of transgression: "She took of the fruit thereof, and did eat, and gave also unto her husband with her, and he did eat." In Titian's canvas this genealogy of sin is made even more explicit than in the Vatican frescoes: the fruit is being given to Eve by a human-headed serpent, whose coils are so much concealed by and intertwined with the branches of the tree that its head — perhaps not unintentionally — evokes the impression of a Cupid *en buste*, instead of being given by Eve to Adam; his gesture even expresses gentle rebuke rather than acceptance.[2]

1. *V.*, II, Pl. 129.
2. In mediaeval art both Adam and Eve are occasionally represented seated, e.g., in the St. Albans Psalter (O. Pächt, C. R.

The other source, I believe, is Dürer's engraving B. 1 of 1504 (Fig. 31). It was under the influence of this world-famous print (already exploited by the companion of Titian's youth, Palma Vecchio, in his wellknown canvas in the Gallery at Brunswick) that Titian not only revised the posture of Eve as she appears in the Loggie, but also placed a particular emphasis on the symbolism of animals and plants. Dürer's Eve is accompanied by a rabbit and a cat (two of the four animals which symbolize the four "humors" whose perfect balance in the human being was disturbed by the fatal bite), the rabbit standing for the sanguine temperament and sensuality, the cat for the choleric temperament and cruelty. Titian's Eve is accompanied by a fox, the symbol of luxury and, even more frequently, of the Devil himself.[3] But near at hand in Titian's picture there is an antidote: the beautifully painted hollyhock (*malva benedicta*) which, from Horace (*Carmina* i, 31, 15f.) through Vincent of Beauvais to the sixteenth-century commentaries on Dioscurides, was credited with curative powers of all kinds and could even be used as a symbol of Salvation.[4]

Dürer's engraving also contains an antidote: the parrot perched on a branch of the Tree of Life (a mountain ash) to which Adam holds on with his right hand. For a very curious reason the Middle Ages had accepted the parrot as a symbol of the virgin birth of Christ. When (to

Dodwell and F. Wormald, *The St. Albans Psalter* [*Studies of the Warburg Institute*, xxv], London, 1960, p. 80, Pl. 14); and a combination of a standing Eve with a kneeling Adam occurs in the *Très Riches Heures de Chantilly*, fol. 25, where, however, Adam's posture can be explained by the artist's wish to parade a classical contrapposto motif transmitted through an Italian intermediary. It is only from the first decade of the sixteenth century that we seem to encounter the combination of a standing Eve and a seated Adam; in addition to Raphael's Camera della Segnatura and the Loggie, we may cite a woodcut by Lucas Cranach (F. W. H. Hollstein, *German Engravings, Etchings and Woodcuts*, Amsterdam, vi, [1959], p. 10), dated 1509 and kindly brought to my attention by Professor Julius S. Held. The opposite situation obtains in Michelangelo's Sistine Ceiling where Eve is shown reclining and accepting an apple from the serpent, while Adam, standing, reaches for an apple of his own.

3. The equation of the fox with the Devil is standard in the Bestiaries; see, e.g., the *Physiologus latinus*, ed. F. J. Carmody, Paris, 1939, p. 29f., xv; T. H. White, *The Book of Beasts*, New York, 1954, p. 53f. Luxury wears a fox on her banner in an engraving by Heinrich Aldegrever (B. 127, for which see G. de Tervarent, *op. cit.*, ii, col. 323).

4. See, above all, *Petri Andreae Mathioli... commentaria in... Dioscoridis... medicam materiam*, ii, 111, Venice, 1558 (first edition Venice, 1554), p. 272f. This text, concluding with the sentence "ius decoctae [malvae] cum radice sua contra omnia venena," was kindly brought to my attention by my friend, Professor W. S. Heckscher. More information may be found in a forthcoming book, to be entitled *The Garden of the Renaissance*, by Professor Mirella Levi d'Ancona.

quote from that monumental collection of *non sequiturs*, Franciscus de Retza's *Defensorium inviolatae virginitatis Mariae*, where all the fairy tales of pagan myth and legend are used as "proof" of Christian truth) young Julius Caesar rode through a forest a parrot addressed him with the words "Ave Caesar," and this is taken not only as proof of the possibility of miracles but also as an allusion to the angelic salutation, "Ave Maria," which proclaims the Virgin Mary as the "New Eve" — "cette Eve régénérée," as Balzac rephrases St. Augustine's "nova Eva"[5] — by the very fact that EVA, read backwards, is AVE.[6]

Titian omitted the parrot.[7] But Rubens, to whom we owe an excellent copy of Titian's canvas felicitously supplementing the largely repainted original, inserted it precisely where it is in Dürer's print (Fig. 32). Since it is very improbable that Rubens made this insertion only because he wanted a spot of red to balance the hollyhock (this effect he could have obtained by blossoms or fruit), we may assume that he had realized the connection which exists between Titian's painting and Dürer's engraving and thus paid homage to the latter while "improving" on the former.[7a]

Titian also alluded to the interpretation of the Virgin Mary as the "new Eve" who blots out the transgression of the old ("origo peccati per Genitri-cem Christi extincta est")[8] in an *Annunciation* which, as early as October 31, 1555, was bequeathed to the Scuola di San Rocco where it can still be admired (Fig. 33).[9] Probably executed in the latter half of the 'thirties, it rather resembles, from a purely compositional point of view, the *Presenta-tion of the Virgin* in the Accademia and the *Venus of Urbino* in the Uffizi (Figs. 41 and 17). Despite the agitated movement of the Angel Gabriel (who seems to have borrowed his garments from a classical Victory and his boots from a classical Mercury) the field is almost schematically

5. Balzac, *La Peau de Chagrin*. For St. Augustine, see, e.g., his Seventh Christmas Sermon (*Patrologia Latina*, XXXIX, col. 1991).
6. For the symbolism of the parrot, see E. K. J. Reznicek, "De Reconstructie van 't'Altaer van S. Lucas' van Maerten van Heemskerck," *Oud Holland*, LXX, 1955, pp. 233 ff.
7. Don Xavier de Salas kindly assured me *in literis* that the parrot was not, as might be thought, obliterated by the partial destruction and subsequent restoration of Titian's picture.
7a. In addition, the parrot, similarly plac-ed, occurs in a *Fall of Man* by Rubens of c.

1600; and it, too, has been correctly ac-counted for by the influence of Dürer's en-graving of 1504 (M. Jaffé, "Rubens and Raphael", *Studies in Renaissance and Baroque Art Presented to Anthony Blunt*, London-New York, 1967, pp. 98 ff., Pl. XX, 1).
8. St. Augustine, Fourth Christmas Sermon (*Patrologia Latina*, XXXIX, col. 1985). The same Sermon, same column, also contains a formula often repeated or paraphrased by mediaeval writers: "Auctrix illa peccati maledicta....auctrix ergo haec meriti benedicta."
9. *V.*, I, Pl. 157. The testator was a juris-consult by the name of Amelio Cortona.

divided by verticals and horizontals. Here, too, we have two axes of symmetry, one formed by the farther edge of the colonnade, the other by the upper edge of the parapet; and here, too, our attention is attracted by a kind of still-life (Fig. 34) placed — apparently as an afterthought since the tiles of the floor are showing through the paint — at the base of the Virgin's *prie-dieu*: a workbasket, an apple, a fig leaf, and a bird which is often referred to as a guinea hen (*faraona*) but, as ornothologists assure me, is in reality a red-legged partridge (*alectoris rufa*).[10]

The workbasket, like the even older spindle, characterizes the Annunciate as one of the virgins entrusted with the task of producing a new curtain for the Temple at Jerusalem. The apple and the fig leaf, however, clearly allude to her role of "nova Eva." And the partridge, its mostly negative connotations notwithstanding, could symbolize the Incarnation itself: the female was believed to be so full of sexual desire that it was able to conceive by the wind that had passed a male, or even by the latter's mating call. But this very fact was susceptible of a positive interpretation: a partridge bearing the motto AFFLATU FECUNDA ("fruitful by a breath of air") could illustrate the fact that the Virgin conceived by the Holy Spirit; and since the Virgin Mary, through the angelic salutation, "conceived through the ear" (*quae per aurem concepisti*), the partridge could visualize the phrase AVDITA VOCE FECVNDA ("fruitful by hearing a voice").[11]

Apart from the lost *Judgment of Solomon* in the Palazzo della Ragione at Vicenza, a few designs for woodcuts (the *Sacrifice of Abraham*, *Samson and Delilah*, the *Drowning of Pharaoh's Host*), a *Judith* owned, in 1533, by Alfonso d'Este, and an early rendering of a subject dear to the great merchants who sent their sons abroad for training, i.e., young Tobit guided by the Angel Gabriel on his quest for the fish whose gall was to cure his father's

10. In this, as in so many other respects, Crowe and Cavalcaselle (*C.-C.*, ɪ, p. 304), referring to the bird as a "partridge," were better informed than some of their modern followers. I am grateful to my friend, Professor Millard Meiss (no mean ornithologist himself), who submitted the problem to Messrs. Charles Rogers and Allan Cruickshank.

11. For these two emblems, see Filippo Picinelli, *Mundus symbolicus*, ɪv, 53, No. 553. For the whole subject, cf. E. Jones, "The Madonna's Conception through the Ear," in *Essays in Applied Psychoanalysis*, London and Vienna, 1923, pp. 261 ff., particularly 279, 286; for my acquaintance with this article I am also indebted to Professor Meiss.

blindness,[12] Titian had only one major occasion to deal with scenes from the Old Testament: in three large pictures originally adorning the ceiling of Santo Spirito in Isola (the Church of the Augustinian canons situated on a tiny island in the Laguna Viva). Transferred to the greater sacristy of S. M. della Salute after the suppression of the Order in 1656, these three pictures represent the *Slaying of Abel*, the *Sacrifice of Isaac*, and the *Triumph of David over Goliath* (Figs. 35-38).[13] They had been commissioned to, but not executed by, Vasari in 1541 and were speedily carried out by Titian in the following years; by the end of 1544 he and the canons were already involved in a lawsuit for payment.[14]

12. For the *Judgment of Solomon* in Vicenza, attested by Vasari (VII, p. 431) and Ridolfi, see *C.-C.*, I, p. 140 and *V.*, I, p. 80; for the *Judith*, *C.-C.*, I, p. 364, and *V.*, I, p. 85. The "*Tobiolo*" — according to Vasari painted for the Church of S. Marziliano (or S. Marziale) "in 1507, when Emperor Maximilian made war on the Venetians" (VII, p. 430) — has come down to us in two versions, both problematical. One (*V.*, I, Pl. 186) is still in S. Marziale; the other (*V.*, I, p. 92, Pl. 197) was originally in S. Caterina and is now in the Accademia. The picture in S. Marziale gives the impression of a later replica; the kneeling St. John the Baptist, whose presence is difficult to account for, can hardly antedate by about forty years the analogous figure in Titian's *St. James* in S. Lio (*V.*, II, Pl. 13), a work of c. 1547. The picture in the Accademia recommends itself by the fact that the buildings in the background are identical with those in the early *Baptism of Christ* in the Museo Capitolino (*V.*, I, Pl. 47; cf. A. H. R. Martindale in his review of S. M. Marconi's catalogue, *loc. cit.*, p. 578f.). But this picture comes from S. Caterina rather than S. Marziliano, and its style is less concordant with Titian's than with that of Sante Zago, to whom it was already ascribed by Boschini (see C. Gilbert, "Sante Zago e la cultura artistica del suo tempo," *Arte Veneta*, VI, 1952, pp. 121ff.). It would thus seem that both the pictures still extant are variations on the lost original.

13. *V.*, I, Pls. 179-181. The Titian literature after *C.-C.* is nearly unanimous in stating that the Church of Santo Spirito in Isola was built by Jacopo Sansovino and "demolished" in 1656 (this even applies to the otherwise excellent article by W. Friedlaender, "Titian and Pordenone," *Art Bulletin*, XLVII, 1965, pp. 118ff.). But with the help of Mrs. Jean Bernstein and Sig. Michelangelo Muraro it could be ascertained that Sansovino's activity was limited to the remodeling of the façade and the choir (G. Lorenzetti, *Itinerario Sansoviniano a Venezia*, Venice, 1929, p. 91), and that what happened in 1656 was only the expulsion of the Augustinian canons and the transfer of all movable art treasures to S. M. della Salute (*Venezia e le sue lagune*, Venice, 1847, II, 2, p. 488; P. Molmenti and D. Mantovani, *Le Isole della laguna Veneta*, first edition, Bergamo, 1904, p. 29). The buildings remained intact and were turned over, in 1672, to the Osservanti when they had been expelled from Candia. In 1806, when all religious orders were suppressed, the buildings were converted into a military depot; according to Lorenzetti, all traces of the old structure have now disappeared. Madlyn Kahr's interesting essay "Titian's Old Testament Cycle," *Journal of the Warburg and Courtauld Institutes*, XXIX, 1966, pp. 193ff., appeared unfortunately too late to be considered here.

14. See Titian's letter of December 11, 1544, reprinted in *C.-C.*, II, p. 73.

This triad (one member of which was used to illustrate the crisis that marked the inception of Titian's fourth phase) shows him caught in a whirlpool of conflicting influences: a classical sarcophagus; Pordenone's lost frescoes (transmitted through engravings by Giacomo Piccini) in Santo Stefano at Venice; Correggio's decoration of the dome of San Giovanni Evangelista at Parma which Titian may have seen in copies or on a short side trip from a visit to Bologna or Mantua; possibly even a fresco of the fourteenth century.[15] From this resulted, on the one hand, an atypical intensification of the emotions, as when Cain continues to attack his brother, already felled and bleeding, "with a ferocity more cruel than Nero's" ("più crudo d'un Neron"); when the tragic resolve of Abraham is contrasted with the touching submission of a childlike Isaac; or when the "horrible and terrifying" ("orribile e tremendo") bulk of Goliath serves as a foil for the devout abandon of a diminutive David. On the other hand, we can observe an equally atypical predominance of bold foreshortenings and a *di sotto in sù* perspective which, as demonstrated by its absence in such parallels as the *Allegory of Wisdom* in the Biblioteca Marciana or the ceiling decoration of the City Hall at Brescia (destroyed but known to us through copies),[16] cannot be accounted for by the mere fact that the three canvases were ceiling pictures.

Their present arrangement in the greater sacristy of S. M. della Salute follows the sequence of events as told in the Bible: the *Slaying of Abel* (*Genesis*, 4), the *Sacrifice of Isaac* (*Genesis*, 22), the *Triumph of David* (I *Samuel*, 17); and the shape of the huge, oblong room, accessible only

15. The connection of Titian's series with Pordenone's lost frescoes in Santo Stefano at Venice was discovered and analyzed by Friedlaender, "Titian and Pordenone," cited above, p. 31, Note 13. It should be noted, however, that these frescoes constituted a cycle of twelve scenes from which Titian selected only three. Friedlaender also points out the more than accidental similarity (independently observed by this writer) which exists between two of the pictures in S. M. della Salute and three of the frescoes in the soffits of Correggio's dome of S. Giovanni Evangelista in Parma. Titian's *Slaying of Abel* reveals the influence of Correggio's interpretation of the same subject (P. Bianconi, *Tutta la pittura del Correggio*, Milan, 1953, Pl. 55; Friedlaender, Fig. 9) as well as of his *Jonah* (Bianconi, Pl. 54; Friedlaender, Fig. 10); and Titian's *Sacrifice of Isaac* presupposes Correggio's rendering of the same scene (Bianconi, Pl. 56; Friedlaender, Fig. 8). Titian's familiarity with, and admiration for, Correggio is stressed by Marco Boschini, *La Carta del navegar pitoresco*, Venice, 1660 (quoted in *C.-C.*, I, p. 430f.), who asserts that Titian was much impressed by "Correggio's cupola" at Parma and that his praise greatly enhanced Correggio's reputation.

16. *V.*, II, Pls. 80, 81; ibidem, p. 59 and Pl. 197. The phrase "orribile e tremendo" is borrowed from Boschini's *Carta del navegar pitoresco*.

through a door in one of its longer walls, made it necessary to display them side by side, i.e. from left to right. In Santo Spirito, a longitudinal church of modest dimensions, their sequence may be supposed to have proceeded from front to back rather than from left to right. But here a curious difficulty presents itself. With only one exception those writers who saw the three pictures before their transfer to S. M. della Salute (i.e. Vasari, Boschini in his *Carta del Navegar* and Ridolfi) are unanimous in listing the *Sacrifice of Isaac* at the beginning and in placing the *Triumph of David* between the two other pictures (*il quadro de mezo*, as one of these authors explicitly states).[17]

Since it is unlikely that two authors living in Venice simply copied Vasari, who may have been in error, we have no right to disregard their testimony; but the sequence recorded by them — apart from being at variance with the Biblical chronology — would have been most unsatisfactory from an artistic point of view, and I am inclined to believe that the sequence intended by Titian (who, we recall, fell out with the canons of Santo Spirito and may have refused to supervise the *mise-en-place* of his paintings in person) was precisely as it is now. The error, then, seems to have been committed when the paintings were installed in Santo Spirito and to have been rectified when they were transferred to S. M. della Salute — with the only difference that, as I said before, the pictures would seem to have been originally intended to be placed on a vertical rather than a horizontal axis (Fig. 35).

Read in this order, the three compositions would have formed a meaningful pattern, the *Slaying of Abel* dominated by a diagonal that runs from lower left to upper right; the *Sacrifice of Isaac* — the figure of Abraham revealing the renewed impact of the *Laocoön* which can also be felt in the nearly contemporary Louvre version of the *Crowning with Thorns* — by a diagonal that runs from lower right to upper left; the *Triumph of David* by

17. Vasari (VII, p. 446); Boschini, *Carta del navegar pitoresco* (published, we recall, in 1660), p. 164f., explicitly refers to the *Triumph of David* as the *quadro de mezo*; Ridolfi, I, p. 175, gives the same order in reverse (*Slaying of Abel, Triumph of David, Sacrifice of Isaac*). In the *Minere della pittura*, first published four years later than the *Carta del navegar pitoresco*, Boschini describes the series already in its present location and arrangement, for which see the little map in M. Muraro, *New Guide to*

Venice and her Islands, Florence, 1956, p. 333. Sansovino, *Venetia città nobilissima et singolare descritta*, Venice, 1581, fol. 83v, exceptionally lists the three pictures in the following order: *Sacrifice of Isaac, Slaying of Abel, Triumph of David*; but Sig. Michelangelo Muraro calls my attention to the fact that in the third edition of Sansovino's work, edited by Giustiniano Martinioni in 1663, when the pictures were already in S. M. della Salute, this statement was revised in favor of the present arrangement.

a less sharply inclined diagonal that starts at the lower left but terminates not at the upper right but in a central apex formed by a radiance of divine light between two nearly balanced masses of clouds. And the glance of the beholder would have been guided from the dark earth, polluted by the first murder, to an effulgent Heaven opening up before his very eyes.

From an iconographical point of view the series may be called a trilogy of homicide: homicide condemned by God, homicide prevented by God and homicide approved by God. But at the same time the three scenes are invested, I believe, with a Christological significance. Abel, "the keeper of sheep, foreshadows the shepherd of men," as St. Augustine puts it.[18] Isaac and, most particularly, David (the ancestor as well as the prototype of the Lord) were also considered prefigurations of Christ. And the specific events represented in Titian's pictures were held to stand for Christ's Passion at the hands of His brethren, the Jews; for His willingness to accept this Passion; and for His triumph over the Devil. "In Abel," says Paulinus of Nola, "Christ was killed by his brother..., in Isaac He was offered as a sacrifice" (*In Abel* [*Christus*] *occisus a fratre...*, *in Isaac oblatus*);[19] and "that David slew Goliath," says St. Augustine as well as countless other authorities, "signifies Christ Who slew the Devil because humility triumphs over pride."[20] Thus, Titian's triad may be read as an allusive — as the early theologians would say, "mystical" — representation of Christ the victim (*Christus occisus*), Christ the instrument of redemption (*Christus oblatus*) and Christ the conqueror of evil (*Christus triumphans*). And it is only with this allusive significance in mind that we can fully appreciate Titian's novel interpretation of David's victory over Goliath.

18. St. Augustine, *De civitate Dei*, xv, 7 (*Patrologia Latina*, xli, col. 445): "...occisus est pastor ovium hominum [i.e. Christus] quem pastor ovium pecorum praefigurabat Abel."

19. Paulinus de Nola, *Epistola* xxxviii (*Patrologia Latina*, lxi, col. 359): "in Abel [Christus] occisus a fratre, in Noë irrisus a filio, in Abraham peregrinatus, in Isaac oblatus." Cf., apart from the passage from St. Augustine quoted in the preceding note and many other Patristic texts, the lucid statement in Bede's *Hexaemeron*, ii (*Patrologia Latina*, xci, col. 69): "Cuncta autem, quae de iustitia vel martyrio Abel, et de pravitate ac damnatione Cain... dicuntur, mystice

dominicae passioni vel conversationi in carne... ac perditioni Iudaeorum testimonium ferunt."

20. St. Augustine, *Enarratio in Psalmum* xxxiii (*Patrologia Latina*, xxxvi, col. 302): "in figura Christi David, sicut Golias in figura diaboli; et quod David prostravit Goliam, Christus est qui occidit diabolum. Quid est autem Christus qui diabolum occidit? Humilitas occidit superbiam." In the *Enarratio in Psalmum* cxliii (*Patrologia Latina*, xxxvii, col. 1856) we read about the Slaying of Goliath: "Provocavit impietas pietatem, provocavit superbia humilitatem, postremo provocavit diabolus Christum."

Ostensibly — and this in itself is, so far as I know, unprecedented — David offers a prayer of thanks to God after having beheaded Goliath. But the way in which he rushes forward and upward gives the impression of both an intercession and an ascension. Detaching and, as it were, liberating himself from the inert, earth-bound mass of the prostrate colossus (whose head is severed but still in place), he appears to be imploring as well as thanking the Deity and he seems to rise to Heaven — a Heaven which quite literally opens itself before his, and the beholder's, eyes — by the sheer force of faith. It is almost symbolic that the figure of Goliath (usually, as required by I *Samuel*, 17, 49, represented "fallen upon his face to the earth") is here patterned after a sinner from pagan antiquity, the slain Aegisthus in an Orestes sarcophagus which, transmitted in at least three nearly-identical replicas and demonstrably familiar to Renaissance artists from the first half of the fifteenth century, was to haunt Titian's imagination for nearly half a century (Fig. 57);[21] the gesture of the praying David, on the other hand — his arms ecstatically raised and joined above his head, partly overlapping his face — is anticipated by that of a Christian saint offering prayers as well as thanks for delivery: the St. George saved from the wheel in Altichiero's fresco in the Oratorio di San Giorgio at Padua (Fig. 39) which Titian knew so well from his sojourn in 1510/1511.

The idea that the series now in S. M. della Salute reveals some influence of Correggio finds support in the nearly contemporary *St. John on Patmos*, originally in the Scuola di San Giovanni at Venice and now in the National Gallery at Washington (Fig. 40). It seems to reflect Correggio's portrayal of the same Saint in San Giovanni Evangelista at Parma,[22] and its iconography is not so vague or arbitrary as would appear from previous

21. See Brendel, "Borrowings from Ancient Art in Titian," Fig. 11 and 19. Brendel's Fig. 11 shows, like our Fig. 57, the Orestes sarcophagus in the Lateran Museum. Others are preserved in the Palazzo Giustiniani (S. Reinach, *Répertoire de reliefs grecs et romains*, Paris, 1909-1912, III, p. 259, No. 1) and in the Vatican (ibidem, p. 388, No. 1). In his decoration of the Jesuits' Church in Antwerp, lost but known to us through sketches and engravings, Rubens represented David raising his arms in similar fashion not in order to pray but, significantly, in order to behead Goliath (see J. R. Martin, *The Ceiling Paintings for the Jesuit Church in Antwerp* [*Corpus Rubenianum Ludwig Burchard*, Part I], Brussels, 1968, pp. 69 ff., Nos. 5 – 5 b and Figs. 31–36).

22. *V.*, I, Pl. 178. For Correggio's *St. John the Evangelist*, cf. Bianconi, *Tutta la pittura del Correggio*, Pls. 64, 68.

discussions.[23] St. John's visionary experience on Patmos begins, it will be remembered, with a vision in which he sees "seven golden candlesticks" (it is significant that he sees the candlesticks first) and in their midst "one like unto the Son of man" (*Rev.* 1, 12-16). It is this scene with which most artists, including Dürer, opened their illustrations of the Apocalypse. But Titian's imagination was fired, I think, by the preceding versicles of the text (10, 11, and the beginning of 12), where St. John hears but does not as yet see the awsome apparition: "I was in the Spirit ... and heard behind me a great voice as of a trumpet... and I turned to see the voice that spake with me." It is the choice of this pregnant moment—prior to the actual "seeing" — which accounts for the contorted movement of the startled visionary.

With this, if one may say so, auditory vision of St. John, we have entered the world of the New Testament; but we have entered it by the back door rather than the front door.

Chronologically, the earliest incident from the "era under Grace" narrated by Titian — and in fact, preceding the actual inception of this era by several years — is the *Presentation of the Virgin*,[24] that colossal canvas which can still be seen in the room for which it was painted: the guest-house of the Scuola della Carità, now incorporated in the Accademia (Fig. 41). Its composition, we remember, is governed by the same principles as the contemporaneous *Venus of Urbino* in the Uffizi and the *Annunciation* in the Scuola di San Rocco: rectangular schematization and isolability of "genre and still-life features." In the *Presentation*, however, Titian was handicapped by three difficulties.

He had to display more architectural perspective than was his custom and suited his inclinations. He had to tag on to the principal scene a kind of Dutch group portrait showing the governing body of the distinguished confraternity which had commissioned the picture. And he had to put up with a rectangular gap in the lower right-hand corner, caused by a doorway which, in contrast to that on the left, was already in existence and had to be reckoned with when the picture was painted.

23. *T.*, p. 397. For a reconstruction of the entire ceiling (including the small marginal panels, probably largely executed by assistants, which are discussed in *V.*, I, pp. 74, 103 and in part illustrated on Pls. 217, 218), see J. Schulz, "Titian's Ceiling in the Scuola di San Giovanni Evangelista," *Art Bulletin*, XLVIII, 1966, pp. 89 ff.

24. *V.*, I, Pls. 148-152.

way, from the sacred event that takes place within it. In indicating the era *ante legem* by a mere torso, he made the beholder aware of the fact that Greek and Roman paganism was no longer a problem while Judaism was still very much alive. And in replacing the merchants — who, though bent on profit, sell things required for the cult — with an old hag selling nothing but eggs — entirely unrelated to even the Jewish ritual — he produced the symbol of a mentality not only unenlightened but incapable of ever seeing the light: the spirit of those of whom the Evangelist (*John* 12, 40) says that the Lord "hath blinded their eyes and hardened their heart."

Of all the other representations of subjects from the New Testament I shall discuss only two: one, because it still tends to be misinterpreted; the other, because it confronts us with what seems to be an anachronism involving more than three hundred years.

The first of these pictures (Fig. 47) is an altarpiece, impressive in spite of the fact that it was carried out with the help of the workshop. In 1554 it was donated by Titian to the Collegiate Church at Medole near Mantua, which still owns it.[27] It shows a dialogue between the Risen Christ and His Mother who is shown kneeling before Him. She is alone; but He is accompanied by some of the patriarchs whom He had freed from Purgatory before His Resurrection: Adam (his posture clearly revealing the influence of Michelangelo's *Risen Christ*), Eve, Noah, and Abraham (the two last-named mentioned together in *Hebrews*, 11, 6-8). And a special expressiveness is lent to this dialogue by the gestures of the two hands, the Virgin's right and the Redeemer's left. According to a preference already noticeable in such early works as the *Bacchanal of the Andrians* (Fig. 114) and the *Assunta* (Fig. 14), they are sharply bent at the wrist and silhouetted against the sky.

In the special literature on Titian, as far as I know it, the Medole Altarpiece is always described as *Christ's Appearance to His Mother*; and while a very competent article devoted to the general iconography of this

27. *V.*, II, Pl. 64. Titian had old relations with the Collegiate Church of S. Maria at Medole. Federico Gonzaga, Duke of Mantua (d. 1540), had granted one of the canonries at Medole to Titian's prodigal son, Pomponio. On April 26, 1554, Titian asked Federico's son and successor, Guglielmo (d. 1587), to authorize the transfer of this benefice to one of Titian's more deserving nephews (*C.-C.*, II, pp. 240 ff., 507), and the altarpiece may well have been donated on the occasion of this nephew's admission to the Chapter of S. Maria at Medole.

subject acknowledges the uniqueness of Titian's composition, it does not specify its theological content.[28]

That Christ appeared to the Virgin Mary after His death is not recorded in the Bible; but from the earliest times it was taken for granted that He, before appearing to so many others, must have appeared to His own mother. He was believed either to have shown Himself to her near the sepulchre on Easter morning or — more frequently in Western art — to have visited her, after His descent into Limbo, in her house on the Sabbath between the Friday of the Crucifixion and the Sunday of the Resurrection. And from the end of the thirteenth century the description of these sweetly sad reunions was embroidered with many touching, sometimes unabashedly sentimental details.

In rendering the unrecorded encounter most artists, except for those few who preferred to show Christ and His mother shaking hands or fervently embracing each other as was described in Pseudo-Bonaventure's *Meditations*, patterned the scene either after the *Noli me tangere* (the Virgin Mary kneeling and facing her son in an out-door setting) or after the *Annunciation* (the Virgin Mary surprised by His appearance while reading or praying in the privacy of her room). And this applies even where Christ, having redeemed the Patriarchs from Purgatory, appears in their company (Fig. 48).[29] But wherever the miraculous event is staged, it is staged on earth. Titian, however, transposes it to Heaven. While he retains what may be called the *Noli me tangere* type, he shows the two figures surrounded by angels and supported by clouds.

In making this unique innovation, Titian, apparently advised by one of the canons of Medole, defined the correct solution of a major theological dispute which had come to a head at the time. Ever since, in 1245, the members of the Carmelite Order had adopted the style and title of *Fratres Beatae Mariae Virginis* and begun to wear a special scapular to insure her

28. J. D. Breckenridge, "'Et Prima Vidit': The Iconography of the Appearance of Christ to His Mother," *Art Bulletin*, xxxix, 1957, pp. 9 ff., specifically p. 30. Cf. now I. Haug, "Erscheinungen Christi," *Reallexikon zur deutschen Kunstgeschichte*, V, cols. 1350 ff., particularly cols. 1360 f.), and T. Dobrzeniecki, "Legenda Średniowieczna W Piśmiennictwie I Sztuce Chrystofania Marii" (with English summary entitled "The Christophany to the Virgin; a Mediaeval Legend in Literature and Art"), *Średniowiecze Studia o kulturze*, ii, 1965, pp. 7 ff. Here, however, the uniqueness of Titian's Medole Altarpiece (unconvincingly connected with the homilies of St. Vincent Ferrer on p. 130) has not been recognized.

29. For the probable origin of this motif — a concretization of Ludolf of Saxony's account, according to which Christ merely *tells* His mother of His descent into Limbo — see Breckenridge, ibidem, p. 28.

protection, they had been spreading the belief that the Virgin Mary would descend into Purgatory on the Saturday after the death of one of her special votaries in order personally to liberate him, particularly of course, if he was a member of the Carmelite Order itself. This belief — formalized in a spurious papal Bull, known as *Bulla Sabbatina* — was untenable from a theological point of view, since only Christ Himself has the power of redemption. Yet it had taken root so firmly that, from 1577, a series of genuine Bulls acknowledged it precisely by restricting it to acceptable limits: while the Virgin Mary was denied the power to redeem in person, she was credited (as she still is in Chapter VIII, 3, 62 of the section *De Ecclesia* adopted by the Vatican Council of 1964) with the office of "assisting the souls of the deceased by her perpetual intercession, pious prayer and special protection."[30] It is this Perpetual Intercession for the Souls of the Deceased — performed, of course, in Heaven rather than in Purgatory or on earth and "neither taking away from nor adding to the dignity and efficaciousness of Christ, the only Mediator" — which is the true subject of Titian's Medole Altarpiece. But so closely did Titian keep to the traditional way of representing Christ Appearing to His Mother in the Company of the Redeemed, that his composition could serve as a model for the most beautiful of those visualizations of the *Bulla Sabbatina* which, all objections notwithstanding, sprang up by 1580 and show the Perpetual Intercession in Limbo rather than in Heaven. Guido Reni's "*Harrowing of Hell in the Presence of the Virgin Mary*" (formerly Dresden, our Fig. 49) is hardly imaginable without the influence, direct or indirect, of Titian's Medole Altarpiece.[31]

30. Cf. E. Panofsky, "Imago Pietatis ..." (cited above, p. 26, Note 42), p. 306, Note 107: "post eorum transitum suis intercessionibus continuis, piis suffragiis et speciali protectioni adiuvabit." Subsequently this limited power of intercession for the souls in Purgatory was extended to certain saints, particularly St. Theresa, who in a well-known composition by Rubens (original in the Antwerp Museum, illustrated in *Rubens, Klassiker der Kunst*, 4th edition, p. 339; reduced replica in the Metropolitan Museum, reproduced in J. A. Goris and J. S. Held, *Rubens in America*, New York, 1947, p. 53, No. A. 73, Appendix Pl. 3) is represented kneeling before Christ, with the souls in Purgatory emerging from the lower margin. But in contrast to Titian's Medole Altarpiece the scene is not transposed to Heaven.

31. For these unorthodox compositions, which begin with Alessandro Allori's altarpiece in S. Marco at Florence, see Breckenridge, *op. cit.*, pp. 30 ff. It should be noted, however, that the picture there reproduced in Fig. 19 as a work of Guido Reni is actually a work of Lodovico Carracci (H. Bodmer, *Lodovico Carracci*, Burg bei Magdeburg, 1939, Fig. 54), the confusion arising from the fact that both paintings are (or, in the case of Reni, were) preserved in the Gemäldegalerie at Dresden. For the real Guido Reni, see C. Gnudi, *Guido Reni*, Florence, 1955, p. 74, No. 51, Fig. 99.

In contrast to this altarpiece, the other picture I should like to discuss is a much earlier and less ambitious work, already briefly mentioned as a characteristic product of Titian's first phase, when he had not as yet entirely disengaged himself from the influence of Giorgione and Leonardo but had already developed a style of his own and, particularly, an unparalleled ability to interpret the human eye as the "window of the soul": the much-repeated *Salome* in the Galleria Doria-Pamphili (Fig. 50).[32]

Salome carrying the charger with the head of the Baptist is shown in front of a piece of masonry which, as indicated by a lock, represents the Saint's prison and is somewhat mysteriously connected with a frontal wall pierced by an arch. Meditative, sad and a little benumbed, she seems to recoil from the face of St. John which yet attracts her side-long glances with irresistible force; a handmaiden — normally found in renderings of Judith rather than Salome but here included, possibly for the first time, in order to produce a poignant psychological contrast[33] —

32. *V.*, i, Pl. 61. I am indebted to Mrs. Edward Fowles for the information that the well-known and very fine replica of the Doria-Pamphili *Salome*, which was sold in London at the beginning of the nineteenth century and passed from the possession of R. S. Ottley to the Benson Collection (*Catalogue of Italian Pictures Collected by Robert and Evelyn Benson*, London, 1914, p. 183, No. 91), is now owned by the Norton Simon Foundation in Los Angeles.

I do not wish to discuss the relative merits of these two versions; but I must take exception to a statement by Dr. Luisa Vertova ("The Princes Doria Pamphili" in D. Cooper, ed. and introd., *Great Family Collections*, London and New York, 1965, pp. 47 ff., specifically p. 74) to the effect that the *Salome* now in the Galleria Doria-Pamphili did not enter this collection until the end of the nineteenth century, allegedly as late as 1894. That the Doria-Pamphili *Salome* was in its present location long before that time is proved by the fact that it gave rise to a battle of the giants as early as the 1870's. Traditionally ascribed to Titian, this painting — always referred to as being in the "Palazzo Doria" — was incomprehensibly attributed to Pordenone by J. A. Crowe and G. B.

Cavalcaselle, *A History of Painting in North Italy*, London, 1871, ii, p. 287. It was reclaimed for Titian by G. Morelli, *Kunstkritische Studien über italienische Malerei*; *Die Galerien Borghese und Doria-Panfili in Rom*, Leipzig, 1890, p. 403 f., endorsed by scholars ever since — with the notable exception of Jacob Burckhardt who, accepting Crowe and Cavalcaselle's attribution, extols "die Herodias des Pordenone bei Doria, welche alle ähnlichen Tiziane in Grund segelt" in a letter of August 23, 1883 (*Jacob Burckhardt, Briefe*, ed. F. Kaphahn, Leipzig, 1935, p. 459). There is, therefore, no reason to claim that there was no *Salome* in the Doria Collection throughout the nineteenth century and to identify the Benson-Simon rather than the Doria-Pamphili painting with the "*Erodiade*" mentioned and assigned to Titian in the *Descrizione raggionata della Galleria Doria* of 1794 (E. Sestieri, *Catalogo della Galleria Ex-Fidecommissaria Doria-Pamphili*, Rome, 1942, p. 341 f.).

33. For other renderings of Salome accompanied by a servant girl, all postdating Titian's painting, see the pictures reproduced in H. Daffner, *Salome; Ihre Gestalt in Geschichte und Kunst*, Munich, 1912, pp. 227, 231, 235.

looks at the heroine with the eyes of a faithful dog who feels and shares his master's distress without comprehending its cause.

It is a very sensuous picture (note, for example, how the locks of the Baptist are brought into direct contact with the bare forearm of Salome), and this sensuousness seems to be fraught with personal connotations. It has been conjectured that the Saint's face bears Titian's own features,[34] and though we can compare it only with portraits made about half a century later, I am inclined to accept this hypothesis. The apparent age of the Baptist (about thirty) agrees with Titian's presumable age at the time when the *Salome* was painted; and in all those traits which tend to remain constant in a human countenance — the curve of the forehead, the conformation of the cheekbones, the arch of the eyebrows, the thin, aquiline shape of the nose — the picture anticipates the late self-portraits (Fig. 7 and Frontispiece) to a surprising degree.

If this interpretation *ad hominem* were admitted, Titian's *Salome* would be the earliest example of those self-portraits *en décapité* in which a love-stricken painter lent his own features to either Holofernes (as is the case with Cristofano Allori's famous *Judith* in the Pitti Palace, where the heroine is impersonated by Allori's mistress, "La Mazzafirra") or to Goliath (as is the case with Caravaggio's *David* in the Galleria Borghese);[35] but even if it were rejected, the amorous implications of Titian's *Salome* are attested by the little Cupid perched, like a sculptured keystone, on the apex of the arch.

The idea of Salome's erotic involvement with John the Baptist is generally considered a romantic invention of the nineteenth century, popularized by Heinrich Heine, Oscar Wilde, Aubrey Beardsley, and Richard Strauss. By and large, this view (formerly shared by myself)[36] is not without justification. But there existed a kind of underground

34. This conjecture, put forward by L. Hourticq, *La Jeunesse de Titien*, Paris, 1919, p. 138, was accepted by Foscari, *Iconografia di Tiziano*, p. 22f., Pl. 8.
35. For Cristofano Allori's *Judith*, allegedly portraying the painter's mistress, La Mazzafirra, and praised in Balzac's *La Cousine Bette* as an anticipated likeness of his charming Josépha Mirah ("la *Judith* d'Alloris, gravée dans le souvenir de tous ceux qui l'ont vue dans le palais Pitti"), see R. and M. Wittkower, *Born under Saturn; The Character and Conduct of Artists*, London, 1963, p. 160f., Fig. 48. For Caravaggio's *David*, see W. Friedlaender, *Caravaggio Studies*, Princeton, 1955, p. 202f., Pls. 41, 41B. These two pictures are conveniently and impressively juxtaposed in M. Wallis, *Autoportret*, Warsaw, 1964, Figs. 18 and 19.
36. E. Panofsky, *Early Netherlandish Painting*, Cambridge, Mass., 1953, I, p. 471, Note 281[1].

tradition which anticipated the modern interpretation by more than seven centuries.

The Gospels (*Matthew* 14, 1-11; *Mark* 6, 22-28) mention the "daughter of Herodias" (and, therefore, stepdaughter of Herod II Antipas) only as "the damsel." It is in Flavius Josephus (*Antiquitates Judaeorum*, XVIII, 136) that the name "Salome" occurs for the first time; and with such rare exceptions as St. Isidore of Pelusium (5th century), the Christian writers were always reluctant to adopt it. They either continued to leave her anonymous or — thanks to a confusion dating back as far as Origen — bestowed upon her the name of her mother, Herodias.[37]

According to the Gospels, this "damsel" is a mere tool in the hands of her wicked mother. It is the latter who — enraged by the Baptist's censure of her incestuous marriage to Herod who had taken her away from his half-brother, Philip[38] — "instructs" her daughter to ask for the Baptist's head as a reward for dancing at Herod's birthday party. There is no implication of love, except for Herod's obvious infatuation with his step-daughter, cleverly exploited by his wife. And it is only as an accomplice *malgré elle* (lighthearted rather than malevolent, "mehr leichtsinnig als boshaft," as Jacob Grimm puts it) that Salome becomes a victim of divine retribution in later legends. According to one of these legends — apparently in order to make the punishment fit the crime — she was decapitated by the ice on which she was walking and which broke beneath her; according to another she was blown into the sky by a blast of air miraculously rushing forth from the mouth of the Baptist's head.

This weird ascension secured for Salome (still commonly referred to as "Herodias" but unequivocally identified as the virginal daughter of the real Herodias and as an incomparable dancer) a place not only in mediaeval demonology but also, curiously enough, in mediaeval hagiology. She was equated with the old, Germanic storm goddess, Frau Hulda, Fru Helle or Fru Helde, and thus assumed a prominent position in the

37. Origen, *Comment. in Matthaeum*, x (*Patrologia graeca*, XIII, col. 893): "She [Herodias] gave birth to a daughter of the same name" (θυγατέρα ἐγέννησεν ὁμώνυμον). Even in the elaborate *Life of St. John the Baptist* formerly ascribed to Domenico Cavalca (*Vite di alcuni Santi scritte nel buon secolo della lingua toscana*, ed. D. M. Manni, III, Florence, 1734, pp. 251 ff.) the daughter of Herodias is referred to only as "la fanciulla." The best account of Salome and the legends surrounding her is still a pseudonymous monograph, Reimarus Secundus, *Geschichte der Salome von Cato bis Oscar Wilde*, Leipzig, n.d. [1909], of which Daffner's book, cited above, p. 42, Note 33, is a mere abstract, valuable only for its illustrations.

38. *Matthew* 14, 3; *Mark* 6, 17f. This Philip, the son of Herod I and Mariamme or Mariamne, is occasionally referred to as "Herodes Boëthos."

Wilde Jagd or *Wildes Heer* (Wild Hunt) that rides the clouds by night; and in this capacity she is said in texts ranging from the tenth century to the twelfth to have been worshipped by one-third of all mankind.[39] But owing to the fortuitous assonance between "Fru Helde" and the Flemish name Verylde or "Verelde," she also came to be identified with a *bona fide* saint: St. Verelde (Pharaïldis in Latin), one of the city patrons of Ghent.

It was, ironically, a canon and scholasticus of St. Pharaïldis in Ghent, named Nivardus, who in the early twelfth century not only identified the patroness of his own church with the stepdaughter (according to him, the real daughter) of Herod but also transformed the Biblical account of the death of St. John into a love story. "Herodias," he tells us, "was madly in love with the Baptist and vowed not to marry any other man." It is out of resentment that Herod orders the execution of St. John and out of amorous despair that Salome requests his head. She embraces it with her "soft arms," drenches it with tears and attempts to kiss it. But the head shies away from her and sends her up into the air. Pursued by the spirit of him who had refused to reciprocate her love, she suffers for a long time, comforted only by the veneration of millions. But ultimately (perhaps because she, like the genuine Pharaïldis, had been faithful to a vow of virginity) she comes to be revered as a saint:

> "Now known as Pharaïldis — once Herodias —
> Unrivaled as a dancer now and evermore."[40]

39. Rather of Verona, *Praeloquia*, i (*Patrologia Latina*, cxxxvi, col. 157f.); Nivardus of Ghent as quoted in the following Note. Cf. Reimarus Secundus, *op. cit.*, iii, p. 47, and Jakob Grimm, *Deutsche Mythologie* (first published in 1835), 4th edition, ed. E. H. Meyer, Berlin, 1875/76, i, p. 235. Further, see Bächtold-Stäubli, *Handwörterbuch des deutschen Aberglaubens*, Berlin and Leipzig, 1927-42, iii, col. 1790f., and vii, col. 10f.

40. Nivardus of Ghent, *Ysengrimus* (often referred to under the arbitrary title *Reinardus Vulpes*), ii, 73ff.; in E. Voigt's edition (Halle, 1884), p. 78f. The passage — cited, e.g., by Grimm, *loc. cit.*, Reimarus Secundus, *op. cit.*, iii, p. 46f., and Bächtold-Stäubli, *op. cit.*, vii, col. 10f. — reads as follows (spelling and punctuation modernized):

"Hac famosus erat felixque fuisset Herodes
Prole, sed infelix hanc quoque laesit amor.
Haec virgo thalamos Baptistae solius ardens
Voverat hoc dempto nullius esse viri.
Offensus genitor comperto prolis amore
Insontem sanctum decapitavit atrox;
Postulat afferri virgo sibi tristis, et affert
Regius in disco tempora trunca cliens.
Mollibus allatum stringens caput illa lacertis
Perfundit lacrimis osculaque addere avet.
Oscula captantem caput aufugit atque resufflat,
Illa per impluvium turbine flantis abit.
Ex illo nimium memor ira Johannis eandem
Per vacuum caeli flabilis urget iter.
Mortuus infestat miseram nec vivus amarat,
Non tamen hanc penitus fata perisse sinunt:

This highly unorthodox version of the Salome story, compounded of folkloristic superstition (the salve applied by witches before rising into the air used to be called *unguentum Pharelis*), sacred legend and romance, could never find official recognition. It left its mark on popular songs and on the customs practiced at the Feast of St. John, that is to say, Midsummer Day, but there seems to be no further trace of it in literature until Jacob Grimm printed the tale of Nivardus in his *German Mythology* (published in 1835), whence it passed into the 19th Canto of Heine's *Atta Troll* (composed in 1841), and thence into the art and literature of the *fin de siècle*. Yet, as Heine rightly says:

> "In der Bibel steht es nicht,
> Doch im Volke lebt die Sage
> Von Herodias blutger Liebe";

> "This is not found in the Bible,
> But the people know the legend
> Of Herodias' bloody love."

In some way or other this "underground version" of the Salome theme must have persisted throughout the centuries.[41] It was revived by Titian; and that it was still remembered in the seventeenth century is evident from at least two pictures. One is a rather indifferent, belatedly Leonar-

Lenit honor luctum, minuit reverentia paenam,
Pars hominum maestae tertia servit herae...
Nunc ea nomen habet Pharaildis, Herodias ante,
Saltria nec subiens nec subeunda pari."
41. For the erotic songs and rituals sung and performed on St. John's day, June 24th (the only birthday of a saint honored by the Church), see (in addition to Reimarus Secundus, *op. cit.*, III, pp. 48 ff.) Bächtold-Stäubli, *op. cit.*, IV, cols. 718 ff., and W. Mannhardt, *Wald- und Feldkulte*, reprinted Darmstadt, 1963, pp. 470 ff. A book by H. G. Zagona, *The Legend of Salome and the Principle of Art for Art's Sake*, Geneva and Paris, 1960, obscures rather than clarifies the historical issues. Designating the name "Pharaïldis" as "Egyptian" (p. 20) and referring to Jakob Grimm's *Deutsche Mythologie* as an anonymous

"volume of folklore" which had "perhaps" come to Heine's knowledge (p. 34 f.), the author takes no cognizance of Nivardus of Ghent and mentions Titian's *Salome* among those renderings of Salome which "concentrated more on the gracefulness of the dancer than on her evil intent" (p. 21). A trace of the "Nivardus version" may perhaps be discerned in such late mediaeval renderings of the Beheading of St. John as a probably Suabian picture of c. 1400, preserved in the Württembergische Staatsgalerie at Stuttgart (H. Th. Musper, "Ein 'Ulmer' Altar von Ende des 14. Jahrhunderts?," *Form und Inhalt; Kunstgeschichtliche Studien Otto Schmitt... dargebracht*, Stuttgart, 1950, pp. 177 ff., Fig. 12), where Salome, having received the head of the Baptist, has gone to her knees and looks upon it with an expression of profound sadness and devotion.

desque portrayal of Salome by an Italo-Dutch painter, Pieter Cornelisz van Rijck, where the scene on the medallion suspended from Salome's necklace admits of only one interpretation (Fig. 51). The other is a remarkable and often copied painting by Guercino (owned by Mr. Denis Mahon in London) which represents Salome visiting St. John in prison (Fig. 52). Gorgeously attired, the love-stricken princess yearningly looks through the window of the Baptist's cell, clutching its bars with her left hand, while he turns disdainfully away from her enraptured glance.[42]

In tracing the strange, eventful history of the Salome legend, we have been led from the orbit of the New Testament into that of hagiology.

The earliest of Titian's works in this domain — in fact, we recall, his earliest work not only surviving but also authenticated and dated by documents — is a cycle of three frescoes in the Scuola del Santo at Padua, executed between December 1510 and December 1511 and representing three miracles of St. Anthony. We have, first, the justification of a wife wrongly accused of adultery: the Saint endows her new-born son with speech and thus enables him to testify to his legitimacy. The second miracle involves the healing of a young man who, having kicked his mother with his foot, had subsequently hacked it off in contrition. Finally, there is the revival of an innocent wife stabbed by her husband in a fit of jealousy but brought back to life by the Saint after the husband repented.[43]

42. The picture by P. C. van Rijck (born at Delft in 1568, settled in Haarlem in 1604 after having spent fifteen years in Italy, died in 1628) was in the New York trade in 1964 and was kindly brought to my attention by Dr. Leo Steinberg. For the painting by Guercino, owned by Mr. Denis Mahon in London, see D. Posner in *Art in Italy 1600-1700* (*The Detroit Institute of Arts*), ed. F. Cummings, preface by R. Wittkower, New York, 1965, p. 98, No. 99. The previous explanation of the subject as "Joseph in Prison Visited by Potiphar's Wife" is untenable because Joseph, a high official at the court of Pharaoh, could not have been represented in the guise of a bearded anchorite who, moreover, wears beneath his cloak the tell-tale shirt of "camel's hair" (*Mark* 1, 6). Mr. Mahon was kind enough to let me know that Abram Breugel, acting as "scout" for Don Antonio Ruffo about 1670, referred to Mr. Mahon's Guercino as a "S.Giovanni in prigione con una Donna che lo tenta" (*Bollettino d'Arte*, x, 1916, p. 190). This is welcome confirmation of what is suggested by the visual evidence.

43. *V.*, I, Pls. 23-31. Cf. Muraro et al., *Pitture murali nel Veneto*...(quoted above, p. 3, Note 2), p. 102f., Fig. 70. The possible influence of Giotto's Arena frescoes on Titian's St. Anthony cycle is stressed in an article by Mr. Allen Rosenbaum which the author was kind enough to let me read before publication.

In two cases — the *Miracle of the New-Born Infant* and the *Miracle of the Irascible Son* — Titian's frescoes deal with the same subjects as Donatello's reliefs on the high altar of St. Anthony's Church, affectionately called *Il Santo*; but Titian wisely refrained from courting comparison. He pursued, so to speak, a policy of non-recognition, and it was in deference to Mantegna's *Triumph of Caesar*, the same master's frescoes in the Eremitani Chapel at Padua and, possibly, Giotto's frescoes in the Arena Chapel (also in Padua) rather than under the influence of Donatello's reliefs, that he adopted a closely-packed, isocephalous arrangement of the figures in front of instead of within the picture space and accorded an unusual amount of prominence to figures represented in pure profile.

This basic independence from Donatello is also exemplified by the fresco which I have singled out for discussion: the *Miracle of the New-Born Infant* (Fig. 53). Donatello's interpretation of this scene (Fig. 54) is almost classicistic in modeling, costume and posture although he combines the three protagonists — the Saint, the mother and the child — into a group not unlike a Presentation of Christ. In Titian's mural nearly all the actors (about half of them shown in profile) are dressed in contemporary garb, a feature particularly conspicuous in the figures of the mother and the young father who storms upon the scene with a truly magnificent sweep of his cape; and a long-distance relationship is established between the mother, on the one hand, and the saint-and-child group, on the other.

All the more remarkable is the fact that, whereas in Donatello's "classicizing" relief the miracle takes place under the protection of the Madonna, in Titian's very "modern" fresco the scene is dominated by the slightly mutilated statue of a Roman emperor.[44] As is usual with Titian's first phase, this statue is still an incidental feature of the *mise-en-scène*. Yet he must have had a reason to include it in the representation of a miracle worked by a saint who had died in 1231 A.D. — all the more so as no comparable feature can be discovered in the two other scenes. The very uniqueness of the motif, however, may provide the clue for its interpretation.

The *Miracle of the New-Born Infant* is the only one of the three incidents which has an official and legal rather than a private and emotional

44. The statue, vaguely reminiscent of the famous *Augustus of Primaporta*, parallels even more closely the principal figure in a relief at Ravenna showing Augustus and his family; cf. L. Curtius, "Zum Antikenstudium Tizians," *Archiv für Kulturge-* *schichte*, xxviii, 1938 (not 1933, as in *V.*, ii, p. 92), pp. 233 ff., Fig. 2. Curtius also observed that the imperious posture of this statue recurs, disguised, in Titian's *St. John the Baptist* in the Accademia (*V.*, i, Pl. 172).

character: it involves the formal accusation of a woman charged with adultery and her equally formal acquittal. Now we know — and so did Titian, as can be demonstrated by the bust of Tiberius in the *Crowning with Thorns* in the Louvre (Fig. 20) — that it was a universal Roman custom to place a statue of the reigning emperor in every tribunal — much as a portrait of the reigning Sovereign is found in every courtroom in the British Commonwealth. For, as Severian puts it, the emperor, "since he is a human being, cannot be present everywhere and therefore an image of him must be erected in every place where his representative dispenses justice so that this image might validate (βεβαιόω) whatever action is being taken."[45] The *Apology* of Apuleius, widely read in the Renaissance, contains a passage which may well be Titian's direct source: it, too, involves an accusation of adultery and the testimony of the accused's own son "before the statue of the Emperor."[46]

Titian's emperor's statue, then, defines the locale of the narrative as what had been a "place of judgment" from time immemorial: Padua was proud of its descent from the Roman Patavium, the birthplace of Livy. But with an inversion *in bonam partem* frequently found in the Christian-ization of pagan motifs, an adult son accusing his mother of misconduct in front of the emperor's image, has been replaced by a small child ex-onerating her in the same setting; and while in pagan times the emperor's statue had embodied the idea of a terrestrial but infallible justice against which there can be no appeal, the emperor's statue in Titian's fresco embodies the idea of a terrestrial and fallible justice (hence, probably, the slightly fragmented state of the image) whose verdicts can be nullified by the miraculous intervention of God and His saints.

Some forty years after his return from Padua — to be exact, on October 11, 1552 — Titian dispatched to Philip II, together with some other pictures, a "portrayal of St. Margaret" which is now preserved in

45. Severianus, *De creatione mundi*, vi, 5, quoted in H. Kruse, *Studien zur offiziellen Geltung des Kaiserbildes im römischen Reiche*, Paderborn, 1934, pp. 79 ff. The locale of the Crowning with Thorns is described as "the hall called Praetorium" in *Mark* 15, 16, and as "the hall of judgment" in *John* 18, 28, 33 and 19, 9.

46. Apuleius, *Apologia*, 85 (ed. R. Helm, Leipzig, 1912, p. 93 f., cited by Kruse, *loc. cit.*). Apuleius, accused of having employed magic practices to inveigle a rich widow into marrying him, is outraged that "a son accuses his mother of shameful extra-marital relations and love affairs (*pudenda stupra et amores*) before the statue of the Emperor [Antoninus] Pius."

the Escorial (Fig. 55).[47] And after still another twelve or thirteen years, about 1565, he revised this composition in one of his ultimate productions, the wonderful *St. Margaret* now in the Prado (Fig. 56).[48]

That these two pictures — both of which may be described as "semi-nocturnes" — have survived, gives us a chance to compare a late with a still later interpretation of the same subject. Even in 1552 Titian's style had not as yet achieved that "coincidence of opposites," abundance and discipline, passion and severity, which distinguishes the *St. Margaret* of c. 1565 from her more plastic and more sinuous predecessor; only in the later picture did he reverse the normal color relations to such an extent that a figure clad in a moss green dress is set out against a landscape painted in all imaginable shades of brown and red without a trace of green. Yet the two pictures bear witness to Titian's enduring loyalty to certain basic experiences which stayed with him, so to speak, throughout his career.

At the beginning of the 'forties, we remember, the passive element of a classical Orestes sarcophagus — the slain Aegisthus — had furnished the model for the slain Goliath. But twenty years before, shortly after 1520, the active element in the same sarcophagus (Fig. 57), the contrapposto movement of the avenging Orestes, had inspired what Keats (*Sleep and Poetry*, 334f.) was to call the "swift bound of Bacchus" when he leaps from his chariot to rejoin Ariadne in a mortal and immortalizing embrace (Fig. 115). And it is still the same Orestes who, in a final transfiguration, recurs in the two *St. Margarets*.[49]

To re-employ this posture for a *St. Margaret*, essentially derived from Raphael's famous picture in the Louvre (designed by himself but executed by Giulio Romano whom Titian appreciated and often visited in Mantua), was not entirely unjustified. St. Margaret, too, performs a "swift bound": she steps forth from the belly of a dragon which had swallowed her; but by the power of the Cross the monster was forced to burst and to release her, in many renderings still gripping her garment with its teeth.

47 *V.*, ii, Pl. 52. For the letter of October 11, 1552, see *C.-C.*, ii, pp. 218ff., 505, where it is, however, taken to refer to the much later picture in the Prado (our Fig. 56). 48. *V.*, ii, Pl. 113. For a not very interesting, though signed, workshop replica, see R. Pallucchini, "Contributi alla pittura Veneta del Cinquecento," *Arte Veneta*, xiii-xiv, 1959-1960, pp. 39ff., especially pp. 47ff., Fig. 63.

49. The influence of the Orestes sarcophagus, first on the *Bacchus* (our Fig. 115) and then on the two *St. Margarets*, was, so far as I know, first pointed out by Brendel, "Borrowings from Ancient Art in Titian," pp. 118, 124. Its connection with the *St. Margarets* — but not with the *Bacchus* — was also stressed by R. W. Kennedy, *Novelty and Tradition in Titian's Art*, p. 13.

It is probably thanks to this legend that St. Margaret was, and is, venerated as the special patroness of childbirth. But the legend itself had resulted from an old and ineradicable confusion between St. Margaret (of whom originally no more was known than that she was the daughter of a priest at Antioch, martyred under Diocletian because of her conversion to Christianity) and an entirely different saint who shares with St. Margaret only her involvement with a dragon-like monster and the first three letters of her name: St. Martha, the sister of Lazarus and Mary Magdalen. These three were believed to have fled the Holy Land by ship and to have spent the rest of their lives in the South of France: the Magdalen was supposed to have died in Aix-en-Provence (or, according to some, in a cave in the "Chaîne de la Ste.-Baume" not far from Marseilles), St. Lazarus in Autun and St. Martha in Tarascon.

The difference between the two saints is this: Saint Margaret came to grips with her dragon while she was in prison, and the means by which she caused its destruction was to make the *sign* of the Cross. St. Martha, on the other hand, courageously approached her *draco ingens* (normally designated as *Tarasca* in Latin and *La Tarasque* in French) in its own lair, in the woods near Tarascon, whence it terrorized the whole valley of the Rhône. She sprinkled it with holy water, hypnotized it by means of a little *wooden* cross, bound it with her own girdle, and led it, like a tame dog, to a place where a group of determined citizens could finish it.

These two legends fused at an early date (before 1300 at the latest), so that St. Margaret, much better known and more widely venerated than St. Martha, tended to absorb a number of features originally belonging to the latter. The situation was further complicated by the fact that St. Margaret was often identified with the "Cappadocian Princess" delivered from still another dragon by St. George, and it is often difficult to determine which of the three saints is meant in a given work of art.[50]

50. A rather fine painting by Simon Vouet, now in the Wadsworth Atheneum at Hartford and repeatedly referred to as "*St. Martha*" (A. Griseri, "La Période romaine de Vouet; Deux tableaux inédits," *Art de France*, I, 1961, pp. 322 ff.; W. R. Crelly, *The Painting of Simon Vouet*, New Haven and London, 1962, p. 216, no. 141; W. Fischer, review thereof in *Kunstchronik*, XVI, 1963, pp. 40 ff., Fig. 1), is certainly a *St. Margaret*. The Saint is dressed like a princess rather than like a woman "cumbered about much serving," and the dragon chews a piece of her garment. For the early pictorial tradition, see the excellent study by J. Weitzmann-Fiedler, "Zur Illustration der Margaretenlegende", *Münchner Jahrbuch der Bildenden Kunst*, XVII, 1966, pp. 17 ff.; for La Ste.-Baume and its role in art, see R. A. Koch, "La Sainte-Baume in Flemish Landscape Painting," *Gazette des Beaux-Arts*, series 6, LXVI, 1965, pp. 273 ff.

In countless cases the delivery of St. Margaret is staged in the open air instead of in prison; she often appropriates not only St. Martha's little cross but also her girdle; and she tends to become closely associated with St. George. In a procession held at Antwerp on August 19, 1520, for example, Albrecht Dürer admired a beautiful girl who, impersonating St. Margaret, led a dragon by her belt and was followed by a "very handsome cuirassier" impersonating St. George.[51]

In a manuscript written at Avignon (in the Rhône Valley!) in 1337, on the other hand, it is St. Martha who legitimately leads her monster — here explicitly inscribed *Tarasca* and interpreted as a symbol of hypocrisy — by her belt (as she still does in the annual "Fête de la Tarasque" at Tarascon) and brandishes the little cross which is lawfully hers (Fig. 58). But, partially protruding from the monster's mouth, there appears none other than St. Margaret, here identified as "Christianity devoured in the likeness of St. Margaret" (*Christianitas devoratur similitudine Margaritae*), much as the Magdalen is here identified with the "spiritual Avignon, the celestial *Curia*" (*Auinio spiritualis, celestium Curia*).[52]

Titian's letter of October 11, 1552, fortunately leaves no doubt that we are confronted with St. Margaret in the Escorial as well as in the Prado. In both cases Titian accepted the then traditional transfer of the open-air setting and the little wooden cross from St. Martha to St. Margaret. But in the Prado version he introduced two further innovations: he added a skull in the lower right-hand corner, a feature taken over from renderings of St. George Slaying the Dragon in the vicinity of its cave where the remains of former victims are very much in evidence; and, more importantly, he included a burning city in the background. This unparalleled motif, unrelated to either the legend of St. Margaret or that of St. George, can be explained only by a new borrowing from the legend of St. Martha, according to which her dragon, the *Tarasque*, not content with devouring men and beasts, indulged in the "devastation of whole villages and towns." How grateful Titian must have been for an excuse thus to enhance the warm glow of his "greenless" landscape by the weird splendor of a conflagration!

This conflagration, set out against a dusky horizon, immeasurably strengthens the impression of a nocturnal event even though the sky is not

51. K. Lange and F. Fuhse, *Dürers schriftlicher Nachlass*, Halle, 1893, p. 119, lines 8-12.
52. R. G. Salomon, "Aftermath to Opicinus de Canistris," *Journal of the Warburg and Courtauld Institutes*, xxv, 1962, pp. 137 ff., Pl. 26b, with many further references to the "Tarasque."

entirely dark. In its full sense (i.e. as a picture where the illumination is exclusively provided by artificial sources of light and/or the moon) the idea of the nocturne was first realized in the earlier of two paintings showing the *Martyrdom of St. Lawrence*.[53]

This earlier version (Fig. 59) is an enormous canvas, measuring about 15 by $8\frac{1}{2}$ feet, in the Gesuiti Church at Venice (in Titian's time the Chiesa dei Crociferi, since it belonged to a confraternity whose members did public penance by carrying crosses in procession). Commissioned by a gentleman named Lorenzo Massolo in order to place his tomb under the protection of his patron saint, it was started some time before November 18, 1548, that is to say, fairly soon after Titian's return from Rome two years before; but its execution, interrupted by two calls to Augsburg and delayed by work for more important patrons, proceeded very slowly: it was not put in place until 1559, two years after Massolo's death.

The later canvas (Fig. 60), much smaller in size, was destined for the Chapel of the Escorial where it still is. On the day of the victorious battle of St.-Quentin (August 10, 1557, which happened to be the day of St. Lawrence), Philip II had vowed to build a monastery dedicated to this saint. This was the "Escorial," completed with astonishing speed; and it was as early as 1567 that Titian's second *Martyrdom of St. Lawrence*, begun by 1564, was installed there.

Conceived under the fresh impact of Rome, the earlier picture fairly teems with classical and Central Italian reminiscences. Several motifs were appropriated from Marcantonio's engraving after Bandinelli (B. 104; Fig. 61) which represents the same subject (though not as a nocturne) and includes several figures derived from Michelangelo, notably the man blowing the fire who repeats the figure similarly employed in Michelangelo's *Sacrifice of Noah*. Another Michelangelesque engraving by Marcantonio, the *Standard Bearer* (B. 481; Fig. 62), utilized by Titian more than forty years before[54] but now restored to its original significance, was

53. *V.*, II, Pls. 66-69; ibidem, Pl. 121. For an excellent comparison between the two versions and their relationship with Cornelis Cort's engraving of 1567 (our Fig. 65), see E. von Rothschild, "Tizians Darstellungen der Laurentiusmarter," *Belvedere*, x, 1931, pp. 202 ff. For classical and other sources, see Brendel, "Borrowings from Ancient Art in Titian," and R. W. Kennedy, *Novelty and Tradition in Titian's Art*, pp. 14 ff.

54. I.e., in the *Triumph of Faith*, for which see below, pp. 58 ff. This particular borrowing was first pointed out by O. Fischel, "Raphaels Auferstehung Christi," *Jahrbuch der Preussischen Kunstsammlungen*, XLVI, 1925, pp. 191 ff., who does not, however, mention the derivation of Marcantonio's —or, perhaps, Raphael's—*Standard-Bearer* from Michelangelo's *Battle of Cascina* (in the Holkham Hall grisaille, top row, second figure from the left).

employed for the soldier on the far right. The boldly foreshortened architecture, though fantastically enriched, reflects such pycnostyle Roman structures as the Temple of Antoninus and Faustina or the Temple of Mars Ultor. The henchman supporting the upper part of the saint's body (while he is being turned over on his grill at his own request) derives from Raphael's *Entombment* now in the Galleria Borghese. The Saint himself is reminiscent of the *Fallen Gaul* in the Grimani Collection at Venice (Fig. 63). The complicated lighting mechanism, with a whitish-yellow ray of supernatural light (*lampo*, as Vasari calls it) out-shining the reddish-yellow flames of the torches and the dark-red glow of the coals, may have been suggested by Raphael's *Delivery of St. Peter* in the Stanza d'Eliodoro. And the torches themselves are as archaeologi-cally correct as those in Mantegna's *Triumph of Caesar*.

The later version (Fig. 60) differs from the earlier one as we should expect it to do. Its composition is richer yet more severely disciplined to a grandiose counterpoint of figural pattern and non-figural background. The elaborate and violently foreshortened architecture of the earlier version has been suppressed in favor of a simple, frontal wall pierced by a monumental arch. As a result, the torch-bearer rushing forth from the colonnaded edifice had to be omitted; but the loss of the luminary accent provided by his torch is doubly compensated by the white plume of a newly added horseman and a new torch stuck into one of the rings which are attached to the base of the statue. The ambition for archaeological accuracy has vanished: the soldiers wear contemporary helmets, hats and weapons. Self-luminous angels proffer the crown of martyrdom to the Saint; and since he now receives the personal attention of the celestial powers, the supernatural ray of light — Vasari's *lampo* — could be replaced by a natural moon. The Saint himself, finally, is shown in partial rather than total foreshortening: instead of thrusting his right foot into the face of the beholder he turns his leg, sharply bent at the knee, into the frontal plane after the fashion of Michelangelo's *ignudo* on the right of Daniel.

The most intriguing iconographical problem is posed by the statue before which the scene takes place (Fig. 64). It is, of course, a very old tradition to stage the martyrdom of an early Christian saint before an idol which he has refused to worship. But such an idol is normally either the statue of a deified emperor or that of an objectionable Olympian, invariably masculine and often nude, such as Apollo, Hercules or Mars. Here, however, we have the statue of a female divinity who, like Phidias' *Athena Parthenos*, carries a statuette of Victory in her hand; but unlike

Phidias' *Athena Parthenos* she is chastely veiled. This costume precludes, I think, her identification with the *Dea Roma*;[55] for while this goddess does carry either a little Victory or a diminutive replica of the Palladium (the famous cult image of Pallas Athena allegedly brought from Troy by Aeneas), she is a warlike goddess reminiscent of an Amazon, invariably helmeted and never veiled.[56] Why, then, should Titian have substituted so virginal and dignified a figure for the traditional, offensive idol worshipped by the pagans?

The answer, I believe, may be found in the principal and most respected text describing the Martyrdom of St. Lawrence: Prudentius' versified *Passio sancti Laurentii*, written only a little more than two centuries after the event and available in print from the early sixteenth century. Prudentius assures us that, when St. Lawrence was martyred, the Roman Empire was well on its way to conversion and that it was his death which tipped the scales in favor of Christianity. "That death of the Holy Martyr," he says, "was the real death of the [pagan] temples. Then Vesta saw her Palladium-guarding shrine deserted with impunity... and Claudia, the vestal, enters thy house, Oh Lawrence."[57]

The veiled statue in Titian's *Martyrdom of St. Lawrence* may thus be presumed to represent Vesta, so specifically referred to in Prudentius' *Passio sancti Laurentii*. That she carries a statuette of Victory may have been suggested by the fact, explicitly alluded to by Prudentius himself, that the Palladium just mentioned was preserved in her temple. Vesta, the guardian of the Palladium, could thus be thought of as a kind of rival

55. Proposed by R. W. Kennedy, *Novelty and Tradition in Titian's Art*, p. 16.

56. See C. Vermeule, *The Goddess Roma in the Art of the Roman Empire*, Cambridge, Mass., 1959; G. Calza, "La figurazione di Roma nell'arte antica," *Dedalo*, VII, 1926-1927, pp. 663 ff. That the authentic appearance of the Dea Roma was well known in the Renaissance is demonstrated by one of Bonasone's engravings in Achille Bocchi's *Symbolicarum quaestionum....libri quinque*, Bologna, 1555 and 1574, IV, No. 124, p. CCLXII (reproduced in D. and E. Panofsky, *Pandora's Box; The Changing Aspects of a Mythical Symbol* [Bollingen Series, LII], New York, 1956 and 1962, p. 66, Fig. 32).

57. Prudentius, *Passio sancti Laurentii* (Pa-

trologia Latina, LX, cols. 294 ff.), lines 509 ff.; this text, included in the *Acta Sanctorum*, August 10, pp. 512 ff., was available in Aldus' edition of Prudentius' poems which was printed between 1501 and 1504:

> "Mors illa sancti martyris
> Mors vera templorum fuit.
> Tunc Vesta Palladios lares
> Impune sensit deseri...
> Aedemque, Laurenti, tuam
> Vestalis intrat Claudia."

Claudia was a vestal whose name, like Tuccia's, had become proverbial: unjustly accused of having violated her vows, she was able to prove her innocence (Ovid, *Fasti*, IV, 305 ff.; Livy, *Ab Urbe condita*, XXIX, 14, 12; Propertius, *Elegiae*, IV, 11, 52).

of the *Dea Roma* in whose hands a statuette of Victory and a small replica of the Palladium were interchangeable. And that Prudentius singles out Vesta as a deity superseded by St. Lawrence is meant to make us see that even the chastest votaries of the chastest goddess were forced to admit the superiority of the Christian faith over every form of pagan devotion.

In the light of Prudentius' poem the statue of the Victory-bearing Vesta, illumined by the heavenly radiance no less than by the torch, thus assumes a double significance. More than a pagan idol *tout court*, it symbolizes the very act of transition from paganism to Christianity. The image seems to transform itself before our very eyes into a monument to the Triumph of the Faith.

The third and last version of Titian's *Martyrdom of St. Lawrence*, then, confronts us not so much with a change from a general "reference to the idolatry of ancient Rome"[58] to the specific reference to a contemporary event as with a development from Faith Triumphant *in potentia* to Faith Triumphant *in actu*. This last version has come down to us in an engraving by Cornelis Cort published, with Titian's authorization, in 1571 and fusing as well as changing the two earlier compositions (Fig. 65).[59] The lower section of this print (reversed, of course, in relation to the two paintings) agrees, apart from a few insignificant additions, with the earlier version in the Gesuiti Church. Its upper section, with the wreath-bearing angels, agrees, however, with the later version in the Escorial, except that all architectural features are blotted out by clouds and that a small but important change has been made in the statue: the little Victory now emphatically greets the angels with her up-raised right arm. The angels themselves now seem to turn their attention to the statue rather than to the martyr; and it is on its base that the words INVICTISS. PHILIPPO HISPANIORUM REGI D. ("Dedicated to the Most Unvanquished Philip, King of Spain") are inscribed.

Everyone seems to agree that these changes were meant to remind the observer of that battle of St.-Quentin which had been won on the day of St. Lawrence in 1557.[60] But then we must ask: what could have prompted Titian to include even in the earlier version — a painting commissioned by a private citizen who happened to bear the name Lorenzo, and executed at a time when the battle of St.-Quentin was still a matter of the future — a

58. R. W. Kennedy, *Novelty and Tradition in Titian's Art*, p. 28, Note 98.
59. See von Rothschild, "Tizians Darstellungen der Laurentiusmarter."
60. See J. Bierens de Haan, *L'Oeuvre gravé de Cornelis Cort*, The Hague, 1948, p. 144.

"pagan idol" so unconventional in form and content, and so easily convertible into a symbol commemorating the victory of a most Catholic King?[61] This, I submit, Titian could not have done had he not from the beginning intended to invest this "pagan idol" with a crypto-Christian significance suggested by Prudentius' allusion to Vesta.

61. It is significant that in a silver relief representing the Martyrdom of St. Lawrence the German sculptor Mathaeus Wallbaum (d. 1632), though manifestly dependent on Cornelis Cort's engraving, replaced the statue of a veiled goddess with the traditional statue of a nude god. R. Rückert ("Zwei Reliefs mit dem Martyrium der Heiligen Katharina und Laurentius," *Jahrbuch der Hamburger Kunstsammlungen*, v, 1960, pp. 191 ff.; idem, *Museum für Kunst und Gewerbe, Hamburg, Bildführer*, II [*Festgabe für Erich Meyer*], Hamburg, 1964, No. 86) correctly recognizes the relief's dependence on Titian and correctly infers the intervention of a print; but he seems to be unaware of the existence of this print in the shape of Cornelis Cort's engraving and does not mention the transformation of the statue.

III

Counterpoint: Mediaeval and Classical Formulae in Disguise

During his stay at Padua, according to Ridolfi, Titian decorated a room in his own house with frescoes showing, curiously enough, the Triumph of Faith. These frescoes, if they ever existed, have disappeared. But how they may have looked can be inferred from a woodcut — not very attractive but crucially important — which represents this very subject and, from a stylistic point of view, agrees with a date of c. 1511 rather than with the date 1508 given by Vasari.[1]

In this gigantic woodcut (Figs. 66-68), printed from five separate blocks and measuring more than twelve feet in length, Titian challenged Mantegna as well as Dürer. He challenged Mantegna in that he emulated that master's *Triumph of Caesar* in general composition and in the relief-like arrangement of the figures, even appropriating from it some individual motifs. He challenged Dürer in that a woodcut designed by a major painter for the express purpose of being published and circulated as a work of art in its own right was something new in Italy, where woodcuts had normally served only as book illustrations or reproductions of paintings. He further broke away from the North Italian tradition in making his first contacts with Raphael and Michelangelo and thus entered upon the stage of pararegional, even international developments.

One of the sibyls, for example, repeats almost literally one of the Muses in Mantegna's *Parnassus*, a group popularized by an engraving formerly ascribed to Zoan Andrea. The Innocents as well as the Abraham presuppose Titian's familiarity with Dürer engravings and woodcuts. The giant figure of St. Christopher derives from Marcantonio's *Standard Bearer* which is believed to have been designed by Raphael (B. 481; Fig. 62) and certainly

1. *T.*, Fold-out Pl. opposite Figs. 326, 327. For documentation and details, see P. Kristeller, *Il Trionfo della Fede* (Graphische Gesellschaft), Berlin, 1906.

58

reveals the influence of Michelangelo.[2] And Dismas, the Good Thief carrying the cross in front of the triumphal chariot, bears witness to the direct impact of Michelangelo's cartoon for the *Battle of Cascina*.[3]

From an iconographical point of view, however, this very "up-to-date" composition harks back to mediaeval traditions. As already observed by Jacob Burckhardt,[4] the program of Titian's woodcut is inspired, in a general way, by Savonarola's *Triumph of the Cross (Triumphus Crucis)*, published in 1497 and, in an Italian translation, in the following year.[5] Savonarola seems indeed to be the first to have visualized Christ in person as a *triumphator* "all'antica." There are, however, several significant discrepancies which impart to Titian's woodcut the character of a Janus head, looking forward and backward at the same time. Savonarola's Christ appears as the Man of Sorrows, crowned with thorns, carrying — in addition to the two volumes of the Bible — the instruments of the Passion and showing His wounds. His chariot is accompanied by the Virgin Mary and is preceded by the patriarchs, the prophets and other personages from the Old Testament; it is drawn by Apostles and preachers; it is encircled by the Holy Martyrs and the Doctors of the Church; it is followed by all those pagans who were prepared to accept the True Faith. And this whole throng is surrounded by the enemies of the Church — led by emperors, kings, princes, philosophers, and heretics — whose idols are being destroyed and whose books are being burnt.

In Titian's triumphal procession, unfolding in one plane instead of in concentric circles, Christ is represented in Majesty, sceptre in hand and seated on the celestial globe, that is to say, as the Eternal Christ (Who, by definition, represents the whole Trinity) rather than as the Christ Incarnate; and the Virgin Mary is absent. The sibyls have been added to the prophets, but the converted pagans as well as the "enemies of the Church" are omitted so that the chariot clearly marks the dividing line between the eras before and after Grace, with Dismas and the Innocents heralding the second of these eras. The chariot itself, instead of being drawn by Apostles and preachers, is drawn by the four symbols or "beasts" of the Evangelists: the Angel of St. Matthew, the Ox of St. Luke, the Lion of St. Mark, and the Eagle of St. John. And the Doctors of the

2. See above, p. 53, Note 54.
3. Cf. — in the Holkham Hall grisaille — the soldier bending forward to look at the hands of a submerged comrade and the soldier rushing in from the right.
4. Jacob Burckhardt, *Die Kultur der Re-*naissance, v, 8 (10th edition, Leipzig, 1908, ii, p. 141).
5. *Edizione Nazionale delle Opere di Girolamo Savonarola, Triumphus Crucis*, ed. M. Ferrara, Rome, 1961, pp. 7 ff. and 296 ff.

Church, relegated by Savonarola to a circle surrounding that formed by the Holy Martyrs, have been entrusted with the task of pushing the wheels.

Most of these innovations can be derived from the illustrations of — or, rather, visual variations on — a text whose influence on the Renaissance had resulted in a kind of obsession affecting art as well as literature and public life: Petrarch's *Trionfi*, probably begun about 1352 and not finished until about five months before his death, on February 12, 1374.[6]

This poem, it will be remembered, describes a sequence of six visions: the Triumph of Love over even the most famous men and women; the Triumph of Chastity over Love; the Triumph of Death over Chastity; the Triumph of Fame over Death; the Triumph of Time over Fame; and, finally, the Triumph of Eternity over Time. As always with Petrarch in contrast to his mediaeval forerunners, all the figures appearing in these visions are conceived in motion; but only the first victor, Love, is described as riding on a chariot "drawn by four steeds whiter than snow." Yet the illustrators of the *Trionfi* almost invariably bestowed the honor of a *currus triumphalis* to the other conquering powers as well. Beginning with Chastity, all of them were provided with chariots drawn by appropriate teams. In most, though not all, cases unicorns were allotted to Chastity, black oxen to Death, elephants to Fame, fast-running stags to Time. And Cesare Ripa's *Iconologia*, that Bible of Renaissance and Baroque iconography, does not scruple to describe each of these conveyances as a "carro dipinto dal Petrarca" ("a chariot pictured by Petrarch"), unconsciously substituting the image for the text. Thus Petrarch's "Chariot of Eternity" (or "Divinity"; the word *divinità* had almost generally displaced the original *eternità*, even though Petrarch's text implies rather than explicitly posits the identity of Eternity with God) was normally depicted and described as a conveyance occupied by the Trinity — whether represented in the guise of the Three Persons or of the Triune God as a single figure — and drawn by either the Evangelists themselves[7] or their symbolic "beasts" (Fig. 69).[8]

6. Prince d'Essling and E. Müntz, *Pétrarque; Ses études d'art, son influence sur les artistes...*, Paris, 1902, *passim*; W. Weisbach, *Trionfi*, Berlin, 1919, *passim*; G. Carandente, *I Trionfi nel primo Rinascimento*, (ed. Rai, n.p.) 1963, *passim*, particularly p. 128, Note 127.

7. See, for example, a Florentine engraving of the fifteenth century, reproduced in d'Essling-Müntz, ibidem, p. 173, or the woodcut in Pietro Pacini da Verona's edition of Petrarch's *Trionfi*, Florence, 1449 (facsimile edition, Rome, 1891), fol. e 1.

8. See, e.g., the Florentine engraving reproduced in d'Essling-Müntz, ibidem, Pl. facing p. 170; a *cassone* from the School of

Titian's *Triumph of Faith* would thus seem to combine the textual data of Savonarola's apparently never-illustrated *Triumphus Crucis* — itself a byproduct of the vogue initiated by Petrarch's *Trionfi* — with the visual data of the Petrarch illustrations.[9] But these illustrations derive in turn from a tradition which can be traced back as far as the twelfth century.

In *Purgatory*, xxix,88 — xxx, 21, Dante "sees" Beatrice (symbolizing Faith) ascending in a vehicle which he defines as a "triumphal chariot (*carro trionfale*) more glorious than those of Scipio and Augustus." This chariot, having only two wheels (which signify the Old and the New Testament), is drawn not by the "beasts" of the Evangelists (these merely encompass and protect the space where the scene is enacted) but by a griffin who, composed of bird and quadruped, symbolizes the two natures of Christ Himself; and Beatrice is invited to enter the chariot with the words "Veni, sponsa, de Libano" ("Come with me from Lebanon, my spouse"). These words come, of course, from the *Song of Songs* (4 ,8); and it is the most authoritative commentator upon this text, Honorius of Autun, who established a direct, almost technological connection between the ancient simile of the chariot — a simile reshaped by Dante *in maiorem Beatricis gloriam* but not as yet applied to Christ Himself — and the four Evangelists. Expatiating upon the penultimate versicle of the Sixth Book ("Anima mea conturbavit me propter quadrigas Aminadab," "My soul troubled me for the chariots of Aminadab"),[10] Honorius pictures the Shulamite woman (typifying the Synagogue not as she is now but as she will be when, inevitably, the power of the Evangelical doctrine drives her

Jacopo del Sellaio, Oratorio di Sant' Ansano near Fiesole, ibidem, Pl. facing p. 152. Our Fig. 69 represents a North French tapestry produced some time after 1508 and now preserved in the Vienna Museum (L. Baldass, *Die Wiener Gobelin-sammlung*, Vienna, 1920, Pl. 6; for further references and the *terminus post quem*, cf. D. and E. Panofsky, *Pandora's Box*, second edition, New York, 1962, pp. 146ff.). In certain instances (e.g., d'Essling-Müntz, p. 148) the Deity is shown enthroned in Heaven rather than proceeding on a chariot, in which case the "beasts" of the Evangelists hover beneath it. Jacques Sarrazin's reliefs in the Musée Condé at Chantilly (d'Essling-Müntz, p. 265f.,

datable 1663) are already influenced by Titian's woodcut; and it is no accident that Titian's portrait — together with those of Raphael, Michelangelo and Sarrazin himself — is here included among the illustrious men appearing in the *Triumph of Fame*.

9. Titian's partial dependence on the Petrarchian tradition was already pointed out by d'Essling-Müntz, p. 199.

10. Thus in the Douai version 6, 11. The notoriously obscure translation in the King James version (here 6, 12) substantially differs from the Vulgate text: "Or ever I was aware, my soul made me like the chariots of Amminadib."

to the belief in Christ[11]) as seated upon a chariot which, as the *Quadriga Christi*, represents the Gospels. Its four wheels, "running throughout the world," symbolize the four Evangelists.

The illustrations (Fig. 70), beginning in the third quarter of the twelfth century, accordingly show a regal woman on a chariot, the wheels of which are embossed with the "Four Beasts."[12] And in Herrade of Landsberg's *Hortus Deliciarum* of 1181, the Church herself is mounted on an animal composed — not only with respect to its heads but also with respect to its feet — of a man, an ox, a lion, and an eagle (Fig. 71).[13]

All the illustrators of Petrarch's last *Trionfo* had to do was to yoke the four sacred "beasts" to the Chariot of Eternity (or Divinity) just as Dante had yoked his griffin to the chariot of Beatrice;[14] and all Titian had to do was to follow in the footsteps of the Petrarch illustrators — replacing the image of the Trinity in the form of three separate Persons by that of Christ in Majesty and ordering the whole procession according to the

11. Honorius of Autun, *Expositio in Cantica Canticorum* (*Patrologia Latina*, CLXXII, cols. 454C-455A): "Quadriga Christi est Evangelium; quatuor rotae sunt quatuor evangelistae, qui circa finem mundi per totum mundum current...Sed in hac quadriga tunc vehit [synagoga], quando per Evangelicam doctrinam ad fidem Christi perducetur." This positive interpretation of the "Chariot of Aminadab," still accepted in the Renaissance (cf. F. Hartt, "Pagnini, Vigerio and the Sistine Ceiling," *Art Bulletin*, XXXIII, 1951, pp. 262 ff., particularly p. 264), is, of course, based on St. Gregory's Commentary on the *Song of Songs* (*Patrologia Latina*, LXXIX, col. 532f.).

12. The miniature here illustrated is in Cod. Vind. 942, fol. 79v (G. Swarzenski, *Die Salzburger Malerei von den ersten Anfängen bis zur Blütezeit des romanischen Stils*, Leipzig, 1908-1913, Pl. CXIX, 401). Miss Rosalie Green kindly informs me that the Index of Christian Art at Princeton lists six further examples, ranging from 1150-75 to 1301: clm. 4550, 5118, 18125; Baltimore, Walters Art Gallery, MS. 29; Sankt Paul im Lavanttal, Archives, MS. XXV, 3, 5; Sankt Florian, Stiftsbibl., XI, 80.

13. A. Straub and G. Keller, eds., *Herrade de Landsberg, Hortus deliciarum*, Strasbourg, 1901, Pl. XXXVIII. This motif recurs in a spiritual encyclopedia of the early fifteenth century (Rome, Cod. Casanat. 1404, fol. 28v) and in a fresco at Mollwitz, Silesia; see F. Saxl, "A Spiritual Encyclopaedia of the Later Middle Ages," *Journal of the Warburg and Courtauld Institutes*, V, 1942, pp. 82 ff., Pl. 25, b, c.

14. The pervasiveness of the idea is illustrated by a miniature in the Casanatensis, cited in the preceding note, fol. 29v: each of the symbolic "beasts," here accompanied by one of the four major prophets, draws a chariot each of which exhibits an appropriate scene from the Life of Christ: the Virgin and Child, drawn by the "Man" of Matthew, and Isaiah; the Flagellation, drawn by the Ox of St. Luke, and Jeremiah; the Resurrection, drawn by the Lion of St. Mark, and Daniel; the Ascension, drawn by the Eagle of St. John, and Ezekiel (described but not illustrated in F. Saxl, "Aller Tugenden und Laster Abbildung," *Festschrift für Julius Schlosser*, Zurich, Leipzig and Vienna, 1927, pp. 104 ff., particularly p. 119).

division between the eras before and after Grace. Even the idea of charging the four Fathers of the Church with the task of pushing the wheels (distasteful to Victorian sensibilities)[15] would seem to have been inspired by illustrations of Petrarch's *Trionfi*. In a particularly sophisticated series of North French tapestries, probably woven in the first quarter of the sixteenth century (though certainly after 1508), the Chariot of Eternity (or Divinity), drawn by the symbols of the Evangelists and riding over the five other powers vanquished in the preceding sections of the poem, is accompanied by the four Fathers of the Church, each standing by one of the wheels; but in the three first tapestries of the same series the wheels of the respective chariots are actually pushed by suitable personifications: those of the chariot of Cupid by *Oysiveté* and *Volupté* (Sloth and Carnal Desire); those of the chariot of Chastity by *Abstinence* and *Temperance* (Fig. 72); and those of the chariot of Death by *Vieillesse* (Old Age).[16]

In his *Triumph of Faith*, then, Titian drew upon a representational tradition ultimately rooted in the religious art of the Northern Middle Ages, but secularized, Italianized and, finally, internationalized in the illustrations of Petrarch's *Trionfi*. More than forty years later, he was to draw upon a tradition on which, thus far, the religious art of the Northern countries seems to have held a monopoly: a painting preserved in the Prado and known all over the world as "*La Gloria*" (Fig. 73).[17]

15. G. Gronau, *Titian*, p. 26.
16. L. Baldass, *Die Wiener Gobelinsammlung*, pp. 1 ff., Pls. 1, 2, 3 (two details in d'Essling and Müntz, *Pétrarque*, pp. 212 and 215). The motif of wheel-pushing persons or personifications still occurs in the *Triumph of Henri de Bourbon-Verneuil* by Antoine Jacquard, where the chariot is so propelled by *Pietas* and *Doctrina*; see F. and H. Bardon, "Une Gravure d'Antoine Jacquard (1622)," *Revue Archéologique*, 1963, 2, pp. 25 ff.
17. *V.*, ii, Pl. 53, engraved by Cornelis Cort; see H. von Einem, *Karl V. und Tizian*, referred to above, p. 8, Note 7. A painting in the National Gallery in London, formerly considered a preparatory *bozzetto*, has been shown to be a copy after Cort's engraving, subsequently altered so as to conform to the original painting (C. Gould, *National Gallery Catalogues; The Sixteenth-Century Venetian School*, pp. 125 ff.). Cort's engraving differs from this original painting — as well as from the London picture in its present state — in several respects; but from an iconographical point of view these differences are not overly important, except for two changes: in Cort's print the orb of Christ is not surmounted by a Cross and the Eagle of Ezekiel rests its talons on a scroll. Cort (like some modern art historians, e.g., *C.-C.*, ii, p. 236, Note; W. Suida, *Tizian*, Zurich and Leipzig, 1933, p. 128) may have interpreted the Prophet Ezekiel, in spite of his turban, as St. John the Evangelist. As observed by H. Tietze, *Tizian; Leben und Werk*, Vienna, 1936,

Begun for Charles V in or about 1551 (from which we may conclude
that the plan of the picture had been thoroughly discussed between the
Emperor and the painter when they had met at Augsburg in the preceding
year) and despatched on October 10, 1554, this huge canvas, measuring
about 10 × 7¹/₂ feet and engraved by Cornelis Cort, may or may not have
been destined for the Capilla Real at Granada, where Charles V had
planned to be buried before the Escorial was thought of. Certain it is,
however, that he took it with him to San Yuste in 1555; and he is said
to have looked at it in his dying days with such persistence and intensity
of feeling that his doctors took fright.

Like the nearly contemporary Medole Altarpiece, Titian's *"Gloria"*
conjures up a celestial apparition observed from a station point elevated
to the level of the apparition itself; but unlike the Medole Altarpiece
(Fig. 47) it permits the beholder to look down, as from an airplane, upon
the sinful earth where the murder of that great persecutor of heresies,
St. Peter Martyr, is being re-enacted on a diminutive scale.[17a]

The visionary character of the composition is stressed by the unusually
luminous and, as it were, diaphanous quality of the colors: three or four
shades of blue; moss green; a solitary spot of red toned down to a rosy
brown. And the upper reaches of the space are filled with a wonderful
golden haze which all but dematerializes the solid forms. The figures in
the lower zone, however, reveal the influence of Michelangelo as well as
the antique.

In a very general way Titian's *"Gloria"* may be said to belong to those
modified All Saints pictures in which, under the recrudescent influence
of St. Augustine's *Civitas Dei*, the community of the Blessed is shown
adoring the Trinity (or the Triune God) rather than the Apocalyptic

p. 210, the figure of Ezekiel resembles a
prophet in Moretto's altarpiece in S.
Giovanni Evangelista at Brescia (G.
Nicodemi, *Il Moretto da Brescia*, Florence,
1921, Fig. 7); but this prophet is Micah,
not Ezekiel, and consequently has no eagle.
17a. As suggested by C. S. Harbison
("Counter-Reformation Iconography in
Titian's *Gloria*", *Art Bulletin*, XLIX, 1967,
pp. 244 ff.) the inclusion of this scene may
have been ordered by Charles V because he
wished to identify himself with the strictly
Athanasian position advocated by St. Peter
Martyr in Trinitarian matters, all the more

so as the problem had assumed new actual-
ity in view of the revival of Arian or Arianiz-
ing doctrines in the sixteenth century (see
e.g., Johannes Cochlaeus, *Commentaria de
actis et scriptis Lutheri*, St. Victor near May-
ence, 1549). Charles V may have wished
officially to dissociate himself from these
heresies because he himself, through his
confessor, Juan Quintana, had had some
early connections with Michael Servetus,
the chief spokesman of anti-Athanasianism,
who was burned as a heretic on October 27,
1553 — just about one year before the
"Gloria" was sent to His Majesty.

Lamb.[18] Reading from lower left to right, it shows in the foreground a beturbaned figure, adapted from Michelangelo's *Battle of Cascina*, which represents not, as has been thought, St. John the Evangelist (this is excluded by the action and the turban) but Ezekiel, the prophet of the Last Judgment; his Eagle can be explained by *Ezekiel* 17, 3: "A great eagle with great wings, long-winged, full of feathers, which had divers colors, came unto Lebanon." Then follows Moses with his tablets, reflecting the impression of the *Fallen Gaul* (Fig. 63) already mentioned in connection with the *Martyrdom of St. Lawrence*;[19] then Noah, raising his ark with an impassioned movement of both arms; and, on the far right, King David, identified by his ermine-trimmed cloak and his psaltery — a figure in which the influence of Michelangelo's *Last Judgment* is blended, as already observed by Ridolfi, with that of the *Laocoön*. The green-clad female figure next to David — derived from a group in Michelangelo's *Last Judgment* which in turn reflects the classical Niobe group (Fig. 75) — may be identified not as the Magdalen but as the Erythrean Sibyl ("more famed and nobler than the others") or, less probably, as the Synagogue ultimately converted to the belief in Christ. The Erythrean Sibyl, the "*Ursibylle*," specialized, like Ezekiel, in eschatology, her prophesies being concerned with the end of the world and the Last Judgment ("Judicii signum tellus sudore madescit") and was therefore paired with David in the Requiem as she is in Titian's picture: "Dies irae, dies illa,/solvet saeclum in favilla,/teste David cum Sibylla." The conversion of the Synagogue, on the other hand, was the precondition of that final triumph of Christianity which was ushered in by the Last Judgment and found fulfillment in what St. Augustine calls the "Eternal Beatitude of the City of God."[20]

18. For the development of the "All Saints picture," see *Reallexikon zur deutschen Kunstgeschichte*, I, cols. 365 ff.; cf. E. Panofsky, *Early Netherlandish Painting*, pp. 212 ff.

19. As observed by Brendel, "Borrowings from Ancient Art in Titian," the influence of this statue is also felt in the *Tantalus*, one of the four paintings executed for Mary of Hungary in 1548-49, for which see below, pp. 147 ff., as well as in the *Martyrdom of St. Lawrence* in the Gesuiti Church, for which see above, pp. 53 ff.

20. For the special position of the Erythrean Sibyl, see W. Vöge, *Jörg Syrlin der Aeltere und seine Bildwerke*, Berlin, 1950, particularly pp. 49 ff., 161 ff., synoptical table facing p. 168. The interpretation of Titian's figure as the "Converted Synagogue" (cf. p. 62 f., especially Note 11), on the other hand, may have been alluded to by Paolo Veronese in an enormous and very beautiful drawing in the Metropolitan Museum, brought to my attention by my friend, Professor Herbert von Einem, who instantly recognized its dependence on Titian's "*Gloria*," particularly with respect to the non-Italian Trinity type (J. Bean and Felice Stampfle, eds., *Drawings from New York Collections*, I, *The Italian Renaissance*, Exhibited at the Metropolitan Museum of Art, Nov. 8, 1965-January 9, 1966, New York, 1965, p. 73 f.,

The personages behind and above these foreground figures are pro-
phets; and in the upper right-hand corner, protected by angels, the whole
imperial family is portrayed: Charles V (with, reposing before him on a
bank of clouds, the bicuspid crown of the Holy Roman Empire, of which
he was to divest himself almost as soon as the painting was completed);
Isabella, his long-defunct Empress; Philip II, his son; and Mary of
Hungary, his sister. Beneath her there appears, apparently in the guise
of Job, Francisco Vargas, the Imperial Envoy to Venice — a portrait
which Titian had included on Vargas' request but with the proviso that
any local painter might change it "with two brush strokes" should
Vargas' presence displease His Majesty; and, next to it on the far right,
there can be seen a portrait of Titian himself.[21]

In the uppermost zone, finally, supported and surrounded by a cloud
of little angels and emitting that radiance which justifies the name "*La
Gloria*," there is enthroned the Trinity, humbly approached by the
Virgin Mary from the left. Placed on a lower level and wrapped in a long
mantle, the saturated blue of which seems to substantialize the ethereal
sky-blue of the robes worn by God the Father and Christ, she steps up to
the Trinity quite alone. St. John the Baptist follows her at a respectful
distance and he in turn takes precedence over the little group of prophets
towards whom the Virgin looks back with a compassionate glance.

It has often been observed that the general composition of the "*Gloria*,"
with the beholder believing himself to be lifted to the celestial spheres
and to look down upon the earth, is most nearly anticipated by Dürer's
Landauer Altarpiece of 1511 (Fig. 74).[22] And since Titian respected and

No. 129). Here Titian's green-clad woman
has been assimilated, in placement and
to some extent even in pose, to the tablet-
carrying Moses. The general iconography
of Veronese's drawing — traditionally de-
fined as "The Final Completion of the
Great and Sublime Mystery of the Re-
demption of the World" — deserves further
study; a special problem is posed by the fact
that Jonathan Richardson Jr.'s English
translation of a now "invisible inscription"
identifies the kneeling figure sponsored by
the Virgin Mary as the "First Author of
Original Sin," viz., Adam, even though in
placement and appearance this figure
rather suggests St. John the Baptist.

21. For the portrait of Francisco Vargas,
see Titian's letter of September 10, 1554
(*C.-C.*, II, pp. 507 f.). Whether the change
was effected I am unable to say; but I
cannot recognize any particular re-
semblance between Job and Aretino either
in the painting or in Cort's engraving (see
C. Gould, quoted above p. 63, Note 17).
For Titian's self-portrait, see Foscari, *Icono-
grafia di Tiziano*, p. 34, and Pl. 22 (good
detail from Cort's print, showing Titian
wearing his beloved skull cap even in
Paradise).
22. Gronau, *Titian*, p. 179; W. Braunfels,
Die heilige Dreifaltigkeit, Düsseldorf, 1954, p.
XXXIII; von Einem, *Karl V. und Tizian*, p. 28.

occasionally emulated the Master of Nuremberg (only about 90 miles from Augsburg), a direct or indirect influence of this work is by no means excluded. Yet, even from a purely iconographical point of view, the differences outweigh the similarities.

In the *Landauer Altarpiece*, as in all late-mediaeval variations on the "All Saints picture," the community of the Blessed — or, as the French call it, *La cour céleste* — is dominated by Christian saints. Titian, on the contrary, restricts the *dramatis personae* to characters from the pre-Christian era, excepting only the Virgin Mary and St. John the Baptist, both of whom were believed to hold an intermediary position between the Old Testament and the New.[23]

Matthew Landauer and his family are represented, as was the usual thing, in their Sunday best. Charles V and his family, on the other hand, are enveloped in pale-grey shrouds. In Dürer's composition the Virgin Mary and St. John the Baptist, both kneeling and praying, are placed on the same level, facing each other; in Titian's, the Virgin Mary is quite alone and occupies a much more prominent position, the Baptist appearing behind her at a distance. In the *Landauer Altarpiece* finally, the Trinity is represented as the "Throne of Mercy," that is to say, as God the Father enthroned and holding the crucified Christ before Him, the whole surmounted by the Dove of the Holy Spirit; in the *"Gloria"* the Trinity is represented according to a formula developed in, and spreading from, the Franco-English and Franco-Flemish milieu of the twelfth century: God the Father and Christ are shown seated side by side, with the Dove hovering between Them (Fig. 76).[24]

These points of divergence raise the question of how Titian's *"Gloria"* (which designation cannot be traced back beyond about 1600)[25] should properly be titled. Francisco Vargas, Aretino, Vasari, and most of the official sources simply refer to it as *"The Trinity,"* a title expanded into

23. Like von Einem (*Karl V. und Tizian*), I find it hard to believe that the four figures beneath St. John the Baptist are meant to represent the Four Evangelists.
24. For the "Throne of Mercy" (*"Gnadenstuhl"*), see Braunfels, ibidem, pp. xxxv ff., perhaps too easily dismissing, on p. xxxix, the importance of a type which shows God the Father enthroned and holding before him a small-sized image of the adult Christ, for which see A. Heimann, "L'Iconogra-

phie de la Trinité, I," in *L'Art chrétien*, I, Paris, 1934. For the English and French Gothic way of rendering the Trinity in the guise of the First and Second Persons enthroned with the Dove of the Holy Spirit hovering between Them (designated by Braunfels as the *"Psalterschema"*), see Braunfels, ibidem, p. xxvi f.
25. Braunfels, ibidem, p. xxxii; von Einem, *Karl V. und Tizian*, p. 27.

"*The Triumph of the Trinity*" in Cort's engraving.[26] Titian calls it alternately "*La Trinità*" and "*Il Paradiso*."[27] The Emperor himself, however, speaks of it, in no less authoritative a document than the codicil to his last will and testament, as "*The Last Judgment*," "*El Juicio Final*."[28]

This imperial interpretation tends to be neglected by modern critics. It is indeed at variance with the facts in several ways, particularly in that in a real Last Judgment Christ would have to appear, as St. Augustine puts it, "not in that form in which He is equal to His Father but in that form in which He is the Son of Man."[29] Yet Charles V did not employ the term "*Last Judgment*" without good reason; and some of the features which distinguish the "*Gloria*" from all analogous compositions may be accounted for by his wish to possess a picture which would combine, as it were, the last two chapters of St. Augustine's *Civitas Dei* into one composition: a picture suggesting both the "Eternal Beatitude of the City of God" (hence Titian's *Paradiso*), where time has ceased to exist, and the Last Judgment, which marks the moment when time is coming to an end but has not as yet been abolished in favor of eternity.

This intrusion of the concept "Last Judgment" upon the concept "Community of the Blessed" — or, if you prefer, *La cour céleste* — explains, I believe, not only the prominence of those "specialists in eschatology," Ezekiel, David and the Erythrean Sibyl, the characterization of the Virgin Mary as *Maria Mediatrix* rather than *Regina Coeli* and the impassioned gesture of Noah, who seems to implore the deity to remember the First Covenant, but also the two most unusual characteristics of

26. See, e.g., Francisco Vargas' letter of June 30th, 1553 to Charles V (*C.-C.*, ii, p. 506 f.; P. Beroqui, *Tiziano en el Museo del Prado*, 2nd edition, Madrid, 1946, p. 124); the inventories of 1556 and 1558 (von Einem, ibidem, p. 27); a privilege, dated February 4, 1567, which grants to Titian a kind of copyright on Cornelis Cort's engravings after his compositions (P. Kristeller, "Tizians Beziehungen zum Kupferstich," *Mitteilungen der Gesellschaft für vervielfältigende Kunst* [supplement to *Die graphischen Künste*], xxxiv, 1911, pp. 23 ff.); Vasari, vii, p. 451 (erroneously describing the Virgin Mary as "La Nostra Donna e Cristo fanciullo").

27. Titian uses the expression "*la Trinità*" in his letter to Charles V of September 10, 1554 (*C.-C.*, ii, p. 507 f.) and in his letter of the same date to Gio. Benevides (Ticozzi, *Vita dei pittori Vecelli*, p. 313.) The term "*il Paradiso*," on the other hand, occurs in Titian's application for the privilege referred to in the preceding Note (Kristeller, ibidem, p. 24).

28. The text of this codicil, dated September 9, 1558, is alluded to in *C.-C.*, ii, p. 236, and reprinted in von Einem, *Karl V. und Tizian*, p. 25, Note 72.

29. St. Augustine, *De Trinitate*, i, 13, 28 (*Patrologia Latina*, xlii, col. 841).

Titian's composition: the appearance of Charles V and his family as supplicants wrapped in shrouds and the predominance of pre-Christian personages among the Blessed.

Exalting themselves by way of self-humiliation (not unlike those prelates, princes and noblemen whose funerary effigies depict them *en transi*, that is to say, as decaying corpses divested of the symbols of terrestrial power and dignity), the members of the imperial family are represented not as donors proleptically admitted to Paradise but as resurrected souls humbly praying for admission ("Pone me cum benedictis"). They rely on the support not so much of those who believed in Christ after His Incarnation, Passion and Resurrection as of those who by a special act of Grace believed in Him even before He came; and this, I think, can be understood in the light of the Thomistic doctrine of "implicit" and "explicit" faith, beautifully summarized in Dante's *Divina Commedia*. "Behold," says the Eagle (a symbol of the Saviour Himself), "behold how many cry 'Oh Christ, Oh Christ'; / But they on Judgment day will be less close / To Him than those who did not know Him yet":[30] those who had been illumined by a light they had not seen will enjoy a privileged position, and therefore exert an all the more potent influence as intercessors, on the very occasion which Titian's "*Gloria*" evoked in the mind of Charles V.

Yet, while the "*Gloria*" is a *Last Judgment* by implication, it remains a *Paradise* in principle. It has rightly been stressed that Titian followed — or, rather, was told to follow — a pattern established in the French late Gothic manuscripts of St. Augustine's *Civitas Dei* (Fig. 77)[31] — a pattern

30. *Paradiso*, XIX, 106-108:
"Ma vedi, molti gridan CRISTO, CRISTO,
Che saranno in giudicio assai men *prope*
A lui che tal, che non conobbe CRISTO."
31. Braunfels, *Die heilige Dreifaltigkeit*, pp. XXXII ff. (Figs. 29, 30); von Einem, *Karl V. und Tizian*, pp. 28 ff. Our Fig. 77 is taken from Paris, Bibliothèque Ste.-Geneviève, MS. 246 (datable 1473), fol. 406, for which see A. de Laborde, *Les Manuscrits à peintures de la Cité de Dieu*, Paris, 1909, II, p. 417 ff. – A comparable reversion to a much earlier though in this case not Transalpine type may be seen in the *Saint Catherine* in the Museum of Fine Arts at Boston (*V.*, II, pp. 61, 72, Pl. 180) which may or may not be identical with the *Santa Caterina* delivered to Michele Cardinal Bonelli in 1567. E. Tietze-Conrat, "Titian's 'Saint Catherine,'" *Gazette des Beaux-Arts*, series 6, XLIII, 1954, pp. 257 ff. (also in *Art Bulletin*, XL, 1958, p. 348), is indubitably right in claiming that the Boston picture, perhaps composed as early as 1518-19 but executed much later (though hardly by Titian himself), is patterned upon a type used for the representation not of St. Catherine of Alexandria but of St. Catherine of Siena — a type which the author illustrates by a woodcut of 1505 but which can be traced back to the end of the Trecento (see G. Kaftal, *Saints in*

retained or developed in missals, in breviaries, in books of hours, in moralistic treatises; and ultimately monumentalized in such altarpieces as Jacob Cornelisz van Oostsanen's Kassel Triptych of 1523 (Fig. 78).[32] It is by the influence of such Augustinian models that we can account for two further peculiarities in Titian's picture which defy the whole tradition of Italian iconography: the splendid isolation of the Virgin Mary (although she is represented standing and interceding in the *"Gloria"* while quietly enthroned in the *Civitas Dei* manuscripts as well as in the Kassel Triptych);[33] and, more importantly, the appearance of the Trinity in the guise of two nearly identical figures symmetrically enthroned, with the Dove of the Holy Spirit between Them.

It is remarkable enough that Titian was instructed to employ a formula so alien to the Italian taste — so alien, in fact, that it is absent from what may be called a sampler of earlier Italian Trinity types[34] and seems to have been employed in Italy only after, and under the influence of, Titian's *"Gloria"* itself — but so pervasive in the Transalpine world that it

Italian Art; *Iconography of the Saints in Tuscan Painting*, Florence, 1952, Figs. 264, 266, 267); but she is not right in assuming that the Boston picture originally *was* a portrayal of St. Catherine of Siena, subsequently transformed into a portrayal of St. Catherine of Alexandria by the addition of a sword, a palm frond and the fragment of a wheel. Mr. Thomas N. Maythem of the Boston Museum of Fine Arts kindly assured me *in literis* that an x-ray made on my suggestion failed to disclose any trace of such a transformation.

32. *Reallexikon zur deutschen Kunstgeschichte*, i, cols. 365 ff., Fig. 3.

33. In an interesting manuscript of Henry Suso's *Horologium Sapientiae* (Brussels, Bibliothèque Royale, MS. iv, 111) the Virgin Mary is seated on the foot-pace of the Throne of the Trinity; see E. Spencer, "L'Horloge de Sapience," *Scriptorium*, xvii, 1963, pp. 277 ff., published also as a separate pamphlet, Brussels, 1964 (here Pl. 8).

34. New York, Morgan Library, MS. 742, a leaf from an Antiphonary ascribed to a follower of Pacino di Bonaguida (Braunfels, *Die heilige Dreifaltigkeit*, Fig. 11). It shows, in the center, the Trinity in the guise of a single figure undistinguishable from a Christ in Majesty (for this "one-man Trinity" and its occasional misinterpretation, see E. Panofsky, "Once More 'the Friedsam Annunciation and the Problem of the Ghent Altarpiece,'" *Art Bulletin*, xx, 1938, pp. 419 ff., particularly p. 433). The margins show Abraham greeting the three angels, the "Throne of Mercy" ("*Gnadenstuhl*"), the Three Persons enthroned behind a vested altar (the "*mysterium fidei* type," for which see Braunfels, pp. xxviii ff.), and even the controversial *tricipitium* type (three heads growing out of one body — a slightly subversive motif which was, however, to retain its popularity from Donatello to Fra Bartolommeo and Andrea del Sarto). Could it be that the reluctance of Italian art to accept the French Gothic type was caused, in part at least, by the lingering influence of the Byzantine tradition from whose point of view the French Gothic "*Psalterschema*" might have amounted to a visual endorsement of the controversial *Filioque* inserted, after *Patre*, into the Athanasian formula "Qui [Spiritus Sanctus] ex Patre procedit"?

invaded, in at least one case, the illustration of Petrarch's sixth *Trionfo*.[35] But even more remarkable is the fact that his instructions also called for the reinstatement of a tradition which, in his time, had become obsolete even in the Transalpine world itself: the tradition of making no visual distinction between the First and the Second Person of the Trinity (except for the tiny cross surmounting the orb of Christ and omitted, perhaps intentionally, in Cort's engraving). This principle of identity had prevailed from the twelfth century up to the fourteenth; but the artists of the fifteenth and sixteenth centuries, including the illustrators of St. Augustine's *Civitas Dei* itself, invariably distinguished the Father from the Son in age and attributes, among them the imperial crown or the papal tiara, both normally reserved to God the Father.[36] When, on April 24, 1453, Jean de Montagnac, priest, commissioned Enguerrand Quarton to paint the famous *Coronation of the Virgin* for the Carthusian Church at Villeneuve-lès-Avignon (originally destined for an "Altar of the City of God"!) he had to stipulate, very specifically, that the Coronation be performed (in "Paradise"!) by a Trinity within Which "no distinction should be made between the Father and the Son": "et du pere au fils ne doit avoir nulle difference" (Fig. 79).[37] Like Jean de Montagnac, it would seem, the theologians of Charles V believed that only the high mediaeval combination of two identical figures with a Dove between them could do full justice not only to the consubstantiality and co-eternity of God the Father and Christ but also to the peculiar role of the Holy Spirit Who, though sharing in this consubstantiality and co-eternity, "proceeds from the Father as well as from the Son" (*de patre filioque procedit*).

35. Thus in the *Triumph of Eternity* (or *Divinity*) in Bibliothèque Nationale, MS. Fr. 22541, reproduced in d'Essling and Müntz, *Pétrarque*, p. 225.

36. One of the rare exceptions, possibly unique, is Dürer's *Heller Altarpiece*, where God the Father is represented as an Emperor while Christ, clad only in a mantle which exposes the upper part of His body, wears a papal tiara. Apparently Dürer had in mind Psalm 109 (110) which, because of its beginning (*Dixit Dominus Domino meo*), played a great role in the discussions about the nature of the Trinity and in versicle 4 (the illustrations of which were the *fons et origo* of what Braunfels has designated as the "*Psalterschema*") contains the words: *Tu es sacerdos in aeternum*, "Thou art a priest for ever."

37. C. Sterling, *Le Couronnement de la Vierge par Enguerrand Quarton*, Paris, 1939, p. 25. According to this contract the "Paradise," where the coronation of the Virgin takes place, had to be indicated by gold ground in order to distinguish it from the natural sky (*chiel*) beneath it. Cf. D. Denny, "The Trinity in Enguerrand Quarton's *Coronation of the Virgin*," *Art Bulletin*, XLV, 1963, pp. 48ff. It is noteworthy that eight years later, in 1461, the same painter is enjoined, with equal emphasis, to depict the Trinity in the guise of three human figures (Sterling, p. 11), as in Fouquet's *Heures d'Etienne Chevalier*.

In one of Titian's latest works a formula of mediaeval religious art —
and a liturgical one at that — even intruded, it would seem, upon the field
of portraiture; and in this case we happen to know that he acted not only
under verbal or written instructions but on the basis of a *bozzetto* supplied,
according to the specifications of Philip II, by the Spanish court painter,
Alonso Sánchez Coello.

On October 7, 1571, the Spanish fleet, commanded by Philip's half-
brother, Don Juan de Austria, had decisively beaten the Turks in a naval
engagement near the entrance of the Gulf of Patras, commonly called
(after the base of the Turkish fleet) the battle of Lepanto. About two
months after this victorious battle Philip's first son by his last marriage,
the Infante Don Fernando, was born. Wishing to commemorate both
these events — the victory and the birth — the King ordered from Titian
a big painting referred to in the documents as "*The Battle*" (*Battaglia*) or
"*The Naval Battle*" (*Batalla Naval*); it was still unfinished on December
22, 1574 and was delivered in the month of September of the following
year (Fig. 80).[38] This painting, now in the Prado, had been commissioned
with the proviso that it have the same dimensions as the equestrian por-
trait of Charles V. This is the case now, but only after the painting had
been not only restored but also substantially enlarged in 1625, a fact from
which we must conclude that what now appears on the strips added on
all sides, particularly the vanquished Turk and the trophies in the lower
left-hand corner, cannot be ascribed to even the workshop of Titian.[39]

In spite of its official designation, the "*Allegory of the Battle of Lepanto*,"
as it is mostly called in recent writing, is not so much a battle piece (the
battle appears, though most impressively, only in the background) as a
portrait charged with dynastic and religious symbolism. It shows the King

38. *V.*, ii, Pl. 131.

39. On December 24, 1625, Vicente
Carducho, better known for his *Dialogos de
la Pintura* (1633) than for his works, was
paid not only for the restoration but also
for the enlargement (*ensanchar* and *alargar*)
of the "*Battle*"; see J. Moreno, "Cómo son
y cómo eran unos Tizianos del Prado,"
Archivo Español de Arte y Arqueologia, ix,
1933, pp. 113ff. In fact a strip of c. 30 cm.
(below the left foot of the King) has been
added at the bottom of the canvas; a strip
of c. 20 cm. (above the feet of the Victory)
at the top; and a strip of c. 50 cm. on
either side. That this was necessary can
best be explained by the assumption that
the picture was so severely damaged at the
margins that sizeable strips had to be
removed and replaced: it is difficult to
imagine that Titian had so considerably
miscalculated the size of the canvas; and
that, if he had, the necessary enlargement
had been delayed for fifty years after the
arrival of the picture. The fact that the
composition was based on a *bozzetto* by
Alonso Sánchez Coello is attested by Jusepe
Martinez's *Discursos practicables del nobili-
simo arte de la pintura* (late seventeenth
century) as quoted in *C.-C.*, ii, p. 396f.

standing before a sumptuously covered table placed on an open terrace; behind him there is a row of tall columns. And he presents his little son to a winged Victory — or, as a Spanish author of the seventeenth century (Jusepe Martinez) has it, an "angel" — who, rushing down from Heaven, holds a laurel wreath in her left hand while with her right she offers the Infante a palm branch and a scroll inscribed MAIORA TIBI, "You Will Do Better."

What interests us here is the fact that the posture of King Philip, raising the little Don Fernando, strikingly resembles a motif encountered in innumerable liturgical books, particularly missals and graduals. In these the opening versicle of Psalm 24 (25), "Ad te, Domine, levavi animam meam," "Unto thee, O Lord, do I lift up my soul" — a versicle all the more memorable as it ushers in the ecclesiastical year on the first Sunday of Advent — is invariably illustrated by a priest officiating before an altar and "lifting up" a little nude child (here, needless to say, a symbol of the soul) to God who, often adored by angels, appears in His Heaven (Fig. 81).[40]

The idea of "lifting up" a new-born prince in this fashion is too unusual to be accounted for by sheer coincidence. In suggesting the program of the picture to his court painter — and through him, to Titian — Philip II seems to have had in mind the formula which for at least three centuries had lent visual expression to the "Ad te levavi." And the liturgical flavor still clinging to the *Allegory of the Battle of Lepanto* makes us understand that the Victory in Titian's portrait was — and occasionally still is — described as an angel, and the table as an altar.[41]

The portrayal of a king in the likeness of a priest re-enacting a Biblical metaphor is, not surprisingly, an isolated case. Yet it exemplifies a general principle, apparently peculiar to Titian, which had helped him to solve unusual problems in portraiture long before the *"Allegory of the Battle of Lepanto"* was composed — except for the fact that this principle had

40. Our Fig. 81 shows the *Ad te levavi* page from a Missal in the Bibliothèque Nationale, MS. lat. 17318, fol. 18 (V. Leroquais, *Les Sacramentaires et les Missels manuscrits des bibliothèques publiques de France*, Paris, 1924, II, p.115 and Pl.XLVIII). The type may ultimately derive from the illustrations of Psalm 84, 12 (85, 11), where — as in the Utrecht Psalter and its derivatives — Earth "lifts up" a childlike Truth instead of permitting the latter to "spring out of the earth" without assistance (cf. E. Panofsky, *Studies in Iconology; Humanistic Themes in the Art of the Renaissance*, New York, 1939 and 1962, p. 157, Note 98, Fig. 112).

41. *C.-C.*, II, p. 397; Gronau, *Titian*, p. 190.

previously been applied to classical rather than mediaeval prototypes: from as early as c. 1540 Titian had started to force classical formulae, evolved within a ritualistic or narrative context, into the service of portraiture — in such a way, however, that he retained from his models only the compositional "schema" (i.e. the pattern produced by the organization of figures into groups and parts into figures) and the emotional atmosphere surrounding this "schema," while every detail was thoroughly modernized. The result is the exact opposite of what we know as an "allegorical" portrait: instead of being confronted with a sixteenth-century admiral masquerading as Neptune, a sixteenth-century cardinal masquerading as St. Jerome, or an eighteenth-century lady masquerading as a Naiad, a Muse or Diana, we have a classical god or emperor recast in the role of a sixteenth-century personage.

This "transplantation" — as opposed to adaptation — of a classical composition resulted in a kind of "classicism in disguise" which is magnificently exemplified by the *Allocution of Alfonso d'Avalos, Marchese del Vasto*, in the Prado (Fig. 83).[42]

The Marchese del Vasto, a cousin by marriage of the much older Vittoria Colonna (who is said to have had a hand in his early education), was one of the most cultured grandees of the sixteenth century and one of the most trusted generals of Charles V. He became acquainted with Titian in 1531 at the latest, and sat to him for a portrait in half length as early as 1532/33 (Fig. 82).[43] The "*Locuzione*," as Vasari calls it, was probably

42. *V.*, ɪ, Pl. 158. For documentation of the statements made in connection with this picture as well as for the entire remainder of this chapter, I may refer to my essay "Classical Reminiscences in Titian's Portraits; Another Note on His 'Allocution of the Marchese del Vasto,'" *Festschrift für Herbert von Einem*, pp. 188 ff. To be added to the *Allocutions* there referred to (p. 198): *Rinaldo Addressing the British Knights* in Fragonard's Ariosto illustrations (E. Mongan, P. Hofer and J. Seznec, *Fragonard Drawings for Ariosto*, New York, 1945, Pl. 120).

43. *V.*, ɪ, Pl. 144. In an otherwise convincing article ("Titian's Portrait of Giulio Romano," *Burlington Magazine*, cvɪɪ, 1965, pp. 172 ff., particularly Note 16), John Shearman agrees with W. Braunfels ("Tizians Allocutio des Avalos und Giulio Romano," *Mouseion, Studien aus Kunst und Geschichte für Otto H. Förster*, Cologne, 1960, pp. 108 ff.) in dating this portrait (now in the collection of the Marquis de Ganay in Paris and documented by a copy from the Ambras collection but occasionally believed to be different from that known to have been painted in 1532-1533) a few years later because both Braunfels and Shearman hold the little helmet-bearer in the Paris picture to be identical with del Vasto's son, Don Francesco Ferrante, who acts in the same capacity in the *Allocution*. I can see no particular reason to postulate the identity of the de Ganay portrait with an undocumented picture of c. 1535-36 rather than with the portrait demonstrably made a few years before, presumably at Bologna (Vasari, vɪɪ, p. 442) but do not wish to be dogmatic about this

ordered in January 1539, when the Marchese represented the Emperor at the inauguration of the Doge Pietro Landi. On November 20, 1540, it was far enough advanced to be described, in minute detail, in a letter by Pietro Aretino; about a month later Titian could part with the *bozzetto*; and it was probably delivered in August 1541.

The picture shows the Marchese in full length, baton in hand, addressing his troops. He shares the platform with his son, Francesco Ferrante, then about nine years of age, who officiates as helmet-bearer to his father and, by the way, bears not the slightest resemblance to the adoring, unkempt little creature — wide-mouthed, chinless, and relegated to a position even more humble than that of the attendant handmaiden in the *Salome* — who discharges the same duty in the earlier portrait. Del Vasto's oratorical gesture, incidentally (arm raised and bent at the elbow and three of the fingers crooked behind the extended thumb and index finger), so much resembles that of one of the "musclemen" — almost a Marchese del Vasto *en écorché* — in Vesalius' nearly contemporaneous *Fabrica corporis humani* (Fig. 84), that it lends further support to the view of those who hold that Vesalius' ingenious illustrator, Jan Stevensz of Calcar, a member of Titian's workshop at the time, enjoyed the active cooperation of his master.[44]

Recent assertions to the contrary notwithstanding,[45] we may take it for granted that the Marchese del Vasto rather than Titian had suggested the subject of the painting. No patron of the Marchese's standing would have given *carte blanche* to his portraitist, and he himself had very good reason to wish for a likeness that would show him in the role of *arringatore*: the painting depicts him in a moment of personal triumph when by his

point. I must insist, however, that the two helmet-bearers (cf. my article cited in the preceding note, p. 191) are not identical. The helmet-bearer in the de Ganay portrait is an exotic-looking servant rather than the future Viceroy of Sicily, and I am inclined to accept Professor Richard Krautheimer's oral suggestion that he may be a dwarf — which would account for the sad and wizened impression of his face and the withered aspect of his little hand.

44. See Vasari, VII, p. 460f.; for the interrelation between Titian, Calcar and Vesalius, see E. Tietze-Conrat, "Neglected Contemporary Sources Relating to Michel-

angelo and Titian," *Art Bulletin*, XXV, 1943, pp. 154ff.; H. W. Janson, "Titian's *Laocoön Caricature* and the Vesalian- Galenist Controversy," ibidem, XXVIII, 1946, pp. 49ff. Cf. W. M. Ivins, Jr., "A Propos of the *Fabrica* of Vesalius," *Bulletin of the History of Medicine*, XIV, 1943, pp. 576ff.; idem, "What About the *Fabrica* of Vesalius?", in *Three Vesalian Essays to Accompany the "Icones Anatomicae" of 1934*, New York, 1952, pp. 43ff.; J. B. de C. M. Saunders and C. D. O'Malley, *The Illustrations from the Works of Andreas Vesalius of Brussels*, Cleveland, 1950.

45. W. Braunfels, "Tizians Allocutio."

eloquence he succeeded — where Charles V had failed — in preventing a major military disaster.

In the Turkish War of 1532, when the Imperial Army was stationed in Hungary, the Italian contingent started a mutiny. The soldiers threatened to disband, and it was the Marchese del Vasto, then Supreme Commander of the Imperial Forces, who persuaded them to remain faithful to their duty and thus assured an orderly return to Italy; we even possess two independent records of the very speech which, I submit, is being delivered in Titian's *Allocution*. The General skillfully flattered the professional and patriotic pride of the Italian mercenaries, identifying himself with their typical grievances (delays in payment, bad food, harsh treatment at the hands of another commander), and he swayed their decision by admirably contrasting the ordered but humdrum existence of the civilian with the military life whose very advantages, he said, made it incumbent on "men of valor" to accept the rough with the smooth. They shouted approval and "rushed to their arms with terrible and resolute courage."

This is the event which Titian had been asked to commemorate. And in discharging this task he resorted to a formula which Roman art had developed to represent what had become a kind of ritual: the *Adlocutio Augusti* shown, for example, in a well-known coin of Emperor Gordian III (Fig. 85), which had been utilized, as early as c. 1485, by an assistant of Domenico Ghirlandaio for the decoration of the Sassetti Chapel in S. Trinita at Florence (Fig. 86).

Like this "numismatic type" of Allocution, as we may call it in contradistinction to the "monumental type" (represented, for example, by the Aurelian reliefs on the Arch of Constantine), Titian's picture shows the speaker on a comparatively low platform (*suggestus*), wearing a short cape pushed back over his shoulders in a fall of quiet, vertical folds, accompanied by a figure of lesser stature than himself, and facing a small group of soldiers. But with the retention of this "schema," the similarity ends: the composition has acquired a new dimension.

The sullen lansquenets in the foreground still form a small, compact group contrapuntally contrasting with the speaker; and the weapon of the ring leader — sultry and menacing even with regard to the color of his doublet — still gives a kind of silhouette effect. But these four figures emerge from the lower margin in three-quarter length which makes them look all the bigger and all the more dangerous; they are placed diagonally in relation to the general, the ring leader facing him so as to turn his back upon the beholder; and, above all, the quartet in the foreground is

contrasted with what Aretino calls "an infinitude" of soldiers in the
middle distance —, an indistinct mass of men-at-arms rather than a
collection of individuals, one of the earliest instances of a real "army" in
the history of painting.

The *Allocution of the Marchese del Vasto* is thus a variation on a Roman
formula which had been revived in the workshop of Ghirlandaio and was
to retain its popularity up to the eighteenth century. Yet Titian's picture
is unique in applying this formula to a portrait and in translating
the ancient text into the language of the present. In all post-classical
Allocutions which I can remember the *dramatis personae* belong to the remote
past, as do the paraphernalia — from the armor of the speakers to the
equipment of the "captive audience." This applies to the fresco in S.
Trinita (Fig. 86), where the speaker is still anonymous; to Giulio Romano's
Allocution of Constantine in the Vatican (Fig. 87); to Rubens' *Allocution of
Decius Mus*; to Fragonard's Ariosto illustrations; and even to Giovanni
Battista Tiepolo's *Allocution* in the National Gallery of Art at Washington
(Fig. 88) whose heroine is, I believe, none other than the beautiful Queen
Zenobia of Palmyra, well known to the modern beholder from Calderón's
play and Gibbon's marvelous paraphrase of the *Scriptores historiae Augustae*.

Titian, however, had no intention to evoke the past *qua* past, and
nothing could be further from his mind than a preoccupation with
archaeological fidelity. Instead of conjuring up the shadows of a legendary
Carolingian knight, a Roman consul, a Roman emperor, or an Asiatic
queen, he recreated a scene that had taken place in 1532 — less than a
decade before the picture was painted — and departed from factual
truth only in that the Marchese's young son, a baby-in-arms in that year,
is proleptically represented as he looked in 1540. The armor of the
Marchese is strictly "up-to-date"; we happen to know that Titian asked
for a suit of armor "after the latest fashion" ("a l'usanza dei di d'oggi")
to give the final touches to the outfit of the Marchese del Vasto. And the
Roman insignia are replaced by modern halberds, swords and spears. It
is this capacity for, as I phrased it, "transplanting" classical models to
the modern soil — even to the soil of portraiture — instead of adopting or
adapting them which gives Titian an unparalleled position in the
rinascimento dell'antichità.

A problem in portraiture no less unusual than that which he solved
in the *Allocution of the Marchese del Vasto* confronted Titian when he was

asked to portray Pope Paul III Farnese together with his two grandsons, Cardinal Alessandro and Prince Ottavio, the natural son-in-law, if one may say so, of Charles V (Fig. 89).[46]

In color this triple portrait — preserved in the Gallery at Naples, painted near the end of Titian's stay in Rome and therefore not quite finished — is a miracle. Three shades of red (the saturated cinnabar of the tablecloth and the Cardinal's *beretta*; the more subdued cinnabar of the Pope's slippers; the saturated crimson of the Cardinal's robe; and the equally sonorous crimson of the Pope's cape and *camuccio*) are perfectly harmonized with each other (which is difficult enough) as well as with the warmly modulated whites in the Pope's beard and cassock and in Ottavio's hose, shoes, collar and plume; otherwise there are only browns, greys and blacks. In short, the picture is a living illustration of Titian's much-quoted *bon mot* to the effect that a good painter needed only three colors: black, white and red. And with regard to composition it is both revolutionary and unique.

To represent a Pope between two younger relatives was in itself no novelty: Raphael had set a splendid example in his *Portrait of Leo X* showing him in the company of his two nephews, Giulio Cardinal de'Medici (later Pope Clement VII) on the left and Lodovico Cardinal de'Rossi on the right (Fig. 90). But Titian's composition differs from Raphael's in three respects. It shows all the personages in full-length (an arrangement which, as far as seated figures are concerned, had thus far been reserved for effigies of popes or princes "in majesty"); it daringly combines subordination with coordination (while Raphael keeps both Cardinals in the background, Titian moves Ottavio Farnese to a plane slightly in front of that of the Pope); and it introduces an element of physical activity and emotional tension hitherto unheard of in portraiture.

Cardinal Alessandro remains coldly aloof, placing his hand on the back of the Pope's armchair and calmly looking at the beholder. The Pope, then about 77 years of age, shrunken and bent, looks at his "idol," young Ottavio, with deep and inarticulate distrust; and Ottavio himself, entering from the right, approaches his grandfather with a movement obsequious and almost fawning yet dangerously resilient and unpredictably tense, his graceful, noiseless step bringing to mind one of the larger felines. Like a seismograph, Titian's perceptive and experienced mind seems to have registered the subterranean disturbances within the Farnese

46. *V.*, II, Pl. 1 and Color Plate preceding it.
Cf. my article cited above, p. 74, Note 42.

family which, only a few years afterward, were to result in a frightful eruption. It was the treachery and disobedience of Prince Ottavio, cautiously condoned by Cardinal Alessandro, which broke the aged Pontiff's heart and, at least indirectly, caused his death on November 10, 1549.[47]

In designing this triple portrait, and in investing it with these sinister overtones, Titian once more made use, I think, of a classical prototype — a prototype related to the Naples picture not only in form but also in its atmosphere of clandestine intrigue: the *Birth of Bacchus* relief in the Vatican which (or a replica of which) he must have seen in Rome. In this relief (to be exploited by Poussin some 110 years later) the group of Jupiter and Mercury — the former seated, the latter receiving the infant Bacchus after his emergence from his hiding place, the thigh of Jupiter, to be conveyed in secret to the nymphs of Nysa — anticipates the group of the old Pope and young Ottavio, except that the seated figure is reversed (Fig. 91). The very fact that Ottavio is represented in pure profile (a form normally employed by Titian only in donor's portraits or when he worked from earlier models) would lead us to suspect the intervention of a classical relief. And Ottavio's pose, his handsome, predatory head deeply bowed, and his legs bent in courtly obeisance, repeats almost *ad literam* the pose of Mercury, the messenger of the gods and the protector of orators, scholars, merchants, and thieves — equally suave, equally eager to please and equally untrustworthy.

Classical influence may also have helped to shape one of Titian's latest masterpieces in portraiture, begun in 1567 and finished before

47. After the murder of Paul's son, Pier Luigi Farnese, on September 10, 1547, Parma and Piacenza had fallen vacant. Charles V wanted the territory for Ottavio Farnese, son of Pier Luigi and husband of the Emperor's natural daughter, Margaret. The Pope wanted it back in the Papal State (which had ceded it to Pier Luigi on August 26, 1545), while Ottavio would receive Camerino and a sum of money. France wanted it for Ottavio's brother, Orazio, who was the husband of Diane de France, natural daughter of King Henry II. In 1549 Ottavio secretly rushed to Parma and succeeded in seizing power with the aid of his own father's murderer, Ferrante Gonzaga, Viceroy of Naples and Governor of Milan. Cardinal Alessandro cautiously but unmistakably sided with Ottavio, defending the latter (still absent in open revolt) against the furious reproaches of the Pope. And it was on the occasion of a meeting between the Cardinal and the Pope, which took place in the Villa Carafa on November 6, 1549, that the 81-year-old Paul III caught the chill of which he died four days later. Cf. L. Pastor, *The History of the Popes*, ed. R. F. Kerr, 3rd edition, St. Louis, XII, 1950, pp. 449-453.

January 1569: the Vienna *Portrait of Jacopo Strada* (or "de Strada"), court counselor and antiquarian to Emperor Maximilian II (but temporarily serving the Elector of Bavaria when Titian made his acquaintance), art dealer, numismatist, amateur architect, amateur engineer, and Titian's good friend and business partner for several years. "They are two gluttons before one plate," *doi ghiotti a un tagliero*, wrote Strada's disgruntled competitor, Niccolò Stoppio.[48]

Many facets of this adventurous personality are reflected in Titian's portrait (Fig. 92). The golden chain and the sword characterize the court counselor; the works of sculpture, the court antiquarian; the books, the scholar; the coins, the numismatist. But it decisively differs from Titian's other portraits.

48. *V.*, II, Pls. 122, 123; cf. my article cited above, p. 74, Note 42. The picture is slightly cut down on the left and disfigured by a cartouche added some time before 1659. For Strada's personality, see J. Stockbauer, *Die Kunstbestrebungen am Bayerischen Hofe* (*Quellenschriften für Kunstgeschichte...*, VIII), Vienna, 1874, *passim*. For his accomplishments as a numismatist, see P. O. Rave, "Paolo Giovio und die Bildnisvitenbücher des Humanismus," *Jahrbuch der Berliner Museen*, I, 1959, pp. 119 ff.; for his relationship with Titian, see, in addition to Stockbauer, H. Zimmermann, "Zur richtigen Datierung eines Porträts von Tizian in der Wiener Kaiserlichen Gemäldegalerie," *Mitteilungen des Instituts für Oesterreichische Geschichtsforschung*, Ergänzungsband, VI, 1901, pp. 830 ff.; for his treatise on engineering (in part plagiarized from Francesco di Giorgio Martini), see L. Reti, "Francesco di Giorgio Martini's Treatise on Engineering and Its Plagiarists," *Technology and Culture*, IV, 1963, pp. 287 ff., Figs. 2-4. Information about Niccolò Stoppio is found in Stockbauer and Zimmermann just cited. Stoppio, who acted for the Fuggers as Strada did for the Elector of Bavaria, was one of those egregious gossips to whom history owes so much inside information, not always reliable but always amusing; and his stories about Strada and Titian must be read with the understanding that Strada and Stoppio were fierce competitors with regard to business as well as social position and that Stoppio's attempts to deal with Titian had been most disappointing. In letters of February 29, 1568, and April 9, 1569, for example (Zimmermann, just quoted), he tells Jacob Fugger that Titian, though very friendly with Strada, had called him "one of those pompous ignoramuses" (*uno delli solenni ignoranti*) and had accused him of cheating the Germans in all imaginable ways ("caccia tante carotte a quelli Tedeschi quanto si può imaginare"; cf. the French phrase "tirer une carotte à quelqu'un") although, according to Stoppio, Titian did the same thing himself; that Strada, in return for his portrait, had promised Titian a sable lining for a fur coat; that (even more gallingly) Strada had received from him a *Dea Pomona* (sometimes identified with the so-called "*Lavinia*" in Berlin, *V.*, II, Pl. 63, which in turn may well be identical with a "*Young Woman Holding a Bowl with Fruit*" once owned by Queen Christina of Sweden), which Stoppio himself had hoped to obtain for Jacob Fugger; and that the aged master, unable to do much work with his trembling hands, had fallen into the habit of leaving the execution of his pictures to assistants (particularly the excellent Emanuel Amberger of Augsburg), of subsequently adding two brush-strokes and selling the paintings as his own.

First, Jacopo Strada, instead of being shown before a neutral background or in a "semi-interior" communicating with the outdoors, is placed in the corner of a richly elaborated but air-tight compartment; this is a Northern formula which can be traced back to Petrus Christus and reached its classic perfection in Holbein's *Portrait of Georg Gisze*, dated 1532 (Fig. 93); quite possibly Titian's Strada portrait was produced with the aid of that elusive Emanuel Amberger of Augsburg who, according to Stoppio, was Titian's "right-hand man" at the time.[49]

Second, the sitter exhibits to the beholder — as though attempting to persuade a prospective buyer — a small replica of Praxiteles' *Aphrodite Pselioumene* (*Venus Putting on Her Necklace*), copies of which exist in several collections. This motif, too, is not without precedent. In an engraving by Agostino Veneziano (B. 418), dated 1531 and claiming to represent the "Academy of the Belvedere," the instructor, Bacchio Brandin, analogously displays a statuette — also a *Venus* — to his students;[50] and Lorenzo Lotto had employed a somewhat similar scheme in his *Portrait of Andrea Odoni* (Hampton Court, dated 1527; Fig. 94), the great Venetian art collector and possibly the owner of Titian's early *Holy Family with St. John the Baptist and St. Catherine*.[51] But Agostino's print is an individualized genre piece rather than a portrait; and Lotto's painting differs from Titian's Strada portrait in principle (foiled by a neutral background and surrounded by major works of sculpture on all sides, Andrea Odoni proffers a tiny idol with one hand instead of holding up for inspection a fair-sized statuette with both). I am therefore inclined to believe in an additional and catalytic influence: that of an Attic stele now preserved in the Musée Calvet at Avignon but first heard of in the Museo Nani at Venice (Fig. 95).[52] In it a mother shows a doll to a girl much as Jacopo Strada (or, for that matter, Bacchio Brandin) displays his Venus statuette. Owing to its close connection with the Levant, Venice was a place where Greek as opposed to Roman sculpture was more easily accessible and more keenly appreciated than in the rest of Italy; it may well be that the Avignon relief had made an impression on Agostino Veneziano and Lorenzo Lotto as well as on Titian.

49. Cf. Stoppio's letter of February 29, 1568, for which see the preceding Note. Even in the color scheme, based on a contrast between crimson and dark green, the Strada portrait somewhat resembles Holbein's *Georg Gisze* and other Augsburg portraits.
50. Reproduced in A. Chastel and R. Klein, *L'Age de l'Humanisme* (*L'Europe de la Renaissance*), Brussels, 1963, Fig. 219.
51. Chastel and Klein, ibidem, Fig. 201. For Titian's *Holy Family* (*V.*, i, Pl. 126), see Gould, *National Gallery Catalogues; The Sixteenth-Century Venetian School*, p. 111.
52. Reinach, *Répertoire de reliefs*, ii, p. 215, 3.

While this connection is admittedly conjectural, classical influence cannot, I think, be doubted in the *Equestrian Portrait of Charles V* in the Prado which Titian painted during his first stay at Augsburg in 1548.[53] It is much larger and much better preserved than the familiar Munich portrait, produced on the same occasion, which shows the Emperor seated in an armchair and dressed in civilian clothes rather than in armor.[54]

Unlike as they are in size and appearance, these two portraits may yet be considered to be spiritual counterparts: they illustrate the dual role of the Imperial Majesty which, according to the beautifully chiastic definition at the beginning of Justinian's *Corpus iuris*, "must not only be adorned with arms but also armed with laws so that both wartime and peacetime can be properly governed."[55]

The Munich portrait (Fig. 96; dated 1548) shows the Emperor resting in an armchair on a kind of loggia, withdrawn, watchful and ineffably lonely. Apart from a brocaded cloth-of-honor and a majestic column, no outward sign of his imperial rank is in evidence and even the Order of the Golden Fleece, his only ornament, is worn not on a red ribbon — as was customary on informal occasions — but on a dark, greenish-grey one which is hardly visible on the black dress. We can easily believe that it was the Emperor's habit to retire into a corner, listening to and observing the others without uttering a word; and it is not without interest to compare the Munich portrait of Charles V with those of his son and successor, Philip II, which invariably show him wearing the Golden Fleece on its formal, gold-enamelled collar of simulated flint and steel and, if he is represented seated, holding a sceptre in his hand.[56]

53. *V.*, ıı, Pls. 22-24. See (in addition to von Einem, *Karl V. und Tizian*, pp. 14 ff., and my own article referred to in Note 42), W. Braunfels, "Tizians Augsburger Kaiserbildnisse," *Kunstgeschichtliche Studien für Hans Kauffmann*, Berlin, 1956, pp. 192 ff.

54. *V.*, ıı, Pl. 21; cf. von Einem, ibidem, p. 20, and Braunfels, ibidem. The picture is so much repainted that only the face and some other areas of the figure are intact. The landscape must even be attributed to a Netherlandish hand, conceivably that of Lambert Sustris. Fortunately all these repaintings do not obscure the composition.

55. "Imperatoriam maiestatem non solum armis decoratam sed etiam legibus oportet esse armatam, ut utrumque tempus et bellorum et pacis recte possit gubernari." For some variations on this theme in sixteenth- and seventeenth-century emblematics, see D. and E. Panofsky, *Pandora's Box*, second edition, 1962, pp. 40 f., 151.

56. For the standing portrait of Philip II in the Prado, see *V.*, ıı, Pls. 43, 44 and color plate. The portrait at Naples (*V.*, II, Pl. 48) is only a workshop replica showing several changes but literally identical with the original with respect to the legs and shoes.

Philip's portraits in an armchair — *V.*, ıı, Pl. 42 (Cincinnati Art Museum) and ibidem, Pl. 49 (formerly Rasch Collection,

Instead of a sceptre, Charles V has a cane characterizing him as a very human sufferer from gout — then a most formidable disease whose treatment was almost as unpleasant as the disease itself. But in a mysterious way Titian manages to convey the impression that this silently observant, middle-aged gentleman — *mal-portant* and dressed like any high official, patrician merchant or prosperous scholar — is the master of more than half the inhabited universe. The cloth-of-honor, the column and the relationship between the figure and the field enhance but do not produce this impression of majesty. Even when the architectural background is blotted out, and the "head room" cut down, we feel that we are in the

Stockholm) — pose an intriguing problem. Neither of the two pictures can be identical with a *boceto rapidissimo* which, as we happen to know, was made at Milan between December 20, 1548, and January 7, 1549 (cf. *V.*, II, p. 54f.): the two extant "armchair portraits" show Philip older, and not younger, than he appears in the standing portrait, which was produced in 1551, and in both he carries a sceptre which would be appropriate only after 1554 when he was made King of Naples and the two Sicilys. Now, Crowe and Cavalcaselle (II, p. 206f.) give a circumstantial account of a portrait, showing Philip II seated in an armchair, which they had seen in the collection of Count Sebastiano Giustiniani-Barbarigo at Padua and which is widely believed to be identical with the Cincinnati version, the latter allegedly having passed from the possession of Count Giustiniani-Barbarigo into that of the German portrait painter, Franz von Lenbach, and hence into that of Thomas J. Emery in Cincinnati. It agrees in fact with the description of Crowe and Cavalcaselle in that it bears the earmarks of a "sketch," and particularly in that the hands are merely blocked out "without even an indication of the fingers." It disagrees, however, with this description in several other respects: in the Giustiniani-Barbarigo portrait Philip wore a black beret rather than a crown and was seated near a window which opened upon a landscape prospect.

From this discrepancy E. Tietze-Conrat, "Titian's Workshop in His Late Years," p. 82, concludes that what Crowe and Cavalcaselle were in fact describing was the picture formerly in Stockholm rather than the Cincinnati version. But the trouble is that Crowe and Cavalcaselle's description does not agree with the "Stockholm version" either, particularly in that the latter shows a clear articulation of both hands. Since Crowe and Cavalcaselle saw only one picture, there are three possibilities. Either Mrs. Tietze-Conrat is right, in which case there would have been some slip-up in the records concerning the provenance of the Cincinnati version, and the portrait formerly in the Rasch Collection would have received some finishing touches, particularly with regard to the hands, after having been inspected by Crowe and Cavalcaselle. Or Crowe and Cavalcaselle did see the Cincinnati picture after all, in which case the latter would have been thoroughly changed after their time, not only by the transformation of the beret into a crown but also by the obliteration of the landscape prospect. Or, finally, Crowe and Cavalcaselle saw a third version, now lost, in which case neither the Cincinnati nor the Stockholm portrait would come from the Giustiniani-Barbarigo collection. The question could easily be clarified by X-raying the Cincinnati picture; but my repeated requests to have this done were disregarded.

presence of an emperor. We feel it not only in the unapproachable expression of his face but in the dignity of his pose: in the contrast between the erect position of the body — emphasized by the exactly horizontal placement of the forearm — and the nonchalant position of the legs; and, above all, in the truly noble arrangement of the hands, one bare, the other gloved. These hands — much closer to each other than in any other comparable portrait by Titian — express what may be called total control: control of self as well as of others.[57]

As the portrait of Charles V in an armchair is the first self-sufficient, unallegorical, and unceremonial single portrait (in contradistinction to coins, seals, book illuminations, allegorical portraits, tombs, public monuments, or group portraits) to show the subject seated but in full-length, so is the portrait of Charles V on horseback (Fig. 97) the first self-sufficient, unallegorical and unceremonial equestrian portrait in the history of painting.

Still, it does have a certain "Denkmalscharakter" not only in derivation but also in purpose.[58] It was painted between April and September 1548 and its purpose was to commemorate that masterpiece of generalship as well as diplomacy, the battle of Mühlberg, where on April 24, 1547 (exactly one year before the painting's inception) the Emperor had decisively defeated the Protestant League of Schmalkalden: with a loss of only fifty men he had inflicted 2000 casualties on his enemies and had captured most of their leaders, including their Supreme Commander, John Frederick, Elector of Saxony.

Here, as in the triple portrait of Paul III and his grandsons, Titian's palette is almost entirely limited to shades of white, black and red. The crimson of the caparison, the plumes and the sash recurs, in a more saturated shade, in the small saddle cloth, while a spot of cinnabar is here reserved for the ribbon of the Golden Fleece; only in the landscape and in the trimmings of the armor do we find some golden yellow, blue and green.

57. In part, but only in part, the impression of majesty which emanates from the Munich portrait of Charles V is due to the fact that he is seated in an armchair — than still a privilege reserved to royalty and princes of the Church. But even if the chair in Lambert Sustris' unfortunate portrait of Erhard Vöhlin of Frickenhausen in the Wallraf-Richartz Museum at Cologne (dated 1552 and clearly patterned upon Titian's Munich portrait of Charles V) had not been deprived of its arms, even then the picture could never be mistaken for the likeness of an emperor. The sitter seems to be crushed rather than exalted by the weight of his regal paraphernalia.

58. See von Einem, *op. cit.*, pp. 14-17.

The Emperor appears precisely as he did when riding into combat[59] on that fateful April day in 1547, spear in hand, his face deadly pale with illness yet unperturbed and imperturbable, his ungainly mouth set in an expression of unshakable resolve, his large eyes focussed on a point so distant that they seem to see nothing and to perceive everything (Fig. 98).

I said "spear in hand." This feature poses an iconographical problem. Commanding generals on horseback, particularly reigning monarchs, may carry — in Northern art at least — a sword;[60] but as a rule they hold the accepted symbol of their authority, the field marshal's baton, as do the Marchese del Vasto and several other generals portrayed by Titian.

We happen to know that Charles V did carry a spear, and not a baton, at Mühlberg, though it was much shorter than the one in Titian's portrait and resembled a hunting spear: "brevem hastam venabulo similem." Why, then, did he ride into battle with such an unusual, ineffective and apparently purely symbolical weapon? And why did he insist on being immortalized by Titian with an even more conspicuous, considerably longer spear which, as I have been informed by experts, is reminiscent of a classical *hasta* rather than a modern lance?[61] The answer is not, or at least not primarily, that the spear was meant to allude to the "Holy Lance" which was preserved in the Imperial Treasury and can still be seen in the Vienna Schatzkammer; this venerable but rather unwieldy object, with a nail from the Cross of Christ strapped to its blade, looks altogether different.[62] The real reason — which also accounts, I believe, for the fact that the Emperor wished to be represented setting out for a battle won a whole year before the portrait was ordered, rather than triumphant after the victory — is twofold.

59. The armor and trappings actually worn by Charles V and his horse at Mühlberg were placed at Titian's disposal, and almost everything can still be seen in the Armeria at Madrid — except the spear (to be more fully discussed later) and the smaller, deep-crimson saddle cloth. Hetzer, *Tizian*, p. 142, believes that this smaller saddle cloth owes its existence to Titian's coloristic imagination; but since it is so small and inconspicuous, it may just as well have been lost in the course of the centuries. 60. The inverted arrow carried by Charles V in Jan Cornelisz Vermeyen's equestrian portrait in the Worcester Art Museum is atypical in that this picture is an allegorical portrait representing the Emperor in the guise of St. James Matamoro; cf. H. W. Janson, "A Mythological Portrait of the Emperor Charles V," *Worcester Art Museum Annual*, i, 1935-36, pp. 19 ff. 61. Daremberg-Saglio, *Dictionnaire d'antiquités grecques et romaines*, Paris, 1877-1919, iii, 1, pp. 33 ff., particularly p. 39, Fig. 3730. 62. H. Fillitz, *Die Insignien und Kleinodien des Heiligen Römischen Reiches*, Vienna, 1954, pp. 13 ff., Figs. 14-16; A. Bühler, "Die Heilige Lanze," *Das Münster*, xvi, 1963, pp. 85 ff.

In the first place, the spear was the weapon of such valiant killers of dragons (that is to say, heresies) as St. George and, very often, St. Michael; in a wider application, it is the weapon of the "Christian Knight" — the *Miles Christianus* described by Erasmus of Rotterdam and glorified in Dürer's famous engraving of 1513 (B. 98; Fig. 99).[63]

In the second place, and perhaps even more importantly, the ancient Romans (as opposed to the Greeks) considered the spear rather than the sceptre to be the principal symbol, in fact the very embodiment, of supreme power;[64] and it is therefore the spear — *hasta, summa Imperii* — which the Roman Emperors, the legal predecessors of Charles V, carried when making their solemn entry into a city, a ritual known as *Adventus Augusti*, and, quite particularly, when opening a campaign or setting out for an important battle, a ritual known as *Profectio Augusti*. Representations of these two scenes are very frequent in Roman art, especially on coins and medals; and in such a *Profectio* the Emperor is invariably mounted, and equipped with a spear. His horse may be shown either pacing, as on a famous coin of Trajan (Fig. 100); or, as in Titian's picture, prancing, as on an equally famous coin of that "philosopher-king" par excellence, Marcus Aurelius (Fig. 101).

Titian's equestrian portrait of Charles V — painted from life down to the minutest details, yet, I believe, influenced by a medal like that of Marcus Aurelius[65] — was thus intended to show him in the double role of a *Miles Christianus*[66] and of a Roman Caesar *in profectione*. Aretino — always inclined to give unwanted advice to artists, and possibly remembering the figures preceding and following the emperor *in profectione* — suggested that Titian include in this portrait, just ordered, two personifications: Religion with a chalice and Fame with a trumpet.[67] This suggestion shows a certain lack of taste; but it also shows a profound

63. This was correctly pointed out by von Einem, *Karl V. und Tizian*, p. 18.

64. See A. Alföldi, "*Hasta—Summa Imperii*; The Spear as Embodiment of Sovereignty in Rome," *American Journal of Archaeology*, LXIII, 1959, pp. 1 ff.; idem, "Zum Speersymbol der Souveränität im Altertum," *Festschrift Percy E. Schramm*, Wiesbaden, 1964, pp. 3 ff.

65. Braunfels, "Tizians Augsburger Kaiserbildnisse," adduces as parallels some representations of early Christian and Byzantine Emperors, particularly the well-

known fourth-century silver dish in the Hermitage, without, however, noticing that representations of this kind are only derivatives of Roman *Adventus* and *Profectiones*, a fact correctly stressed by A. Grabar, *L'Empereur dans l'art Byzantin*, Paris, 1936, p. 48.

66. It may be mentioned that the E Ǝ device of the Order of the Golden Fleece possibly means "*Eques Ecclesiae*" (F. Deuchler, *Die Burgunderbeute*, Berne, 1963, p. 362).

67. *P.-C.*, II, p. 212 f.

understanding for Titian's and his august patron's intention: the intention to stress the importance of a battle which had saved both the Catholic faith and the Holy Roman Empire.

The uniqueness of the spear motif in the rendering of a reigning monarch on horseback is accentuated by the fact that the two greatest portraitists of the seventeenth century, both working in Madrid under the direct impact of Titian's picture, deemed it necessary to replace the spear with the customary marshal's baton: Rubens in his *Equestrian Portrait of Philip IV of Spain*, transmitted through a good copy in the Uffizi (Fig.103); and Velázquez in his equestrian portrait of the same monarch, still preserved in the Prado (Fig. 102).

IV

Reflections on Time

Unlike so many other painters of the Renaissance and the Baroque — Leonardo, Dürer, Michelangelo, Poussin, Salvator Rosa — Titian was neither a *peintre philosophe*, nor a *peintre poète*, nor a *peintre scientifique*, nor a *peintre savant*; it is difficult to imagine him writing poetry or composing a treatise — even a letter — on art-theoretical or mythographical questions. But that he was not a *litérateur* does not mean that he was illiterate; that he was not an intellectual does not mean that he was unintelligent; that he was neither a scholar nor a philosopher does not mean that he, the friend of Andrea Navagero, Sebastiano Serlio, Jacopo Strada, and Pietro Bembo no less than of Aretino, was out of touch with scholarship and philosophy.

He was indubitably familiar with what was discussed and written about in the sixteenth century much as we are familiar with what is discussed and written about today (say, nuclear physics or psychology) — discussed and written about not always profoundly or even correctly but always with animation. And his own paintings bear witness to his personal involvement with the basic and interconnected problems of human existence: the nature of life and death, the nature of time and — for him the problem of all problems — the nature of beauty and love.

Today we shall discuss his pictorial reflections on Time and we shall start with the inconspicuous yet, I believe, significant fact that in no less than seven, possibly eight, of Titian's portraits — beginning with that of Eleonora Duchess of Urbino, the daughter of Isabella d'Este (Fig. 104), and including the triple portrait of Paul III and his grandsons (Fig. 89) — there appears an object extremely rare in other portraits of the Renaissance: a table clock.[1]

1. For the portrait of Eleonora Duchess of Urbino, produced between 1536 and 1538, see *V.*, i, Pl. 143. It is a companion piece to that of her husband, Francesco Maria

This attribute carries, like most attributes, a variety of meanings. Since such "miniaturized" versions of the mechanical clock — itself, it seems, an innovation of the early fourteenth century — were fairly recent (c. 1440) and quite expensive at the time, a table clock may well have been a kind of status symbol like the hand-bell in Raphael's *Portrait of Leo X and His Nephews* (Fig. 90); but it had moral implications as well.

Henry Suso entitled one of his most widely read treatises *Horologium Sapientiae* (in French: *Horloge de Sapience*).[2] Because of its well-regulated movement (we still speak of "clockwork regularity") the mechanical clock, though not as yet reduced to a height of five or six inches, suggested itself to Christine de Pisan (1363-1431) as a specific symbol of temperance; and from the middle of the fifteenth century through Peter Bruegel the table clock proper became an attribute of this Virtue in all conceivable media, particularly in funerary sculpture (Fig. 105).[3]

della Rovere (*V.*, i, Pl. 142), and this poses a problem in that a squared drawing, also preserved in the Uffizi (*V.*, i, p. 69; *T.*, Fig. 101; H. Tietze and E. Tietze-Conrat, *The Drawings of the Venetian Painters in the 15th and 16th Centuries*, New York, 1944, p. 317, No. 1911, Pl. lxv, 1), shows the Duke in a similar pose but in full rather than three-quarter length and within a round-topped frame. It has been assumed that the painted portrait, too, originally showed the Duke in full length and was subsequently cut down so as to match the portrait of the Duchess; but this view was contested by Hetzer (in Thieme-Becker, *loc. cit.*) who therefore doubts the authenticity of the drawing. Since the drawing is unquestionably genuine, we are confronted with two possibilities. If Tietze and Tietze-Conrat are right, the Duke's portrait in the Uffizi should show unmistakable signs of having been truncated at the top and at the bottom. (A technical examination suggested by this writer was unfortunately never performed.) Should it turn out to be intact we may form the hypothesis that the drawing post-dates the painted portrait instead of preceding it — the Duke looks, in fact, a little older, and his posture more nearly approaches frontality — and was destined for a monu-

mental, memorial portrait commissioned after his murder in 1538. This hypothesis would permit us to accept the authenticity of the drawing even if the Uffizi portrait of the Duke should prove intact and would explain not only the squaring (normally indicative of a drawing made in preparation for a painting) but also the unusual, niche-like format normally reserved for altarpieces and wall paintings and heroizing, as it were, the person portrayed.

For Titian's other portraits exhibiting table clocks, see *V.*, i, Pl. 163; ii, color plate preceding Pl. 1 (our Fig. 89); ii, Pls. 27, 45, 92, 193 (text, p. 53f., our Fig. 106), and — a slightly doubtful case — 163B (text, p. 68).

2. See H. Michel, "*L'Horloge de Sapience* et l'histoire de l'horlogerie," *Physis, Rivista di Storia della Scienza*, ii, 1960, pp. 291ff.; further, E. P. Spencer, "L'Horloge de Sapience," cited above, p. 70, Note 33. For the much debated question when the mechanical clock was invented, see L. White, *Medieval Technology and Social Change*, Oxford, 1962, pp. 122ff.

3. See R. Tuve, "Notes on the Virtues and Vices, i," *Journal of the Warburg and Courtauld Institutes*, xxvi, 1963, pp. 264ff., particularly 277-282. Understandably Miss

On the other hand, however, the newfangled table clock continued to carry the implications of the earlier hourglass (which first appears in the illustrations of Petrarch's *Trionfo del Tempo*): the implications of Time and Death.[4] Time, "devourer of all things" (*tempus edax rerum*), and Death who accomplishes what Time relentlessly prepares, share their most distinctive attributes, the scythe and the hourglass; and table clocks produced in Germany, the center of their manufacture, tend to bear such uncomfortable inscriptions as "Una ex illis ultima" ("One of these hours will be the last".)[5]

The table clock in Titian's portraits, then, would seem to serve the double purpose of an *insigne virtutis* and a *memento mori*, replacing, in the latter respect, the death's head so popular in sixteenth-century portraiture. And its more melancholy significance, well known, no doubt, to both the painter and his patrons, is poignantly obvious where — in one of the pictures chosen by Charles V to accompany him to San Yuste but known to us only through a good copy (ascribed to Rubens) — the table clock is placed, right in the center of the foreground, between the Emperor and his dead wife (Fig. 106).[6] The inference is that, for Titian, the symbol of the table clock carried (in addition to its purely social significance) the double connotation of temperance and transience.

Titian's preoccupation with the destructive power of time manifests itself from the very inception of his career. It is revealed in a picture so early (c. 1505) that most modern scholars ascribe it to Giorgione: *The Old Woman ("La Vecchia")* in the Accademia at Venice (Fig. 107).[7]

Tuve did not extend her admirable investigation to tomb sculpture; nor does she refer to Henry Suso.

4. Cf. de Tervarent, *Attributs et symboles*, I, col. 220. In Guillaume de la Perrière's *Theatre des bons engins* (Paris, 1539), for example, the notion of time is consistently expressed by a table clock, winged (No. LXXI) or unwinged (No. LXVIII).

5. See Eduard Mörike's charming poem *Besuch in der Kartause*. For further references, cf. Panofsky, *Studies in Iconology*, pp. 79ff.

6. *V.*, II, p. 53f., Pl. 193. The double portrait (cf. Müller Hofstede, "Rubens and Titian," cited above, p. 8, Note 7) is mentioned in the list of paintings transported to San Yuste (*C.-C.*, II, p. 236) and in Titian's own letter of September 1, 1548, for which see below, pp. 184ff., *Excursus* 5.

7. See G. M. Richter, *Giorgio da Castelfranco, Called Giorgione*, Chicago, 1937, p. 240f., No. 79, Pl. 56. Independently, Michelangelo Muraro proposed to attribute the picture to Titian rather than to Giorgione in A. Grabar and M. Muraro, *Treasures of Venice*, Cleveland, Ohio, 1963, p. 168f. Chastel and Klein, *L'Age de l'Humanisme*, p. 330 and Color Plate xxiii, favor the attribution to Giorgione.

In spite of its most unsatisfactory condition, this painting is almost alarmingly impressive. And this very forcefulness, this inexorable veracity in the depiction of features once beautiful but now distorted and corroded (though hardened and vitalized rather than softened and weakened) by old age, endows it with a *terribiltà* which, in my and at least one other scholar's opinion, militates against its attribution to the gentle master of Castelfranco. Giorgione had all imaginable qualities of a great painter, enhanced by an exquisite taste which recoiled from evil and ugliness; but he lacked the power to terrify. There is nothing less terrifying than his "*Tempest.*" Titian's world, however, extended all the way from the idyllic to the tragic, from tenderness to brutality, from the seductive to the repulsive, from the sublime to the almost — though never quite — vulgar. "*La Vecchia,*" it seems to me, belongs to the same race as do the horrible egg woman in the *Presentation of the Virgin* (Fig. 42) and the equally horrible nurse in the Prado *Danaë* (Fig. 158).

In these two pictures a contrast is implied between the depravity and ugliness of the old women and the innocence and beauty of, respectively, the little Mary and the still virginal Danaë. In "*La Vecchia,*" however, the contrast between youth and old age is made explicit not only by the attitude of the old woman but also by an inscription. The old woman challenges the beholder with her glance; she addresses him with her half-opened mouth; she points at herself with her right hand; and the significance of this gesture is underscored by a scroll inscribed with the words COL TEMPO — "By Dint of Time." She thus presents herself as a living example of the destructive power of Time much as the *transis* on late mediaeval tombs, already mentioned, present themselves as nonliving examples of this power. Like these *transis*, she apostrophizes the observer with an admonition such as *Tales vos eritis fueram quandoque quod estis*, "Such you will be for I was what you are." In a sense "*La Vecchia*" is even more chilling than those decaying corpses: being alive, she represents not only a *memento mori* but also — or, rather, more so — a *memento senescere*.

A similar message seems to be conveyed, though in different language, by a somewhat later and less terrifying picture: the so-called *Young Woman Doing Her Hair*, probably executed between 1512 and 1515, in the Louvre (Fig. 108).[8]

8. *V.*, I, Pl. 59. For want of personal knowledge I must reserve judgment about a variant recently discovered in the Castle at Prague and listed as a work of Titian in

Ostensibly, this painting represents a young woman arranging (not properly combing, as may occasionally be read) her hair while her lover assists by holding two mirrors — one before, the other behind her. She looks into the square mirror which in turn reflects the image in the circular one so that she can examine the flowing tresses on the right side of her head, which have still to be taken up, while being able to see also the left part of her coiffure which has already been "done" and has to be matched.

No one knows whether we are faced with a simple genre picture, a double portrait or an allegory. It has been proposed to identify the two personages with Titian himself and an anonymous paramour; with Alfonso d'Este and his mistress, Laura Dianti (who possibly became his third wife); or with Federico Gonzaga and Isabella Boschetti. But none of these identifications is demonstrable or even plausible. The gentleman in the picture bears no resemblance to either Titian, Alfonso d'Este or Federico Gonzaga, and the date of the painting probably precedes the inception of Titian's relations with the Court of Ferrara (c. 1516) and certainly that of his relations with the Court of Mantua (1523). I am inclined to interpret the heroine of the painting as a kind of "*La Vecchia*" in reverse, addressing the beholder not with a "Such you will be for I was what you are" but with a

"You may well be what we are now; but soon
Both you and we will cease to love and live."

The man is steeped in so deep a shadow — a motif unparalleled in Titian's oeuvre, and probably significant in itself — that, in spite of his

an inventory of 1685, where it is described as "Ein Weibsbild, so sich entkleyden thuet": J. Neumann, *Obrazárna Pražského Hradu*, Prague, 1964, pp. 204 ff., No. 66; a French translation of the text, unillustrated, was published, under the title *La Galerie de Tableaux du Château de Prague*, by the Académie Tchécoslovaque des Sciences, Prague, 1963 (here pp. 282 ff., No. 66); a German translation entitled *Die Gemäldegalerie der Prager Burg* appeared in 1966 (here pp. 296–305, No. 66, with four ills.). Cf. T. Gottheiner, "Rediscovery of Old Masters at Prague Castle," *Burlington Magazine*, cvii, 1965, pp. 601 ff., Figs. 3, 4. Whatever the status of the Prague picture may be, it is hardly, as has been claimed, the "original" of the Louvre version. The latter, in addition to its convincing style and quality, can boast a most distinguished pedigree, belonging as it does to the "Mantuan pictures" in the collection of Charles I of England, whence it took the much-travelled route to the collections of Everhard Jabach and Louis XIV. And the argument that the Prague painting must be the original because it shows several *pentimenti* (not cogent in itself) is further weakened by the fact — ascertained by the Laboratoire du Musée du Louvre and kindly communicated to me by Professor Millard Meiss — that equally important *pentimenti* are present in the Louvre version.

presence, the woman seems to be alone with her thoughts; and the direction of these thoughts is revealed by the apparently unmotivated sadness of her glance. What we have before us is beauty looking at herself in a mirror and suddenly seeing there transience and death. We have only to read some of Shakespeare's sonnets, for example, Nos. 3 and 77, to find this idea expressed in words: "Look in thy glass and tell the face thou viewest..."; and "Thy glass will show thee how thy beauties wear." Queen Christina of Sweden had a mirror, designed by Bernini, where the glass is being unveiled by Time himself in order to "reveal... the decay of the viewer's beauty and youth."[9]

Small wonder that the mirror — that awe-inspiring device which could symbolize self-awareness as well as self-indulgence, and was credited with magic powers from times immemorial — was the standard attribute not only of Prudence and Truth but also of Vanity — in the sense of being inordinately pleased with oneself as well as in the more terrible sense of the Preacher's "Vanity of vanities; all is Vanity"; and it is not surprising that it came to be associated with death.[10]

That these more sinister implications of the mirror motif were very much alive in Titian's imagination at the time cannot be questioned. A technical investigation of the much-debated *Vanitas* in the Pinakothek at Munich (Fig. 109) has disclosed that the mirror, not as yet included in the underpainting, was added by Titian himself when the picture received its final form about 1515, even though the precious objects reflected in it — symbolizing, of course, the "treasures upon earth, where moth and rust doth corrupt" and spurned by a personification of Virtue — were not entered until the middle of the sixteenth century.[11] And the

9. R. Wittkower, *Gian Lorenzo Bernini*, 2nd. ed., London, 1966, p. 211f., Figs. 56, 57. My friend Carl Nordenfalk informs me that the design was actually executed on a large scale but unfortunately in so perishable a material (gilt clay) that only literary evidence survives. For another Bernini drawing (location unknown), in which Time holds what is probably a circular mirror, see H. Brauer and R. Wittkower, *Die Zeichnungen des Gianlorenzo Bernini*, Berlin, 1931, Pl. 113a (also reproduced in Panofsky, *Studies in Iconology*, Fig. 58a).

10. See G. F. Hartlaub, *Zauber des Spiegels*, Munich, 1951, *passim*; Guy de Tervarent, *Attributs et symboles*, II, col. 273. For a particularly impressive *Vanitas*, where the figure holds up a mirror reflecting the flame of an oil lamp with one hand while with the other she points at a death's head, see Gerard Honthorst's painting in the Galleria Corsini at Rome (illustrated in *Philosophy and History; Essays Presented to Ernst Cassirer*, Oxford, 1936, and New York, 1963, Fig. 4 facing p. 233).

11. *V.*, I, Pl. 58; cf. A. Neumeyer, *Der Blick aus dem Bilde*, Berlin, 1964, p. 57. For the technical examination of the Munich *Vanitas* and its interpretation, see E. Verheyen, "Tizians 'Eitelkeit des Irdischen'; Prudentia et Vanitas," *Pantheon*, XXIV, 1966, pp. 88ff. His interpretation of the reflec-

fact that the mirror held up by Giovanni Bellini's *"Vana Gloria"* transforms the beholder's reflection into a mask of horror speaks for itself.[12]

In Titian's *Young Woman Doing Her Hair* the idea of transience and death lends an allegorical significance to what looks like a straightforward, erotic genre piece. The opposite is true of an overtly allegorical composition belonging to the same period and preserved in several replicas (the original, formerly in Bridgewater House is now on deposit in the National Gallery at Edinburgh): *The Three Ages of Man* (Fig. 110).[13] Where the woman in the Paris picture evokes a vision of love overshadowed by the threat of time, *The Three Ages of Man* evokes a vision of the threat of time seen through the medium of love.

There were many different ways of periodizing the life of man.[14] Perhaps the most popular division was that into four periods — infancy, adolescence, maturity, and old age — neatly corresponding to the four times of day, the four seasons of the year, the four humors, the four elements, the four directions of space, and other tetrads. Isidore of Seville (*Etymologiae*, xi, 2) divided the human life into six (unequal) sections: infancy, childhood, adolescence, youth, senescence, and old age. Others proposed a division into seven decades, a system widely accepted because it permitted the coördination of every age with one of the planets; it is still reflected in the famous speech of the melancholy Jaques in Shakespeare's *As You Like It*, ii, 7, as well as in Schopenhauer's *Vom Unter-*

tion in the mirror may be supported by the fact that the representation of Virtue in the guise of an elderly woman holding a distaff — the symbol of industriousness since Adam and Eve — was standard in Northern renderings of the Choice of Hercules; see, e.g., E. Panofsky, *Hercules am Scheidewege und andere antike Bildstoffe in der neueren Kunst* (Studien der Bibliothek Warburg, xviii), Leipzig and Berlin, 1930, Figs. 30, 32, 34, 36, 38, 42, 46.

12. Venice, Galleria dell'Accademia. For the convincing interpretation of this Allegory (Hartlaub, *Zauber des Spiegels*, Fig. 172, with many further references), see Wind, *Bellini's "Feast of the Gods"* (cf. above, p. 4, Note 3), p. 48f., Note 14, Fig. 53. I failed, however, to find a combination of the mirror with Nemesis in Alciati's Emblem xlvi (ILLICITVM NON SPERANDVM) or in either of his two other Emblems involving that goddess.

13. *V.*, i, Pl. 48. The authenticity of the composition is attested by Vasari (vii, p. 435) and I do not see any reason for doubting that the Bridgewater-Edinburgh picture is the original executed for the father-in-law of a certain Giovanni da Castel Bolognese, in whose house at Faenza it was inspected by Vasari. About a hundred years later it belonged to Queen Christina of Sweden.

14. See F. Boll, "Die Lebensalter," *Neue Jahrbücher für das klassische Altertum*, xvi (xxxi), 1913, pp. 89ff. (also published separately).

schied der Lebensalter. Some, reversing the numbers, preferred to divide human life into ten periods of seven years each (instead of seven periods of ten years each); and some even increased the number of "ages" to twelve.

The simplest and oldest scheme — as old as the Sphinx who takes it for granted in one of the riddles she proposes to Oedipus — is, however, a division of human life into three phases, only one of them perfect, which can be equated with the Three Forms of Time: infancy which, like the future, abounds in potentialities not as yet realized; vigorous adulthood (comprising both youth and maturity) which, like the present, combines potentiality and actuality into a state of climactic perfection; and old age which, like the past, has nothing left but the remembrance of *le temps perdu.*

This system — in a sense, the most saddening of all — was accepted by Titian throughout his life; but while still young himself, he conceived of the Three Ages of Man in terms of love. The scene in the Edinburgh picture is dominated by a couple so conspicuous in color as well as sheer size that nothing else caught the attention of Vasari: "In a beautiful landscape," he writes, "there is a shepherd to whom a peasant girl offers some flutes so that he might play them."

This description is specific enough to permit the identification of the picture; it is, however, not quite accurate in one small but significant point. A single player can play a double flute (*diaulos*) but not, so far as I know, two separate flutes at the same time. What the girl does is not so much to offer her partner two flutes "so that he might play them" as to offer him one flute so that he might play a duet with herself—a duet, of course, of love. Her gestures may even suggest an exchange: the flute held in her left hand, the smaller of the two, is intended for her; whereas the other, held in her right with its mouthpiece close to her own lips, is intended for him.

This couple, needless to say, represents the second, "perfect" stage of human life. The third is represented by an old man, relegated to the background, who, having outlived all those who had been dear to him, is lost in meditation about death; but what is important — and, so far as I know, unique — is that the visible object of this meditation is not, as was the usual thing (see, for example, Ripa's *Meditatione della Morte* or, for that matter, Shakespeare's *Hamlet*), one death's head but two: the old man reflects not so much about death in general as about the death of two defunct lovers.

Even infancy is represented by a couple of lovers: two children asleep in each other's arms who represent a stage of life when love is neither actual (as with the couple on the left) nor a thing of the past (as with the sad old man in the background) but present, as it were, *in potentia*. What is somewhat difficult to explain is the action of the figure associated with the sleeping children. Winged, which the children are not, this *amorino* — or, if you prefer, *angelino* — casts an affectionate glance upon the children, as though standing guard over them, while firmly planting his hands against the tilted trunk of a leafless tree, apparently already severed from its root. According to a tradition as old as the Bible the dry tree stands for Death while the green tree stands for Life.[15] A group of green trees is therefore appropriately associated with the young couple on the left; and the winged little spirit — a combination of Cupid and guardian angel — tries to prevent the dead tree from falling upon the sleeping children. He keeps or pushes it away to protect two budding lives from all the dangers that might prevent them from running full cycle.

The Three Ages of Man, if I may be permitted to digress a little, seems to have produced an immediate, or nearly immediate, effect on Titian's *Bacchanal of the Andrians*, executed in 1518-19 and briefly touched upon in the Introduction (Fig. 114).

This famous painting, copied by Rubens and Poussin and in several respects miraculously anticipating Watteau, belongs to a series of pictures

15. See G. B. Ladner, "Vegetation Symbolism and the Concept of the Renaissance," *De Artibus Opuscula* XL; *Essays in Honor of Erwin Panofsky*, New York, 1961, pp. 303 ff., with ample references, to which may be added F. Hartt, "*Lignum Vitae in Medio Paradisi;* The Stanza d'Eliodoro and the Sistine Ceiling," *Art Bulletin*, XXXII, 1950, pp. 115 ff., 181 ff. I am most grateful to Professor Giles Robertson for calling my attention to the fact that the final version of the picture now at Edinburgh differs from an earlier composition (inferable from an X-ray, an etching by Valentin Lefèbre of ca. 1680 and a description by Joachim Sandrart, who seems to have inspected the work in 1628) in several respects. The old man in the background, surprisingly absent from Lefèbre's print, while already holding two skulls in his hands, had originally two or three more skulls at his feet (Sandrart describes the locality as a "church yard"); the group of children was changed so as to eliminate a pair of wings the original owner of which is now difficult to determine; and the third flute — in addition to the two held by the girl in the left-hand foreground — is more clearly visible in the right hand of her lover. To what extent these changes would force us to revise the iconographic interpretation of the picture can be determined only when the visual data will have been clarified. At any rate, their presence tends to corroborate the authenticity of the painting now at Edinburgh.

which adorned the Studio (also referred to as *stanzino* or *camerino d'alabastro*) of Alfonso d'Este in the Castle at Ferrara; they were illegally removed from this Castle by Pietro Cardinal Aldobrandini, the Papal Legate to Ferrara, when his uncle, Pope Clement VIII, annexed it to the Pontifical State in 1598.

The decoration of this Studio seems to have developed around the *Feast of the Gods* (Fig. 2), completed with Titian's help in 1514, and later revised by him to match his independent contributions to the ensemble.[16] In devising the program in and after 1514, the Duke does not seem to have thought of Titian at all. From his court painter, Dosso Dossi, he ordered a picture rather similar to Bellini's and traditionally designated as "*The Feast of Cybele*"; Vasari (VI, p. 474) calls it only a *Baccanaria di uomini*, a "*Bacchanal of Men*."[17] He tried to enlist the coöperation of Raphael from whom he wanted a *Triumph of Bacchus* and, possibly, a *Triumph of Ariadne*. And he gave one commission to, of all people, Fra Bartolommeo. As late as February 19, 1517, Titian's only obligation to the Duke was an enigmatical painting, apparently unrelated to the Studio and possibly never completed, which is laconically referred to as "The Bath" (*Il Bagno*).[18]

Raphael did nothing, however, and Fra Bartolommeo died in 1517, leaving behind only a drawing of the subject entrusted to him (Fig. 111):[19]

16. See above, p. 4, Note 3.

17. London, National Gallery. See C. Gould, *National Gallery Catalogues; The Sixteenth-Century Italian Schools (excluding the Venetian)*, London, 1962, p. 53, and idem, *The Sixteenth-Century Venetian School*, pp. 102 ff., with copious references and excellent summaries of the problems posed by the Studio of Alfonso d'Este. To be added: F. Saxl, "A Humanist Dreamland," *Lectures*, London, 1957, pp. 215 ff.; H. Bardon, *Le Festin des Dieux* (cited above, p. 4, Note 3), p. 3.

18. In a letter of February 19, 1517, Titian assures Alfonso that he had not forgotten, but was daily working on, "the *Bath* which your Illustrious Lordship ordered from me": *C.-C.*, I, p. 179; Italian text in Campori, "Tiziano e gli Estensi," (cited above, p. 21, Note 27), p. 585. It has been suggested that the word *Bagno* might be a misspelling of *Bagho—Baccho* (Wind, *Bellini's "Feast of the Gods*," p. 58), in which case Titian's letter would refer to the *Bacchus and Ariadne* now in the National Gallery at London, our Fig. 115. This picture, however, is the last of the Ferrara cycle, completed as late as 1523. If the *Bagno* mentioned in the letter of February 19, 1517, were indeed a misspelled *Baccho*, the *Bacchus and Ariadne* would have been planned even before the "*Feast of Venus*" and the *Bacchanal of the Andrians* were commissioned. Quite possibly the *Bagno* ordered by Alfonso some time before February 19, 1517 is identical with a picture referred to as "*Le Donne del Bagno*," promised to Federico Gonzaga and mentioned by the latter's Venetian envoy, Giacomo Malatesta, in a letter of February 5, 1530 (*C.-C.*, I, p. 446). Even at this late date this picture was "solamente designato," and may have been offered to Alfonso's nephew when Alfonso himself no longer wanted it.

19. Identified by Wind, ibidem, pp. 58 ff., Fig. 65.

a charming scene, described by Philostratus, where many Cupids are seen disporting themselves before the sacred grotto of Venus and doing homage either to herself or to her image (*Erotes*; *Imagines*, I, 6).[20] Thus Alfonso turned to Titian, who in a letter of April 1, 1518, enthusiastically responded to the Duke's suggestion of what he calls a "most ingenious subject which could not be more gratifying to my heart" — a subject almost certainly identical with that originally assigned to Fra Bartolommeo.[21]

The first result of this commission was Titian's so-called "*Feast of Venus*" in the Prado, finished as early as October 1519 (Fig. 113). It reveals Titian's acquaintance with Fra Bartolommeo's drawing in that Philostratus' casual reference to a "silver mirror" offered to Venus as an *ex-voto* is felicitously elaborated into the image of a maiden actually offering it with such abandon that the mirror has been mistaken for a tambourine;[22] but Titian's painting is novel and inimitable in every other respect. We need only compare it with a drawing by Giulio Romano, produced more than ten years later (Fig. 112),[23] to perceive the difference between an artist who interprets Philostratus' text in terms of isolated figures and groups carefully disposed within a perspective space, and one who fuses these figures and groups into a surging sea of diminutive humanity, intending to express the generative force as such rather than its individual manifestations.

Alfonso's suggestions were not limited, however, to Philostratus' *Erotes*. Simultaneously he commissioned Titian with two further pictures for his

20. Philostratus' text is not quite clear in this respect, saying only that the beholder "senses" (νόει) the goddess while he actually sees the *ex-votos* dedicated to her: gilded sandals, golden pins and a silver mirror, all suspended from the walls of her sacred grotto. Artists, of course, tended to conceive of the scene as taking place before a statue of Venus, if not before the goddess herself; cf. R. W. Wallace, "*Venus at the Fountain* and the *Judgment of Paris*," *Gazette des Beaux-Arts*, 6th series, LV, 1960, pp. 11ff.

21. *C.-C.*, I, p. 181. For the Italian text, see Campori, "Tiziano e gli Estensi," p. 586f., in part reprinted in E. Tietze-Jonrat, "Titian's Allegory of 'Religion,'" *Cournal of the Warburg and Courtauld Institutes*, XIV, 1951, pp. 127ff. I cannot imagine, however, that Titian would have

welcomed the Duke's suggestion with such genuine enthusiasm had this suggestion involved the rather ponderous "*Allegory of Religion*" now in the Prado (our Fig. 193), for which see pp. 186ff., *Excursus 6*.

22. *V.*, I, Pls. 78, 79. For Titian's use of Fra Bartolommeo's drawing, see Wind, *Bellinis "Feast of the Gods*," p. 58f. For the antecedents of his non-classical Venus, holding a seashell in her hand instead of standing upon it, see Panofsky, *Renaissance and Renascences*, pp. 87, Note 2, and 205, Note 3. The erroneous designation of the silver mirror in Titian's painting as a tambourine is found in Brendel's otherwise excellent "Borrowings from Ancient Art in Titian," p. 117.

23. Chatsworth, Duke of Devonshire; see F. Hartt, *Giulio Romano*, New Haven, 1958, p. 159, Fig. 354.

Studio: the *Bacchanal of the Andrians*, based again on Philostratus, completed at the same time as the *"Feast of Venus"* and now reunited with it in the Prado (Fig. 114);[24] and the *Bacchus and Ariadne*, inspired by Ovid and Catullus, now in the National Gallery at London (Fig. 115).[25] Both these compositions have already come up in our discussions here and there, and to the *Bacchus and Ariadne* — for which Alfonso d'Este, much to his disgust, had to wait until January 19, 1523 — we shall revert when we discuss the subject "Titian and Ovid."

The *Bacchanal of the Andrians*, however, must be considered now, because it seems to echo, however discreetly, the theme of *The Three Ages of Man*.

24. *V.*, I, Pls. 80-82; cf. the literature referred to in this Chapter, Notes 17 and 25.
25. *V.*, I, Pls. 111-113; see also p. 97 Note 18 and pp. 141 ff. Wind's proposal (*Bellini's "Feast of the Gods,"* p. 60f.) to interpret the three paintings as *exempla* of the three stages of love described in Pietro Bembo's *Asolani* ("Chaotic Love" represented by the *"Feast of Venus,"* "Harmonious Love" by the *Bacchanal of the Andrians*, "Transcendent or Divine Love" by the *Bacchus and Ariadne*) is very attractive — except for the fact that the *Bacchanal of the Andrians* is more "harmonious" than the *"Feast of Venus"* only in that all the participants are (with one exception) adults; more importantly, it does not seem justifiable to single out a close-knit trilogy, so to speak, from a program which, at the time of Titian's entry upon the scene, included at least two more pictures, i.e., Bellini's *Feast of the Gods*, and Dosso Dossi's *"Feast of Cybele."*

According to the record of the excellent Annibale Roncagli, made when all the pictures were removed from the Studio in 1598, the three Titians were not even on the same wall. As he entered, the visitor faced Titian's *"Feast of Venus"* and Dosso Dossi's *"Feast of Cybele"*; whereas on the wall to his left he saw Titian's *Bacchus and Ariadne*, followed by the *Bacchanal of the Andrians* and Bellini's *Feast of the Gods*. Whether any pictures were planned or even executed for the remaining walls we do not know; in the end, these walls may have been occupied by bookshelves or covered with tapestries. For the small, oblong *"Stories of Aeneas"* by Dosso Dossi, which may have served as a kind of frieze and were not appropriated by Cardinal Aldobrandini (two of them now preserved, respectively, in the Barber Institute of Birmingham and in the National Gallery of Canada at Ottawa), see A. Mezzetti, "Le 'Storie di Enea' del Dosso nel 'Camerino d'Alabastro' di Alfonso I d'Este," *Paragone*, new series, IX, 1965, No. 189, pp. 71 ff. E. Battisti ("Disegni inediti di Tiziano e lo studio d'Alfonso d'Este," *Commentari*, V, 1954, pp. 191 ff.; expanded version, entitled "Mitologie per Alfonso d'Este" in the same author's *Rinascimento e Barocco, Saggi*, Turin, 1960, pp. 112 ff.) believes that what he calls the third phase of the program — already incorporating the *"Feast of Venus"* but not as yet the *Bacchanal of the Andrians* and the *Bacchus and Ariadne* — was meant to include, instead, a populous vintage scene, for which a squared drawing exists in Madrid. But the authenticity of this drawing is questionable; its markedly oblong format (about 1 : 1.5) does not agree with that of the other paintings, which is more nearly square; and its subject — pure genre — would not fit in with the strictly mythological character of the program in its entirety.

As described in Philostratus' *Andrians* (*Imagines*, ɪ, 25), the Island of Andros is so thoroughly dominated by Bacchus that its very river consists of wine rather than water and thyrsi grow on its banks instead of reeds. The inhabitants — including a "multitude of infants" — are always in a state of Bacchic inebriation and ecstasy and like to entertain their wives and children with songs in praise of the "divine river." Bacchus himself honors the Island with a visit, arriving by ship in the company of Tritons, "Laughter" and "Revelry."

Titian treated this text even more freely than the same author's *Erotes* in the "*Feast of Venus*." Bacchus and his attendants are absent — for the very good reason that his theophanic appearance had to be reserved for the *Bacchus and Ariadne*. And the "multitude of infants" is reduced to one — for the equally good reason that such a multitude had been preëmpted by the "*Feast of Venus*." As a result, the specific scene depicted by Philostratus has been converted into a Bacchanal *tout court* — so much so that a talented German engraver, Melchior Küsel, could transform it, by an almost imperceptible change, into a *Worship of the Golden Calf* (*Icones Biblicae Veteris et Novi Testamenti*, Nuremberg, 1679, p. 56). It has, however, been enriched and elaborated in other ways.

Philostratus' reference to the Andrians' fondness for singing songs in praise of wine (which is, we remember, what the "divine river" of Andros consists of) was concretized into the sheet of music right in the center of the foreground. Its French text ("Chi boyt et ne reboyt/Il ne scet que boyre soit," "He who drinks and does not drink again/Does not know what drinking is") is reminiscent of the still current French proverb "Qui a bu boira" ("He who has drunk will drink again"), frequently quoted by Balzac and Maupassant as well as Simenon; and its very modern score — a canon — can be ascribed to none other than Adriaan Willaert, the great composer from Bruges who had appeared in Italy in 1516. Active at Ferrara from c. 1520 at the latest, he became Master of the Chapel at St. Mark's in 1527 and was certainly acquainted with Titian; he may be said to have done for modulation in music what Titian himself was doing for coloration in painting.[26]

26. The proverb "Qui a bu boira" is quoted, e.g., by Balzac in *La Cousine Bette* and elsewhere; in Maupassant's *La Rempailleuse*; and in Simenon's *Antoine et Julie*. For the canon on the music sheet, see G. P. Smith, "The Canon in Titian's Bacchanal," *Renaissance News*, vɪ, 1953, pp. 52 ff. (unconvincingly contested by T. Dart, ibidem, vɪɪ, 1954, p. 17). Adriaan Willaert, born at Bruges about 1480, is known to have been in Ferrara in 1524, but he may have arrived there at a considerably earlier date. He was Master of the Chapel at St. Mark's in Venice from

The variety of ways in which the figures in Titian's *Bacchanal of the Andrians* react to wine reminds us of a famous "Aristotelian" text (*Problemata*, **xxx**, 1) where these variations — from loquaciousness to silent brooding, from recklessness to complete indolence, from anger to lachrymosity — are carefully described and analyzed according to the quantity of wine consumed as well as to the character of those who consume it, and where special emphasis is placed upon the aphrodisiac effect of wine: "Venus and Bacchus," it says at one point, "are rightly said to belong together." This text — quoted or cited by innumerable Renaissance writers as the *locus classicus* for the belief that the melancholic humor, its psychological effects comparable to that of wine, is the precondition of genius[27] — also makes frequent reference to the distinction between childhood (παῖδες), youth (νεότης) and old age (γῆρας). And this confirms my belief that Titian's *Bacchanal of the Andrians*, too, reflects his preoccupation with the Three Ages of Man and that this notion served, as it were, as an ordering principle for his painting.

All the participants are young adults able to enjoy a life enhanced by the gift of Bacchus and the concomitant allurements of Venus — except for two cases: the infant in the foreground, the sole remnant of

1527 and died in 1562. As I learn from my friend, Professor E. E. Lowinsky (who plans to revert to the subject within a wider context), the canon in Titian's painting is revolutionary in that it moves from C to D, from D to E, from E to F♯, from F♯ to G♯, from G♯ to A♯, and then back to C. This, according to Professor Lowinsky, means that the canon applies the theory of Aristoxenus (discarded by the Middle Ages on the strength of objections raised by Boëthius but revived and defended in the Renaissance), according to which the octave can be divided into six whole tones or twelve semitones. For a borrowing from Michelangelo's *Battle of Cascina* in Titian's *Bacchanal of the Andrians* (the recumbent soldier on the extreme right of the Holkham Hall grisaille repeated in the youth behind the young woman raising a bowl), see *T.*, p. 17. The influence of Beccafumi is seen in the magnificent figure pouring wine from a caraffe; cf. a composition (our Fig.

116) which exists in several drawings and an engraving and likewise, but less closely, derives from Michelangelo's cartoon (F. Knapp, *Nachtrag zu K. Frey, Die Handzeichnungen Michelagniolos Buonarroti*, Berlin, 1925, Pl. 337, and E. Panofsky, "Bemerkungen zu der Neuherausgabe der Haarlemer Michelangelo-Zeichnungen durch Fr. Knapp," *Repertorium für Kunstwissenschaft*, XLVIII, 1927, pp. 25 ff.).

27. See now R. Klibansky, E. Panofsky and F. Saxl, *Saturn and Melancholy; Studies in the History of Natural Philosophy, Religion and Art*, London and New York, 1964, pp. 15-42 (text and translation, pp. 18-29) and *passim*. The various effects of wine are described right at the beginning in order to clarify the distinction between such substances as have no influence on character and conduct (e.g., milk or honey) and those which do, i.e. wine and the "black bile" (μέλαινα χολή) from which the word *melancholia* is derived.

Philostratus' "multitude," who can do nothing but pass water; and the lonely old man in the background — probably not "Silenus" — who has withdrawn from the group of revelers to seek refuge on a far-off hill. He sleeps the sleep of lethargy and impotence, thus forming a sharp and saddening contrast to the beautiful maenad in the right-hand foreground.[28] Close to the naughty infant, and indeed akin to him in that she has temporarily renounced the privilege of adult self-awareness, this maenad also sleeps; but her sleep, due to overparticipation rather than non-participation, is that of blissful exhaustion.

Near the end of his career — or, rather, because he believed this end to be imminent — Titian remembered, and paid a last tribute to, the doctrine of the Three Ages of Man. But while the youthful master had connected these three phases of human existence with the varieties of erotic experience, the aged master interpreted them as symbols of a philosophical concept. The work I have in mind is a painting recently donated to the National Gallery in London which, owing to its apparent obscurity, is not in favor with some contemporary connoisseurs but captured the imagination of a contemporary painter interested in "the content of shape" as well as in "the shape of content": *The Allegory of Prudence* produced, it would seem, about 1565 or even a little later (Fig. 117).[29]

28. There is, I think, no very good reason to connect this maenad with Ariadne (Wind, *Bellini's "Feast of the Gods"*, p. 60). That Catullus likens the abandoned Ariadne to a Bacchante (*Carmina*, LXIV, 60-71) does not, *ipso facto*, qualify her as an Andrian, unless one accepts the interpretation — so far as I know, undocumented — of the name "ARIADNE" (nominative singular) as an anagram of ANDRIAE (possessive or dative singular, or nominative plural).

29. *V.*, II, Pl. 120. The picture, formerly owned by Mr. Francis Howard, was sold at Christie's on November 25, 1955 and disappeared from public view until it fortunately entered the National Gallery in London (cf. *New York Times*, June 17, 1966, p. 22). For its iconography (first discussed by my late friend Fritz Saxl and myself in *Burlington Magazine*, XLIX, 1926, pp. 177ff.), see E. Panofsky, "Titian's *Allegory of Prudence*; A Postscript," *Meaning in the Visual Arts*, New York, 1955, pp. 146ff. (Italian translation, *Il Significato nelle arti visive*, Turin, 1962, pp. 147ff.), where the pertinent documentation may be found. Cf. also E. Wind, *Pagan Mysteries in the Renaissance*, New Haven, 1958, p. 45, Note 1. To the examples of three-headed Prudence thus far adduced we may add a miniature in Nicole Oresme's translation of Aristotle's *Ethics*, The Hague, Museum Meermanno-Westreenianum, MS. 10 D 1, fol. 110, where the three heads of *Prudence* are represented as death's heads (Klibansky, Panofsky and Saxl, *Saturn and Melancholy*, p. 310, Fig. 101). The contemporary painter referred to in the text is, of course, Ben Shahn: *The Shape of Content*, Cam-

The only "emblematic" picture ever produced by Titian, it illustrates — or, rather, visually paraphrases — a maxim directly stated in an inscription. This inscription reads EX PRAETERITO / PRAESENS PRVDENTER AGIT / NI FVTVRV[M?] ACTIONEM DETVRPET ("[Instructed] by the past, the present acts prudently lest the future spoil [its] action"). And the words are so distributed that they are related to a double triad of heads analogous in position as well as in treatment. The word PRAETERITO belongs to the face of an old man seen in full profile, turned to the left and surmounting a wolf's head. The word PRAESENS belongs to the face of a man in vigorous middle age seen in full front view and surmounting a lion's head. And the word FVTVRV[M] belongs to the face of a beardless youth seen in pure profile, turned to the right and surmounting a dog's head. The phrase PRAESENS PRVDENTER AGIT, finally, constitutes, as it were, the keystone of the whole composition.

The picture, then, glorifies Prudence as a wise employer of the Three Forms of Time: the present learns from the past and acts with due regard to the future. And these Three Forms of Time appear equated with the Three Ages of Man.

In both these respects Titian did not depart from a well-established tradition — except that the magic of his brush imparted a semblance of palpable reality to the two frontal heads in the center (that of the man in the prime of life and that of the lion) while dematerializing, so to speak, the two profile faces on either side (those of the old man and the wolf on the left, those of the youth and the dog on the right): Titian gave visible expression to the contrast between that which is and that which either has been or has not as yet come into being.

The idea that Prudence applies past experience to the present with due consideration of the future is a commonplace classical notion traditionally imputed to none other than Plato. It survived throughout the Middle Ages and the Renaissance, in literature as well as in art. Prudence, one of the Cardinal Virtues in Christian theology, could be portrayed wielding

bridge, Mass., 1957, p. 116; cf. the advertisement for Thornton Wilder's *Plays for Bleecker Street* in the *New York Times*, December 17, 1961. Mrs. J. Hill's proposal to identify (on the basis of imagined physiognomical similarities) the middle-aged as well as the youthful face in Titian's picture with Ippolito Cardinal Medici (J. Hill [née Cotton], "An Identification of Titian's 'Allegory of Prudence' and Some Medici-Stuart Affinities," *Apollo*, LXIII, 1956, p. 40f.) seems utterly fantastic to me, all the more so as the Cardinal died as early as 1535 and as no attempt is made to explain the presence of the old face and the animals' heads, or to account for the inscription.

three mirrors suitably inscribed. She could be equipped with a brazier from which burst forth three flames; she could be impersonated by a cleric handling three books also suitably inscribed; and she could be represented, in analogy with an unorthodox Trinity type and in anti-cipation of Titian, as a three-headed human being having an aged and a youthful face, both turned to profile and symbolizing, respectively, the past and the future, while a middle-aged face, seen in front view, would symbolize the present.[30] In the niello pavement of Siena Cathedral (fourteenth century) this triple-headed Prudence (Fig. 118) is a woman (as was natural inasmuch as the word *prudentia* and its vernacular deri-vatives are feminine), and the supremacy of the present is stressed not only by the size of the head in the center but also by the fact that it is crowned.

But in the Italian Renaissance, even before Titian, this three-headed Prudence could reassume the masculine sex, as in a relief from the School of Antonio Rossellino, explicitly inscribed PRVDENZA, in the Victoria and Albert Museum (Fig. 119). And in a drawing by Baccio Bandinelli, now in the Metropolitan Museum (Fig. 120), the central head even seems to be a self-portrait; whereas the head standing for the future belongs to a handsome but inexperienced youth, and that personifying the past suggests a Roman emperor as well as an ideal type frequently found in Leonardo's drawings and, according to some, reflecting Leonardo's own features.[31] Bandinelli, in his proverbial arrogance, thus seems to declare his superiority over his successors as well as his forerunners, including even the masters of ancient Greece and Rome, and claiming thereby the place universally allotted to his great rival, Michelangelo.[32]

30. French miniature formerly in the R. F. Forrer Collection, illustrated in Panofsky, *Studies in Iconology*, Fig. 50; for a specimen as early as the middle of the twelfth century, see a niello pavement in Hildes-heim Cathedral. Here the bust of three-headed Time appears in a central roundel between six others, exhibiting, respectively, Life, Death and the Four Elements (A. Bertram, *Geschichte des Bisthums Hildesheim*, I, Hildesheim, 1899, p. 172, Fig. 57).

31. Bandinelli's drawing, now in the Metropolitan Museum of Art, New York, was brought to my attention by its former owner, Mr. J. Springell, who also provided me with a photograph; it was published by Bean and Stampfle, eds., *Drawings from New York Collections*, I (referred to above, p. 65, Note 20), p. 52, No. 75. For the view that Leonardo, before wearing the beard so well known to us from the Turin self-portrait, looked more like the "ideal type" found in so many of his art-theoretical and anatomical drawings (which in turn somewhat resemble the profile head turned to the right in Bandinelli's drawing), see R. Herrlinger, "Ein neues Selbstbildnis Leonardos?," *Zeitschrift für Kunstwissenschaft*, VII, 1953, pp. 47 ff.

32. Vasari, *Proëmio* to the Third Part of the *Vite* (IV, p. 13). In the *Life of Bandinelli* (VI, p. 194f.) Vasari characterizes him as a

The upper or anthropomorphic zone of Titian's *Allegory of Prudence*, then, stands firmly within a long and purely Western tradition. The three animal's heads beneath the triad of human faces, however, have a different and rather complicated history.

In Hellenistic Egypt there was worshipped a god named Serapis. The cult image in his temple — a work of Bryaxis of Mausoleum fame, which is known to us through coins — showed him enthroned with a three-headed monster at his feet: a quadruped encircled by a serpent and bearing on its shoulders the heads of a wolf, a lion and a dog (Fig. 121). What this amiable monster — apparently enjoying a popularity of its own since it was reproduced in small-scale statuettes quite by itself, apparently for the benefit of pious pilgrims (Fig. 122) — really signified, nobody seems to know. Perhaps it was no more than an Egyptified Cerberus, two of whose original dog's heads had been replaced by those of animal-headed divinities such as jackal-headed Anubis and lion-headed Sekhmet, in order to stress Serapis' supremacy.[33] Pseudo-Callisthenes' *Romance of Alexander*, probably of the fourth century A.D., speaks only of a "polymorphous animal the essence of which no one can explain."

Macrobius, however, that prodigious polymath of the early fifth century A.D., knew exactly what the companion of Serapis symbolized. He attempted to prove that Serapis, like all other major divinities, was only a special manifestation of the sun god; and since the movement of the sun produces and determines time, he asserted that the monster represents Time, the serpent denoting Time in general and the three animal's heads the Three Forms of Time: the lion's head, he says, stands for "the present, whose position between past and future is strong and fervent; the wolf's head, for the past, because the memory of things belonging to the past is devoured and carried away. The image of the dog, trying to please, denotes the future of which hope always paints a pleasant picture."

This zoömorphic image of Time — unassociated as yet with the idea of Prudence — was buried in the Macrobius manuscripts for more than

major master and an excellent draftsman but adds that his virtues might be more keenly appreciated after his death than in his lifetime: he had made himself so objectionable by his discourteous manner, his litigiousness and his irrepressible habit of minimizing the merits of other artists that the hostility to his person prevented the just evaluation of his artistic achievement.

33. Cf. F. Cumont, *Textes et monuments figurés relatifs aux mystères de Mithra*, Brussels, 1896-1899, I, pp. 74 ff.; II, p. 53.

900 years. It was resurrected by that great resuscitator, Petrarch, who, however, associated it not with the outlandish sun god, Serapis, but with the familiar Graeco-Roman sun god, Apollo. Thus the Macrobian monster penetrated that interesting class of late mediaeval literature which is concerned with, or influenced by, mythography. In fifteenth-century book illumination we find countless Apollos connected with, and often enthroned upon, a three-headed animal composed of lion, wolf and dog (Fig. 123). But these fifteenth-century representations were based only on texts, and not on classical images; and these texts were somewhat ambiguous in that they say only that the three heads were "conjoined in one body having one single serpent's tail" ("quae... in unum tantum corpus cohibebant, unam solam caudam serpentis haben-tia")." Their illustrations thus show a triple-headed reptile rather than a triple-headed quadruped. It took the new learning of the sixteenth century, attempting to reinterpret the written sources in the light of visible and tangible monuments, to produce Jan Collaert's *Apollo* engraving after Giovanni Stradano (1523-1605) where the Macrobian monster is restored to its authentic, Cerberus-like form (Fig. 124).

Simultaneously, however, the almost obsessive interest in Egyptian — or, rather, supposedly Egyptian — hieroglyphs, caused by the discovery of Horapollon's *Hieroglyphica* in 1419 and intensified by the concomitant rise of emblematics, led to a new and unexpected development. The association of the Macrobian monster with both Serapis and Apollo came to be loosened, and its three heads came to be separated from their body, whether that of a reptile or that of a quadruped, so that only a kind of triple animal portrait *en buste* remained.

This zoömorphic *signum triceps* or *tricipitium*, as it was called, made its first appearance in that somewhat turbid but abundant mainspring of the erudite and often recondite current in Cinquecento art and letters, the *Hypnerotomachia Polyphili* of 1499 (Fig. 125). And it soon usurped the function originally exercised by the anthropomorphic triad handed down from the Middle Ages: it could be used as an independent and, because of its Egyptian origin, more fashionable and sophisticated hieroglyph or symbol not only of Time but also of Prudence.

In the *summa* of High Renaissance emblematics, Pierio Valeriano's *Hieroglyphica* (first published in 1556), the *tricipitium* therefore occurs twice: once as an attribute of the sun god Apollo, who here, Egyptian fashion, wears the three animal's heads on his own shoulders; and once as an independent hieroglyph or symbol of Prudence. Ripa personifies

"Wise Counsel" (*Consiglio*) by a dignified old man, standing on a bear's head and a dolphin, and wearing on his neck a heart suspended on a chain. In his right hand he holds a book on which an owl is perched; and in his left, the *tricipitium* (Fig. 126): Wise Counsel conquers haste (the dolphin) and anger (the bear); its decisions must be approved by the heart as well as by the mind (the heart suspended from a chain); it must be founded on industrious nocturnal study (the book and the owl); and it must be directed by Prudence. How the dry tree of this complex allegory could blossom forth at the hands of a gifted artist is shown by Artus Quellinus' enchanting frieze, appropriately adorning the Council Chamber of the Town Hall (now Royal Palace) at Amsterdam. Here all the attributes of Ripa's *Consiglio* come to life as little genre scenes: the dolphin and the bear are being curbed by putti (the dolphin by one, the bear by two) while a third putto proudly displays the heart on its chain (Fig. 127); the owl is perched on its book in self-sufficient isolation; and the *tricipitium*, standing for Prudence, is being interrogated by the eternal asker of questions (whom the Renaissance could thus interpret as a personification of Wisdom as well as Ignorance), the Sphinx.

Nowhere, however, except in Titian's painting, have I found the Egyptian, zoömorphic *tricipitium* combined with the three human heads of the Western tradition. And in uniting these two symbols of Time and Prudence Titian not only increased their psychological impact by forcing the beholder to compare the characteristics of old age, the prime of life and youth with the characteristics of the wolf, the lion and the dog; he also charged the whole composition with an intensely personal significance.

There has been considerable speculation about the practical purpose of Titian's *Allegory of Prudence*, and it has been considered to be a so-called *timpano*: a cover serving to protect another, more elaborate picture. But the *Allegory of Prudence* is elaborate enough to stand by itself, and it is difficult to imagine for what kind of painting the *timpano* would have been suitable. Its emblematic character would have been inappropriate for a Biblical or mythological subject; and it is unlikely to have covered a portrait because the three human faces themselves are portraits. There can be little doubt that the hawk-eyed old man turned to the left is the aged Titian himself who was, if my chronology is correct, in his middle eighties at the time when the painting was produced; the middle-aged man in the center is his son and heir, Orazio, born, we recall, some time before 1525 and thus a man in his early forties at the time; and the young man turned to the right is

Titian's favorite *nipote*, Marco Vecelli, born in 1545 and thus a youth in his early twenties.[34]

We may instead propose, with all due reservations, that the picture might have been intended to conceal what we would call a wall safe — a little cupboard recessed into the wall and destined to protect such valuables as money, jewels and documents. *Ripostigli* (or *ripositigli*) of this kind can still be seen in many an Italian palace; and that the *Allegory of Prudence* was intended for the concealment of such a receptacle would be concordant with both its iconography and its date.

From c. 1565, Titian attempted to secure the financial future of his clan. He tried to recover all outstanding debts. In 1567 he "copyrighted" the engravings based on his compositions. In 1569 he obtained, after prolonged negotiations, the transfer of his cherished broker's patent to the faithful Orazio. Like the aged Hezekiah, he "set his house in order"; but, as with Hezekiah, "the Lord still added to his days." It would be understandable had he decided to place the most precious portable assets which he intended to leave to his heirs under the protection of Time and Prudence.

What the uninstructed beholder may dismiss as an abstruse conundrum thus turns out to be a moving human document, nobly contrasting with Bandinelli's unabashed self-glorification: the proudly resigned abdication of a great king in favor of a beloved heir-apparent and an equally beloved heir-presumptive. It is as meaningful as it is beautiful that the virile face of Orazio Vecelli is vigorously modelled and clearly divided into two areas of light and shade; whereas the face of young Marco is blurred by an excess of light and Titian's own recedes into the shadow. "All art is one, remember that, Biddie dear," says Henry James' Nick Dormer when his charming but not very bright young sister insists that "the subject does not matter."

34. Cf. the donors' portraits in the *Madonna della Misericordia*, *V.*, II, p. 74, Pl. 184 (detail in Panofsky, *Il Significato nelle arti visive*, Fig. 47). This picture, commissioned in 1573 and mostly executed by Orazio and Marco Vecelli, is still later than the *Allegory of Prudence*, and Marco has grown a moustache; but we are obviously confronted with the same personages.

V

Reflections on Love and Beauty

We, children of a century which tends to restrict the word "beauty" to such compounds as "beauty-spot" or "beauty-parlor" and to talk of "sex" rather than "love," find it hard to recapture the spirit of a period when these two terms, "love" and "beauty," were not only taken seriously but dominated the thought and conversation of the intellectual and social élite. Chiefly responsible for this glorification, even sanctification, of the erotic and aesthetic experience was the Neoplatonic movement inaugurated by Marsilio Ficino in the sixth decade of the fifteenth century.

Where Thomas Aquinas had been careful to separate the good from the beautiful, and both from the ultimate perfection which is God, Ficino — the first author to use the phrase "Platonic love" — could claim that "the soul is inflamed by the divine splendor, which glows in a beautiful human being as in a mirror, and is mysteriously lifted up, as by a hook, in order to become God";[1] and we can easily understand that such a philosophy was as inescapable then as psychoanalysis is today. Often distorted and diluted, but all the more effective for this very reason, it spread from Florence throughout the civilized world — from philosophers, scholars and natural scientists to poets, artists, courtiers, great ladies, and great courtesans. No period in history has produced such a profusion of discourses "on love" as the first half of the sixteenth century.[2]

The Neoplatonic doctrine of love and beauty thus filled the very air which Titian breathed. Most of the discourses "on love" just mentioned

1. Marsilio Ficino, *Theologia Platonica* (*Marsilii Ficini Opera.....omnia*, Basel, 1576, p. 306), quoted by P. O. Kristeller, *The Philosophy of Marsilio Ficino*, New York, 1943, p. 267; cf. also Panofsky, *Renaissance and Renascences*, pp. 182 ff. (with some bibliography on p. 182, Note 1).

2. Cf. Panofsky, ibidem, and *Studies in Iconology*, pp. 129 ff., particularly 145 ff.

originated in the North Italian milieu and were printed in Venice. Pietro Bembo, the author of the *Asolani* and the spokesman of Neoplatonism in Baldassare Castiglione's *Cortigiano*, was a personal friend of Titian's. And Titian himself, we remember, lent an erotic connotation even to a philosophical allegory such as *The Three Ages of Man* (Fig. 110) and to the Biblical story of Salome (Fig. 50); he was no less responsive than Michelangelo to the new gospel of Neoplatonism — only he responded in a very different manner. His secular paintings may be said to constitute, by implication, a sustained commentary on love; and some of these "comments by implication" crystallized into explicit statements.

The earliest and most famous of these is, of course, the *"Sacred and Profane Love"* — a title which does not occur until 1693 — in the Galleria Borghese (Fig. 128).[3] Commissioned by Niccolò Aurelio (then Secretary to the Council of Ten, later Grand Chancellor of the Serenissima, and a life-long friend of Pietro Bembo), it was probably executed toward 1515, and marks the moment at which Titian's disengagement from the Giorgione tradition became irreversible. True, the cluster of buildings on the left literally repeats, in reverse, an unquestionably Giorgionesque motif (recurring in the background of Titian's early *Noli me tangere*[4] and in the landscape which he had superimposed upon that in Giorgione's Dresden *Venus*),[5] except that an enormous tower has been added and lends a war-like aspect to the picturesque complex. But the predominant colors are two shades of crimson and various shades of white, brown, beige, and golden yellow, with very little green even in the landscape. And, more important, Titian has entered a new phase in his relationship with classical antiquity.

Here, so far as I know, is the first time that he employs a classical model for one of the *dramatis personae*, and not only for a simulated work of sculpture forming part of the *mise-en-scène*, as he had done in the Antwerp Altarpiece and in the *Miracle of the Speaking Infant*: the posture of the nude figure derives from a classical motif typified by those Nereids who

3. *V.*, ɪ, Pls. 64-69 and color plate. For bibliography, see P. della Pergola, *Galleria Borghese*, ɪ, *I Dipinti*, Rome, 1955, pp. 129 f. For a few additions, cf. the references in E. B. Cantelupe, "Titian's *Sacred and Profane Love* Re-examined," *Art Bulletin*, xlvɪ, 1964, pp. 218 ff.

4. *V.*, ɪ, Pls. 39, 40; cf. Gould, *National Gallery Catalogues, The Venetian Sixteenth-Century School*, pp. 109 ff.

5. *V.*, ɪ, p. 95, Pls. 41 and 203.

on Roman sarcophagi so often help the deceased to attain a blissful here-after (Fig. 129).[6] A new Pygmalion, Titian infused a piece of sculpture with the breath of life while on the marble basin of the fountain he con-structs a relief, classical in style but freely invented, which remains a piece of sculpture. And this combination of an actual classical figure metamorphosed into a living woman with an imaginary event cast in the form of a simulated classical relief raises the fateful question: What does it all mean?

A whole library has been written about this problem and will doubtless continue to grow. I believe that an interpretation put forward by myself more than thirty years ago,[7] accepted by some and contested or modi-fied by others, is still substantially valid, all the more so as the most serious objections which have been raised against it can now be met with newly discovered evidence.

We witness a dialogue between two beautiful young women seated or perched on the rim of a sculptured marble basin which is possibly, though not demonstrably, an adapted Roman sarcophagus. That this dialogue is about love is attested by a Cupid who, placed between them, agitates the crystal-clear water in the basin, the overflow of which escapes through a copper spout. The two protagonists resemble each other like twins but differ very much in costume and conduct. One of them, nude except for a white loin cloth and a magnificent crimson mantle billowing back from her left shoulder, ecstatically holds aloft a flaming vase. The other, her head crowned with a myrtle wreath and her face averted, is sumptuously arrayed in a white dress with crimson sleeves (of a much lighter shade than the mantle of the nude) and chamois gloves; she maintains a calm, re-flective attitude, holding a bunch of roses in her right hand while her left

6. The connection between Titian's picture and the Nereid sarcophagi was first ob-served by Curtius, "Zum Antikenstudium Tizians," (cited above, p. 48, Note 44) and endorsed by Brendel, "Borrowings from Ancient Art in Titian." For the significance of marine divinities as guides of departed souls to immortality, see the literature referred to in E. Panofsky, *Tomb Sculpture; Its Changing Aspects from Ancient Egypt to Bernini*, New York, 1964, p. 22, Note 1.

7. E. Panofsky, *Hercules am Scheidewege* (quoted above, p. 94, Note 11), pp. 173 ff.; more circumstantially restated in *Studies*

in Iconology, pp. 150 ff. The most important later contributions — in addition to those cited on p. 110, Note 3 and in the following notes — are those by W. Friedlaender, "La Tintura delle Rose (the Sacred and Profane Love) by Titian," *Art Bulletin*, xx, 1938, pp. 320 ff.; R. Freyhan, "The Evolution of the Caritas Figure in the Thirteenth and Fourteenth Centuries," *Journal of the Warburg and Courtauld Institutes*, xi, 1948, pp. 68 ff., particularly p. 85 f.; and E. Wind, *Pagan Mysteries in the Renaissance* (cited above, p. 102, Note 29), pp. 122 ff.

hand and forearm rest on a large, closed vessel of gold. On the rim of the basin between the two women, but nearer to the nude, we see a chased, silvergilt bowl.

The meaningful juxtaposition of two women, similar in appearance but distinguished by the fact that one is nude, the other draped, was thoroughly familiar to mediaeval art.[8] Here, both in the East and in the West, the draped figure stands for a saintly or lofty principle whereas the nude evoked, if not the idea of carnal pleasure, at least the idea of the natural or, as the phrase goes, "unregenerate" state of man. In a Byzantine miniature of the ninth century (Fig. 130), St. Basil is shown extolling "Heavenly Life" (draped) at the expense of "Worldly Happiness" (nude); and in late Gothic art a nude figure stands for Nature while a draped one seems to personify Reason or Grace (Fig. 131).

In the Renaissance, however, nudity became an attribute of positive principles — not only of Truth but also, to give a selection from Ripa, of such exalted concepts as Feminine Beauty, Genius (*Ingegno*), Friendship, Soul, Clarity or Radiance (*Chiarezza*), and Eternal as opposed to Transient Bliss.[9] All differences notwithstanding, Ripa's description of the two last-named personifications — *Felicità Eterna* represented as "a nude figure lifting a flame heavenward," *Felicità Breve* as "a figure draped in white and yellow, adorned with precious stones and other ornaments and holding a vessel full of coins and precious stones" — so closely corresponds with Titian's picture that mere coincidence seems highly improbable. In fact, it has recently been shown that Ripa's de-

8. For all this and what follows, cf. Panofsky, *Studies in Iconology*, pp. 154 ff., Figs. 109-111. The Duc de Berry's medal of Constantine (Fig. 131), where Nature and Grace are shown sitting on either side of the Fountain of Life — utilized by the sculptors of the Certosa di Pavia — has even been suspected of having had a direct influence on Titian's "*Sacred and Profane Love*" (G. von Bezold, "Tizians himmlische und irdische Liebe," *Mitteilungen aus dem Germanischen Nationalmuseum*, 1903, pp. 174 ff.).

9. Apart from Giovanni Pisano, the rehabilitation of female nudity seems to have started with renderings of Truth, the earliest instance known to me still being a miniature of 1350-51 (Panofsky, *Studies in Iconology*, Fig. 114); the persistence of this tradition even in the Northern countries is attested by the woodcuts in the early editions of Maffeo Vegio's (Mapheus Vegius') *Philalethes*, Nuremberg (Regiomontanus), c. 1473-1474, and Strasbourg (Heinrich Knoblochtzer), c. 1478-1480, for which see A. Schramm, *Der Bilderschmuck der Frühdrucke*, Leipzig, 1920-1943, XVIII, Fig. 357, and XIX, Fig. 201. It goes without saying that more conservative writers and artists retained the pejorative implications of nudity throughout the Renaissance and Baroque periods; see J. M. Steadman, "The Iconographical Background of Quarles' 'Flesh' and 'Spirit,'" *Art Bulletin*, XXXIX, 1957, p. 231 f.

scription was, if not conceived, at least rewritten under the picture's direct influence.[10]

Formulated almost a century after the picture was completed, Ripa's text does not, of course, prove that the two women in Titian's painting should be labelled "Ever-Lasting and Transient Bliss"; and no one has ever claimed that they should. But it does prove that an educated beholder of the sixteenth century had no doubts as to the loftier nature of the nude figure, and that it is not so arbitrary as some critics would have us believe[11] to interpret the vessel treasured by her draped companion as a receptacle for gold and jewels. Admittedly there is no way of telling what precisely a closed vessel contains. But the very fact that it is closed makes it probable that it contains something; and since it is itself of gold, its contents cannot be trivial. In any event the vessel signifies terrestrial splendor as opposed to divine illumination symbolized by the flaming vase in the hand of the opposite figure. How, then, should the two figures be named?

In his *Treatise on Architecture* (IX, 5) Leone Battista Alberti — paraphrasing the Greek adjectives οἰκεῖος and ἐπείσακτος — distinguishes between "genuine, innate beauty" and "ornament which smacks of the adventitious"; and the poet Scipione Francucci, the first author to give an explicit description of Titian's "*Sacred and Profane Love*" (1613), frames his description almost as though he had Alberti and Ripa in mind. He refers to the two women as *Beltà ornata* and *Beltà disornata*, adding that "the noble heart loves and reveres unadorned beauty whereas the barbarous heart delights in barbarous ornament"; and he likens beauty "poor in gold and rich in innate grace" to the sun whose only garments are his own rays.[12]

10. G. de Tervarent, "Les deux Amours; A propos d'un tableau du Titien à la Galerie Borghèse à Rome," *Bulletin de l'Institut Historique Belge de Rome*, XXXV, 1963, pp. 121 ff. As observed by de Tervarent, the two earliest, unillustrated editions of Ripa's *Iconologia* (Rome, 1593, and Milan, 1602) still provide *Felicità Breve* with a cornucopia; it is only in the third edition (Rome, 1603) that this description of the attribute is replaced by the much-debated *bacile pieno di monete e gemme*. This emendation can be accounted for either by the assumption that Ripa saw Titian's picture (whose whereabouts between the time of its execution and 1613 are unknown) before 1593 but failed then to notice the golden vessel and rectified his description some ten years later; or, perhaps preferably, by the assumption that he had thought up the allegory independently of Titian's picture and changed it, after having seen the latter, shortly before 1603.

11. Wind, *Pagan Mysteries*, p. 123.

12. For the text, see Panofsky, *Studies in Iconology*, p. 160, Note 102a.

Pedantic and censorious as they are, Francucci's lines, characteristically opposing "gold" to "innate grace," thus sum up what had become a kind of creed in the Renaissance: the notion that unadorned beauty, clothed only in a celestial radiance, is superior to beauty adorned; and that these two kinds of beauty correspond to two kinds of love and two kinds of lovers. And there is evidence to show that these two kinds of love and lovers were connected with two different Venuses.

Praxiteles, we are told in a passage from Pliny frequently quoted in the Renaissance, had produced two statues of Venus, one draped, the other nude; and it was the nude statue — refused by the inhabitants of Kos but accepted by those of Knidos — upon which the sacred name of Ἀφροδίτη οὐρανία, "celestial Venus," was conferred (Lucian, *De imaginibus*, XXIII). The contrast between nudity and non-nudity (the former, as has been seen, invested with an almost metaphysical halo in the Renaissance) thus came to be associated with the contrast (conclusively formulated in the speech of Pausanias in Plato's *Symposium*) between Ἀφροδίτη οὐρανία and Ἀφροδίτη πάνδημος, the celestial and the "vulgar," ordinary Venus, each of them the mother of a Cupid congenial to her own nature. The terrestrial Venus, as we read in the *Symposium* and in Marsilio Ficino's immensely influential Commentary thereon (quoted, for short, as *De amore* or *Il convito*), which was the basic text for all those later treatises on love, was produced, in the natural fashion, by Zeus and Dione (Jupiter and Juno); whereas the celestial Venus, the older of the two (and, according to Plato, though not to his followers, exclusively concerned with love among males), had no mother at all but miraculously emerged from the ocean upon the immersion of the genitals of Uranus, the god of Heaven. And where the celestial Venus leads us into a realm beyond sensory perception, the terrestrial Venus rules the world of nature accessible to the eye and ear.

Botticelli stated this difference in two famous works: the *Birth of Venus*, where the celestial Venus is swept ashore on a shell, and the *Realm of Venus*, conventionally known as *"La Primavera,"* where the terrestrial Venus holds gentle sway over the flowering earth.[13] And Mantegna had been asked to include in a picture, which may or may not have been replaced by Lorenzo Costa's *Gate of Comus* in the Louvre,[14] "two Venuses, one nude, the other draped," "doi Veneri, una vestida, laltra nuda."

13. See Panofsky, *Renaissance and Renascences*, pp. 191 ff.; cf. Wind, *Pagan Mysteries*, pp. 100-120.

14. For this painting, possibly laid out by Mantegna, see Wind, *Bellini's Feast of the Gods*, p. 46 f., Fig. 59.

"*The Two Venuses*" (*duae Veneres*) — or, to adopt the terms used in Ficino's *De amore*, "*The Double Venus*" (*Venus duplex*) or "*The Twin Venuses*" (*geminae Veneres*) — is, therefore, what I still hold to be the most adequate title of Titian's "*Sacred and Profane Love*." And the strongest argument against this designation — that the flaming vase in the hands of the nude figure, well known as an attribute of Christian Charity, does not "occur as an attribute of Venus"[15] — can be refuted by the fact that a Celestial Venus, unmistakably identified as such by her nudity as well as by the presence of a Cupid and a dolphin, displays this very attribute in a statue as close as possible to Titian's painting in time and place: Giovanni Dentone's *Venus* which dominates the façade of Falconetto's Loggia Cornaro in Padua, built in 1524-25 (Fig. 132).[16]

The conventional title "*Sacred and Profane Love*" is thus right and wrong at the same time. It is right in that Titian's painting presents a contrast between two forms of love, one more exalted than the other. It is wrong not only in that Love (*Amore*) is normally personified by a masculine figure in Italian art (it is characteristic that the term *Amore sacro e profano*, first occurring, we recall, in 1693, was changed to "*La Donna Divina e Profana*" as early as 1700)[17] but also, and more importantly, in that the adjectives "sacred" and "profane" imply a dichotomy rather than a scale of values within what is essentially the same experience.

Celestial love — frequently called "divine" in postclassical writing — longs for, enjoys (*fruitur*) and procreates a beauty surpassing what we call reality; terrestrial love — frequently called "natural" or "human" — longs for, enjoys and procreates a beauty inherent in the material world (*in mundi materia*). But both long for, enjoy and procreate beauty. To quote Ficino *ad verbum*: "Both Venuses are honorable and praiseworthy, for both pursue the procreation of beauty, though each in her own way."[18]

15. Wind, *Pagan Mysteries*, p. 126, text and Note 4. For some passages containing different but essentially identical designations of the "Two Venuses," see Panofsky, *Renaissance and Renascences*, p. 198, Note 3.
16. See N. Ivanoff, "Allegorie dell'Odeon e della Loggia Cornara a Padova," *Emporium*, cxxxviii, 1963, pp. 209 ff., Fig. 1; cf. C. Semenzato, "Gian Maria Falconetto," *Bollettino del centro internazionale di studi d' architettura Andrea Palladio*, iii, 1961, pp. 70 ff., and G. Fiocco, *Alvise Cornaro, il suo tempo e le sue opere*, Vicenza, 1965, pp. 44 ff., Fig. 29. The flaming vase should therefore not induce us to place too Christian an interpretation upon Titian's painting. For the photograph reproduced in Fig. 132 I am indebted to Dr. Ivanoff.
17. De Tervarent, "Les deux Amours," p. 127.
18. Ficino, *In Convivium Platonis Commentarium*, ii, 7 and vi, 7, *Opera omnia*, pp. 1326 f., 1344 f.
This work was all the more influential as it existed in Italian translations — the earliest

In fact, terrestrial or human love can and should form a transition to, and ultimately enter into a blissfully harmonious union with, celestial or divine love.

The dialogue in Titian's painting, then, is conducted in a spirit of persuasion and not of altercation. Each of the two Venuses has her characteristic attributes. One displays such tangible paraphernalia of terrestrial beauty as finery, roses and the cryptic golden vessel; and she is wreathed with myrtle which, less perishable than the rose, symbolizes the lasting and legitimate joys of marriage (not for nothing is it referred to as *myrtus coniugalis* in Latin literature).[19] The other has no attribute except the mantle — comparable to that which is spread for her by the welcoming Hora in Botticelli's *Birth of Venus* — and the flame which rises heavenward. Each of the two figures, finally, is set out against a suitable sector of background, the whole amounting to a *paysage moralisé*.[20] Behind the terrestrial Venus, and dominated by the fortified castle already mentioned, there is a wooded hill offering safe shelter to a couple of hares or rabbits, "sacred to Venus"; behind the celestial Venus there is a verdant plain dominated by the steeple of a peaceful village, offering pasture to a flock of sheep and serving as a hunting ground for two mounted huntsmen and their greyhound who — significantly, it would seem — pursue a hare or rabbit instead of leaving it alone with its mate.

Yet the two goddesses in Titian's picture are sisters — even twin sisters — rather than enemies. The deep glance with which the celestial Venus looks down at her interlocutor (who maintains, and not by accident, a less "elevated" position) is not one of hostility, let alone contempt, but one of profound understanding. And Cupid, stirring and, as

produced between 1469 and 1474 by Ficino himself — which were widely circulated in manuscript (nine manuscripts, five of them of the sixteenth century, are still in existence) long before two new Italian versions, one by Cosimo Bartoli, the other by Hercole Barbarasa, were simultaneously published in Florence and Rome in 1544. See P. O. Kristeller, *Supplementum Ficinianum*, I, Florence, 1937, pp. cxxvf., 89-93, where the eight manuscripts then known (D.,L 11., R 17., M 11., M 23., M. 27., P 8., Co 3.) are enumerated (see also p. xif.); a ninth is mentioned in the same author's *Studies in Renaissance Thought and Letters*, Rome, 1956, p. 164. My thanks go to Professor Kristeller for his kindness in guiding me through this *selva oscura*.

19. Cf. Panofsky, *Studies in Iconology*, p. 161, with further references; cf. also Wind, *Pagan Mysteries*, p. 123. It may be mentioned that the rather conspicuous belt worn by the draped figure in Titian's painting is both an attribute of Venus and one of the most common marriage symbols.

20. This term (Panofsky, *Studies in Iconology*, pp. 64, 150) has become so popular that W. H. Auden could give the title "*Paysage Moralisé*" to a major poem (*The Collected Poetry of W. H. Auden*, New York, 1945, p. 47f.).

it were, "homogenizing" the water, may be presumed to symbolize the principle of harmonization by virtue of which the two forms of love represented by the two Venuses, though different in rank, are one in essence.

The simulated relief on the front of the fountain, however, shows, in addition to the half concealed coat-of-arms of Niccolò Aurelio, a scene which does not belong to the domain of either of the two Venuses (Fig. 133); and this may be the reason why this scene, instead of being included in a world of imagined reality, is relegated to a world of petrified fiction, why the action is charged with violent passion and why the place of honor is allotted to an animal. There is, according to the Platonists, a third kind of love which Ficino and Pico della Mirandola call *amor ferinus* or *amore bestiale* in contradistinction to both *amor divinus* and *amor humanus* and which, according to Ficino, should not be dignified with the name of "love" at all; rather it should be considered a kind of disease resulting from the retention of harmful humors in the heart. Whereas divine or celestial love ascends to the realm of the mind, and whereas terrestrial or human love remains within the realm of vision, bestial love descends to the sense of touch and causes its votaries — or, rather, victims — to indulge in "sexual intercourse without moderation" or in unnatural practices.[21]

It is the nature and effects of this *amor ferinus* that are depicted in the simulated relief. In it the principal motif is a huge, unbridled horse which a rather indistinct figure seeks to control by getting hold of its mane. On the left, a man grabs the hair of a woman as if to capture her by force. On the right, a fattish adolescent — not really a satyr, since he has no goat's feet (and even less Adonis, as has been proposed), but very

21. See Panofsky, *Studies in Iconology*, p. 144, Note 50; for Pico's modification of this triadic doctrine (more or less corresponding to Bembo's division of love into "chaotic," "harmonious" and "transcendent"), cf. ibidem, Note 51. In order to assign a Venus even to the lowest form of love Pico posits two "celestial Venuses" of different status: he reserves the prerogatives of Plato's — and Ficino's — "celestial" Venus to a *Venere Celeste* No. 1, who is the daughter of Uranus; and he raises Plato's — and Ficino's — ordinary, natural or terrestrial Venus to the rank of a *Venere Celeste* No. 2, who is the daughter of Saturn. This theory is justifiable by the fact that Cicero (*De natura deorum*, III, 59) interpolates between a "first Venus, the daughter of Caelus and Dies" and a "third Venus, the daughter of Jupiter and Juno," a "second Venus," born of the sea-foam alone; certain mythographers (e.g., the Mythographus III, 1, 7) even ascribe the origin of the "first Venus" to the genitals of Saturn rather than to those of Uranus. Thus Pico's *Venere Volgare*, still the daughter of Jupiter and Juno, appears demoted to the status of a "third Venus" and could be associated with that purely sensual form of love which Ficino had excluded from the realm of any Venus.

possibly *Amor ferinus* himself — is being savagely beaten. And near the right-hand margin, there appear two figures carrying a stake or pale, no doubt in order to tie the victim to it and to torture him further.

The unbridled horse was the most popular Renaissance symbol of unbridled passion. Pierio Valeriano introduces it as the hieroglyphic sign for *Meretricia procacitas* (harlot-like shamelessness), supporting this unflattering characterization by quotations ranging from Homer and Virgil to Psalm 31 (32), 9. The *Hypnerotomachia Polyphili* designates it as *equus infoelicitatis*. And the whole development reaches an unforgettable climax in the description of mating horses in Shakespeare's *Venus and Adonis* (stanzas 44-54).[22] The attempted rape on the left of Titian's simulated relief speaks for itself. The flagellation scene on the right — no matter

22. Pierio Valeriano's characterization of the horse as a symbol of *Meretricia procacitas* is found in his *Hieroglyphica*, IV, 24. For another passage, almost equally long, where the horse stands for *Immoderatus impetus*, see ibidem, IV, 20 (cf. Wind, *Pagan Mysteries*, p. 124). This symbolism of the horse in Renaissance art and the importance of Pierio Valeriano for its dissemination were first recognized by K. Giehlow, "Dürers Entwürfe für das Triumphrelief Kaiser Maximilians I im Louvre," *Jahrbuch der kunsthistorischen Sammlungen des Allerhöchsten Kaiserhauses*, XXIX, 1910-11, pp. 14 ff., particularly p. 52. For the erotic symbolism of the horse in Late Antique sources, see E. Simon, "Nonnos und das Elfenbeinkästchen aus Veroli," *Jahrbuch des deutschen archäologischen Instituts*, LXXIX, 1964, pp. 279 ff., particularly p. 322. For an impressive emblem inscribed SEMPER LIBIDINI IMPERAT PRVDENTIA (a heroic young man subduing a horse by means of a bridle while an unbridled horse rears and two other unbridled horses disport themselves in the background), see Giulio Bonasone's engraving in Achille Bocchi's *Symbolicarum quaestionum ... libri quinque*, IV, p. CCXLVI, no. CXVII (cited by Wind, p. 124, Note 3, and reproduced in *Reallexikon zur deutschen Kunstgeschichte*, V, col. 105). And a particularly elaborate allegory of this kind — of special interest because it is nearly contemporary with Titian's "*Sacred and Profane Love*" and also presents itself in the guise of a simulated classical relief — is found in a donor's portrait in the Detroit Institute of Art which bears the forged inscription RAPHAEL VRBINAS PINXIT A.D. MDVI but is in reality the cut-out fragment of an altarpiece produced by a provincial follower of Raphael's (Girolamo Nardini?); see F. Zeri, "Me pinxit," *Proporzioni*, II, 1948, pp. 162 ff., particularly p. 179, Fig. 214 (referred to in de Tervarent, *Attributs et symboles*, II, col. 417). It shows three nude young men who in the presence of four elderly dignitaries beat back three unbridled horses in order to gain access to a trophy similar to that in the illustration of the Emblem IVSTA VINDICTA in the first edition of Andrea Alciati's *Emblemata* (Augsburg, Steyner, 1531, fol. B. 7v, changed in later editions). It consists of a helmet and a mace suspended from a dry tree. In Ripa's *Iconologia* the helmet — an attribute of Minerva, the Dea Roma, etc. — signifies such desirable qualities as *Ingegno*, *Intelletto*, *Prudenza*, and, above all, *Fortezza*; and a mace or club, reminiscent of Hercules, denotes *Fortezza* as well as *Libertà*. The moral is that only by conquering uncontrolled appetites can youth attain the strength of mind and body which insures freedom and wins the approval of an older, wiser generation.

whether one prefers to think of it as sheer punishment or as a kind of purification rite preceding the rise of love from a sub-human to a human state[23] — describes the chastisement of bestial love. And that this chastisement is to be continued at a stake or pale suggests, all differences in spirit notwithstanding,[24] the visual influence of those popular paintings and prints which, ultimately based on Ausonius' *Cupido cruciatur*, render the castigation of Cupid in this very fashion.[25]

If I am permitted a self-quotation, "Titian's '*Sacred and Profane Love*' is not a document of neo-mediaeval moralism but of neo-Platonic humanism."[26] The two Venuses hold sway over the two spheres of a world within which, as Ficino puts it, love is an „innate and uniting force that drives the higher things to care for the lower ones, the equal things to some special communion with each other, and finally induces all lower things to turn toward the better and higher ones"[27] — a world to which even bestial love may ultimately be admitted provided that it subjects itself to an ordeal whereby it ceases to be what it was.

The same humane and humanistic tolerance, which in Titian's "*Sacred and Profane Love*" applies to the rivalry between what is accessible to the senses and what is not, also applies to the rivalry between the senses themselves.

These were always divided into the "higher" and the "lower" ones, and the philosophers were unanimous in claiming that only the senses of sight and hearing but not the senses of taste, smell and touch enable the mind to perceive beauty and thus to gain access to the related worlds of love, cognition and art. Even today, we say that something looks or sounds "beautiful"; whereas we say that something tastes, smells or feels "good."

There was, however, a fundamental disagreement as to the relative merits of the two "higher" senses. One school of thought, glorying in its

23. Wind, *Pagan Mysteries*, p. 124f., correctly calls attention to the role of flagellation and other tortures in pagan initiation rites. For their parallels or antecedents in primitive environments, see J. Hastings, *Encyclopaedia of Religion and Ethics*, Edinburgh, 1908-21, vii, pp. 314ff.
24. In this respect, too, I quite agree with Wind, ibidem, p. 125.

25. A. Warburg, *Gesammelte Schriften*, Leipzig and Berlin, 1932, i, pp. 183, 369; cf. Wind, *loc. cit.*
26. Panofsky, *Studies in Iconology*, p. 151.
27. Kristeller, *The Philosophy of Marsilio Ficino*, p. 112.

descent from Heraclitus and championed by Plato, insisted that sight is the noblest and most accurate of all the senses;[28] and this doctrine was, of course, enthusiastically accepted by those art theorists of the Renaissance who claimed that painting was the queen of all the arts. Leonardo's panegyrics on the sense of sight are as well known as Dürer's; the former, drawing the logical conclusion from the Platonic position, explicitly declared that "music is to be termed only the sister of painting, for it is subject to the sense of hearing, a sense second to the eye."[29]

Aristotle, however, a thinker speaking for the intellect rather than for the sensations and emotions, and one for whom reading was an acoustic rather than a visual experience, maintained that hearing alone gives speech and contributes most to learning and that a man born blind "would be wiser (φρονιμώτερος) than a man born deaf and mute."[30]

Marsilio Ficino, in his by now familiar Commentary on Plato's *Symposium*, proposed a reasonable compromise. Barring, of course, the senses of taste, smell and touch from the temple of Beauty and Love (they are conducive only to *amor ferinus*), he confers equal honors upon the senses of sight and hearing; he even elevates both of them to the level of Mind: "There are three kinds of beauty, that of the souls, that of the bodies and that of sounds; that of the souls is perceived by the mind, that of the bodies we perceive through the eyes, that of sounds through the ears; love is always content with the mind, the eyes and the ears."[31] Yet the discussion went on throughout the Renaissance. The two most serious Cinquecento writers on love, Leone Ebreo and Baldassare Castiglione,

28. See, e.g., Plato, *Timaeus*, 47 A-D; *Phaedrus*, 250 D; *Republic*, VI, 507 G. For Heraclitus, see Polybius, *Historiae*, XII, 27.
29. Thus Leonardo in his *Trattato della pittura* (A. P. McMahon, *Leonardo da Vinci, Treatise on Painting*, Princeton, 1956, p. 25, facsimile fol. 16). For other key passages see ibidem, p. 6, facsimile fol. 4v; p. 7, facsimile fol. 12v; p. 18, facsimile fol. 8 (particularly interesting because Leonardo here quotes the time-honored definition of the eye as the *finestra dell'anima*); p. 23, facsimile fol. 15v. See also Leonardo's statement in the *Codice Atlantico*, ed. G. Piumati, Milan, 1894-1904, fol. 90; or Luca Pacioli, *Divina proportione*, Venice, 1509 (*Quellenschriften für Kunstgeschichte*, new series, II, Vienna, 1889, p. 35). Dürer's

famous phrase: "Dann der alleredelst Sinn der Menschen ist Sehen" (or "das Gesicht") recurs in his drafts for a preface to his contemplated treatise on painting no less than four times (Lange and Fuhse, *Dürers schriftlicher Nachlass*, pp. 240, 14; 294, 19; 309, 16; 312, 19).
30. Aristotle, *De sensu*, I, 437 A 3-17; *Metaphysics* A I, 980 A 24-B 25. I owe the acquaintance with these passages to my friend, Professor Harold F. Cherniss.
31. Ficino, *Comm. in Convivium Platonis*, I, 4, *Opera omnia*, p. 1322f. Cf. also a letter to Giovanni Cavalcanti, *Opera omnia*, p. 631 f.: "Lucem vero...cogitatione, aspectu, auditu duntaxat attingimus." Both passages are referred to in Kristeller, *The Philosophy of Marsilio Ficino*, p. 307.

accepted the conciliatory solution of the founder. The majority decided in favor of sight. But two important authors, both Venetians, decided in favor of hearing; Giuseppe Betussi (*Il Raverta*, Venice, 1544) without reservations; and Pietro Bembo at least to the extent that he credits the ear with the ability directly to perceive the beauty of the soul whereas the eye can directly perceive only that of the body.[32]

It is in the light of this discussion that Otto Brendel — and I agree with him at least in principle — proposed to interpret a group of pictures by and after Titian which deal with a novel subject calculated to stimulate the carnal passions (by the juxtaposition of a nude woman with a fully dressed gentleman) as well as to intrigue the mind: *Venus and a Musician.*

Titian's point of departure, it would seem, was a *Venus* probably executed, with some assistance from the workshop, between 1545 and 1548 and possibly intended for — though hardly ever commissioned by — Charles V (Fig. 134). It can now be admired in the Uffizi together with the *Venus of Urbino* and may be termed a second edition thereof — revised *alla Romana*, even *alla Michelagniolesca*.[33] The slender girl, snugly ensconced in a sumptuous interior, turned to three-quarter profile and challenging the spectator with her alluring glance, has been transformed into a mature woman, reclining in an open loggia, displaying her robust body in almost full frontality and giving her attention to the caresses and whispers of little Cupid. The hand of the extended arm no longer performs a *Venus Pudica* gesture *à la* Giorgione but rests on the thigh; and the legs are uncrossed so that the lower contour of the figure describes a unified, protracted curve.[34]

32. See O. Brendel, "The Interpretation of the Holkham *Venus*," *Art Bulletin*, xxviii, 1946, pp. 65 ff.; cf., however, the objections raised by U. Middeldorf, ibidem, xxix, 1947, pp. 65 ff. For Giuseppe Betussi's dialogue, *Il Raverta*, Venice, 1544 (not cited by Brendel), see the reprint in G. Zonta, *Trattati d'amore del Cinquecento*, Bari, 1912, pp. 3 ff., particularly p. 17: "... tosto più entro con l'udito, ch'è più spirituale [degli occhi], penetrare [la bellezza]."

33. *V.*, ii, Pl. 35. This picture, offered to Grand Duke Cosimo II by Paolo Giordano Orsini in 1618, may well be identical with the elusive *Venus* promised to Charles V by Titian in a letter from Rome, dated December 8, 1545 (cf. *V.*, ii, p. 53) and brought with him to Augsburg in 1548 (letter to Nicholas Granvelle of September 1, 1548, for which see *V.*, ii, p. 54). There is, however, no evidence to show that the picture was undertaken at the initiative of Charles V or even accepted by him. If so, it would be the only "pagan" picture produced by Titian for, or at least acquired by, Charles V rather than Philip II.

34. It is in these two important respects — frontalization of the body and unification of the contour — that Titian's composition seems to reveal, all differences notwithstanding, the influence of Michelangelo's *Venus* executed, probably in 1532-33, for

This "*Uffizi Venus No. 2*," as it may be called, was not only employed for the illustration of a scene from Ariosto's *Orlando Furioso* (x, 95 ff.)[35] but also formed the nucleus of numerous variations — no less than five, not counting obvious copies — on the theme now under discussion. These variations may be divided into two groups. In "Group A," probably executed about 1550, Venus is combined with an organist; in "Group B," datable about ten years later, the organist is replaced by a lute player.

The earliest member of "Group A" is, I believe, the *Venus with the Organ Player* in Berlin, where the player bears a perhaps more than accidental resemblance to the then Crown Prince, Philip II (Fig. 135); it would be tempting to suppose that he himself had suggested the subject.[36] Here the scene is set out against a hilly landscape, in which respect the painting still agrees with the "*Uffizi Venus No. 2*"; it disagrees, however, with two slightly later versions of the new theme, both preserved in the Prado: one (signed and in my opinion the earlier and better of the two) retains the Cupid and represents Venus as a generalized, "ideal," type (Fig. 136); the other (unsigned), discards the Cupid in favor of a somewhat awkwardly placed pillow and represents the goddess in the guise of an individual person, presumably the patron's mistress (Fig. 137).[37]

Bartolommeo Bettini (cf. de Tolnay, *Michelangelo*, iii, Princeton, 1948, pp. 194 ff., Figs. 287-289). Both Michelangelo's *Venus* and *Leda* (for the latter, see de Tolnay, ibidem, pp. 190 ff., Figs. 279, 280, 282-285 and below, p. 146, Note 20) were accessible to Titian in copies by Vasari, brought by the latter to Venice in 1541 and acquired by Don Diego Hurtado de Mendoza, whom Titian portrayed at this very time (Vasari, vii, p. 670; cf. *V.*, i, Pl. 162, erroneously provided with the same caption as Pl. 163). For Mendoza's very interesting personality, see E. Spivakovsky, "Diego Hurtado de Mendoza and Averroism," *Journal of the History of Ideas*, xxvi, 1965, pp. 307 ff.

35. Drawing in the Musée Bonnat at Bayonne, engraved by Cornelis Cort (*T.*, Fig. 172; datable, I think, after rather than before 1545). It shows Angelica threatened by a monster (*l'Orca*) and saved by Ruggiero who descends from the skies on his hippogryph; but the drawing con-

stitutes one of those interesting cases in which the mind of an artist illustrating a given text is swayed by images retained in his memory from visual experience rather than by images suggested to his inventiveness by the written word. According to the poem (*Orlando Furioso*, x, 66-111), Angelica — like her classical prototype, Andromeda — should be chained to a rock and not comfortably reclining in the pose of Titian's own Venuses.

36. *V.*, ii, Pl. 34. The picture is signed but cannot be traced beyond the eighteenth century (Collection of Prince Pio of Savoy).

37. The provenance of and relationship between the two Prado pictures pose an intricate problem. The signed canvas No. 421, with Cupid (*V.*, ii, Pl. 32, our Fig. 136), is mentioned as being in the Alcazar in 1636 (F. J. Sánchez Cantón, *Museo del Prado, Catalogo de las pinturas*, 1963, p. 697) and would seem to be identical with *una Venere in sul letto con un*

In these two paintings the hilly landscape is replaced by a formal park with a grand avenue, a sculptured fountain, deer, and peacocks; and the simple portative organ has become a more elaborate instrument, its case embellished with a carved ornament and its pipes arranged on two symmetrical diagonals instead of one horizontal. But more important is the change in the position and behavior of the player.

In the Berlin picture he has lost all contact with his instrument. Both hands are off the keyboard and his right leg is swung over the bench so that, apart from the other leg, his whole body is turned toward the reclining goddess at whom he looks with rapt attention. In the two Prado paintings this triumph of the sense of sight over the sense of hearing is less complete. Here the legs of the organist are still turned to the left. In order to look at the nude woman he must turn sharply at the hip and must lean over backward, thus enabling the beholder to see the keyboard (invisible in the Berlin picture) and to realize that one or — in the signed version — both of the player's hands are still on the keys. This means, I think, that the supremacy of visible beauty (incarnate in the nude) over the audible charms of music is no longer uncontested. Far from abandoning his instrument altogether, the player now attempts to enjoy the world of sight while not cutting himself off from the world of sound.[38]

organista [*not* "suonatore di organo"] *di Titian* which is listed among the thirty-two works of art selected by Emperor Rudolf II from the Granvelle collection and paid for with 13,000 "talari." This list is attached to a letter of François de Granvelle, Count of Cantecroy (or Cantecroix) of July 24, 1600. Published by H. Zimerman, "Urkunden, Acten und Regesten aus dem Archiv des k.k. Ministeriums des Innern," *Jahrbuch der kunsthistorischen Sammlungen des Allerhöchsten Kaiserhauses*, VII, 2, 1888, pp. L ff., No. 4656, it seems to confirm the view, shared by Valcanover, that the picture was actually acquired (and not rejected, as stated in *T.*, p. 382, and Brendel, "The Interpretation of the Holkham *Venus*," p. 66) by Rudolf II and subsequently presented by him to Philip III of Spain (1598-1621). The unsigned canvas No. 420, without Cupid (*V.*, II, Pl. 33, our Fig. 137), on the other hand, is mentioned as being in the Alcazar fifty years later, i.e. in 1686

(Sánchez Cantón, ibidem), and would seem to be identical with a picture painted for the Venetian jurisconsult Francesco Assonica, which Ridolfi (I, p. 194) describes as "una femina [avoiding the term *Venere*, perhaps because of the absence of Cupid] al naturale à canto alla quale stavasi un giovinetto suonando l' organo." According to Ridolfi, this picture was in England at the time of his writing, i.e. some time before 1648, and seems to have been acquired, for 165 pounds, by Philip IV (1621-1665) after the death of Charles I of England. I agree with Valcanover in feeling that Prado 421 antedates Prado 420 and see no reason to assume, with Brendel, that Titian first eliminated the Cupid (present in the Berlin picture) and reinstated him afterward.

38. I hesitate to accept the interpretation — ultra-Platonic where Middeldorf's (p. 121, Note 32) is anti-Platonic — of the musician's posture as a re-

We thus witness a slight but unmistakable shift from a total to a partial victory of the visual over the aural experience of beauty. And this shift ultimately resulted in an almost perfect balance between these two spheres in what I have called "Group B."

This "Group B" is represented by two paintings nearly identical except for the landscape and the degree of finish: a canvas now in the Fitzwilliam Museum at Cambridge, which has passed through the collections of Emperor Rudolf II of Germany and Queen Christina of Sweden (Fig. 138); and the much-debated — and, as has recently been shown, much less "authentic" — "*Holkham Hall Venus*" in the Metropolitan Museum which can be traced back only to the collection of Prince Pio of Savoy (Fig. 139).[39]

enactment of that "ἐπιστροφή, the reversal of vision by which alone a mortal can hope to face transcendent beauty" (Wind, *Pagan Mysteries*, p. 123, Note 1). This "turning about" is described in the famous cave simile in the Seventh Book of the *Republic*; but here this "conversion" is not as yet designated as ἐπιστροφή (as is the case with such later writers as Proclus and in all Early Christian writing beginning with *Acts* 15, 3, and the Greek version of *Ecclesiasticus*, 18, 21). Plato himself uses the term ἐπιστροφή only once — in *Republic*, x, 620 E — and here with reference to the spindle of the Fates. Plato and his successors, moreover, describe a "conversion" from illusion (later, false beliefs) to ultimate reality (later, the true Faith); the posture of Titian's musicians expresses only a "conversion" from one sphere of aesthetic experience to another. In addition, the musician's psychological attitude develops, as will be seen, from "conversion" — that is to say, the rejection of one set of values in favor of another — to comparative impartiality.

39. *V.*, II, Pls. 72 (New York) and 73 (Cambridge). As far as the question of authenticity is concerned, see, for the *Holkham Hall Venus*, E. Tietze-Conrat, "The Holkham Hall Venus in the Metropolitan Museum," *Art Bulletin*, XXVI, 1944, pp. 266 ff.; her ensuing correspondence with H. B. Wehle, ibidem, XXVII, 1945, p. 82f. and G. Evans, "Notes on Titian's *Venus and the Luteplayer*," ibidem, XXIX, 1947, pp. 123 ff.; Mrs. Tietze-Conrat's reply, ibidem, XXX, 1948, p. 78; and her concluding remarks in *Art Bulletin*, XL, 1958, pp. 347 ff., particularly p. 351. For the Cambridge version (first mentioned in the Prague inventory of 1621), see W. G. Studdert-Kennedy, "Titian: The Fitzwilliam Venus," *Burlington Magazine*, C, 1958, pp. 349 ff.; and, for the results of a technical examination of both versions, the conclusive article by J. W. Goodison, "Titian's 'Venus and Cupid with a Lute-Player'..." *Burlington Magazine*, CVII, 1965, p. 521 f. From the evidence here adduced it appears, first, that both pictures were designed by Titian; that the New York version, incorporating a number of changes made in the Cambridge version, postdates the latter; and that the Cambridge version is "from Titian's hand almost throughout," whereas the Holkham Hall picture was never finished in his workshop and was "subjected to alterations by a later Venetian painter, probably towards the very end of the sixteenth century." There is, however, no evidence to show that these alterations were made by Domenico Tintoretto, much less that he is responsible for the picture in its entirety.

However we may judge the relative merits of these two pictures, certain it is that they represent a final and radical change in iconography: the organist has become a lute player. This metamorphosis means more than the replacement of a keyboard instrument by a stringed one. It means that a musician interrupted in the act of making music by the sight of visual beauty embodied in Venus has been transformed into a musician doing homage to the visual beauty embodied in Venus by the very act of making music. It is difficult to play the organ and to admire a beautiful woman at the same time; but it is easy to serenade her, as it were, to the accompaniment of a lute, while giving full attention to her charms.[40]

This basic transformation is in keeping with two further changes. Firstly, the Cupid in the two later paintings crowns the goddess with a wreath of flowers instead of caressing her and whispering into her ear; secondly — and more importantly — Venus herself is now addicted to music. In her left hand she holds a recorder; a viola da gamba is leaning against her couch; and near it on the floor there can be seen two "part-books," one of them clearly inscribed TENOR.

Venus has thus become the queen of all beauty, whether perceived through the eye or through the ear. And within the sphere of music itself her domain includes the rustic and often lascivious tunes of the pipe or flute (exemplified not only by the recorder in her left hand but also by the shepherd's dance in the middle distance) as well as the nobler, uplifting harmonies of stringed instruments and polyphonic song (exemplified not only by the viola da gamba and the "part-books" but also by the Apollonian swans in the water on the left). Titian, musician as well as painter, has in the end accorded equal dignity to the senses of hearing and of sight.

The content of the *"Sacred and Profane Love,"* its extremely oblong format and the presence of a myrtle wreath make me inclined to think of it as a marriage picture. It shows, to be sure, only one coat-of-arms where we would expect either two or none;[41] but this is not without

40. Professor E. E. Lowinsky calls my attention to the interesting fact that Adriaan Willaert — already mentioned in connection with the *Bacchanal of the Andrians* — had published an arrangement of Verdelot's Madrigals (originally set, as usual, for voices only) for voices and lute: *Intavolature de li Madrigali di Verdelotto da cantare et sonare nel Lauto intavolati per lo eccellentissimo Musico Messer Adriano Vuillaert*, Venice, 1536.

41. Wind, *Pagan Mysteries*, p. 127, Note 3.

parallel in pictures unquestionably connected with a marriage,[42] and Niccolò Aurelio's coat-of-arms is so carefully tucked away among the elements of the relief on the marble basin (Fig. 133) that it gives the impression not so much of an explicit heraldic statement as of a heraldic cypher or cryptogram almost comparable to the Vespucci wasps in Botticelli's London *Mars and Venus*.[43]

We are on safer ground with a much-repeated composition produced in the early 'thirties, just about half-way between the *"Sacred and Profane Love"* and the various versions of the *Venus with an Organ Player*: an allegorical double portrait in the Louvre (Figs. 140, 141), formerly believed to represent Alfonso d'Avalos, Marchese del Vasto taking leave of his wife, Mary of Aragon, when departing for the Turkish War in 1532.[44]

This identification has long been abandoned because no resemblance exists between the Marchese (Figs. 82 and 83) and the sad, haggard hero of the Louvre painting; nor does this hero seem to be identical with Titian himself who, it has been thought, might have painted the picture to commemorate the death of his beloved Cecilia in 1530.[45] It must be admitted that Titian resembles the gentleman in the Louvre picture more closely than does the Marchese del Vasto. But Titian had bluish rather than dark brown eyes, and he would hardly have represented himself and his dead wife in the guise of Mars and Venus. And it is in the role of these divinities that the principal characters in the Louvre picture are cast.

42. Dr. Olga Raggio of the Metropolitan Museum very kindly collected for me the following examples: P. Schubring, *Cassoni...*, Leipzig, 1915, Nos. 576 and 577, a Florentine *cassone* of 1477, bearing only the coat-of-arms of Paola Gonzaga but not those of her husband, Count Görs; Schubring, Nos. 48-50, a marriage box, likewise Florentine, carrying only one coat-of-arms (according to Schubring, that of the bride); Schubring, Nos. 754 and 892, two Venetian *cassoni* of c. 1500, bearing only one coat-of-arms each but identifiable as marriage chests by the scenes represented. Apparently it was customary to omit the arms of the groom if the bride was richer than he was or outranked him, as was obviously the case with the Gonzaga-Görs marriage. Thus the *"Sacred and Profane Love"* may, after all, have been intended for the marriage of a young, probably female relative of Niccolò Aurelio.

43. See E. H. Gombrich, "Botticelli's Mythologies: A Study in the Neoplatonic Symbolism of His Circle," *Journal of the Warburg and Courtauld Institutes*, VIII, 1945, pp. 7ff., particularly p. 49 and Pl. 13, a, c, e.

44. *V.*, I, Pl. 131; cf. Panofsky, *Studies in Iconology*, pp. 160ff., and p. ix in the edition of 1962. W. Friedlaender's recent attempt at interpreting the Louvre portrait as well as the related *Venus between Eros and Anteros* (see below, pp. 126–137) in his essay "The Domestication of Cupid" (*Studies in Renaissance and Baroque Art presented to Anthony Blunt*, London – New York, 1967, pp. 51f.) appeared too late to be refuted here.

45. Hourticq, *La Jeunesse de Titien*, pp. 226ff.

Brought up in the Homeric tradition, we are accustomed to thinking of Mars and Venus as illicit lovers cuckolding Vulcan. But according to a pre- and para-Homeric tradition — surviving throughout the Middle Ages in East and West, accepted by the astrologers, sanctioned by the symbolic cosmology of such poets as Statius, Lucretius and Nonnus, and enthusiastically welcomed by the Platonists of the Renaissance — their alliance was legitimate as well as fruitful. The gentle power of Venus subdues and tempers the ferocity of Mars who — like the planet named after him — always "follows Venus while Venus always precedes him" and whose union with her produced a daughter named Harmonia.[46]

Botticelli and Piero di Cosimo considered "Mars and Venus" a suitable subject for marriage *cassoni*; it seems to have been Titian, however, who in the so-called "*Allegory of the Marchese del Vasto*" revived the Roman custom of actually portraying married couples of high standing in the guise of these two deities (Fig. 142). Titian thereby set the example for a whole group of later Venetian marriage pictures (Fig. 143).[47]

The heroine, then, is a bride playing Venus to the bridegroom's Mars. And the three other figures personify the three theological Virtues in classical disguise. Love is represented by a Cupid whose traditional weapons, the bow and the quiver, have been replaced by a bundle of shafts, a symbol of Unity long before the time when Scilurus, King of Scythia, had demonstrated to his sons that a single javelin could easily be broken whereas a bundle of them could not. The girl behind Cupid is Faith, characterized by her gesture ("a woman who places her right hand upon her breast," says Ripa s.v. *Fede Cattolica*); and since she wears a wreath of myrtle on her head, she is specifically designated as *Marital* Faith. The third figure is identified as Hope by her ecstatic upward glance (*occhi alzati*) and by the basket of flowers — flowers belonging to Hope because she is defined as "the expectation of fruit" (Fig. 141).[48]

46. See Gombrich, "Botticelli's Mythologies," pp. 46 ff.; cf. Panofsky, *Studies in Iconology*, pp. 163 ff., and G. Tschmelitsch, "*Harmonia est Discordia concors*"; *Ein Deutungsversuch zur "Tempesta" des Giorgione*, Vienna, 1966.

47. Panofsky, ibidem, with reference to the matrimonial significance of the quince; Wind, *The Feast of the Gods*, p. 37, Fig. 22.

48. For all this, see Panofsky, *Studies in Iconology*, pp. 161 ff. For the history and significance of the gesture of what I have called Marital Faith (the gesture of "laying one's hand open to one's heart," mentioned by Ripa also *s.vv. Promissione, Querela a Dio* and *Teologia*), see the Chapter *Conscienter affirmo* in J. Bulwer, *Chirologia or the naturall Language of the Hand*, London, 1644, p. 88 — a passage the acquaintance with which I owe to Mrs. Madlyn Kahr. The face of Hope, originally not included in the composition (cf. below, p. 129), shows a more "pictorial" style than the other heads.

Yet this painted epithalamium — and from this point of view its interpretation as a leave-taking or even as a memorial to a person no longer living is understandable and possibly correct — is overshadowed by melancholy. The glance of the young wife is pensive rather than joyous. In the eyes of her husband this meditative mood is deepened into "sweetly-sad" sorrow. And the idea of transience is eloquently expressed by a symbol even more conspicuous than Cupid's bundle: the sphere of glass in the young woman's lap. The sphere as such can symbolize a great variety of things, among them Instability (specifically the fickleness of Fortune), the Universe and — as the most perfect form — "Freedom from Contrariety," that is to say, Harmony. But that it consists of glass can indicate only that this harmony is subject to destruction by fate or death. "Glass signifies by its fragility the vanity of all things on earth," says Ripa.[49]

These dark implications are much less poignant in the composition as originally conceived. When the Louvre picture was recanvased there appeared — and, fortunately, could be salvaged except, apparently, for a strip of c. 15 cm. at the top — what corresponds to the *sinopie* so frequently discovered beneath Trecento and Quattrocento murals: an unbelievably beautiful under-drawing in brown brush, already reminiscent of a "*Picasso Ingriste*" (Fig. 140 a).[50] This "*sinopia*" differs from the final composition not only in style but also in significance. The two principal characters are dressed and posed in somewhat similar manner

49. See (in addition to the sources quoted in Panofsky, *Studies in Iconology*, p. 162 and p. ix in the edition of 1962): A. Doren, "Fortuna im Mittelalter und in der Renaissance," *Vorträge der Bibliothek Warburg*, 1922-23, I, pp. 71 ff., particularly p. 143; H. R. Patch, *The Goddess Fortuna in Mediaeval Literature*, Cambridge, Mass., 1927, particularly pp. 45, 148; O. Brendel, "Symbolik der Kugel," *Mitteilungen des deutschen archaeologischen Instituts, Röm. Abteilung*, LI, 1936, pp. 1 ff.; and, most particularly, L. L. Möller, "Bildgeschichtliche Studien zu Stammbuchbildern, II; Die Kugel als Vanitassymbol," *Jahrbuch der Hamburger Kunstsammlungen*, II, 1952, pp. 157 ff. For the glass ball in particular (*Studies in Iconology*, p. 162, Note 114), cf., e.g., Publilius Syrus,

Sententiae, 189 (ed. O. Friedrich, Hildesheim, 1964, p. 44): "Fortuna vitrea est: tum cum splendet, frangitur," whence the German adage: "Glück und Glass, wie leicht bricht das."

50. My warmest thanks go to Madame Hélène Adhémar, to whose kindness and generosity I owe the photograph here reproduced as well as the authorization to do so. What I am unable to determine is the significance of the long, cylindrical object emerging from behind the armored gentleman and almost looking like the barrel of a musket. It may be a baton (like the three batons in the Portrait of Francesco Maria della Rovere, *V.*, I, Pl. 142); but then its relation to the figure would be difficult to explain.

— except for the fact that in the "*sinopia*" the young woman wears pearls in her ears and, more importantly, that the gentleman places his hand on his own breast as does the personification of Faith in the final version — rather than on that of his companion. Cupid with his bundle of sticks has been left unchanged, and the figure characterized as Marital Faith in the painting is clearly present in the "*sinopia*" although her posture and gesture are very different and her attribute, the myrtle wreath, is not as yet indicated. Absent, however, are the glass ball (the heroine quietly rests her hands on her lap and looks at Cupid instead of sadly contemplating the translucent sphere) and the maiden with the flower basket, personifying Hope. The upper right-hand corner of the "*sinopia*" is occupied by indistinct shapes which may, or may not, have been intended to indicate the heads of flying *putti*.

These basic changes can best be explained, I think, by an admittedly unverifiable, perhaps even fanciful, hypothesis: by the hypothesis that either the groom or, more probably, the bride had died before the picture sketched out on the canvas was carried out in color. For a normal marriage picture the *dramatis personae* appearing in the "*sinopia*" would be entirely sufficient: groom and bride in the guise of Mars and Venus, the former taking a kind of private matrimonial oath by placing his hand on his breast; Love with his bundle, the symbol of Unity; and Marital Faith.

Assuming, however, that death had intervened between the planning and the execution of the picture — so that what I have called a painted epithalamium now had to serve, at the same time, as an *in memoriam* — the changes and additions would be explicable. The man's new gesture would express his desperate wish to retain what he has lost rather than his devotion to what he hopes to possess; the expression on the face of Marital Faith would have been changed in order to express nostalgic yearning rather than quiet confidence; the pearl earring would have been omitted as an ornament unbecoming a woman bereft of her lover or even no longer living; the sphere of glass, originally absent, would have been introduced as the symbol of *fragilitas humana* which has taken its toll; and the figure of Hope, likewise missing from the "*sinopia*," would have been added as a promise of final reunion in the hereafter.

About thirty years later, probably between 1560 and 1565, Titian completed the so-called "*Education of Cupid*" (Fig. 144). Resuming the idea of a composition in half length, he here combined Venus with a

9

Cupid emerging from the lower margin and two subsidiary female figures. Most probably another marriage picture and now, as chance would have it, facing the "*Sacred and Profane Love*" in the same room of the Borghese Gallery,[51] it differs from the "*Allegory of the Marchese del Vasto*" not only in its pronouncedly oblong format (which is more nearly akin to that of the "*Sacred and Profane Love*") and its almost sombre color scheme (brown, brownish reds, very dark crimson, equally dark moss green, white, and a little blue) but also in iconography.

The two subsidiary figures carry, respectively, a bow and a quiver full of arrows. Venus, now wearing a crown, (as she does, e.g., in Bronzino's London *Allegory*), just interrupts herself in the act of blind-folding Cupid with a golden-yellow bandage. And Cupid himself has received a companion: another Cupid, his eyes uncovered, snuggles up behind Venus and claims her attention with a persuasive gesture.

The intervening years had seen the rapid and ubiquitous diffusion of one of the most influential books in history: Andrea Alciati's *Emblemata*, the fountainhead of that mighty stream of emblem books which did not run dry until the nineteenth century.

Alciati's book, first published in 1531, re-edited and translated more than a hundred and fifty times (nearly ninety editions appeared during Titian's lifetime alone) and all the more important to artists because it as well as all its derivatives was profusely illustrated,[52] lent credence and authority to the reinterpretation — or, rather, misinterpretation — of a

51. *V.*, ii, Pls. 114-116 and color plate. Cf. della Pergola, *Galleria Borghese* (cited above, Note 3), p. 131f.; Panofsky, *Studies in Iconology*, pp. 165 ff.; Wind, *Pagan Mysteries*, pp. 75 ff. While I disagree with Wind on several points (particularly with regard to his claim of superiority for blind as opposed to clear-sighted love, and to his failure to take into account Alciati's Emblem cx) I readily admit that his analysis has caused me to modify my own position in other respects.

52. For emblem books in general, see M. Praz, *Studies in Seventeenth-Century Imagery* (*Studies of the Warburg Institute*, iii), London, 1939; revised second edition, Rome, 1964; W. S. Heckscher, "Emblem, Emblembuch" in *Reallexikon zur deutschen Kunstgeschichte*, v, cols. 85 ff. It was Professor Heckscher who kindly informed me of the fact that

some ninety editions of Alciati's *Emblemata* (including translations) appeared between 1531 and the year of Titian's death. According to him, the first known edition in which the now accepted numeration appears is *Francisci Sanctii Brocensis commentarium in Andreae Alciati Emblemata*, Lyons (Rouille), 1573; this numeration was retained in all subsequent editions excepting the "*editio optima*" published by P. P. Tozzi at Padua in 1621. Here an "objectionable" emblem, normally omitted, is included as No. lxxx so that the emblem normally numbered lxxx bears the number lxxxi and the numbers of all the following emblems have been raised by one digit. The Eros-Anteros emblem already occurs in the *editio princeps*, Augsburg (Steyner), 1531, fol. D 5v.

classical myth forgotten during the Middle Ages but revived in the Renaissance: the myth of Eros and Anteros, "Love" and "Counter-Love."[53] According to the authentic versions of this myth, Eros (or Cupid), the god of love, refused to grow until he received a counterpart in the person of Anteros (considered to be either another son of Venus or a son of Nemesis) who was charged with the task of awakening in those who were loved "love in return" or of avenging all kinds of offenses against the god of love; in either case he acted not as a foe but as an ally or friendly rival of Eros himself. In classical art this friendly rivalry was expressed in many ways: by a wrestling match for the possession of a palm branch; a torch race; a game of dice (*astragaloi*); a competition for quinces (symbolic of matrimony); even a cock-fight. But since the Greek preposition ἀντί may mean "against" as well as "in return," some Renaissance writers,[54] elaborating on a still doubtful passage in Servius' *Commentary on Virgil*, transformed Anteros from a god of mutual love into a god who either extinguishes love entirely ("*Amor Lethaeus*") or subdues sensual — to use the Platonizing terminology, terrestrial — love in favor of virtuous — or celestial — love.

Alciati, in contrast to more classical-minded mythographers and antiquarians such as Mario Equicola, Celio Calcagnini, Giglio Gregorio Giraldi, or Vincenzo Cartari,[55] sanctioned this moralistic interpretation.

53. See E. Panofsky, "Der gefesselte Eros (zur Genealogie von Rembrandts Danae)," *Oud Holland*, L, 1933, pp. 193 ff.; idem, *Studies in Iconology*, pp. 126 ff.; R. V. Merrill, "Eros and Anteros," *Speculum*, XIX, 1944, pp. 265 ff.; de Tervarent, "Les deux Amours," quoted above, p. 113, Note 10; idem, "Quelques mots sur le bas-relief d'Evreux," *Académie Royale de Belgique, Bulletin de la Classe des Beaux-Arts*, XLVI, 1964, pp. 192 ff.; idem, "Eros and Anteros or Reciprocal Love in Ancient and Renaissance Art," *Journal of the Warburg and Courtauld Institutes*, XXVIII, 1965, pp. 205 ff.; J. R. Martin, *The Farnese Gallery*, Princeton, 1965, particularly pp. 87 ff.; E. Verheyen, "Eros et Anteros; 'L'Education de Cupidon' et la prétendue 'Antiope' du Corrège," *Gazette des Beaux-Arts*, series 6, LXV, 1965, pp. 321 ff. Cf. also the ensuing correspondence between Messrs. Soth and Verheyen, supplemented by a letter of

M. Laski in *Art Bulletin*, XLVII, 1965, pp. 542-544. This letter furnishes proof that Correggio's pictures in the National Gallery at London and in the Louvre were traditionally interpreted as renderings of the "mundane" and the "celestial" Venus as early as between c. 1630 and c. 1640. Alciati's "Anteros Amor Virtutis" (Emblem CIX) has entered Ripa's *Iconologia* under the title "Amor di Virtù."

54. Especially Pier Hedo (Petrus Haedus), *De amoris generibus*, Treviso, 1492, and Giovanni Battista da Campo Fregoso (Fulgosus), *Anteros*, Milan, 1496.

55. Vincenzo Cartari, *Le Imagini de i Dei de gli Antichi*, first illustrated edition Venice, 1571, pp. 500 ff., basing his discussion (as usual) on G. G. Giraldi, draws a sharp distinction between Anteros, the god of mutual love, and "Amor Lethaeus," the god who dampens amorous ardor; in the illustration (p. 504) he renders the former,

In one of his emblems (CIX according to the standard numeration apparently introduced about 1570) *Anteros Amor Virtutis* has given up all his weapons in return for the crowns of the Four Cardinal Virtues (Prudence, Justice, Fortitude, and Temperance). In the following emblem (CX) Anteros — here designated as *Anteros Amor Virtutis alium Cupidinem superans* and therefore not only wreathed with laurels but also equipped with bow and arrows — has disarmed the "other Cupid," has tied him to a tree or column and burns his weapons. And in all editions prior to the Lyons edition of 1548, when the illustrators became a little careless, the woodcuts belonging to this emblem show the vanquished Eros blindfolded while the victorious Anteros enjoys the power of sight (Fig. 145).

The illustrations of Alciati's Emblem CX are thus the earliest works of art in which clear-sighted or angelical, and blind or terrestrial love (it should be remembered that the "blind bow-boy" did not acquire his bandage until the early thirteenth century)[56] were united in one picture and in which their contrast was raised to a humanistic level. This idea was still exploited by such important seventeenth-century painters as Poussin and Guido Reni, both of whom illustrated Alciati's emblem almost *ad literam* (Fig. 146);[57] and it would be an unbelievable coincidence if Titian's *"Education of Cupid"*, where we find three motifs characteristic of this emblem in combination, did not imply, all changes in interpretation notwithstanding, the contrast between Eros and Anteros as defined by Alciati. For what most conspicuously distinguishes *"The Education of Cupid"* from the *"Allegory of the Marchese del Vasto"* is first, that we have not one Cupid but two; second, that one of these (the only "blind Cupid" in Titian's œuvre) is being blindfolded, whereas the

according to the orthodox tradition, as a Cupid trying to wrest a palm branch from another Cupid, and the latter as a Cupid extinguishing a torch in a pool of water. For a whole pre-Alciatian "life history" of Eros and Anteros, painted by Garofalo in 1517 and based on a program supplied by Celio Calcagnini, see E. Schwarzenberg, "Die Lünetten der 'stanza del tesoro' im Palast des Lodovico il Moro zu Ferrara," *Arte antica e moderna*, VII, 1964, pp. 131 ff., 297 ff. Following the classical tradition, Garofalo shows how Anteros came into being because, without him, Eros would not grow and how they lived in friendly rivalry rather than in enmity ever after.

56. Panofsky, *Studies in Iconology*, pp. 103 ff.
57. The best version of Reni's painting is preserved in the Palazzo Spinola at Genoa (C. Gnudi, *Guido Reni*, Florence, 1955, p. 57, No. 12, Fig. 16); another version of the composition (our Fig. 146) is in the Museo Nazionale at Pisa (Panofsky, "Der gefesselte Eros," pp. 196 ff., Figs. 4, 5; de Tervarent, "Les deux Amours," p. 125 f., Fig. 6; both these articles referring to Alciati). It is to be regretted that de Tervarent, Fig. 2, and Verheyen, Fig. 13, reproduce prints from Alciati editions postdating Rouille's Lyons edition of 1548, where (p. 89) Eros, like Anteros, has lost his bandage.

other, causing Venus to interrupt this process with respect to his companion,[58] is not; and, third, that the two young women doing homage to Venus in the "*Allegory of the Marchese del Vasto*" have been equipped with bow and arrows in the later composition.

The inference is that Titian's two Cupids are variations on Alciati's Emblem cx. They can still be properly designated as Eros and Anteros, and they retain some of their connotations — some but not all: Titian would not have been Titian had he not transmuted rather than repeated Alciati's antithesis.

An attempt has been made to reverse the roles of Eros and Anteros on the ground that leading spokesmen of Neoplatonism believed blind love to be superior to "seeing" love: according to them, blind love "transcends the intellect" and leads the way from mere sight — or "insight" — to ultimate fulfillment.[59] But all the passages adduced in support of this view — passages from Pico della Mirandola, Ficino, Lorenzo de' Medici, and the *Hypnerotomachia Polyphili* — are not, it seems to me, relevant to our problem. Their concern is not with the case of one form of love vs. another form of love but with the case of love vs. non-love — the case of appetitive emotion vs. cognitive observation and reasoning.

They oppose the lover (*amante*, *amans*) to the observer (*chi cerca veder*, *qui videt*) and to the investigator (*inquirens*). They oppose pleasure (*godere*, *gaudium*) to visual perception (*vedere*, *visio*). They oppose joyous fulfillment and love (*fruire*, *frui*, *amor*) to rational thought (*render ragion*, *humana inquisitio*, *intellectus*). As good Neoplatonists the authors often — but by no means always — decide in favor of a spontaneously erotic experience, blind to the light of reason, and against an experience clarified by merely "human" perception and analysis.[60] But nowhere do they conceive of

58. Panofsky, *Studies in Iconology*, p. 166: "She [*scil.*, Venus] has already stopped blindfolding him [*scil.* the Cupid in her lap]." Wind, *Pagan Mysteries*, p. 77, Note 3, writes as if I had claimed that Venus was *loosening* the bandage (which is a very different thing) and concludes from the position of her fingers that she is tightening it. In reality she does neither the one nor the other. Interrupted by the intervention of the Cupid approaching her from behind, she has halted the process of blindfolding the Cupid in her lap; for the time being, she does nothing but listen. That her action has come to a temporary standstill is confirmed by the position of the bandage itself. Had she interrupted the process of tightening it both ends would have to be taut; as it is, only the end which she holds with her left hand is taut while the end which she holds with her right has been allowed to slacken.

59. Wind, *Pagan Mysteries*, pp. 53 ff., 76 f.

60. It is in his letter to Lorenzo de'Medici (*Opera omnia*, pp. 662 ff., partially quoted by Wind, p. 76) that Ficino most unequivocally opposes *amor* to *humana inquisitio*; and in discussing the blindness of love (according to "Orpheus") Pico della Mirandola claims that this blindness

this contest between love and non-love as a contest within the realm of love itself.

That Titian's two Cupids — both of them personifications of Love — are direct descendants of Alciati's "Anteros, love of Virtue" and "The other Cupid," is further confirmed — decisively, I think — by the difference in their wings. In the Alciati tradition Anteros is nearly always somewhat older and bigger than Eros (in Guido Reni, for example, Anteros has reached the age of an adolescent while Eros still remains a child). But even where this difference in age and size is insignificant — as in the earlier Alciati woodcuts themselves — even then the wings of Anteros are noticeably larger than those of his rival. This difference — anticipated in classical reliefs and, within the context of the Alciati tradition, expressive of the notion that Anteros is capable of a sustained flight into higher spheres whereas Eros can only skim about the fruits and flowers of the earth — is retained in Titian's two Cupids even though they are equal in age. And this contrast in size is sharpened by a contrast in coloration — all the more conspicuous as the general color scheme of the painting is fairly subdued. The fair-sized wings of the "seeing" Cupid are almost colorless: grey, white and brown. The rudimentary little wings of his blindfolded companion sparkle, like those of a humming-bird, with vivid touches of golden-yellow, lemon-yellow and red — the strongest color accents in the whole painting.

Thus the Alciatian antithesis between Anteros and Eros persists; but like the antithesis between the two Venuses in Titian's "*Sacred and Profane*

denotes the superiority not of one kind of love over another but of love over the intellect: "Ideo amor ab Orpheo sine oculis dicitur, quia est supra intellectum" (quoted by Wind, ibidem, p. 56). On the other hand, it should be kept in mind that Ficino, explicitly reserving for himself the right of multiple interpretation (*Opera omnia*, p. 1370, quoted and justly emphasized by Gombrich, "Botticelli's Mythologies," p. 37), is by no means consistent in disparaging observation and reason in favor of enjoyment and emotion. In a letter to Lorenzo de'Medici, dated February 15, 1490 (*Opera omnia*, p. 919f.), he says that Socrates was right in preferring Minerva — standing, of course, for the contemplative life — to Venus and Juno — standing, respectively, for the voluptuous and the active life — and suggests that Lorenzo de'Medici may do well to favor all three goddesses. In the appendix to the Commentary on *Philebus* (Kristeller, *The Philosophy of Marsilio Ficino*, p. 358, and *Supplementum Ficinianum*, I, pp. 80 ff.) Ficino gives preference to Minerva; and in several other passages (*Opera omnia*, pp. 675, 780, 847, 922 ff.) he unequivocally casts his vote in her favor against Venus alone or against a triad of Venus, Pluto (= Plutus) and Juno—standing, respectively, for Pleasure, Wealth and Power; he even accepts Minerva as his own tutelary divinity. For this aspect of Ficino's doctrine, see Kristeller, *The Philosophy of Marsilio Ficino*, p. 358f.

Love" — and that between visible and audible beauty in his renderings of Venus and a musician — it has ceased to be an irreconcilable dichotomy. Alciati's Anteros, like Guido Reni's, has fettered and disarmed his rival and destroys the latter's weapons while retaining his own. In Titian's picture these weapons — only one set of them! — are offered to Venus herself. The "seeing" Anteros can merely apply persuasion, though to what purpose remains a moot question: he may wish to claim the weapons for himself; he may be enjoining Venus to unblind the "other Cupid" so as to raise him to a higher level (in the sixteenth century blind Cupid could even "unblind" himself by accepting the doctrines of Plato);[61] or he may be suggesting to share the use of the weapons with his rival once the latter has regained his sight. But however we may interpret the purpose of his action, it always amounts to the establishment of a *modus vivendi* between what still must be called "celestial" and "terrestrial" love.

It has rightly been pointed out that the arrow "flies and hits blindly like passion" (more literally, "desire") whereas the bow, "held steadily in its place, is used with a seeing eye."[62] And this contrast between the two components of Cupid's equipment is consistent with the character of the two figures who carry them. The maiden holding the arrows — or, rather, temporarily withholding them — wears her hair loose and is voluptuously attired so as to disclose her left breast; the maiden with the bow, seen from the back, the expression of her face dispassionate rather than full of eager expectation, her hair carefully kept in place, and her costume supplemented by a leathern shoulder strap, looks like Diana.

Is it possible to name the three women in Titian's "*Education of Cupid*"?[63] Scipione Francucci (1613), again our earliest witness, describes the principal figure as Venus and the two ancillary figures as "two nymphs hostile to Love" and bent on defeating the "perfidious Cupid of the bandaged eyes" — an interpretation apparently alluded to by Jacopo

61. See Lucas Cranach's amusing picture in the Philadelphia Museum of Art where Cupid seems to "take off" for a flight into higher spheres, removing his bandage from his eyes with his right hand and using a big volume inscribed PLATONIS OP[ERA] as a "launching pad." Cf. Panofsky, *Studies in Iconology*, p. 128f., Fig. 106; idem, *Renaissance and Renascences*, p. 190, Fig. 145.

62. Wind, *Pagan Mysteries*, p. 75f., with reference to a passage from Pico della Mirandola, already adduced in a different context in Panofsky, *Studies in Iconology*, p. 227.

63. This title, it seems, was not proposed until the nineteenth century. *C.-C.*, II, p. 355, seem to claim credit for the discovery that the picture shows "Venus and two Graces teaching Cupid his vocation."

Manilli (1650) who briefly lists the picture as "a Venus with two nymphs." But Carlo Ridolfi (1648), as well as the old inventories of the Borghese collection, identifies the subject as "the Graces with Cupid and some shepherdesses."[64]

Francucci's statement is arbitrary in that it attributes to both the "nymphs" hostility to love; but it is not without value in that it reflects a tradition according to which Venus is the heroine and the *Amor bendato* carries a less favorable connotation than his companion. Ridolfi's statement, manifestly wrong in that it omits one "Cupid" and gratuitously adds "some shepherdesses," may yet contain a grain of truth in that it equates the three female figures with the Three Graces.

The Neoplatonic movement had profoundly changed the concept of the Three Graces. As a triad, they retained, in one way or another, their old significance as a symbol of Friendship or Concord. As individuals, however, they outgrew their roles of mere handmaidens (*pedissequae*) of Venus and were interpreted as independent entities, each invested with a meaning of her own. Pico della Mirandola did not hesitate to define them as members of a secular Trinity, the first person of which is identical with Venus; the initiated, he says, "must understand the division of the unity of Venus into the Trinity of the Graces."[65] And in two medals ascribed to Niccolò Fiorentino this "Trinity" is made explicit in two slightly but significantly different ways. In a medal made for Pico himself (Fig. 147) the Graces are identified, reading from left to right, as PVLCHRITVDO-AMOR-VOLVPTAS (Beauty, Love and Pleasure), with the central position accorded to Love; in a medal made for Giovanna degli Albizzi, probably on the occasion of her marriage to Pico's pupil, Lorenzo Tornabuoni (Fig. 148), they are identified as CASTITAS-PVLCHRITVDO-AMOR (Chastity, Beauty and Love), with the central position accorded to Beauty.[66]

64. Panofsky, *Studies in Iconology*, p. 167; Wind, *Pagan Mysteries*, p. 77, Note 5.

65. This passage from Pico's *Conclusiones* was saved from oblivion by Warburg, *Gesammelte Schriften*, I, p. 327, with reference to an amplification of it in Pico's commentary on Girolamo Benivieni's *Canzone d'amore*, where the Graces are defined as three aspects of the *bellezza ideale*. Cf. Panofsky, *Studies in Iconology*, p. 168 f., and idem, *The Iconography of Correggio's Camera di San Paolo* (Studies of the Warburg Institute, XXVI), London, 1961, pp. 56 ff.; further, Gombrich, "Botticelli's Mythologies," pp. 32 ff., with a most interesting survey of the diverse and in part conflicting interpretations of the Three Graces even within Ficino's own writings; Wind, *Pagan Mysteries*, pp. 31 ff., 39 ff., 71 ff., 100 ff.

66. For the difference between these two versions, see the excellent analysis in Wind, ibidem, pp. 72 ff. For a more recent discussion, cf. J. Poesch, "Sources for Two Dürer Enigmas," *Art Bulletin*, XLVI, 1964,

Young Raphael fused, as it were, these two interpretations in his charming little panel in the Musée Condé at Chantilly where the Three Graces are characterized, very discreetly, as *Castitas* (shown in front view, wearing a loin cloth and no ornament) on the left; *Pulchritudo* (seen from the back, thus needing no loincloth, and wearing a small necklace) in the center; and *Voluptas* (seen in front view, yet wearing no loincloth, and sporting a more conspicuous necklace) on the right.[67]

Titian's picture, then, would seem to show Venus — who, at the same time, represents the Grace called "Beauty" — waited upon by the Graces called "Pleasure" and "Chastity", and thus achieves the ultimate resolution of the conflict between Eros and Anteros, i.e. "terrestrial" and "celestial" love. And it should be remembered that the Three Graces were widely held to have been entrusted with the education of both Eros and Anteros.[68]

This subject is, if anything, even more suitable for a bridal picture than that of the "*Sacred and Profane Love*." Even before Titian's time the perfect bride had been thought of as combining chastity and amorous abandon — not only in Italy but even in the Germanic North, where Dürer portrayed an attractive girl in two pictures, one casting her in the role of Virtue, Piety or *Castitas*, the other in the role of Pleasure, Love or *Voluptas*.[69] And I am inclined to believe that a much-debated painting by Bartolomeo Veneto in the Städelsches Kunstinstitut at Frankfurt (Fig. 149)[70] represents neither a courtesan nor the goddess

pp. 78 ff., particularly, pp. 80 ff. (apparently without knowledge of Wind). I disagree, however, with Miss Poesch's interpretation of the subject of Dürer's engraving B. 75 ("*The Four Witches*") as a combination of the Three Graces with the Judgment of Paris.

67. This distinction was first observed by Wind, *Pagan Mysteries*, p. 80.

68. In addition to the reference given in *Studies in Iconology*, p. 169, Note 136, see the sources cited by A. H. Gilbert in his review of this book in *Art Bulletin*, XXII, 1940, p. 174.

69. For these two portraits, presumably representing a girl named Katharina Fürlegerin, see E. Panofsky, *Albrecht Dürer*, 3rd edition, Princeton, 1948, I, p. 41; II,

p. 16 f., Figs. 67, 68. In an *Allegory of Love* by Garofalo in the National Gallery at London the presence of a lizard and a goat is held to illustrate the notion that the true lover should be as shy as the former but as passionate as the latter (C. Gould, *National Gallery Catalogues; The Sixteenth-Century Italian Schools*, p. 65).

70. See G. Swarzenski, "Bartolomeo Veneto und Lucrezia Borgia," Städel-Jahrbuch, II, 1922, pp. 63 ff.; J. Held, "Flora, Goddess and Courtesan," *De Artibus Opuscula* XL: *Essays in Honor of Erwin Panofsky*, 1961, pp. 201 ff., particularly p. 216, Fig. 19; Chastel and Klein, *L'Age de l'Humanisme*, p. 331, Pl. XXVI; A. Neumeyer, *Der Blick aus dem Bilde*, Berlin, 1964, p. 55.

Flora *tout court* but a young bride in the guise of Flora. Like so many Floras in half length, she proffers a bunch of flowers; she casts a provocative glance at the beholder; she has arranged her hair in equally provocative ringlets; she wears precious jewelry; and she has no qualms about exposing her left breast. All these symbols and attributes of *Voluptas* should not, however, have obscured the fact that she wears a bridal veil on top of a hair band of blue-and-pink shot silk, and that her head is encircled with a wreath of myrtle — *myrtus coniugalis*. Again we are faced with an allegorical marriage portrait; and the mythological image which this portrait is meant to evoke is not that of Flora the courtesan but that of Flora, the happy wife of Zephyr, who proudly proclaims that "her nuptial bed is never disturbed by any dissension."[71] It is perhaps not by accident that Rembrandt's earliest portrayal of his Saskia in the guise of Flora (the painting in the Hermitage) dates from 1634, the year of their marriage.[72]

71. Ovid, *Fasti* v, 206: "Inque meo non est ulla querela toro." That the North Italian Cinquecento did not object to a respectable bride being portrayed as invitingly as in Bartolomeo's Frankfurt picture is demonstrated, e.g., by Paris Bordone's *Mars and Venus* in Vienna, where the décolleté of the lady is even more daring. Yet this painting is unequivocally determined as a marriage picture by the presence of a quince (Panofsky, *Studies in Iconology*, p. 163, Fig. 121; Wind, *Bellini's Feast of the Gods*, p. 37, Fig. 22; our Fig. 143). For a Roman relief representing Eros and Anteros competing for quinces (alluded to above, p. 131), see Reinach, *Répertoire de reliefs*, II, p. 452, No. 1.

72. See J. Rosenberg, *Rembrandt*, Cambridge, Mass., 1948, p. 43, Fig. 61.

VI

Titian and Ovid

In the secular compositions thus far discussed the mythological element, if present at all, is restricted to characters and static situations; it does not extend to dramatic events. In the "*Feast of Venus*" and in the *Bacchanal of the Andrians*, in the "*Sacred and Profane Love*" and in the "*Allegory of the Marchese del Vasto*," in the "*Education of Cupid*" and in the various versions of *Venus and a Musician* — in all these paintings the classical gods and goddesses, even if not impersonated by contemporaries, appear as embodiments of a general idea or principle, and not as the heroes or heroines of an individual narrative. We are expected to comprehend what they are or stand for but not to share in what they do or suffer.[1]

When Titian wished to tell a real *favola* (apart from the ever-attractive Lucretia theme,[2] he seems to have had little interest in classical subjects

1. This is also true, e.g., of the mythological characters in the lost ceiling paintings for the Town Hall of Brescia (*V.*, II, p. 59, Pl. 197) and of the original, secular version of the problematic "*Allegory of Religion*," for which see pp. 186ff., *Excursus* 6.

2. See, apart from the two doubtful *Suicides of Lucretia* at Hampton Court (*V.*, I, Pl. 114) and Vienna (*V.*, I, Pl. 52), and an in my opinion even less acceptable picture representing the same subject whose present location is unknown (*V.*, I, Pl. 1), two late representations of Lucretia and Tarquinius: one, in the Fitzwilliam Museum at Cambridge (*V.*, II, Pl. 136, executed with some assistance but signed by Titian and engraved by Cornelis Cort), which shows (and possibly with a vague recollection of a Raphaelesque composition transmitted by Enea Vico's engraving B.

XV, p. 287f., No. 15) the actual rape; the other, in the Vienna Kunstakademie (*V.*, II, Pls. 137, 138), which shows the moment preceding it. Like A. E. Popp ("Tizians Lukrezia und Tarquin...", *Zeitschrift für Bildende Kunst*, LVI, 1921, pp.9ff.), I am inclined to consider the Vienna picture to be not a *modello* for the Cambridge painting but a later, revised version thereof — reduced, as it were, to a "close-up," intensifying the psychological impact at the expense of dramatic action and diminishing the amount of nudity just as do the later version of *Diana and Callisto* (*V.*, II, Pl. 86, our Fig. 172 as compared to *V.*, II, Pl. 85, our Fig. 164); the Munich version of the *Crowning with Thorns* (*V.*, II, Pl. 134, our Fig. 12, as compared to *V.*, I, Pl. 170, our Fig. 20); and the final version (C) of the "*Allegory of Religion*" discussed below pp.

of a non-mythological character) he normally found his textual inspiration in Ovid.[3] Given Ovid's role in Western humanism from c. 1100 up to our own day — no other classical author treated so great a variety of mythological subject matter and was so assiduously read, translated, paraphrased, commented upon, and illustrated — this fact is neither surprising nor unusual; not for nothing do many printed editions of Ovid's *Metamorphoses* and their paraphrases bear such subtitles as *"Bible des poètes,"* *"Malerbibel"* or *"Schildersbijbel."*[4]

Yet Titian's relationship to the "poet between two worlds," as he has been called, is rather special. He must have felt an inner affinity to an author profound as well as witty, sensuous as well as aware of mankind's tragic subjection to destiny. And it was precisely this inner affinity which enabled Titian to interpret Ovid's texts both literally and freely, both with minute attention to detail and in a spirit of uninhibited inventiveness. No other major artist interested in mythological narratives relied so largely on Ovid, and from a single phrase of the text drew visual conclusions of such importance. Yet no other major artist indebted to Ovid hesitated so little to supplement the text with other sources and even, in at least one case, to change its essential significance. Small wonder that

186 ff. (*V.*, II, Pl. 185, our Fig. 195 as compared to *V.*, II, Pl. 130, our Fig. 193, and the version engraved by Giulio Fontana, our Fig. 194). For a *Death of Milo of Crotona*, transmitted only through an anonymous woodcut (J. D. Passavant, *Le Peintre-Graveur*, Leipzig, 1860-64, VI, p. 237, No. 70, not listed in *V.*), see H. Tietze and E. Tietze-Conrat, "Tizian-Graphik," *Die graphischen Künste*, new series, III, 1938, pp. 8 ff., 52 ff., particularly p. 64 and Fig. 13.

3. Even if we were to accept the *Woods of Polydorus* in the Museo Civico at Padua (*V.*, I, Pls. 4B, 6, 7; cf. M. Bonicatti, *Aspetti dell' Umanesimo nella pittura Veneta dal 1455 al 1515*, Rome, 1964, p. 201 f., Fig. 100), as authentic, we should have to assume that its main source (Virgil, *Aeneid*, III, 19-56) was supplemented by Ovid, *Metamorphoses*, XIII, 404-407; for it is only in these verses (athetized by modern scholarship but never questioned in the Renaissance) that mention is made of the maddened Hecuba about to be transformed into a barking

dog (Hecabe = Hecate?). Ovidian subjects also prevail among mythological pictures known to us only through literary references: the *Punishment of Ixion* (see below, pp. 147 ff.); *Jason and Medea* (see below, p. 154; *Metamorphoses*, VII, 9-403); a *Pomona* (see above, p. 80, Note 48; *Metamorphoses*, XIV, 622-771); and a *Rape of Proserpina* ordered for Ferrante Gonzaga by his brother, Federico; (*C.-C.*, I, p. 400; *Metamorphoses*, V, 376-571).

4. See M. D. Henkel, "Illustrierte Ausgaben von Ovids Metamorphosen im XV., XVI. und XVII. Jahrhundert," *Vorträge der Bibliothek Warburg*, 1926-27, pp. 58 ff., particularly p. 59. Petrus Berchorius' *Moralized Ovid* is now available in a critical edition by J. Engels, *De formis figurisque deorum* (Werkmateriaal, 3, uitgegeven door het Instituut voor Laat Latijn), Utrecht, 1966. See also Panofsky, *Renaissance and Renascences*, pp. 75-81, and the excellent critical bibliography by J. Engels, "Berchoriana," *Vivarium*, II, 1964, pp. 62 ff., 113 ff., and III, 1965, pp. 128 ff.

Titian, as an interpreter of Ovid, felt free to use all kinds of visual models, ancient or modern, while yet, on the whole, remaining independent of the specific tradition which flourished all around him in countless illustrated editions, translations and paraphrases of the *Metamorphoses*.[5]

The earliest of Titian's Ovidian narratives — a prime example of multiple derivation with respect to textual as well as visual sources — is his final contribution to the decoration of Alfonso d'Este's Studio in the Castle at Ferrara: the *Bacchus and Ariadne*, now in the National Gallery in London, for which, we recall, the Duke had to wait until the spring or early summer of 1523 (Fig. 115).[6]

The subject of the picture is so unusual even in classical,[7] let alone postclassical, art that Annibale Roncagli — the gentleman who recorded the paintings illegally removed from Ferrara in 1598 — could not properly identify it: he describes the painting as "a picture of square format, by the hand of Titian, in which Laocoön is depicted." This statement is understandable in that the snake-encircled figure in the right-hand foreground bears a probably more than accidental resemblance to the Vatican group, seen in side view, of which a plaster cast must have become accessible to Titian just about 1520.[8] That Titian included this snake-encircled figure at all is due to the fact that he depicted the train

5. Of the more than thirty publications of this kind which, according to Henkel, ibidem, p. 234f., appeared during Titian's lifetime, no less than fifteen were printed in Venice, among them the first illustrated edition (containing an Italian translation of the original text rather than Berchorius' moralization and embellished with Renaissance rather than late Gothic woodcuts), published in 1497; and the charmingly worded and illustrated paraphrase in *ottava rima* by Titian's good friend, Lodovico Dolce, published in 1553.

6. *V.*, I, Pls. 111-113; cf. above, pp. 97 and 99. For the most important literature, see Wind, *Bellini's Feast of the Gods*, pp. 56 ff.; idem, "A Note on Bacchus and Ariadne", *Burlington Magazine*, XCII, 1950, pp. 82 ff. (in reply to the review by G. Robertson, ibidem, XCI, 1949, p. 295 f.); G. H. Thompson, "The Literary Sources of Titian's *Bacchus and Ariadne*," *The Classical Journal*, LI, 1956,

pp. 259 ff.; cf. also Gould, *National Gallery Catalogues; The Sixteenth-Century Venetian School*, pp. 102 ff. To be added: Brendel, "Borrowings from Ancient Art in Titian," p. 118, and R. W. Kennedy, "Apelles Redivivus," p. 166 (Mrs. Kennedy, however, would seem to overemphasize the importance of Catullus at the expense of the more important passages in Ovid's *Fasti* and *Ars amatoria*).

7. The only approximate parallels — some Roman sarcophagi apparently unpublished but kindly brought to my attention by my friend, Professor P. H. von Blanckenhagen — show Bacchus quietly descending, not leaping, from his chariot.

8. See the Resurrected Christ in the Brescia polyptych, *V.*, I, Pl. 101 (our Fig. 15); the gait of the snake-encircled figure may have been influenced, however, by a Bacchic relief still preserved in Mantua (Reinach, *Répertoire de reliefs*, III, p. 49, No. 3).

of Bacchus (as already noted by Lomazzo and Ridolfi) on the basis of
Catullus' description of an imaginary tapestry showing Bacchus and his
retinue in search of Ariadne (*Carmina*, LXIV, 257-265) — a description
which not only enumerates such standard motifs as the brandishing of
thyrsi, the beating of cymbals and tambourines and the throwing of the
limbs of a dismembered heifer but also includes the telltale reference to
certain votaries "girding themselves with coiling serpents" (*pars sese
tortis serpentibus incingebant*).

With regard to Titian's picture, however, this Catullus passage ac-
counts only for the equipment and behavior of Bacchus' followers. The
actual subject was inspired by Ovid — and, characteristically, by two
entirely different passages neither of which is found in the *Metamorphoses*.
One of these passages — and in this respect I agree with Edgar Wind — is
Ovid's glowing evocation of Ariadne's second and final encounter with
Bacchus in *Fasti*, III, 459-516. Ariadne, abandoned by Theseus on the
Island of Naxos, is rescued by Bacchus who finds her asleep on the shore.
Then he, too, deserts her to conquer India. She walks on the water's edge
in despair, declaiming against the faithlessness of both her lovers and
wishing for her death. But Bacchus, having returned from his triumph
and having followed her "from behind" (*a tergo forte secutus*), appears to
her for a second time. He "dries her tears with kisses," and she dies in his
arms to share his immortality: "'Let us attain together the summit of
heaven,' says the god" (*Et, pariter coeli summa petamus, ait*). The jewels of
her diadem are transformed into the constellation known as Corona (the
"Cnossian Crown") clearly discernible in the upper left-hand corner of
Titian's picture. It is only by the phrase *a tergo forte secutus* that we can
account for the averted posture of Ariadne.[9]

But to explain the action of Bacchus himself — and in this respect I
must agree with G. H. Thompson — we have to postulate the additional
influence of Ovid's *Ars amatoria* (I, 525-564). Here (as also in the briefer
reference in *Metamorphoses*, VIII, 174-182) the difference between Bacchus'
first and second encounter with Ariadne is deliberately obscured. Bacchus
already calls Ariadne his "wife," promises her immortality and announces
that the Cnossian Crown will always direct "the doubtful ship" at sea;
she still sighs and weeps for Theseus as if he had just left and she had never

9. See Wind, *Bellini's Feast of the Gods*,
p. 58. The general posture of the figure—
torso seen from the rear, left arm lowered
and face turned up — seems to derive from
a well-known classical maenad type (Rei-
nach, ibidem, pp. 161, No. 2, and 424,
No. 3).

encountered Bacchus before.[10] But it is the *Ars amatoria*, and the *Ars amatoria* only, which supplies the textual basis for the most unforgettable motif in Titian's unforgettable picture: the "swift bound of Bacchus from his chariot," as Keats was to phrase it. "This said, the god did from his chariot leap Lest she be frightened by his tigers..." ("Dixit et e curru, ne tigres illa timeret,/*Desilit*...").

It has been mentioned in passing that Titian borrowed the pose of Bacchus (which, we remember, was to be resumed in the two *St. Margarets*) from a classical Orestes sarcophagus (Fig. 57);[11] faced with the task of expressing supreme emotion, he turned to classical art as to a treasure house of what Warburg felicitously called *Pathosformeln* ("patterns of passionate emotion"). But here as elsewhere Titian bettered the instruction. Unifying as well as intensifying the rhythm of his classical model, he lowered the right arm, brought the head down to a level lower than that of the left shoulder, and provided the figure with wings, as it were, by the addition of a crimson mantle billowing back with a magnificent sweep. The idea of the "leap," however, was suggested by Ovid's *Desilit*.

One small but significant change, bearing witness to that combination of respect for the letter with freedom of the spirit which characterizes Titian's attitude toward Ovid, is the replacement of Bacchus' "tigers" (which the poet in turn had substituted for the more usual panthers) with smaller felines, spotted rather than striped, which the experts have identified as hunting leopards or cheetahs.[12] Cheetahs, as their Hindustani name implies, are an Indian species; and their substitution for Ovid's tigers would seem to have been motivated by two considerations. Firstly, the painter wished to gratify his patron's interest in rare, exotic animals — an interest characteristic of most Renaissance aristocrats but so marked

10. Much ink has been spilled over the question whether the small sailboat, indistinctly visible in the far distance on the left, merely forms part of the maritime scenery or belongs to Theseus, as claimed by Ridolfi. Even if it did, its presence would not compel us to assume that Titian's painting represents the first, and not the second, encounter between Bacchus and Ariadne: if the boat were Theseus' it could be a visual footnote referring to Ariadne's initial abandonment which was the precondition for both her encounters with Bacchus. In fact the account in the *Fasti*, indubitably referring to the second of these encounters, describes Ariadne as complaining of Theseus as well as Bacchus (line 473f.) and begins with the lines (459f.):

"Protinus adspicies venienti nocte Coronam
Gnosida. Theseo crimine facta Dea est."

11. See above, p. 50, Note 49.

12. See Gould, *National Gallery Catalogues; The Sixteenth-Century Venetian School*, p. 103. The Greek πάρδαλις, employed by Philostratus in *Imagines*, I, 15 and 19, denotes a panther (*Pardel* in archaic German) or, *de rigueur*, a regular leopard, but hardly ever a tiger.

in Alfonso d'Este that, in 1520, he requested Titian to portray a gazelle kept in the Palazzo Cornaro (Titian dutifully went there, only to learn that the animal had died; but he offered to fulfill the Duke's desire by producing an enlarged copy of a picture once made by Giovanni Bellini).[13] Secondly, and more importantly, Titian wanted to make it perfectly clear that Bacchus had returned from India. Inconspicuous though it is, the presence of the cheetahs confirms the assumption that the subject of Titian's picture is Bacchus' second, and final, encounter with Ariadne: in assimilating the god to Orestes, Titian transformed a man who kills what he hates into a god who immortalizes, but thereby destroys, what he loves.

It took an interval of more than twenty years, and a special concatenation of circumstances, to call into being Titian's next mythological narrative: the *Danaë* at Naples (Fig. 150).[14] Painted in Rome for Ottavio Farnese (the natural grandson, we recall, of Pope Paul III),[15] this picture served a threefold purpose: it was meant to please a young prince with the depiction of an erotic subject; to do justice to a classical myth of which no classical representation was known in the Renaissance; and to challenge Michelangelo.

In Ovid the story of Danaë — the beautiful daughter of Acrisius, King of Argos, whom her father had imprisoned in a tower of bronze in order

13. *C.-C.*, I, p. 232 f.; cf. E. Tietze-Conrat, "Giovanni Bellini and Cornaro's Gazelle," *Gazette des Beaux-Arts*, series 6, XXIX, 1946, pp. 187 ff., and XXX, 1946, p. 185.
14. *V.*, II, Pls. 4–5; Bock von Wülfingen, *Tiziano Vecellio, Danaë* (cited above, p. 12, Note 10). H. Tietze, "An Early Version of Titian's Danaë...," *Arte Veneta*, VIII, 1954, pp. 199 ff., attempted to defend the view that the Danaë picture formerly in the Hickox Collection in New York (*V.*, II, p. 65, Pl. 152) is an original preceding the Naples canvas. In my opinion it is a workshop variant fusing the Naples with the Madrid version (*V.*, II, Pl. 58); with the latter it shares, apart from the lack of a loin cloth, the little dog and the position of the fingers of the right hand. For the iconography of the Danaë myth, cf. Panofsky, "Der gefesselte Eros"; L. D. Ettlinger in *Reallexikon zur deutschen Kunst-geschichte*, III, cols. 1029 ff.; W. S. Heckscher, "Recorded from Dark Recollection," *De Artibus Opuscula* XL: *Essays in Honor of Erwin Panofsky*, pp. 187 ff. For a Danaë play by Baldassare Taccone which had the distinction of being performed at Milan on January 31, 1496, in settings designed by Leonardo da Vinci but does not seem to have had any influence on painting, see K. T. Steinitz, "Le Dessin de Léonard de Vinci pour la représentation de la Danaë de Baldassare Taccone," *Colloques internationaux du centre national de la recherche scientifique (Sciences humaines)*, *Le Lieu théâtral à la Renaissance*, Paris, 1964, pp. 35 ff.
15. I must contritely admit that in my essay "Der gefesselte Eros" a nonexistent "Cardinal Ottaviano Farnese" was erroneously substituted for Prince Ottavio Farnese.

to protect her from any intercourse with men but who, approached by Jupiter in the guise of a golden shower, became the mother of Perseus — is frequently alluded to but not circumstantially told.[16] And with one late exception[17] it was not included in the cycles of miniatures, woodcuts or engravings which illustrate the manuscripts or printed editions of Ovid's *Metamorphoses* and its paraphrases.

The Middle Ages, therefore, represented and interpreted Danaë, according to context, in many different ways: as a contemporary princess surrounded by a bevy of young ladies-in-waiting instead of what the classical sources call a "nurse" or an "old woman," while Jupiter approaches her disguised as a salesman of jewelry (*Recueil des histoires de Troie*); as a personification of Modesty, *Pudicitia*, protected by her tower which thus became a symbol of Chastity (*Fulgentius metaforalis*); or even as a prefiguration of the Virgin Mary: "If Danaë," asks our old friend, Franciscus de Retza, "conceived from Jupiter through a golden shower, why should the Virgin not give birth when impregnated by the Holy Spirit"? ("Si Danaë auri pluvia praegnans a Jove claret,/Cur Spiritu Sancto gravida Virgo non generaret"?).

Jan Gossart could develop a charming, child-like *Danaë* from the mediaeval "*Pudicitia* type." The Italian Renaissance, however, started from scratch; and except for such enchanting *hapax legomena* as the Danaë scene in Baldassare Peruzzi's little frieze in the Villa Farnesina and Correggio's voluptuous masterpiece in the Borghese Gallery, the Cinquecento and Seicento renderings fall into two classes. In one — which includes Annibale Carracci's *Danaë* formerly in Bridgewater House[18] and Rembrandt's famous picture in the Hermitage (Fig. 151)[19] — the figure of the heroine is assimilated to the Venetian type of the reclining Venus so that

16. Ovid, *Metamorphoses*, IV, 611, 697f.; VI, 113; XI, 117. Further see *Ars amatoria*, III, 415f. (important because an "old woman" is mentioned as Danaë's companion); *Amores*, II, 19, 27f.; III, 4, 21f.

17. Jean Le Pautre, referred to by Henkel, "Illustrierte Ausgaben von Ovids Metamorphosen," p. 134.

18. Unfortunately destroyed; see J. R. Martin, *The Farnese Gallery*, p. 96. For an illustration of Peruzzi's *Danaë*, see Saxl, *Lectures*, II, Pl. 126b.

19. C. Brière-Misme's attempt to prove that Rembrandt's Leningrad picture represents Semele rather than Danaë ("La

'Danaë' de Rembrandt et son véritable sujet," *Gazette des Beaux-Arts*, series 6, XXXIX, 1952, pp. 305ff., 373ff.; XLI, 1953, pp. 27ff., 70ff.) cannot be taken seriously — not only in view of the documents and of a drawing in the Brunswick Museum (cf. J. Rosenberg, *Rembrandt*, I, p. 162f.) but also because in all known renderings of the Semele story the heroine expresses fear and horror rather than joyous expectation. Peruzzi's frieze (see preceding note), where the two scenes are represented almost side by side, makes the difference abundantly clear.

expectation is substituted for fulfillment. In the other, she is assimilated to Michelangelo's *Leda* where we witness the climactic moment of what Goethe calls "the loveliest of all scenes."

This "Leda type" was adopted by Primaticcio in his fresco in the Gallery of Francis I at Fontainebleau (painted some time after 1540, lost but transmitted through an engraving by Léonard Thiry as well as through a tapestry in the Vienna Museum, Fig. 152), and by Titian in his Naples picture. It is just possible that Titian knew Primaticcio's composition either through Léonard Thiry's engraving or through a drawing (he can hardly have met Primaticcio in person, for when the latter went to Rome between 1540 and 1542 he did so only in order to buy works of art for Francis I and is not likely to have stopped at Venice). But certain it is that Primaticcio as well as Titian developed their compositions from Michelangelo's *Leda* of 1530 which, we know, was familiar to both of them. Primaticcio could have seen the original — as well as Rosso's copy of it (Fig. 153) — in France, probably at Fontainebleau itself;[20] Titian could have seen Vasari's copy which the latter had brought to Venice in 1541 and sold, together with a copy after Michelangelo's *Venus*, to Titian's friend and client, Don Diego Hurtado de Mendoza.[21]

I have no doubt that Titian's heroic *Danaë* was intended to compete with the *Leda* of Michelangelo who, on the occasion of a visit to Titian's Roman workshop, praised it highly "as one does in the painter's presence" (privately, he restricted this praise to "color and technique" while regretting that the Venetian painters had never learned the principles of good design). But there are, needless to say, as many differences as there are similarities. Michelangelo's *Leda*, as rightly stressed by Charles de Tolnay, lowers her head and closes her eyes as in a dream; Titian's *Danaë* consciously, blushingly and joyfully abandons herself, and her pose, the foot of the raised leg firmly supported by the

20. Michelangelo had painted his *Leda* for Alfonso d'Este in recognition of the latter's hospitality in 1529 but refused to hand it over to Alfonso's envoy who had incurred the artist's displeasure. In 1531 he gave it to his unfortunate pupil, Antonio Mini, who emigrated to France and attempted to sell it to Francis I; but Mini was swindled out of it, and the picture reached Fontainebleau only after some litigation but probably not later than c. 1540. See

H. Thode, *Michelangelo, Kritische Untersuchungen*, II, p. 311; de Tolnay, *Michelangelo*, III, pp. 190 ff.; P. Barocchi, *Il Rosso Fiorentino*, Rome, 1950, pp. 78 ff.
21. See above, p. 121f., Note 34. That Michelangelo's *Leda* was copied (or, rather, recopied) in Venice soon after Vasari's visit in 1541 is demonstrated by a mid-sixteenth-century Venetian painting in the Museo Correr (de Tolnay, ibidem, Fig. 283).

couch instead of being suspended in mid-air (as in the *Leda*), gives the impression of both rapture and relaxation. In addition, two or three other threads seem to have gone into the fabric of Titian's composition. He must himself have looked at what seems to have been the classical source of Michelangelo's *Leda*: a Roman relief transmitted through a sixteenth-century drawing (Fig. 154)[22] which anticipates the Naples picture not only in the position and action of the supporting arm (quite differently placed and employed in Michelangelo's *Leda* as well as in Primaticcio's *Danaë*) but also in the presence of a Cupid on the right — a figure perhaps not really belonging to the Roman relief but demonstrably attached to it in the sixteenth century. And in dramatizing the posture of this Cupid into a violent, awestruck contrapposto, with the movement of the head opposing rather than following that of the torso and the legs, Titian emulated not only the Lysippian *Eros Bending His Bow* in the Museo Capitolino but also — perhaps even more so — his favorite among Michelangelo's statues: the *"Risen Christ"* in S. Maria sopra Minerva (Fig. 27).[23]

A spirit of heroic grandeur, intensified by the combined impact of Michelangelo and the antique, also pervades a series of four mythological narratives commissioned to Titian during his first stay at Augsburg, that is to say, in 1548, by Charles V's sister, Mary of Hungary, then Regent of the Netherlands.[24] In 1549, they adorned the upper hall of her palace at Binche but had to be removed at the approach of the French army in 1554. Transported to Spain two years later, they found their place in the Royal Palace at Madrid where they fell prey to the notorious conflagration of 1734. Two of them, severely damaged (*maltratado*, as a Spanish source has it), could be restored and survive in the Prado;[25] the other two were entirely destroyed, though one of them is at least known to us through an engraving by Giulio Sanuto.

22. Drawing in the *Codex Coburgensis*. Veste Coburg, MS. HZ II (reproduced, e.g., in de Tolnay, ibidem, p. 192, Fig. 281, but mistakenly referred to as being in the "Codex Pighianus" in Berlin in the list of illustrations, p. 273, and in the index, p. 251).
23. See above, p. 26, Note 42.
24. *V.*, II, Pls. 30, 31, and p. 55f., Pl. 195. For some additions to the bibliography, see Panofsky, *Studies in Iconology*, p. 217 and p. xiii in the edition of 1962.
25. The otherwise excellent article by A. van de Put, "Two Drawings of the Fêtes at Binche for Charles V and Philip (II) 1549," *Journal of the Warburg and Courtauld Institutes*, III, 1939-40, pp. 49 ff., is inaccurate in designating the two Prado pictures as "copies."

10*

The subject of this foursome is taken from Ovid's *Metamorphoses*, IV, 455-461.[26] In a special corner of Hades designated by Ovid as the "abode of the evil-doers" (*sedes scelerata*) — which may account for the fact that the room of the Royal Palace where Titian's pictures were installed was known as either the "Room of the Furies" or the "Room of the Damned" (*Pieza de las Furias* or *Pieza de los Condenados*) — Juno observes the punishment of four great sinners in the following sequence and manner: Tityus, the violator of Latona, whose liver (the seat of amorous passion) is forever devoured by a vulture (Fig. 155); Tantalus, the betrayer of Olympian secrets, forever reaching in vain for food and drink (Fig. 156); Sisyphus, the cleverest and most perfidious of men, forever carrying uphill and losing a heavy rock (Fig. 157); and Ixion, the would-be seducer of Juno herself, forever swirling around on his wheel.

Titian seems to have intended the Ovidian order in such a way that he divided the series of four pictures into two pairs facing each other on opposite walls: the *Tityus* (one of the two canvases surviving in the Prado and misinterpreted as "*Prometheus*" as early as the sixteenth century)[27] faced the *Tantalus*, transmitted through Sanuto's print, across the room; the *Sisyphus* (the other surviving member of the series) similarly faced the *Ixion*. As can be inferred from a drawing, at Binche, at least, the *Tityus* and the *Sisyphus* were on the same wall.[28]

The *Tityus* may or may not have been influenced by Michelangelo's rendering of the same subject in one of his Cavalieri drawings;[29] but certain it is that the posture of Tantalus — reclining on rocks surrounded by water — derives from the *Fallen Gaul* already mentioned twice (Fig. 63);[30] and this boldly unclassical adaptation of a classical motif enabled Titian to show the unfortunate hero — for the first time and perhaps uniquely— in the very predicament described by Homer and Ovid: "Unable to catch the waters while the overhanging tree escapes his grasp"

26. Ovid's enumeration is more complete than that in Homer's *Odyssey*, XI, 576ff. (athetized by modern scholarship but quoted in as early a source as Plato's *Gorgias*, 525 E), where Ixion is omitted; and those in Virgil's *Aeneid* (VI, 595ff.) and *Georgics* (IV, 481ff.), where Sisyphus and Tantalus are absent.

27. This misinterpretation occurs in Vasari (VII, p. 451), in Juan C. Calvete's description quoted by van de Put, "Two Drawings of the Fêtes at Binche,"and even in Cornelis Cort's engraving of 1566, for which see O. Raggio, "The Myth of Prometheus; Its Survival and Metamorphoses up to the Eighteenth Century," *Journal of the Warburg and Courtauld Institutes*, XXI, 1958, pp. 44ff., particularly p. 58, and Pl. 9c.

28. Van de Put, ibidem, Pl. 8a.

29. Thode, *Michelangelo, Kritische Untersuchungen*, II, p. 358.

30. Brendel, "Borrowings from Ancient Art in Titian," p. 122 (see above, p. 65, Note 19).

(*Metamorphoses*, IV, 458f.: *tibi, Tantale, nullae/Deprenduntur aquae, quaeque imminet effugit arbor*). In addition, the assimilation of the pose of Tantalus to that of the *Fallen Gaul* made him an admirable counterpart to the *Tityus*: both figures are shown recumbent rather than standing and produce a fine, chiastic pattern, the body of Tityus placed high but sloping downward, his right arm lowered; the body of Tantalus placed low but sloping upward, his right arm raised.

The *Ixion*, we recall, has left no trace. And of the *Sisyphus* we can say only that this grandiose figure, burdened to the point of collapse — but never allowed to collapse — and set out against a magnificently infernal background, represents another attempt to infuse a classical scheme of movement[31] with the *terribiltà* of Michelangelo.

In the summer of 1554, Philip II, then still Crown Prince, received (as we learn from a letter addressed to him by Titian some time after July 25th) a second edition of Ottavio Farnese's *Danaë*; the picture (Fig. 158), which was still unfinished the year before, is preserved in the Prado.[32] The significant stylistic difference between the two versions — the second more assiduously repeated than the first[33] — has already been mentioned in the Introduction. From an iconographical point of view, we can observe a stronger accentuation of both the erotic and the ominous elements. The presence of a little dog, the rumpled bedclothes, the omission of the loin cloth in favor of a *Venus pudica* gesture (which, as so often, emphasizes what it pretends to conceal) lend a more intimate character to the scene; moreover, the expression on the blushing face of

31. See, e.g., one of the basket carriers on the tomb of M. Vergilius Eurysaces in Rome (Reinach, *Répertoire de reliefs*, III, p. 236, No. 1).

32. *V.*, II, Pl. 58; Bock von Wülfingen, *Tiziano Vecellio, Danaë*. The approximate date of Titian's letter (Ticozzi, *Vite dei pittori Vecelli di Cadore*, p. 312; cf. *C.-C.*, II, p. 237) can be inferred from the fact that he congratulates the King on his marriage to Mary Tudor which had taken place on July 25, 1554. For a recently identified drawing made in preparation of the head of the old nurse (Bayonne, Musée Bonnat), see K. Bauch, "Zu Tizian als Zeichner" (cited above, p. 38, Note 26), Fig. 3. In this drawing the face of the old woman is much more "grotesque" than in the painting where, as observed by Eugenia Zarnowska (cited by Bauch, p. 39), her appearance is considerably beautified *ex post facto*.

33. See, in addition to the pastiche referred to on p. 144, Note 14, the paintings in Leningrad (*V.*, II, Pl. 59) and Vienna (*V.*, II, Pl. 60), where the couch is strewn with roses and the nurse somewhat resembles the personification of Hope in the Louvre "*Allegory of the Marchese del Vasto*" (fig 141).

the de-heroized — and, if one may say so, de-Michelangelized — *Danaë*
is so enraptured yet so remote that she seems to "die" in the Elizabethan
sense of the word.

On the other hand, the atmosphere is one of dark foreboding. The
golden shower, almost reddish, bursts forth from the dark clouds in
a somber, thunderous sky (Jove seems to appear not as "Jupiter
Pluvius" but as "Jupiter Tonans," manifesting himself not in a gently
descending stream of gold but in a terrific explosion); and the hideous
old nurse, who has replaced the Lysippian Cupid of the earlier version,
serves not only to set off the youth and beauty of Danaë but also to stress
the miraculous nature of an event which in the old woman excites only
greed but transforms her young mistress into a chosen vessel destined to
give a savior to the world.

In the letter of 1554, which refers to this second *Danaë* as already in
Philip's possession, Titian announces the shipment of another mytho-
logical narrative which, despite the difference in size and format (c. $6\frac{1}{8}'$
by c. $6\frac{3}{4}'$ as against c. $4\frac{1}{6}'$ by $5\frac{5}{6}'$), he conceived as a kind of companion
piece of the *Danaë*: a *Venus and Adonis* (Fig. 159) which, according to
Titian, would offer a pleasant variety in the decoration of a *camerino*
because it gave occasion to show the forms from the back where the
Danaë showed them in front view; still other aspects, he goes on to say, he
hopes to give in renderings of *Perseus and Andromeda* and *Jason and Medea*.

The *Venus and Adonis* was first sent to Madrid; but it was soon forwarded
to London where Philip resided as the newly-wed King Consort of Mary
Tudor. It arrived some time before December 6th, 1554, on which day
Philip angrily complained about the picture's condition: it was disfigured
by a horizontal break in the middle, severing the head of Venus from her
body. Still discernible, it serves to distinguish the original in the Prado
from the many replicas and variants produced, with or without his personal
participation, in Titian's workshop.[34]

34. *V.*, II, Pl. 57. For Philip's angry letter, enjoining his officials to send no pictures in the future without his special instructions, see *C.-C.*, II, p. 509. For replicas and variants, cf. the excellent summary in Gould, *National Gallery Catalogues; The Sixteenth-Century Venetian School*, pp. 98 ff. They can be divided into two groups: Group A, which is quite close to the Prado original in format as well as in iconography (apart from some unimportant changes in costume), comprises the original in the Prado and the paintings in the London National Gallery (*V.*, II, Pl. 56) and in the Galleria Nazionale at Rome (*V.*, II, p. 68, Pl. 162 B). The members of Group B (apparently somewhat later than Group A) are not only smaller and more

In fulfilling his promise to show "the female form from the back," Titian had recourse to a classical model distinguished by the fact that a seated figure, seen from the rear, is turned in such a way that head and feet are pointing in opposite directions. About the nearest analogue I could find is the nude in the so-called *"Bed of Pòlyclitus"* (Fig. 160); but it is through the intermediary of the beautiful Hebe in Raphael's *Marriage of Psyche* (probably executed by Francesco Penni) in the Villa Farnesina (Fig. 161)[35] that the motif seems to have come to Titian's attention. And in an attempt to justify this inversion of the Venus figure Titian not only left the path of the established illustrative tradition but in a very real sense rewrote the whole myth — for which he was severely censured by Raffaello Borghini as early as 1584.[36]

pronouncedly oblong in format but also show significant iconographical changes; this group is represented by the pictures in the National Gallery at Washington (*V.*, II, Pl. 90) and in the Metropolitan Museum at New York (*V.*, II, Pl. 91). In Group A Cupid is asleep on his back while in Group B he flees the scene in terror, clutching a dove; both features allude to the frustration of Venus' love for Adonis, a motif which in Group A is further emphasized by an upturned vessel in the left-hand foreground. In Group B the chariot in the clouds (Gould is indubitably right in believing that this chariot, drawn by doves, belongs to Venus and neither to Apollo nor Jupiter) is replaced by a mere radiance; and the third dog, looking straight up to the divine apparition in Group A, is consequently omitted. For an unusually small specimen of group A in the M. de Marignac Collection at Paris — identifiable with a *quadretto d'Adonis* referred to by Titian in a letter of May 24, 1562 (*C.-C.*, II, p. 524) — see E. Tietze-Conrat, "Titian's Workshop in His Late Years," pp. 79, 85.

35. For the *"Bed of Polyclitus"* and its influence on Renaissance art see J. v. Schlosser, "Über einige Antiken Ghibertis," *Jahrbuch der kunsthistorischen Sammlungen des Allerhöchsten Kaiserhauses*, XXIV, 1904, pp. 125 ff., and E. H. Gombrich, "The Style *all'antica*: Imitation and Assimila-

tion," *Studies in Western Art, Acts of the Twentieth International Congress of the History of Art*, Princeton, 1963, II, pp. 31 ff., particularly p. 37 and Fig. 19. In the version illustrated by Gombrich the figure agrees with Titian's *Venus* also in that the right leg is lifted to a nearly horizontal position; but in outline and rhythm Titian's *Venus* is more closely akin to Raphael's Hebe; I am both glad and sorry to see that the same observation was made by Cecil Gould, "The *Perseus and Andromeda* and Titian's *Poesie*," *Burlington Magazine*, CV, 1963, pp. 112 ff. (followed by a correspondence, not relevant to our problem), ibidem, pp. 281, 413 f. The relief from the *"Ara Grimani,"* claimed as Titian's source by Brendel, "Borrowings of Ancient Art in Titian," p. 122, Fig. 22, is very different from Titian's Venus in all distinctive points.

36. Raffaelo Borghini, *Il Riposo*, Florence, 1584, in the Florentine edition of 1730, p. 49 (quoted in R. W. Lee, *"Ut pictura poesis*; The Humanistic Theory of Painting," New York, 1967, p. 44), takes Titian to task for his departure from Ovid in "depicting Adonis fleeing from Venus, who is shown in the act of embracing him, whereas he very much desired her embraces" ("fingendo Adone da Venere, che sta in atto di abbracciarlo, fuggire; dove egli molto disiderava i suoi abbracciamenti").

The *locus classicus* for the story of Venus and Adonis is in the Tenth Book of Ovid's *Metamorphoses* (519-end). Accidentally wounded by one of Cupid's arrows, Venus falls in love with Adonis, the beautiful hunter; she loves him so much that she herself takes up hunting in a small and harmless way. Although Adonis reciprocates her love the goddess fears his passion for big and dangerous game. "Mingling her words with kisses," she warns him against pursuing such animals as lions, bears or boars; and to prove her point she tells him how she had engineered the transformation of Hippomenes and Atalanta into a lion and a lioness, thereby incurring the everlasting hatred of warlike beasts. Warning him once more, she leaves the scene of their pleasures — according to some, Mount Lebanon — and departs for Cyprus in her swan-drawn chariot. It is only after her departure that Adonis' "courage defeats her admonitions." Left to his own devices, he goes boar hunting and meets his death.

This tale conjures up an image quite different from Titian's painting. Ovid's Adonis, responsive rather than recalcitrant, does not break away from the entreaties of Venus; only after her air-borne departure (echoed in Titian's picture and its nearest relatives, except for the fact that her chariot is drawn by doves rather than swans) does he yield to the temptation of the chase. Titian's Adonis, however, tears himself away from Venus almost as Joseph tears himself away from the wife of Potiphar, while little Cupid, reduced to impotence, lies on his back.

The illustrated Ovid editions — including the *Métamorphose d'Ovide figurée* with the extremely influential woodcuts by Bernard Salomon (first edition Lyons, 1557) — contain, as a rule, only two Adonis scenes: Venus and Adonis as happy lovers, she holding him in her lap; and her lament after his death. Even the inventive Rosso, in one of the frescoes in the Gallery of Francis I at Fontainebleau, confines himself to an admirable variation on the lamentation scene, enriched by reminiscences from Bion of Smyrna's *Dirge on Adonis*.[37] It was Titian who invented what may be called "The Flight of Adonis" in contradistinction to the "Leave-Taking of Venus" as represented in a drawing by Antonio Molinari and hinted at (by the approach of her unoccupied chariot) in an otherwise conventional etching by or after Hans Bol (Fig. 162).[38]

37. Cf. E. and D. Panofsky, "The Iconography of the Galerie François I^{er} at Fontainebleau," *Gazette des Beaux-Arts*, series 6, LII, 1958, pp. 113ff., particularly pp. 139ff., Figs. 33-35 (on p. 142, line 4, "Fortune" should read "Nemesis").

38. For the etching by or after Hans Bol (1534-1593), see Henkel, "Illustrierte Ausgaben von Ovids Metamorphosen," p. 111, Note, and F. W. H. Hollstein, *Dutch and Flemish Etchings, Engravings and Woodcuts*, Amsterdam, 1949ff., III,

We are tempted to look for a Renaissance text which might have inter-posed itself between the *Metamorphoses* and Titian's painting and would account for his bold and much imitated transformation of a "Leave-Taking of Venus" into a "Flight of Adonis." But not even the learned editors of the *New Variorum Shakespeare* have succeeded in finding such a text.[39]

Why should Shakespearean scholars have bothered to look for it? Because they are troubled by the same problem as are the art historians. Shakespeare, like Titian, interprets Adonis as a reluctant lover; in stanza 136 of *Venus and Adonis* he describes Adonis' flight from Venus as follows:

> "With this he breaketh from the sweet embrace
> Of those faire armes which bound him to her brest,
> And homeward through the dark lawnd runs apace;
> Leaves love upon her backe, deeply distrest.
> Looke, how a bright star shooteth from the skye,
> So glides he in the night from Venus eye."

Reading these lines, we are inclined to doubt the assumption that Shake-speare inadvertently fused, or confused, his hero with such truly frigid or misogynist characters as Glaucus, Narcissus, Hippolytus, or Hermaphro-ditus. Shakespeare's words, down to such details as the nocturnal setting and "love upon her backe deeply distrest," sound like a poetic paraphrase of Titian's composition. And, given the fact that the painting ordered by Philip II had remained in England for several years and was widely accessible in sixteenth-century prints by Giulio Sanuto (dated 1559) and Martino Rota (died 1583),[40] I venture to propose that Titian — just as he was to inspire Keats with his "swift bound of Bacchus" — inspired Shakespeare with a new version of the Venus and Adonis story, a version well motivated on artistic grounds (i.e. by the painter's intention to

p. 52, Nos. 164-193 (not illustrated). The photograph reproduced in our Fig. 162 was kindly supplied by Miss L. C. J. Frerichs of the Rijksprentenkabinet at Amsterdam. The drawing by Antonio Molinari, brought to my attention by Miss Judith Colton, is reproduced in M. Muraro, *Catalogue of the Exhibition of Vene-tian Drawings from the Collection Janos Scholz*, Venice, 1957, p. 41, Pl. 59 (here incorrectly captioned *"Diana and Actaeon"*).

For a tentative interpretation of Titian's much-debated *"Pardo Venus"* in the Louvre as another variation on the Venus and Adonis theme, see pp. 190ff., *Excursus* 7.
39. *The New Variorum Shakespeare*, Phila-delphia, xxii, 1938, pp. 391 ff.
40. F. Mauroner, *Le Incisioni di Tiziano*, Padua, 1941 and 1943, p. 58, No. 1, Pl. 49, with the date misprinted as 1558; Rota's engraving is mentioned but not illustrated on p. 61, No. 1.

present the principal figure from the back) but not anticipated, it would seem, in any literary source.[41]

In the letter of 1554, we recall, Titian promised to favor Philip II with two further pictures displaying "the female form": a *Jason and Medea* and a *Perseus and Andromeda*. Of the *Jason and Medea* no trace or further mention can be found; whereas the *Perseus and Andromeda* may well be identical with the wonderful painting in the Wallace Collection in London to which we shall shortly return. But before this painting was delivered Titian despatched to Spain two other Ovidian "mythologies" which, according to a letter of June 19, 1559, were then nearing completion; on September 22 or 27 they were on their way. One was *Diana and Her Nymphs Surprised in Their Bath by Actaeon* (Fig. 163), the other *Diana Discovering the Pregnancy of Callisto* (Fig. 164); both, formerly preserved at Bridgewater House, are now on deposit in the National Gallery at Edinburgh.[42]

41. Titian's unprecedented "*Leave-Taking of Adonis*" exerted an enormous influence. Suffice it to mention Veronese's picture in Darmstadt (G. Fiocco, *Paolo Veronese*, Rome, 1934, No. 19) and the instances adduced by L. Freund in *Reallexikon zur deutschen Kunstgeschichte*, I, 1937, cols. 195 ff. Even Rubens' renderings of *Venus and Adonis* in Düsseldorf (*Rubens, Klassiker der Kunst*, 4th edition, p. 29) and in the Metropolitan Museum (Goris and Held, *Rubens in America*, p. 38, No. 77, Pls. 77, 78) depend on Titian's painting, of which Rubens had made a copy now lost but listed in the inventory of his estate; in his own composition, however, Venus is no longer seen from the back but remodeled after the fashion of the dying Creüsa in classical Medea sarcophagi. Titian's *Venus Spurned by Adonis* was ingeniously transformed into a *Fortune Spurned by Virtue* in Giuseppe Porta's roundel in the Salone of the Libreria Marciana (see N. Ivanoff, "Il ciclo dei filosofi della Libreria Marciana a Venezia," *Emporium*, CXL, 1964, pp. 207 ff., Fig. on p. 210).

42. *V.*, II, Pls. 84, 85; both pictures are included in the list of December 22, 1574, referred to p. 162, Note 61. For the dates, see Titian's letters of June 19, 1559 (*C.-C.*, II, p. 512 f.) and September 22 or 27, 1559 (ibidem, pp. 278 ff., 515 ff.). When Garcia Hernández, Secretary to Philip II, speaks of "los dos quadros de Diana y Calisto" (letter of August 3, 1559, ibidem, p. 515) he apparently fails to distinguish between two subjects both of which involve Diana in her bath. In the letter of September 22 or 27, Titian himself correctly speaks of "*Atteone*" and "*Calisto*." The Actaeon picture was treated in a charming monograph by E. K. Waterhouse, *Titian's Diana and Actaeon* (Charlton Lecture on Art), Oxford, 1952. Diana's wanton cruelty in punishing the innocent victim of an accident not of his making called for motivation at an early date. According to Hesiod and Stesichorus, Actaeon had dared to seek the love of Semele, the mistress of Zeus (cf. H. Hoffmann, "Eine neue Amphora des Eucharides-Malers", *Jahrbuch der Hamburger Kunstsammlungen*, XII, 1967, pp. 9 ff.). In his *Bacchae*, 337 ff., Euripides suggests that Actaeon had claimed to be a more successful hunter than Diana; and in a few later sources (Diodorus, *Bibliotheca*, IV, 81, 4; Nonnus, *Dionysiaca*, V, 301 ff.; Hyginus,

In contrast to the *Danaë* and the *Venus and Adonis* these two paintings are counterparts in the strictest sense of the term, matching each other in format, size, composition, and content; there is every reason to suppose that they were meant to be placed on the same wall, the Actaeon picture on the left, the Callisto picture on the right. Both paintings are dominated by nearly symmetrical systems of intersecting diagonals and exhibit curtains symmetrically placed in the upper corners. Both show a rectangular pillar in the middle distance, slightly shifted to the right in the left-hand picture and slightly shifted to the left in the right-hand picture. And both show Diana in the role of a beautiful and cruel goddess of Chastity wreaking her vengeance upon an innocent victim.

A most distinguished and sensitive critic, Ellis Waterhouse, has called the *Diana and Actaeon* the "first Baroque composition." In many ways this judgment, which may be applied to the Callisto picture as well, is justifiable. There is a "horror of uprights and horizontals": even the basin in the Actaeon scene is tilted; and so, for that matter, is the pedestal of the fountain statue (a putto carrying a water-spouting urn) in the *Diana and Callisto*. The mountains, woods and cornfields in the background are, as Waterhouse aptly puts it, a "descending current"; the figures in the second plane are darkened *in toto* (except for the nymph lurking behind the rusticated pillar in the Actaeon picture, who was painted in as an afterthought) as though a shadow had fallen over them; and the dominant colors — chiefly blue, crimson, white and golden-brown — stand out with that glowing yet menacing clarity which we can observe before a thunderstorm. It is no accident that Rubens, well acquainted with Titian's two pictures from his stays at Madrid in 1624 and 1628, borrowed from them not once but repeatedly.[43]

Fabulae, CLXXX) her cruelty — commented upon by Ovid himself in *Metamorphoses*, III, 253-256 — is accounted for by the suggestion that Actaeon was in love with or even attempted to violate Diana.

43. Mention may be made of the *Bathsheba at the Fountain* in Dresden (*Rubens, Klassiker der Kunst*, 4th edition, p. 347), the principal figure apparently borrowed from the nymph crouching upon the basin in Titian's Actaeon picture and the Negro attendant possibly inspired by the analogous figure in the same composition; of *Diana Surprised by Satyrs* in Berlin (*Rubens,* *Klassiker der Kunst*, p. 429), the principal figure repeating the same motif and the nymph embraced by a satyr apparently derived from the figure near the left-hand margin of Titian's Callisto picture. In a somewhat freer form, the crouching nymph recurs in Rubens' *Diana and Callisto* in the Prado (*Rubens, Klassiker der Kunst*, p. 433). Titian's nymph in turn may have been developed from one of the two figures in the upper left-hand corner of an engraving, ascribed to Jean Mignon, after Luca Penni, its subject perhaps a variation on the Callisto theme: *B.*, XVI, p. 415, No. 99;

Yet this trend toward the Baroque is counteracted by two entirely different currents: by the continuing influence of classical art;[44] and by a renewed and very powerful impact of Mannerist tendencies. The elements of the composition are held together neither by the unifying force of light and shade nor by a kind of gravitational pull into depth but by what might be called a "complex rhythmical concatenation" which operates primarily within, or parallel to, the picture plane. And the figures are more elongated and, as it were, more easily movable at the joints than is compatible with the standards of both the Baroque and the High Renaissance. A direct borrowing from a Mannerist composition has long been recognized in the nymph seen from the back in the Actaeon picture: she comes from Parmigianino's *Bath of Diana*, a drawing preserved in the Uffizi but popularized through a chiaroscuro print ascribed to Ugo da Carpi (Fig. 165) and an engraving by Antonio Fantuzzi.[45] It is true that Parmigianino's nymph is in turn derived from a figure in Marcantonio's *Judgment of Paris* (engraving B. 245 after Raphael); but there are other similarities as well, and the whole idea of shifting the accent from "Diana and Actaeon" to "Diana and Her Nymphs in Their Bath" may well have been prompted by Parmigianino's apparently extremely popular composition.

The story of Actaeon is told, at great length and with great power, in the Third Book of Ovid's *Metamorphoses* (131-252). The unfortunate huntsman, a grandson of Cadmus, innocently surprises Diana and her nymphs in the Boeotian woods where they are bathing in their sacred spring. Outraged, the goddess sprinkles his head with water, exclaiming: "Now tell that you have seen me naked — provided you are able to tell"!

F. Herbet, "Les Graveurs de l'école de Fontainebleau, iv", *Annales de la société historique et archéologique du Gâtinais*, xviii, 1900, p. 336, No. 23.

44. R. W. Kennedy, *Novelty and Tradition in Titian's Art*, p. 25, Note 76, calls attention to the Mars and Sylvia sarcophagus in the Lateran (Reinach, *Répertoire de reliefs*, iii, p. 273, No. 5).

45. For the derivation of this figure from Parmigianino (and for the latent Mannerism of the two Diana pictures in general), see Hetzer, *Tizian*, p. 148. Cf. R. W. Kennedy, ibidem, with further references, and A. E. Popham, "Drawings by Parmigianino for the Rocca of Fontanel-

lato," *Master Drawings*, i, 1963, pp. 3 ff., particularly pp. 6 and 10, Pl. 6. For the chiaroscuro print ascribed to Ugo da Carpi (*B.*, xii, p. 122, No. 22), see G. Copertini, *Il Parmigianino*, Parma, 1932, ii, p. 35 f., Pl. 12; for the engraving by Fantuzzi, F. Bardon, *Diane de Poitiers et le mythe de Diane*, Paris, 1963, p. 24 f., Pl. iii. The figure recurs in a print in Mariette's "Scrapbook of Parmigianino" in the Metropolitan Museum of Art, ascribed to Andrea Meldolla called Schiavone and kindly brought to my attention by Mr. Hyatt A. Mayor; this print is a kind of abridged variation on Parmigianino's *Bath of Diana*.

He is transformed into a stag and torn to pieces by his own hounds. Titian's picture shows only the first act of the tragedy, the unpremeditated, fatal invasion of Diana's privacy; what is to come is indicated only by a symbol: the stag's head affixed to the pillar.

In representing Actaeon before the change, Titian harks back to the woodcuts in the earliest illustrated Ovid editions, beginning with the first of 1497 (Fig. 166); most later illustrations show him, proleptically, with a stag's head on his shoulders. Such is the case, for example, with several miniatures and paintings (among them a picture by Veronese in the Philadelphia Museum of Art); with the woodcut in the *Trasformationi* by Titian's good friend, Lodovico Dolce (Venice, 1553, Fig. 167); and with Bernard Salomon's woodcut in the *Métamorphose d'Ovide figurée* of 1557 (Fig. 168).[46] The only thing which Titian may conceivably have appropriated from Bernard's elegant little print is the general attitude of Actaeon and the substitution of a stone basin — albeit of very different form — for what Ovid refers to as a "spring surrounded by grassy banks" (III, 161 f.: "*Fons.../margine gramineo patulos succinctus hiatus*").

In essence, however, Titian's beautiful and sinister composition is not significantly indebted to any previous illustration of the Actaeon myth, and it differs from all of them — and, so far as I know, also from subsequent renderings — not only by such personal touches as the red curtain and the negro girl somewhat incongruously attending Diana but also by the unexpected presence of an architectural setting: a curious combination of a rusticated pier with a dilapidated Gothic vault, the only Gothic vault in Titian's oeuvre. But just what looks like a triumph of poetic license is in reality the triumph of an imagination fertilized by attentive reading and intelligent thought. "There was a valley densely filled with pines and pointed cypresses, named Gargaphia and sacred to short-skirted Diana," says Ovid in setting the stage for the fateful event (III, 155-160). "In its utmost recesses there is a sylvan cave, not produced by any art. Nature's own genius had imitated art (*simulaverat artem | Ingenio natura suo*); she had erected a natural arch (*nativum ... arcum*) of live pumice stone and soft tufa."

46. For miniatures, see, e.g., such Christine de Pisan manuscripts as Oxford, Bodleian Library MS. 421, fol. 49 (F. Saxl and H. Meier, *Catalogue of Astrological and Mythological Illuminated Manuscripts of the Latin Middle Ages*, London, 1953, III, 2, Pl. xliv, Fig. 115); for a painting from the School of Fontainebleau, preserved in the Louvre, see C. Sterling and H. Adhémar, *Catalogue général des peintures du Louvre; Ecole Française, XIVe, XVe et XVIe siècles*, Paris, 1965, No. 101, Pl. 221.

In the mind of a sixteenth-century painter well acquainted with architects and theorists of architecture this description of an arched structure contrived "by nature's own genius in imitation of art" was bound to conjure up two closely interrelated ideas: the idea of rustication and the idea of the Gothic style. Rustication — *il ronchioso*, as Alberti calls it — was recommended for such intentionally "artless" artifacts as fountains and grottoes. Sebastiano Serlio (as I learn from my friend, Professor Wolfgang Lotz) calls a rusticated piece of architecture "parte opera di natura, e parte opera di artefice" (*Libro quarto d'architettura*). And Gothic was considered a "natural" style derived from those primeval shelters which were supported by unsquared timbers instead of by columns shaped and proportioned according to the "rules of art" — a style whose piers still seemed to look like trees and whose pointed arches still seemed to retain the memory of living branches meeting in mid-air.[47]

Titian thus took his clue from Ovid's description; but he reversed the accent. Instead of depicting a cave where the "genius of nature" had imitated art, he depicted an architectural setting where art had followed the "genius of nature." For him and his contemporaries a Gothic vault, combined with a rusticated pier, was the man-made equivalent of what Ovid describes as a structure "produced by nature in imitation of art." And the ruined state of this structure, together with the inclination of the basin already mentioned as a compositional device, gives the impression that nature is reclaiming her own.

Like Actaeon, Callisto, whose story is told in the preceding book of Ovid's *Metamorphoses* (ii, 401-531; cf. also *Fasti*, ii, 153-192) is a guiltless victim of divine injustice. A daughter of Lycaon, King of Arcady, she belonged to the retinue of Diana. When she rests unguarded after a strenuous chase Jupiter, insidiously assuming the appearance of Diana herself, caresses and violates her, leaving her pregnant. Nine months later Diana and her nymphs decide to have a bath. Callisto, ashamed of her condition, refuses to join in and is forcibly undressed by her companions. Diana banishes her from her flock and she gives birth to a boy named Arcas. The ever-jealous Juno first mistreats her and then transforms her into a she-bear. As such she leads a miserable life for many years until

47. This definition of the Gothic style was set down in writing as early as about 1515 in the famous report, perhaps jointly pro- duced by Raphael and Bramante, on Roman antiquities; cf. Panofsky, *Renaissance and Renascences*, p. 23 f.

her own son, grown into a mighty hunter, nearly kills her. At this moment Jupiter intervenes, transposing mother and son to the firmament: Callisto is transformed into the constellation known as *Ursa Maior*, the "Great Bear" (mostly referred to as "the Wain" or "the Big Dipper" in English); Arcas into the constellation of Boötes or Arctophylax (the "Bear's Keeper"). But Juno, still vengeful, forces the *Ursa Maior* to stay above the horizon for all eternity so that she may not find refreshment and purification in the ocean as the other constellations do.

In style, Titian's *Diana and Callisto* represents, like its companion piece, a fusion of Mannerist tendencies ("complex rhythmical concatenation" and "elongation") and classical influence. The little water carrier serving as a fountain statue has many classical ancestors.[48] The violent gesture of the nymph on the far left, uncovering Callisto with "such an emphasis" that her raised arm almost covers her own face, is likewise anticipated in ancient art;[49] and so is the pose of Diana herself. While the lower part of the figure is still reminiscent of those Nereids one of whom had served as a model for the celestial Venus in the "*Sacred and Profane Love*" (Fig. 129), its upper part — the right arm extended and lowered, the left arm resting on the shoulder of an attendant nymph — seems to reveal the influence of Hellenistic "relief pictures."[50]

In iconography, however, Titian's *Diana and Callisto* remains, like its counterpart, a creation almost *ex nihilo*. The previous representations of Callisto's banishment (unfortunately we do not know what Giorgione did with the subject on certain "roundels and cupboards," *rotelle e armari*, mentioned by Ridolfi)[51] have no appreciable relationship with Titian's composition. Where the discovery of Callisto's pregnancy — omitted in Bernard Salomon's *Métamorphose d'Ovide figurée* of 1557 — is shown at all she is depicted standing, and the scene tends to be combined with her seduction, as in the woodcuts of the first illustrated edition of 1497 and

48. See Brendel, "Borrowings from Ancient Art in Titian," Figs. 16, 17.

49. Cf., e.g., Reinach, *Répertoire de reliefs*, II, p. 285, No. 1; better illustration in Saxl, *Lectures*, II, Pl. 145 h.

50. For the gesture of Diana see, e.g., the Paris and Oenone relief in the Palazzo Spada (Reinach, ibidem, III, p. 324, No. 3). For the combination of a figure similarly posed with a female companion, see the Venus-and-Helen groups in the reliefs in Naples (Reinach, III, p. 80, No. 4), in the Palazzo dei Conservatori (Reinach, III, p. 198, 1) and in the Vatican (Reinach, III, p. 388, No. 4). The relationship of the Diana with the Venus in Giulio Romano's *Marriage Feast of Psyche* in the Palazzo del Tè at Mantua (Hartt, *Giulio Romano*, II, Fig. 254), suggested by R. W. Kennedy, *Novelty and Tradition in Titian's Art*, Note 77, seems less convincing to this writer.

51. Ridolfi, *Le Maraviglie della pittura*, ed. cit., I, p. 98.

their derivatives (Fig. 169), with her mistreatment by Juno[52] or even with her flight from her son long after her transformation into a she-bear, as in Dolce's *Trasformationi* of 1553 (Fig. 170).[53] Nowhere, not even in Léonard Thiry's series of twelve engravings all devoted to the myth of Callisto,[54] do we find a precedent for the two features most characteristic of Titian's picture: the interpretation of Diana as an imperious figure sitting in judgment, as it were (elsewhere, she is shown either arguing with Callisto or bathing in the water); and, above all, the beautiful and cruel violence of the undressing scene, with Callisto writhing on the ground. To re-encounter the second of these features we must go forward to Rembrandt's early and rather vulgar picture in the collection of Prince Salm-Salm at Anholt in Westphalia (Fig. 171). All differences in style and spirit notwithstanding, Rembrandt could not, I think, have conceived this composition without the influence of Titian. The very idea of combining the stories of Actaeon and Callisto in one painting may not be without significance; and in the Callisto section we find concrete reminiscences of Titian not only in the humiliated victim but also in some of the nymphs, notably the one seen from the back.[55]

A problem is posed by a second version of the Diana and Callisto picture, preserved in the Vienna Museum (Fig. 172).[56] It differs from the

52. See, e.g., a privately owned painting ascribed to Bonifazio Veronese (B. Berenson, *Italian Pictures of the Renaissance; Venetian School*, London, I, 1957, p. 43; II, Pl. 1143) which shows, in one and the same setting, the seduction, the bathing scene, Callisto's maltreatment by Juno, and, in the background, her prayer to Juno.
53. L. Dolce, *Le Trasformationi*, Venice (G. Giolito), 1553, p. 44.
54. J. D. Passavant, *Le Peintre-Graveur*, VI, Nos. 85-96, described in Herbet, "Les Graveurs de Fontainebleau, I", ibid., XIV, 1896, pp. 95 ff.
55. Bode, No. 196; *Rembrandt, Klassiker der Kunst*, 3rd edition, p. 168, dated 1635 — a prime example of what Jacob Burckhardt calls Rembrandt's "frevlerische Art" in dealing with subjects from classical mythology; cf. Henkel, "Illustrierte Ausgaben von Ovids Metamorphosen," p. 121 f. Titian's *Diana and Callisto* — though not, so far as I know, his *Diana and Actaeon* — was ac-

cessible in an engraving by Cornelis Cort, dated 1566 (Mauroner, *Le Incisioni di Tiziano*, p. 60, No. 8). Rembrandt's inventory of 1656 specifically mentions "art books" containing prints after Titian and Raphael (C. Hofstede de Groot, *Die Urkunden über Rembrandt, 1575-1721*, The Hague, 1906, document 169, Nos. 196, 205, 214, 216, 246). This may account for the fact that specific reminiscences of Titian can be discovered only in the Callisto section, but not in the Actaeon section, of Rembrandt's painting.
56. *V.*, II, Pl. 86. Cf. A. Stix, "Tizians 'Diana und Kallisto' in der Kaiserlichen Gemäldegalerie in Wien," *Jahrbuch der kunsthistorischen Sammlungen des Allerhöchsten Kaiserhauses*, XXXI, 1914, pp. 335 ff., unconvincingly maintaining that the Vienna picture had left Titian's workshop before 1566 so that Cort's engraving would have been executed, *contra usum*, on the basis of a preparatory drawing.

Edinburgh original not only by its airier, less compact composition (reduction in size of the curtain, omission of the figure crouching at the feet of Diana, disengagement of Diana from the figure originally supporting her, transformation of the fountain into a less massive and more conventional structure) but also by an attempt to reduce the amount of naked flesh. The gorgeous nude on the left is replaced by a draped figure, its contrapposto movement conforming to a scheme which Titian had repeatedly used some twenty years before,[57] and Callisto herself has not as yet been deprived of her clothing.

The puzzling fact is that the underpainting is reported to agree with the original, from which we must conclude that what had been planned as a straight replica was changed — at the last moment, so to speak — into a variant. That all these changes were made by Titian *propria manu* seems doubtful; but they must have been effected on his orders and probably with his personal participation, all the more so as they agree with the tendencies of his very latest phase.[58] I incline to believe that the Vienna picture — in Austrian possession from the early seventeenth century — belongs to those full-scale replicas, seven in number, of nearly all the mythologies executed for Philip II which had been produced in Titian's workshop and were offered to, and probably accepted by, Emperor Maximilian II in 1568.

This offer — made under the tacit assumption that the paintings were authentic works of Titian — was transmitted through Maximilian's Venetian Envoy, Veit von Dornberg, in a letter of November 28th. The list enclosed in this letter mentions, in addition to the *Callisto*, an *Actaeon Surprising Diana in Her Bath*; but it also mentions a picture showing the horrible sequel to this unintended sacrilege: the *Fable of Actaeon, Transformed into a Stag and Torn to Pieces by His Own Hounds*.[59] A painting of this

57. See the *Crowning with Thorns* in the Louvre, *V.*, I, Pl. 170 (our Fig. 18); the *Ostentatio Christi* in Vienna (*V.*, I, Pl. 174); and the *Resurrection* in Urbino (*V.*, I, Pl. 176).

58. Cf. above, p. 139, Note 2.

59. See *V.*, II, p. 61f. The document was first published by A. Buff, "Rechnungsauszüge, Urkunden und Urkundenregesten aus dem Augsburger Stadtarchive," *Jahrbuch der kunsthistorischen Sammlungen des Allerhöchsten Kaiserhauses*, XIII, 2, 1892, pp. 1 ff., Nos. 8804, 8806, 8808. Von Dornberg's letter is in Latin while the list subjoined is in Venetian Italian — from which we may conclude that the latter had been supplied by Titian himself. It includes the following items: "La fabula de Endimione et Diana. — La fabula de Ateon a la fonte. — La fabula del'isteso, trasmutato in cervo et lacerato da suoi cani. — La fabula de Calisto, scoperta graveda alla fonte. — La fabula de Adone, andato alla caza [caccia] contra il voler de Venere, fu dal Cinghiale uciso. — La fabula de Andromeda ligada al saso et liberata da Perseo. — La fabulla de la Keuropa [*sic*]

description is referred to as having been "started" (*incominciato*) by himself in Titian's letter to Philip II of June 19, 1559.[60] There is no evidence, however, that it ever reached Madrid, and it is not included in the list, submitted by Titian to the King in 1574,[61] of paintings delivered to him "during the last twenty-five years."

This omission in itself is not conclusive because the list of 1574 enumerates only such pictures as had (according to Titian) not yet been paid for and leaves out such pictures as he could no longer remember.[62] Yet it remains unlikely that Titian should have forgotten, or not been paid for, a painting so closely connected with the other *Actaeon* picture and the *Callisto*; and we are justified, I think, in assuming that the only *Actaeon Torn by His Hounds* attributable to Titian and still extant — a painting owned by the Earl of Harewood and traceable to the collections of Archduke Leopold William of Austria and Queen Christina of Sweden but not traceable to Spain (Fig. 173) — belongs to the set offered to Maximilian II in 1568.[63]

That the landscape plays a more dominant role than in the other Ovidian narratives follows from the subject, and the composition is of the

portata da Jove converso in tauro. — Et tutti detti quadri sono a buonissimo termine et sono un palmo più largi che quello della Religion..." Of the "fable of Endymion and Diana," mentioned *primo loco* but not an Ovidian subject, nothing whatever seems to be known. So far as I know, there is no evidence for the hypothesis that the Vienna *Diana and Callisto* was destined for Titian's own house (R. W. Kennedy, "Apelles Redivivus," p. 167). For the *Religion*, see pp. 186ff., *Excursus* 6.

60. *C.-C.*, II, p. 512f., referred to above, p. 154, Note 42.

61. See the list subjoined to Titian's letter to Antonio Perez of December 22, 1574 (*C.-C.*, II, p. 539f.).

62. It is interesting to compare the list of 1574 with that transmitted to Maximilian II by Veit von Dornberg in 1568 (see above, p. 161, Note 59). Apart from seven religious paintings, a *Venus with Cupid Holding a Mirror for Her* and the much-debated *Nuda con il Paese con el Satiro* (for which see pp. 190ff., *Excursus* 7), the list of 1574 comprises the following mythological

subjects: *Venus and Adonis*; *Exposure of Callisto*; *Actaeon Surprising Diana and Her Nymphs*; *Andromeda*; *Abduction of Europa*. It neither contains the elusive *Endymion* nor the *Death of Actaeon*. And neither Veit von Dornberg's list of 1568 nor Titian's list of 1574 refers to the *Danaë*.

63. *V.*, II, Pl. 87. The picture is generally — and justly — held to be authentic, except by Hetzer in Thieme-Becker. That it was in the possession of Archduke Leopold William (which makes it all the more probable that it was never in Spain but belonged to the set offered to Emperor Maximilian II in 1568, for which see above, p. 161, Note 59) is attested by David Teniers the Younger's portrayal of the Archduke's Brussels collection (Vienna, Kunsthistorisches Museum; see T. Frimmel, *Gemalte Galerien*, Bamberg, 1893, p. 7f.), which also shows the portrait of Jacopo Strada (our Fig. 92) and where the *Death of Actaeon* appears in the upper right-hand corner. Queen Christina may have obtained it on the occasion of her visit to Brussels in 1655.

highest originality. In the Ovid illustrations the actual death of Actaeon is rarely represented; and when it occurs, particularly in Bernard Salomon's *Métamorphose d'Ovide figurée* (where, we remember, Actaeon already wears a stag's head in the bathing scene), he is entirely transformed into a stag and thrown to the ground to meet his end (Fig. 174) as does, e.g., the boar on the December page in the *Très Riches Heures de Chantilly*. In Titian's picture, however, the intermediary stage of transformation is reserved for the finale of the story. Actaeon, still human except for the head, is still on his feet and desperately struggles to hold his own against his hounds. And just the fact that his body continues to be that of a human being while his head has become that of a speechless animal lends a terrifying actuality to the words of Ovid (*Metamorphoses*, III, 229ff.) which, I think, Titian had in mind when he conceived his composition: "He longed to cry out, 'I am Actaeon, recognize your master'; the words refused obedience to the will" (*Clamare libebat | 'Actaeon ego sum, dominum cognoscite vestrum'; | Verba animo desunt*). No less remarkable is the fact that the gruesome scene is relegated to the middle distance: the front plane is occupied by the superbly graceful figure of the victorious goddess who streaks through the woods shooting her arrows, utterly at peace with herself and the world. Even in classical art I know of only one representation of the Death of Actaeon where Diana plays a comparable role;[64] and here again Titian's imagination seems to have been fired by a few lines of Ovid. His account of Actaeon's end (*Metamorphoses*, III, 251 f.) concludes with the words: "Not till he had died from his many wounds was the wrath of quiver-bearing Diana assuaged" (*Nec nisi finita per plurima vulnera vita | ira pharetratae fertur satiata Dianae*).

The third and final pair of mythologies produced by Titian for Philip II consists of two canvases showing, respectively, the *Rape of Europa* (Fig. 175) and the *Liberation of Andromeda by Perseus* (Fig. 176). It seems

64. In one of the metopes from Selinus (Reinach, *Répertoire de reliefs*, I, p. 399, No. 3) and in a krater now in Hamburg (cf. H. Hoffmann as quoted p. 154, note 42) Diana stands quietly by while Actaeon is attacked by his hounds, and in two Etruscan urns (ibidem, III, p. 25, No. 5, and p. 444, No. 1) she leaves the scene, looking back. As I learn from Professor P. H. von Blanckenhagen, it is only in a Pompeian mural now destroyed that a Diana storming through the woods is combined with the Death of Actaeon: C. Dawson, *Romano-Campanian Mythological Landscape Painting* (Yale Classical Studies, IX, New Haven, 1944, pp. 136ff., Pl. xii, Fig. 37). Postclassical renderings of the Death of Actaeon do not, as a rule, include the figure of Diana at all.

11*

singularly fitting — though it is probably quite accidental — that two unmitigated tragedies should be followed by two tales ending happily (Europa, as will be remembered, became the Queen of Crete or even a goddess, and gave her name to one third of the world), and that the cycle beginning with the miraculous conception of Perseus should end with his most brilliant deed.

The *Rape of Europa*,[65] first mentioned in Titian's letter of June 19, 1559 just referred to, was sent to Madrid about three years later (to be exact, on April 26, 1562) and is now the glory of the Isabella Stewart Gardner Museum in Boston. The history of the *Andromeda*, promised to Philip II as early as 1554, is still a little problematical; we cannot even be absolutely sure — although the balance of the evidence is in favor of the first alternative — whether the picture now in the Wallace Collection at London is identical with that sent to Philip II in 1567 and included in the list subjoined to Titian's letter of December 22, 1574, or whether it belongs to the set of replicas offered to Emperor Maximilian II in 1568.[66]

65. *V.*, II, Pl. 88. For a fine appreciation of the composition and color scheme of this picture, see A. Pope, *Titian's Rape of Europa*, Cambridge, Mass., 1960. For the letter of June 19, 1559, cf. above, p. 154, Note 42; for that of April 26, 1562, *C.-C.*, II, pp. 319 ff., 524. The provenance of the Boston painting can be traced back only to the Duc de Grammont (early seventeenth century); but it bears an authentic signature and its quality leaves no doubt as to its authenticity.

66. *V.*, II, Pl. 89; see now Gould's excellent study, "The *Perseus and Andromeda* and Titian's *Poesie*," referred to above, p. 151, Note 35. For the letter of 1554, see above, Note 32; for that of 1559, Note 42; for that of December 22, 1574, Notes 61, 62; for the set offered to Maximilian II, Note 59; for the date of delivery (1567, added to the list of 1574), cf. P. Hofer, "Die Pardo-Venus Tizians," *Festschrift Hans R. Hahnloser*, Basel and Stuttgart, 1961, pp. 341 ff., particularly pp. 342 and 352. Lodovico Dolce, in his *Dialogue* of 1557, claims that a *Perseus and Andromeda* had then already been sent to Spain — whereas Vasari still saw and greatly admired a painting representing this subject when he visited Titian's workshop in 1566. In its present state, the picture in the Wallace collection — whose provenance cannot be traced back beyond the collection of the Duc de la Vrillière and the Duc d'Orléans (both eighteenth century) — is difficult to reconcile with a date as early as c. 1555. But, as Gould has shown, the painting underwent a basic transformation at a time when it was nearly completed and had to be changed in order to match the firmly dated *Abduction of Europa*. We are thus confronted with two alternatives. Either the London picture is identical with that delivered to Philip II in 1567, in which case it would have been retained in Titian's workshop for ten years after the publication in 1557 of Dolce's *Dialogue* (Dolce, having seen it in a nearly finished state when he prepared his treatise, may simply have assumed that, when he went to press, it had already been despatched). Or it belongs to the set offered to Maximilian II in 1568, in which case it would be difficult to explain why it was executed in two stages. I am inclined to agree with Gould in accepting the Wallace *Andromeda* as the painting owned by Philip II since 1567 but thoroughly transformed between c. 1555 and the date of delivery.

Certain it is, however, that — although probably started shortly after 1554 — it did not receive its final form until Titian had decided to pair it with the *Rape of Europa*, on which he worked, we remember, from 1559 to 1562.

These two compositions form almost ideal counterparts.[67] Both are essentially seascapes. Both are controlled by diagonals, running from lower left to upper right in the *Rape of Europa* and from lower right to upper left in the *Liberation of Andromeda*. In both pictures one of the upper corners is reinforced, so to speak, by balanced masses — the Perseus figure in the Andromeda picture, a couple of Cupids in the *Rape of Europa* — which fulfill a compositional function analogous to that of the curtains in the two Diana scenes.

The *Rape of Europa* is circumstantially described by Ovid (*Metamorphoses*, II, 833-875; *Fasti*, V, 603-620); and the subject has so long and consistent a tradition in literature as well as art that all representations of it have a kind of family likeness. From an iconographical point of view, even Titian's picture holds relatively few surprises and does not presuppose his acquaintance with such more recondite authors as Moschus.[68] That the bull is white and wears a garland, put on his head by Europa herself, that she holds on to one of his horns, that she lifts her feet to protect them from the waters, that her scarf is blown back by the wind: all these enticing details were set down by Ovid, repeated and embroidered upon in dozens of paraphrases (including a couple of beautiful stanzas in Politian's *Giostra*), and frequently exploited by artists long before Titian. Bernard Salomon's woodcut in the *Métamorphose d'Ovide figurée* of 1557, for example, agrees with Titian's picture even in that the landscape is dominated by a sizable mountain (Fig. 178). And that the motif of a little Cupid riding a dolphin was at home in North Italian renderings of the subject is demonstrated, curiously enough, by an early Dürer drawing copied from a Quattrocento original (Fig. 177).[69]

Yet even within the limitations of an unusually uniform tradition Titian's painting remains original not only in its almost iridescent colors (the water changing from greenish in the foreground to deepest blue near the shore, the brown of the hills echoed in the cloth beneath Europa,

67. See Gould, ibidem.
68. This was unconvincingly claimed by B. H. M. Mutsaers, "Literaire Bronnen voor Maarten de Vos' Ontvoering van Europa," *Album Discipulorum Jan van Gelder*, Utrecht, 1963, pp. 63 ff.

69. For the representational tradition of the Abduction of Europa, see Panofsky, *Meaning in the Visual Arts*, pp. 53 f., 239 f. (in the Italian translation, pp. 55 f., 230 ff.); cf. idem, "Letter to the Editor," *Art Bulletin*, xxx, 1948, pp. 242 ff.

the "Renoir-like" rose of her scarf recurring in many places, even in the dolphin) and in the agitated yet perfectly balanced composition but also in interpretation.

The most obvious anomaly is the pose of Europa herself. She reclines rather than sits on the back of the bull, displaying, as has been said, her "ample charms in a pose of an ungainliness which only fear could sanction."[70] True, the element of fear does enter Titian's composition just as it enters Ovid's description: "She is afraid and, carried off, looks back to the relinquished shore" (*pavet haec litusque ablata relictum/respicit*). But his Europa looks upward rather than back. She reveals, in addition to fear, a kind of rapture befitting a mortal maiden carried away by a god. In her facial expression, in the position of her legs, even in the shadow crossing her face — in all these respects she bears, I feel, a more than accidental resemblance to the *Danaë* in the Prado (Fig. 158). Were it not for the different movement of the arms she might be called a Danaë seen from above.

In this movement of the arms, however, the figure differs not only from the *Danaë* but also from Ovid's text and from all its previous illustrations, including Bernard Salomon's woodcut. According to Ovid, Europa should clutch a horn of the bull — usually the horn nearest to her — with one hand while the other rests on his back. Titian's Europa, however, uses her right hand to raise her scarf as though attempting to protect herself from the arrows of the Cupids; and with her left she clasps the farther horn of the bull, her arm thus passing behind his neck. Just as the position of her body suggests surrender as well as fear, so does the action of her arms suggest an embrace as well as a desire for self-preservation.

The *Liberation of Andromeda* (based on *Metamorphoses*, IV, 663-752) owes, we recall, its present appearance (Fig. 176) to a thorough remodeling after 1559. In the original composition, apparently conceived four or five years earlier and sufficiently advanced to leave clear traces of a "first state" in the X-ray photograph (Fig. 180), the figure of Andromeda is not only less elongated but also differently posed. Instead of floating, as it were, before the rock, one arm raised, the other lowered, she stands firmly on the ground, both arms chained above her head. And Perseus — though this is less certain — seems to come to her rescue on foot rather than in flight.

70. Waterhouse, *Titian's Diana and Actaeon*, p. 21.

We have, then, a supervening influence which changed a composition conforming to the standards of c. 1555 to one conforming to those of c. 1560, and once more the combined effect of Mannerism and classical antiquity can be discerned. The extreme elongation and sweepingly calligraphic design of the Andromeda seem to reflect the impression of such models as Parmigianino's *Bath of Diana* (Fig. 165), possibly even that of Benvenuto Cellini's relief now in the Bargello at Florence.[71] The slanting posture of her body and the position of her legs, on the other hand, still bring to mind the Nereids which had attracted Titian's attention some forty-five years earlier (Fig. 129);[72] and the graceful, S-shaped curve of her arms is reminiscent of classical maenads.[73]

These reminiscences, however, might not have come to life in Titian's mind had they not been called up by Bernard Salomon's woodcut of 1557 (Fig. 179), published just a few years before the composition was revised. Here the new, S-shaped curve formed by Andromeda's arms — originally, we remember, both upraised — is clearly prefigured. And while this woodcut shows Perseus borne by Pegasus, the earlier Ovid illustrations, notably that in the Venice edition of 1508 and Cellini's relief, anticipate the idea that he can cleave the air with his own footwings (Fig. 181).[74]

This is precisely how Ovid himself imagined the scene: "Perseus, resuming his wings, ties them to both his feet" (*pennis ligat ille resumptis / parte ab utraque pedes*); and here again we can observe that Titian not only looked at prints, pictures and works of sculpture but also read the text. There are three features for which, so far as I know, there is no precedent in the representational tradition of the Andromeda myth: first, as acutely observed by Mrs. Ruth Kennedy, branches of coral can be seen on the shore; second, Perseus, in a Tintorettesque foreshortening not often encountered in Titian, plunges down "heels over head" rather than "head over heels"; third, he brandishes, instead of a normal sword (or, as

71. Gould, "The *Perseus and Andromeda* and Titian's *Poesie*," p. 114.

72. I cannot see much similarity between the *Andromeda* and one of the daughters of Niobe adduced in this connection by Brendel, "Borrowings from Ancient Art in Titian," p. 122, Fig. 31, and R. W. Kennedy, *Novelty and Tradition in Titian's Art*, p. 12, Fig. 34.

73. See, e.g., the tomb at Arlon in the Belgian province of Luxembourg (Reinach, *Répertoire de reliefs*, ii, p. 161, No. 2).

74. *Ovidio Metamorphoseos vulgare . . .*, Venice (A. di Bandoni), 1508, fol. xlviii, already mentioned in this connection by R. W. Kennedy, *Novelty and Tradition in Titian's Art*, Note 79. Another instance is found in the Mayence Ovids of 1545 and 1551 (here fol. xliv verso), for which see Henkel, "Illustrierte Ausgaben von Ovids Metamorphosen," p. 105f.

in Bernard Salomon's woodcut, even a spear) a weapon sharply curved and looking like a crossbreed between scimitar and sickle. In all these respects, I think, Titian took his cue from the *Metamorphoses* itself. Here the origin of the coral is narrated at the end of the Andromeda story.[75] Perseus' weapon is thrice referred to as "crooked," "curved" or "sickle-shaped" (*teloque accingitur unco; ferrum curvo tenus abdidit hamo; falcato verberat ense*).[76] And his descent from the air is graphically described as "head foremost," *praeceps*. Like Dürer in his *Apocalypse*, Titian could achieve a phantasmagoric effect by following a text *ad literam*.

Just as Titian's last religious painting, the *Pietà* in the Accademia (Fig. 23), is in a sense a farewell to the antique and Michelangelo, so is his last mythological painting, the "*Nymph and Shepherd*" in the Vienna Museum — likewise unfinished[77] — a farewell to the antique and Giorgione (Fig. 182).

It has long been observed that the reclining nude is patterned after a composition by Giorgione (lost, but partly transmitted through an engraving by Giulio Campagnola, Fig. 183) which was in turn derived from a classical source.[78] Needless to say, Titian not only transformed but

75. *Metamorphoses*, IV, 740-752, for which see R. W. Kennedy, "Apelles Redivivus," p. 166, Note 46: the seaweeds on which Perseus has deposited the petrifying head of Medusa are changed into coral.

76. *Metamorphoses*, IV, 666, 720, 727. All these expressions circumscribe, of course, the Greek word ἅρπη. But even in classical sculpture (as in an Etruscan urn preserved at Volterra and illustrated in Reinach, *Répertoire de reliefs*, III, p. 465, No. 1) this ἅρπη is normally rendered not as a sickle-shaped weapon but as a straight sword with a hook rectangularly projecting from its blade. This form was retained in such illuminated manuscripts as were unusually faithful to a late antique prototype (e.g., British Museum, MSS. Cotton Tiberius B. V., Pars I and Harley 647, both illustrated in Saxl and Meier, *Catalogue of Astrological and Mythological Manuscripts*, III, 2, Pl. lxi); whereas Benvenuto Cellini in his famous statue in the Loggia dei Lanzi devised a sword the blade of which tapers off into a kind of kris. All of this

tends to confirm the assumption that the form of the weapon brandished by Titian's Perseus was inspired by the Ovid text rather than by a visual model.

77. *V.*, II, Pl. 141. The canvas is slightly cut down on either side.

78. See Saxl, *Lectures*, I, p. 171; II, Pl. 112a; cf. G. M. Richter, *Giorgio da Castelfranco*, Chicago, 1937, p. 215f. As for the classical archetype of Giorgione-Campagnola and Titian, Saxl believes in a direct connection between Titian's picture and the print but convincingly proposes that the latter was developed from the figure of Tellus frequently found in Roman sarcophagi (significant examples: Reinach, *Répertoire de reliefs*, III, pp. 210, No. 3, and 291, No. 2). Brendel, "Borrowings from Ancient Art in Titian," p. 124f. and Fig. 36, assumes a direct derivation of Titian's picture from a Roman gem where, however, the rather clumsily posed "nymph" (in reality a thyrsus-bearing maenad) substantially differs from both the classical Tellus type and Titian's nude, particularly in the

transfigured his model. He added a shepherd holding — but not playing — a flute. He placed the nude upon a panther's skin (not necessarily the attribute of a maenad but, according to Cristoforo Landino and Ripa, a symbol of unquenchable *libido*) and turned her head away from that of her companion. He provided her with a left arm whose curious position intensifies the impression that she has withdrawn into a world of her own. And he enveloped the whole scene in the mystery of a strangely cheerless bucolic landscape, with a broken tree in the background — a landscape where a maximum of tone is combined with a minimum of color.

That a painting of this size (nearly 5 by more than 6 feet, even though the canvas was cut down on either side) should be a mere genre piece, as its conventional title implies, appears improbable, and various interpretations have been suggested: another comment on the relationship between the senses of sight and hearing;[79] Diana and Endymion;[80] Daphnis and Chloë; Venus and Aeneas; Orpheus and a Maenad.[81] But the scene is too much fraught with emotion to be an allegory, and this emotion is too restrained and sombre for any of the suggestions proposed.

To me these despondent lovers, so near to each other in body yet so far apart in sentiment, suggest the story of Oenone, one of the most pathetic figures in Greek — or, rather, Hellenistic — mythology. A nymph living in the Ida mountains near Troy, she was dear to Paris when he, banished from his father's court, lived as a lowly shepherd rather than a prince. Abandoned by him in favor of Helen (an event which she, endowed with the gift of prophesy, had long foreseen and feared), she never ceased to love him. Yet, when he was hit by a poisoned arrow and implored her to heal his wound by means of potent herbs, she refused — or was forbidden — to save his life. Overcome by grief and remorse, she killed herself; and both were buried in one tomb.

There are classical reliefs, demonstrably known in the sixteenth century, where Paris, like Titian's "shepherd," is clad in Phrygian

position of the legs. Since Titian's figure agrees with that in Campagnola's engraving even in the position of her right arm, which has no parallel in any of the classical examples, his direct dependence on Giorgione-Campagnola remains a virtual certainty.

79. See O. Brendel, "Letter to the Editor," *Art Bulletin*, XXIX, 1947, pp. 67 ff., particularly p. 69.

80. Thus *T.*, p. 400.

81. Personal communication from Dr. Klauner in Vienna, kindly transmitted to me by Dr. Gerhard Schmidt. The "Orpheus and Maenad" interpretation was proposed by G. Tschmelitsch referred to above, p. 127, Note 46.

trousers and makes music on a rustic instrument (Fig. 184).[82] And if the two figures in Titian's picture were interpreted as Paris and Oenone — still united but oppressed by the shadow of impending separation and doom — the "gloomy grandeur"[83] of this melancholy pastoral would become understandable. It was inspired, I believe, by Ovid's treatment of the Oenone theme.

In his *Epistolae* or *Heroides*, Ovid collected twenty-one imaginary letters written by the great lovers of the past. And the fifth of these letters (only three of them attributed to men) is addressed to Paris by the abandoned Oenone. She pours out her sorrow; she professes her lasting love; and she evokes the memory of their past happiness:

> "You, now a son of Priam, were (to let
> Respect give way to truth) a servant then;
> I deigned to wed a servant, I, a nymph!
> Amidst the flocks we often took our rest
> Protected by a tree; and, intermixed
> With leaves, the grass became our bridal couch";
> *Qui nunc Priamides (absit reverentia vero)*
> *Servus eras; servo nubere nympha tuli.*
> *Saepe greges inter requievimus arbore tecti*
> *Mixtaque cum foliis praebuit herba torum.*

These lines (*Heroides*, v, 11 ff.),[84] I submit, anticipate not only the subject and the setting — the grassy ground, the goat nibbling at the

82. See the end from a sarcophagus in the Palazzo Doria-Pamphili (Reinach, *Répertoire de reliefs*, III, p. 246, No. 2) at Ince Hall (Reinach, II, p. 452, No. 2) which is here illustrated after a drawing in the *Codex Coburgensis* reproduced in C. Robert, *Die Antiken Sarkophag-Reliefs*, Berlin, 1890 ff., II, Pl. IV, No. 10a. Even in the Judgment scene Paris was occasionally represented in Phrygian shepherd's dress: sarcophagus in the Villa Medici at Rome (Reinach, III, p. 312, No. 1), likewise copied in the *Codex Coburgensis* (Robert, ibidem, Pl. v, No. 11).

83. Thus, Gronau, *Titian*, p. 199.

84. In this letter Oenone also alludes to her knowledge of medicinal herbs, unfortunately unavailing against love, and thereby anticipates the tragic end of the story (told by Apollodorus and others), i.e. her refusal or inability to use this knowledge for the cure of Paris' mortal wound. For representations of Oenone's refusal to save the life of Paris by Géricault and A. J. B. Thomas, see L. Eitner, "Géricault's 'Dying Paris' and the Meaning of his Romantic Classicism", *Master Drawings*, I, 1963, pp. 21 ff. The beginning of the passage quoted alludes to the fact that Paris, abandoned in the mountains as an infant, was long believed to be the son of the shepherd who had found and saved him. Professor Dario A. Covi kindly informs me that — according to a document which he has published in *Art Bulletin*, XLVIII, 1966, pp. 97 ff., particularly p. 99 — Andrea del Verrocchio (d. 1488) owned a copy of Ovid's *Heroides* ("*le pistole d'Ovigio*"), apparently in an Italian translation.

foliage of the broken tree on the right, the big "protecting" tree on the left — but the very mood of Titian's *ultima poesia*.[85]

85. Since I have never seen the original, which comes from the collection of Thomas Howard Earl of Arundel and Surrey (died 1646) and is now in the Archiepiscopal Palace at Kroměříž, formerly Kremsier, in Czechoslovakia, I do not dare pronounce on the authenticity of the now almost generally accepted *Flaying of Marsyas* (*V.*, ɪɪ, Pl. 143; cf. J. Neumann, *Titian, The Flaying of Marsyas*, London, 1962 [German translation, Prague, 1962]; P. Fehl, "Realism and Classicism in the Representation of a Painful Scene: Titian's 'Flaying of Marsyas,'" *Czechoslovakia Past and Present* [Czechoslovak Society of Arts and Sciences in America], scheduled for publication in the near future). It is admittedly difficult to attribute this painting to anyone else (although in view of the *Pietà* in the Accademia one might think of the very versatile Palma Giovane); but it is equally difficult to accept Titian's responsibility for a composition which in gratuitous brutality (the little dog lapping up the blood) not only outdoes its model, one of Giulio Romano's frescoes in the Palazzo del Tè at Mantua (for its connection with the Kroměříž picture see F. Hartt, *Giulio Romano*, p. 111, Fig. 172, where the authenticity of the *Flaying of Marsyas* is doubted as it is in Hetzer's article in Thieme-Becker), but also, and more importantly, evinces a *horror vacui* normally foreign to Titian who, like Henry James' Linda Pallant, "knew the value of intervals." In the Kroměříž picture no square inch is vacant. If the *Flaying of Marsyas* were rejected it would also be hard to accept the *Boy with Dogs* in the Boymans Museum at Rotterdam (*V.*, ɪɪ, Pl. 140) which is apparently by the same hand and from the same period. Director Ebbinge-Wubben was kind enough to impart to me the results of a recent examination of the Rotterdam canvas. As conjectured by Tietze (*T.*, p. 392), it is not a complete composition but a mere fragment, roughly torn off from rather than cut out of a larger painting; and it measures only 99.2 by 111 cm. while all available references give its dimensions as 128 by 180 cm. For the subject, one may think of Cupid mastering two dogs of different temper as in a painting by Paolo Veronese in the Alte Pinakothek at Munich; cf. also A. P. de Mirimonde, "La Musique dans les Allégories de l'Amour," *Gazette des Beaux-Arts*, Series 6, ʟxɪx, 1967, pp. 319 ff., Figs. 11 and 12.

Excursus 1

Some Bibliographical Notes

There is, so far as I know, no special Titian bibliography comparable to E. Steinmann's and R. Wittkower's masterly *Michelangelo Bibliographie, 1510-1926* (published in 1927 and supplemented by Steinmann's *Michelangelo im Spiegel seiner Zeit*, 1930) or even to H. W. Singer's less impeccable *Versuch einer Dürer Bibliographie* (second edition, 1928). The reader must have recourse to the very thorough bibliographical appendix to T. Hetzer's article in Thieme-Becker's *Allgemeines Künstlerlexikon*, XXXIV, 1940, pp. 168-172; and, for contributions published after that date, to the fairly extensive but not always reliable bibliographies in G. A. dell'Acqua, *Tiziano*, Milan, 1958, pp. 95 ff. (arranged in chronological order) and F. Valcanover, *Tutta la Pittura di Tiziano*, Milan, 1960, II, pp. 88 ff. (arranged in alphabetical order). In his text, the present writer has confined himself to citing such books and articles as are relevant to the special problems discussed.

Even with regard to primary sources the situation is exceptionally difficult. In contrast to the letters of Michelangelo, Dürer, Rubens, Salvator Rosa, or Poussin, Titian's letters (cf. E. Tietze-Conrat, "Titian as a Letter Writer", *Art Bulletin*, XXVI, 1944, pp. 117 ff.) have never to my knowledge been collected and edited *in toto*. In most cases the texts are available only in such time-honored publications as S. Ticozzi, *Vite dei pittori Vecelli di Cadore*, Milan, 1817; M. G. Bottari and S. Ticozzi, *Raccolta di lettere sulla pittura, scultura ed architettura...*, Milan, 1822-1825, continued by M.-A. Gualandi, *Nuova raccolta di lettere...*, Bologna, 1844-1856 (see also idem, ed., *Memorie originali Italiane risguardanti le belle arti*, Bologna, 1840-45, and cf. Julius Schlosser-Magnino, *La Letteratura artistica*, 3rd edition, Florence and Vienna, 1964 [hereafter referred to as "Schlosser"], pp. 484, 507 f.); G. Gaye, *Carteggio inedito d'artisti dei*

172

secoli XIV. XV. XVI., Florence, 1839-40; Z. Bicchierai, *Lettere d'illustri Italiani non mai stampate*, Florence, 1854; G. Campori, "Tiziano e gli Estensi," *Nuova Antologia*, XXVII, 1874, pp. 581 ff. (supplemented by G. Gronau, "Alfonso d'Este und Tizian," *Jahrbuch der kunsthistorischen Samm- lungen in Wien*, N.F.,II, 1928, pp. 233 ff.); A. Ronchini, "Delle relazioni di Tiziano coi Farnese," *Atti e memorie delle R. Deputazioni di storia patria per le provincie Modenesi e Parmensi*, Modena, 1864; A. Luzio, "Tre Lettere di Tiziano al Cardinale Ercole Gonzaga," *Archivio storico dell'Arte*, III, 1890, pp. 207 ff.; and, above all, the appendices to J. A. Crowe and G. B. Caval- caselle, *Titian: His Life and Times*, London, 1877 (2nd edition, London, 1881; Italian edition, Florence, 1877-78; German translation, with certain interesting additions, Leipzig, 1877). Pietro Aretino's letters addressed or referring to Titian — our richest source of firsthand infor- mation — are, however, accessible in a modern edition curiously omitted in Valcanover's bibliography: *Lettere sull' arte di Pietro Aretino, commentate da F. Pertile, a cura di E. Camesasca*, Milan, 1957-60 (cf. Schlosser, pp. 401, 720).

Such publications as those by Gaye, Campori, Ronchini, and Crowe and Cavalcaselle also contain a number of documents other than letters which must be regarded as primary rather than secondary sources: con- tracts, patents, privileges, records of payment, official memoranda, and the like. Documents relating to Titian's all-important dealings with the Hapsburg dynasty have been collected by M. R. Zarco del Valle, "Un- veröffentlichte Beiträge zur Geschichte der Kunstbestrebungen Karl V. und Philipp II. mit besonderer Berücksichtigung Tizians," *Jahrbuch der kunsthistorischen Sammlungen des Allerhöchsten Kaiserhauses*, VII, 1888, pp. 221 ff., and A. Buff, "Rechnungsauszüge, Urkunden und Urkunden- regesten aus dem Augsburger Stadtarchive," *ibidem*, XIII, 2, 1892, pp. 1 ff. For others, see, e. g., G. Cadorin, *Dello Amore ai Veneziani di Tiziano Vecellio* ..., Venice, 1833.

The secondary sources may be divided into two groups, contemporary and non-contemporary. Among the contemporary sources the most important ones are the *Diarii* of Marino Sanudo or Sanuto, published by R. Fulin and others (Venice, 1879-1903), which run from 1496 to 1533; and, above all, the *Notizia d'opere di disegno* by Marcantonio Michiel, still occasionally referred to as the "Anonimo Morelliano" because his *Notizia* was first published as "scritta da un'anonimo" by the learned Abbate Jacopo Morelli, Bassano, 1800 (cf. Schlosser, pp. 214 ff., 221 ff.). Identi- fied and critically edited by G. Frizzoni, Bologna, 1884, reëdited, with

important revisions and a German translation, by T. Frimmel, *Der Anonimo Morelliano* (*Marcanton Michiels*) *Notizia d'opere del disegno* (*Quellenschriften für Kunstgeschichte...*, new series, I), Vienna, 1888, and translated into English by G. C. Williamson, London, 1903, Michiel gives a surprisingly perceptive and reliable account of works of art in all media and of all periods which he had seen in North Italy, notably in the great private collections at Venice — an account which covers the years from 1521 (at the latest) to 1543. Less trustworthy, in spite — or because? — of the author's personal acquaintance with Titian, yet indispensable is the information supplied by Lodovico Dolce's *Dialogo della pittura... intitolato l'Aretino*, Venice, 1557, reprinted Florence, 1735; Milan, 1862; Florence, 1910; German translation by C. Cerri in *Quellenschriften für Kunstgeschichte*, II, Vienna, 1871; English translation by W. Brown, London, 1770; new edition (Vol. I) by P. Barrocchi, 1960 (cf. Schlosser, pp. 392f., 401, 720). And this is also true of Giorgio Vasari's *Vite de' più eccellenti pittori, scultori et architettori*, 2nd edition, Florence, 1568 (*Le Opere di Giorgio Vasari*, ed. G. Milanesi, Florence, 1878-1885, VII, pp. 425-471). Vasari had met Titian at Venice in 1541 and again in Rome, where he served him as a kind of honorary guide, in 1545-46; but it was only when he revisited Venice in May 1566 and was received in Titian's house that he could round out the meager information available to him when he published the first edition of the *Vite* in 1550.

Among the non-contemporary secondary sources — in addition to inventories, catalogues and guide books — the most important ones are these: Francesco Sansovino, *Venetia, Città nobilissima et singolare descritta*, Venice, 1581, revised and augmented by Giovanni Stringa, Venice, 1604, and Giustiniano Martinioni, Venice, 1663 (cf. D. von Hadeln, "Sansovinos Venetia als Quelle für die Geschichte der venezianischen Malerei," *Jahrbuch der Königlich preussischen Kunstsammlungen*, XXXI, 1910, pp. 149ff., and Schlosser, pp. 367f., 379); Giovanni Paolo Lomazzo, *Trattato dell'arte della pittura*, Milan, 1584, reprinted Rome, 1844; English translation by R. Haydocke, Oxford, 1598 (cf. Schlosser, pp. 395f., 402); idem, *Idea del tempio della pittura...*, Milan, 1590, reprinted Bologna, 1785 (cf. Schlosser, pp. 396f., 402f., 721); the *Breve Compendio della vita del famoso Titiano Vecellio di Cadore*, an anonymous biography ascribed by some to Giovanni Mario Verdizotti and published on the initiative of Tiziano Vecelli the Younger, called Tizianello (the son and pupil of Marco Vecelli whom Titian had taken into his house about 1560-65), Venice, 1622, reprinted, under a slightly different title, by the Abbate

Acordini, Venice, 1809 (cf. Schlosser, pp. 470, 560); Carlo Ridolfi, *Le Maraviglie dell'arte o vero le vite degl'illustri pittori Veneti...*, Venice, 1648, excellently edited and commented upon by D. von Hadeln, Berlin, 1914-1924 (cf. Schlosser, pp. 531, 559); Marco Boschini, *La Carta del navegar pitoresco...in l'alto mar de pitura*, Venice, 1660; idem, *Le Minere della pittura ...di Venezia*, Venice, 1664 (second edition, much enlarged and retitled *Le Ricche Minere della pittura Veneziana*, Venice, 1674). For Boschini's works, cf. Schlosser, pp. 547 ff., 561f., 727.

As far as recent monographs on Titian are concerned, I must limit myself to an even smaller and admittedly subjective selection. By far the best (except for its inadequate index) is still Crowe and Cavalcaselle's *Titian: His Life and Times*, already cited. Outdated in many respects, it remains unmatched in the wealth of factual documentation and the breadth and precision of historical insight. It is one of those Victorian classics like Moritz Thausing's *Dürer*, Hermann Grimm's *Michelangelo* or Karl Justi's *Velazquez*, which — practically without illustrations — demand to be read rather than "consulted" and place their heroes on the stage of history (world history as well as local or even private history) as full, three-dimensional personages instead of neglecting (as we are all inclined to do) human reality in favor of sociological, philosophical or artistic "problems."

Of later monographs, all of them indebted to Crowe and Cavalcaselle, the following may be mentioned: the very readable and reasonable book by G. Gronau, *Tizian*, Berlin, 1900 (English translation, London and New York, 1904); C. Ricketts, *Titian*, London, 1910; O. Fischel, *Tizian* (*Klassiker der Kunst*, 5th edition, Stuttgart, 1929). In independence and penetration, but also in a certain hierophantic oracularity, there stand out the works of T. Hetzer (to whom we owe the excellent Titian entry in Thieme-Becker's *Künstlerlexikon* already referred to): *Die frühen Gemälde des Tizian*, Basel, 1920 and *Tizian*; *Geschichte seiner Farbe*, Frankfurt, 1935, 2nd edition, 1948. Where Hetzer tends to be overcritical, W. Suida, *Tizian*, Zurich and Leipzig, 1933 (Italian translation, Rome, 1933; French translation, Paris, 1935) sins in the opposite direction — which has, however, the advantage that reproductions of even the most doubtful paintings attributed to Titian at the time can be found in his book. A *juste milieu* between an over-critical and an uncritical attitude is aimed at by H. Tietze, *Tizian*; *Leben und Werk*, Vienna, 1936, and its abridged and revised but not always improved English version: *Titian*; *The Paint-*

ings and Drawings, New York, 1950. The second half of our century saw the publication of R. Pallucchini's *Tiziano*, Bologna, 1953-54 (very informative but not illustrated) and its antitheses (placing the emphasis upon pictures rather than text), i.e., G. A. dell'Acqua, *Tiziano* (already cited on p. 172); G. Delogu, *Tiziano*, Bergamo, 1951 (not seen); L. Venturi, *Titian*, New York, 1954 (not seen); M. Valsecchi, *Tiziano*, Milan, 1958; and A. Morassi, *Titian* (The Great Masters of the Past, XIII), Greenwich, Conn., 1965. Last but not least there must be mentioned F. Valcanover's indispensable *Tutta la Pittura di Tiziano* (already cited on p. 172) which, in spite of its small size and other shortcomings, is the closest available approximation to a "corpus" of paintings by, after and ascribed to Titian.

Excursus 2

The Problem of Titian's Birth Date

The problem of Titian's birth date is well summarized in C. Gould, *National Gallery Catalogues*; *The Sixteenth-Century Venetian School*, pp. 94 ff., and *P.-C.*, III, pp. 477 ff. For a handy collection of the documentary evidence, cf. F. J. Mather, Jr., "When Was Titian Born?," *Art Bulletin*, XX, 1938, pp. 13 ff.

Until, after some preliminary rumblings, Sir Herbert Cook advanced the date of Titian's birth to 1488-1490, the master was generally thought to have been born in 1477, thus reaching the age of ninety-nine. This is, so to speak, the "official" version, adopted by the Vecelli family and sanctioned by Titian himself in his famous letter to Philip II of August 1, 1571 (*C.-C.*, II, p. 538), in which he asks for payments due to him and describes himself as "the King's servant, now ninety-five years of age." It is supported by a report of the Spanish envoy, Garcia Hernández, of October 15, 1564 (*C.-C.*, II, p. 534f.) which says that Titian was "nearly ninety" but did not show it; by Raffaello Borghini's *Il Riposo* of 1584 (reprinted at Florence in 1730) according to which Titian died in 1576 "at the age of ninety-eight or ninety-nine"; by the anonymous biography published on the initiative of Tiziano di Marco Vecelli, known as "Tizianello," in 1622 (see above p. 174); and by Ridolfi's *Le Maraviglie dell' arte* of 1648.

This "official" version has been questioned on several grounds. Borghini, Tizianello's Anonym and Ridolfi are secondary sources; Garcia Hernández simply repeats what Titian and his family had told him. And Titian himself may have exaggerated his age because he wanted to arouse the King's sympathy with an "old servant" of almost incredible age. It can, unfortunately, not be denied that Titian did not mind a little inaccuracy when he wanted to get, or save, some money. On September 10, 1554 (*C.-C.*,ii, p. 508) he told Charles V that he had been put to great expenditures by the recent marriage of his daughter, whereas this marriage did not take place until June 19th of the following year (*C.-C.*, ii, p. 248); and his tax declaration of 1566 (*C.-C.*, ii, p. 364f.) would land him in jail today.

These considerations tend to devaluate what looks like first-hand evidence for the birth date of 1477. And the still earlier date of 1473, deducible from the Parish Register of San Canciano (according to which Titian died at the age of a hundred and three), can be discarded *a priori* because it is unsupported by any other source and proves only that whichever member of Titian's household reported the death to the Parish priest had added four more years to the official figure (cf. M. Valsecchi, "Forse sono troppi i 103 anni di Tiziano," *Tempo*, 1955, June 16, written in reply to L. Borgese, "Una documentata prova che Tiziano morì all'età di centotrè anni," *Corriere dell'Informazione*, 1955, May 30-31). "Taufregister sind sprichwörtlich falsch," says Theodor Fontane (*Briefe an Georg Friedlaender*, ed. K. Schreinert, Heidelberg, 1954, p. 239.)

A birth date of 1488-1490 is suggested by a statement of Lodovico Dolce, a personal friend of Titian's, according to which the latter was a young man (*giovanetto*), "not even twenty years of age" (*non avendo venti anni*), when he joined forces with Giorgione at the Fondaco de' Tedeschi in 1508 (*Dialogo della pittura*, Venice, 1557); and it seems to be supported by the absence of any painting demonstrably produced by Titian before that year.

Vasari, never very careful in checking his dates for consistency, contradicts himself. At the very beginning of his biography (vii, p. 426) he places Titian's birth in 1480, which is near enough to the "official" figure of 1477; but in another passage (p. 428) he states that Titian was "no more than eighteen years old" when he "began to follow the manner of Giorgione"; and in still another (p. 459) he claims that Titian was "about seventy-six", *circa settantasei anni* (not, as printed in *P.-C.*, iii, p. 478, *sessantasei*), when Vasari visited him in 1566, which would place his birth

in c. 1490. But Vasari's statements on pp. 428 and 459 manifestly depend on Dolce's; and if Titian overstated his age in order to influence Philip II, Dolce may have understated it in order to make his friend appear more precocious than he really was. Since — according to Dolce himself — Titian's first teacher was Sebastiano Zuccato, a mosaicist rather than a painter, the young genius may have lost some time before entering the workshop of Gentile Bellini, which would account for the absence of real *juvenilia*.

In short, no definite conclusion can be drawn from the written sources. We may, however, venture upon some inferences from Titian's early altarpiece in the Antwerp Museum (*V.*, I, Pls. 10-12, our Fig. 16). It shows St. Peter enthroned and, kneeling before him and recommended by Pope Alexander VI (here cast in the incongruous role of another, if minor, saint), Jacopo Pesaro, the donor. Jacopo Pesaro, born in 1460 and destined to reach an age of eighty-seven, had taken orders as a Dominican and in 1495 was invested with the bishopric (*in partibus*) of Paphos on Cyprus, the place where Venus was supposed to have emerged from the sea. In 1502, Alexander VI made him commander and apostolic commissioner of the fleet assembled against the Turks (hence the helmet, an attribute apparently unsuitable to an ecclesiastic, and the resplendent banner which shows the Borgia coat-of-arms impaled with that of the Pesaro family); and toward the end of August of that year (not on June 28, on which day he had only been invested with the symbol of his dignity, the pontifical banner) Jacopo succeeded in capturing the island of Santa Maura, the ancient Leucadia. The fleet can be seen in the background of the Antwerp altarpiece; and the relief on the base upon which the throne of St. Peter is resting (a relief which, as my late lamented friend, Dr. Paul Coremans, assured me, is consubstantial with the rest of the entirely homogeneous picture) has been shown to refer both to Jacopo's victory and the cult of Venus (R. Wittkower, "Transformations of Minerva in Renaissance Imagery," *Journal of the Warburg Institute*, II, 1939, pp. 194 ff., particularly pp. 202 f.).

It is hard to believe that the Antwerp picture, clearly intended to glorify the events of 1502, was commissioned when these events had become a thing of the remote past. Nor is it probable that Titian unduly procrastinated in this case: had he done so, Jacopo Pesaro would not have entrusted him, in 1519, with a second altarpiece, the celebrated *"Pala Pesaro"* in S. M. Gloriosa dei Frari — intended to commemorate not only Jacopo but his entire family, yet still displaying the Borgia arms

together with those of the Pesaro. This second altarpiece (*V.*, I, Pls. 122, 123) was solemnly unveiled on December 8, 1526.

I am therefore inclined to believe that the Antwerp altarpiece was ordered not later than 1503, perhaps as a memorial to Alexander VI who died on August 18th of that year, when the memory of Santa Maura was still fresh; and that it was executed without much delay. These two assumptions are concordant with the apparent age of the donor (born, we recall, in 1460), who in the Antwerp altarpiece looks like a man not older than from forty to forty-five and seems to be from fifteen to twenty years younger than he is in the "*Pala Pesaro*" of 1519-1526 (Figs. 185 and 186); moreover, the Antwerp altarpiece — still rather Bellinesque in style — does not as yet reveal the influence of Giorgione.

If these assumptions are correct, Titian would have been a young but independent painter about 1503 so that the date of his birth would fall between the two extremes of 1477 and 1490: he would have been born in the first half of the 'eighties. This estimate conveniently, though in all likelihood accidentally, agrees with a report of the Spanish Consul, Thomas de Cornoça, who, in a letter of December 6, 1567, assures Philip II that Titian "with his eighty-five years" would continue to serve His Majesty as long as he lived, thus dating the master's birth in c. 1482 (G. Gronau, "Tizian's Geburtsjahr," *Repertorium für Kunstwissenschaft*, XXIV, 1901, pp. 457 ff.).

Excursus 3

The Battle of Cadore

For Titian's lost battle piece (*V.*, I, p. 86 ff. and II, Pl. 192), see E. Tietze-Conrat, "Zu Tizians 'Schlacht bei Cadore'," *Mitteilungen der Gesellschaft für vervielfältigende Kunst* (supplement to *Die graphischen Künste*), XLVIII, 1925, pp. 42 ff.; eadem, "Titian's '*Battle of Cadore*,'" *Art Bulletin*, XXVII, 1945, pp. 205 ff.; eadem, "Titian's Design for the *Battle of Cadore*," *Gazette des Beaux-Arts*, series 6, XXXIV, 1948, pp. 237 ff., 297 ff.

The picture which Titian had so boldly offered to undertake in 1513, and which took him exactly one quarter of a century to deliver, was destroyed by fire on December 20, 1577. Its appearance can be inferred from five in part interdependent sources: an engraving by Giulio Fon-

12*

tana, dated 1569 (Fig. 187); an anonymous print, preserved, so far as I
know, only in one impression in the Albertina at Vienna; a drawing by
Rubens, preserved in the Municipal Printroom at Antwerp and almost
certainly based on Fontana's engraving (see M. Jaffé, "Rubens and
Giulio Romano at Mantua," *Art Bulletin*, xL, 1958, pp. 325 ff., Note 7;
for further information, cf. J. G. van Gelder, "The Triumph of Scipio
by Rubens," *Duits Quarterly*, 8, 1965, pp. 5 ff., with a good illustration
on p. 8); a painted copy in the Uffizi (*V.*, ii, Pl. 192, our Fig. 188); and
a beautiful drawing in the Louvre (most probably a preparatory sketch
by Titian himself) which was published by E. Tietze-Conrat in the
Gazette des Beaux-Arts, *loc. cit.* (also reproduced in *V.*, i, p. 87, and *T.*, Pl.
105; our Fig. 189).

E. Tietze-Conrat correctly considers the Uffizi copy — which largely
agrees with the Louvre sketch — to be a more adequate rendering of
Titian's composition than Fontana's pronouncedly oblong engraving,
where the whole group of horsemen on the right, carrying a banner
distinct from that of the detachment crossing the bridge (and absent
from the Albertina print as well as from the Uffizi copy and the Rubens
drawing) has been added. The Uffizi copy differs from the Louvre
sketch chiefly in that the commanding general seen in the lower right-
hand corner of the Uffizi copy and — farther to the left, of course —
near the lower margin of Fontana's print is a simple artillerist in the
sketch (in the Rubens drawing this figure is not included at all); and in
that the banner of the opposing forces — the Eagle of the Roman and,
consequently, the German Empire — is not so clearly recognizable in
the sketch as it is in the Uffizi copy and in Fontana's print. What is
difficult to determine is the subject.

The sources prior to Vasari speak only of "The Battle" (*la battaglia*):
Titian himself in his application of 1513 (*C.-C.*, i, p. 153); the Council
of Ten in a threatening letter to Titian of 1522 (*C.-C.*, i, pp. 164, 168);
and Lodovico Dolce in 1557. In the stern decree of June 23, 1537 (*C.-C.*,
i, p. 162, Note, and ii, p. 4f.) this "battle" is specified as the "land battle"
(*bataglia terrestre*), probably in contradistinction to a naval engagement.
Vasari (vii, p. 439) designates the subject as "The Defeat of Chiaradad-
da" (*la rotta di Chiaradadda*), now mostly referred to as the Battle of
Aguadello; and it is only in Ridolfi's *Maraviglie*, published as late as
1648, that we find it explicitly identified as the "Battle of Cadore."

Vasari's designation can be discarded not only because the terrain
around Chiaradadda is perfectly flat but also because a painting in the

Sala del Maggior Consiglio would hardly have commemorated one of the worst defeats ever suffered by the Republic of Venice: at Chiaradadda, the Venetian army was routed by the French on May 14, 1509, and its commander, Bartolommeo Dalviano (or d'Alviano) was captured. It is a reasonable assumption that, when Titian was commissioned to replace — or, rather, to cover up — a ruined fresco of the fourteenth century, he was supposed simply to repeat its subject, which was the Conquest and Destruction of Spoleto by Barbarossa: "Urbs Spoletana, quae sola Papae favebat, obsessa et victa ab Imperatore deletur" (G. B. Lorenzi, *Monumenti per servire alla storia del Palazzo Ducale di Venezia*, Venice, 1868, quoted by *C.-C.*, ii, p. 7). This conquest and destruction of Spoleto is an incident in the long struggle between Barbarossa and Pope Alexander III — a struggle so closely connected with the real and legendary history of Venice that the whole decoration of the north wall of the Sala del Maggior Consiglio, as reconstructed after the fire of 1577, was devoted to its pictorial glorification. It was in Venice that the final peace between the warring parties was concluded in 1177, and it was from Alexander III that the Doge Sebastiano Ziano was said to have received the most important symbols of his office, the "white taper" and the ring used in the ceremony of the Doge's "Marriage to the Sea." The appearance of a burning town in the background of Titian's *Battle* still seems to reflect the original subject.

In its final form, however, Titian's picture cannot have been intended to represent the Conquest and Destruction of Spoleto — for the simple reason that the imperial army, bearing the banner with the Roman Eagle, is clearly losing. The banners of the winning party, moreover, show the coats-of-arms of the two great Venetian families whose members had vanquished Maximilian I in the Battle of Cadore in the early spring of 1508: that of the Dalviano (*barry of gules and argent*) in all renderings except the Rubens drawing; and that of the Cornaro (*three lions passant argent*) in the added section of the Fontana print. In the Battle of Cadore (for details, see *C.-C.*, i, pp. 96 ff.) the victorious Venetian army was commanded by the same Bartolommeo Dalviano who was to lose the day at Chiaradadda in the following year; but he shared the honors of Cadore with the military commissioner (*proveditore*), Giorgio Cornaro; and these two leaders — both represented in person in Francesco Bassano's *Battle of Cadore*, one of the fifteen paintings which now adorn the ceiling of the Sala del Maggior Consiglio — owed their success in outflanking the imperial army to the expert guidance and vigorous assistance of the

loyal inhabitants, prominently including several members of the Vecelli family.

The most probable inference is that the subject of Titian's battle piece was changed, some time before its completion, from the Conquest and Destruction of Spoleto to the Battle of Cadore. And that this change was common knowledge during Titian's lifetime, and many years before Ridolfi, is demonstrated by the fact that Giulio Fontana saw fit to add the banner of the Cornari to that of the Dalviani in his engraving of 1569. Andrea Gritti, Doge from May 20, 1523 to his death on December 28, 1538, and well known for his pro-French and anti-German inclinations, may have permitted himself the malicious pleasure of substituting for the victory of a German emperor over a Pope in the twelfth century the defeat of a German emperor at the hands of the Serenissima in 1508; and Titian may have accepted this change of subject all the more readily as his own relatives had played an important and well-remembered role in that defeat. But in view of the officially correct relations between Venice and Maximilian's grandson and successor, Charles V, it would have been unwise to advertise the reinterpretation of the scene by an inscription. And this may account for the fact, already noted as an anomaly by Sansovino (C.-C., II, p. 7), that Titian's battle piece, in contrast to all the other members of the series, "bore no inscription underneath."

Excursus 4

Titian and Seisenegger

Since the publication of G. Glück's essay "Original und Kopie," *Fest-schrift für Julius Schlosser*, Zurich, Leipzig and Vienna, 1927, pp. 224 ff., most scholars consider Titian's Prado *Portrait of Charles V* (*V.*, I, Pl. 132, our Fig. 6), showing the Emperor in full-length and accompanied by a big "water dog," to be an improved copy after a nearly identical portrait by the Austrian court painter, Jakob Seisenegger, which is preserved in the Vienna museum and bears this artist's signature as well as the date, 1532 (Fig. 190); see, for example, *T.*, p. 383; H. von Einem, *Karl V und Tizian*, pp. 8 ff.; C. Gould, *National Gallery Catalogues*; *The Sixteenth-Century Italian Schools*, p. 106 f.; K. Löcher, *Jakob Seisenegger, Hofmaler Kaiser Ferdinands I*

(Kunstwissenschaftliche Studien, XXXI), Munich and Berlin, 1962, pp. 32 ff., 88; J. Müller Hofstede, "Rubens und Tizian," cited above, p. 8, Note 7; J. Pope-Hennessy, *The Portrait in the Renaissance* (Bollingen Series XXXV, 12), New York, 1966, p. 171, kindly brought to my attention by Mr. Robert Bergmann. Only C. Nordenfalk, "Tizians Darstellung des Schauens" (ignored by Löcher but recently supported by A. Cloulas, "Charles Quint et le Titien," *L'Information d'histoire de l'art*, IX, 1964, pp. 213 ff., particularly pp. 219 ff.), attempted to show that Seisenegger worked after Titian rather than the other way around.

That Titian's portrait is superior to Seisenegger's not only with regard to the pose and proportions of the figure but also in every other respect (even the dog seems to have acquired a soul, as it were) goes without saying but does not warrant any conclusions. Dürer's copies after Mantegna, Pollaiuolo and "Jacques de Gérines" are in many ways superior to their respective originals; and in Balzac's *La Bourse* an ingenious young painter, anxious to please his paramour, copies a very bad portrait of her father ("le dessin en est horrible"), yet considers the result "one of his best works." Seisenegger's "dryness," "lifelessness" and *"maladresse"* cannot, therefore, be used as arguments for Titian's priority; and there are strong reasons to accept the opposite view. As pointed out by previous writers, the portrait in full-length is a Northern rather than Italian form which, prior to Titian's *Charles V*, is exemplified in Italy only by Carpaccio's *Portrait of a Knight* in the Thyssen Collection at Castagnola near Lugano (Pope-Hennessy, p. 320, Note 20) and by Moretto da Brescia's *Portrait of a Gentleman* in the National Gallery at London, dated 1526 (C. Gould, just quoted). Copyists normally simplify their models; whereas Seisenegger's portrait is more elaborate than Titian's in such details as the marble pattern of the floor or the ornamental buckle on the dog's collar. And even more important is the fact that Titian was still in Venice on November 8, 1532 (*C.-C.*, I, p. 456) whereas Seisenegger's picture (made in Bologna according to his own testimony) is dated in this very year. Even if Titian had reached Bologna before the end of 1532, of which there is no evidence, both his and Seisenegger's portraits would have been executed within about six weeks; and we can hardly assume, as does Mlle. Cloulas, that the inscribed date on Seisenegger's picture refers to the solemn entry of the emperor into Bologna on November 13, 1532 rather than to the execution of the painting. To commemorate an important dynastic and political event (Charles V had come to meet Pope Clement VII) by the inconspicuous inscription on a portrait, giving

nothing but the year and inseparable from the initials of the artist, would be without parallel in the history of art.

It may be added that the motif of the big "water dog," reduced to what archaeologists call a *protome* and snuggling up to his master, seems to be taken over from a woodcut by Hans Burgkmair which shows this artist interrupted in his work by the visit of Charles V's grandfather, Maximilian I (briefly referred to in Löcher, *op. cit*, pp. 33 and 73, Note 185; illustrated e.g., in A. Chastel and R. Klein, *L'Age de l'Humanisme* [*L'Europe de la Renaissance*], p. 189; our Fig. 191). This woodcut forms part of a series illustrating Maximilian's quasi-autobiographical romance, the *Weiss-Kunig*; and since this admirable but ill-fated work, widely known and commented upon in Austrian circles throughout the sixteenth century, was not published until 1775, Burgkmair's woodcut is more likely to have come to Seisenegger's than to Titian's attention in 1532-1533.

Excursus 5

The Portraits of Empress Isabella

Titian's memorial portraits of Charles V's Empress, Isabella of Portugal, confront us with a difficult problem, for which see P. Beroqui, *Tiziano en el Museo del Prado*, second ed., [Madrid], 1946, pp. 61 ff.; cf. *V.*, I, p. 89; G. Gronau, "Titian's Portrait of the Empress Isabella," *Burlington Magazine*, II, 1903, pp. 281 ff.; Mme. L. Roblot-Delondre, "Les Portraits d'Isabelle de Portugal, épouse de Charles-Quint," *Gazette des Beaux-Arts*, 4th series, I, 1909, pp. 435 ff.: G. Glück, "Bildnisse aus dem Hause Habsburg; I. Kaiserin Isabella," *Jahrbuch der kunsthistorischen Sammlungen in Wien*, N.F., VII, 1933, pp. 183 ff.; *P.-C.*, III, p. 490 f.; Müller Hofstede "Rubens and Tizian," cited above, p. 8, Note 7.

Titian's all-important letter concerning the earliest of these portraits (*C.-C.*, II, p. 501, referred to above, p. 9) is dated "Venice, October 5, 1545"; and it refers not to one but to two *ritrati della Ser^{ma} Imperatrice* which Titian had just consigned to Charles V's envoy, Don Diego Hurtado de Mendoza. The plural is used throughout in this letter, even in Titian's final request not to permit the interference of other painters ("ch'un altro metta la man in *essi*").

The dateline conflicts with the fact that Titian was in Rome, and not in Venice, in the fall of 1545; the reference to "two portraits" rather than one conflicts with a later letter of Titian to the Emperor, correctly dated "Rome, December 8, 1545" (Beroqui, p. 63f.; Glück, p. 209). According to this second letter, he had sent, again to Mendoza and only "a few months ago" (*alcuni mesi sono*), his own "memorial" portrait (singular!) of the defunct Empress together with "that other one" which had been given to him as a model ("il ritratto della sta. memoria della Imp[eratri]ce sua consorte fatto di mia mano con qu[el] altro che mi fu dato da lei per esempio"), that is to say, together with that "ritratto ...molto simile al vero, benchè di trivial pennello" which had been mentioned in Aretino's letter to Ferrante Montese of July 1543 (*P.-C.*, ii, p. 9) and which was to form the basis for all subsequent developments.

While the letter of December 8, 1545 complicates the situation as regards the number of portraits produced and despatched by Titian at the time, it solves the question of whether the error in the dateline of the letter of October 5 involved the year (as assumed, e.g., by *C.-C.* and W. Suida, *Tizian*, p. 165) or the place. Had the pictures been sent on October 5, 1544 Titian could not have said, on December 8th of the *following* year (that is to say, more than one year and two months later), that they had been shipped "a few months ago"; and a delivery at a date as early as before October 5, 1544 is all the more improbable as Aretino, in a letter also written in October 1544 (*P.-C.*, ii, pp. 26ff.; Beroqui, p. 64), describes the "splendid portrait" of the Empress as still unfinished. The problematic letter, then, would seem to have been written on October 5, 1545, but in Rome rather than in Venice.

The number of portraits then despatched remains uncertain. But since Aretino mentions only one picture of the Empress, and since Titian in his letter of December 8th, 1545, so carefully distinguishes between the „memorial" portrait *fatto di mia mano* and "that other one" which had been given to him *per esempio*, I incline to believe that his earlier letter (October 5, 1545) uses the plural only by mistake, probably due to the fact that two portraits of the Empress — his own and that which had been given to him as a model — had been despatched together.

Aretino describes the unfinished portrait inspected by him in October 1544 as showing the Empress "holding some flowers in her lap" (*alcuni fiori in grembo*). Since this is not true of the portrait preserved in the Prado (*V.*, ii, Pl. 25; our Fig. 8), the picture of 1544-1545 must be considered lost. It is, however, known to us through a painted replica first published, but

identified with Titian's "trivial" *esempio* and attributed to Alonso Sánchez
Coello, by its then owner, Mme. Roblot-Delondre (see her article just
quoted; Gronau, 1903, p. 282; cf. also Beroqui, Plate facing p. 60 and
Glück, Fig.164) and through an engraving by Pieter de Jode (Glück, Fig.165,
our Fig. 192). These renderings show that the portrait of 1544-1545 differed
from the Prado version not only by the presence of the flowers — and,
incidentally, by the presence of the Imperial Crown reposing on the
window sill — but also by an entirely different costume. The Prado
picture, in which the almost ethereal beauty of the defunct Empress
poignantly contrasts with the splendors of her costume and jewelry,
would seem to be identical with a later portrait mentioned among several
other pictures ready for delivery "in a few days" (including the double
portrait of Isabella and Charles V which was to accompany the Emperor
to San Yuste) in a letter addressed by Titian to Chancellor Nicholas
Granvelle on September 1, 1548 (Beroqui, p. 95f.; Glück, p. 210); it
may thus be presumed to have been produced during Titian's first stay
at Augsburg. The dress worn by Isabella in the double portrait agrees,
however, with that which she wears in portraits after Jakob Seisenegger,
for which see A. Scharf, "Rubens' Portraits of Charles V and Isabella,"
Burlington Magazine, LXVI, 1935, pp. 259ff. (cf. also above, p. 90 and Fig.
106). From this we may perhaps conclude that it was this costume which
she wore in Titian's "trivial" prototype.

Excursus 6

The Allegory of Religion

The *Allegory of Religion* in the Prado (*V.*, II, Pl. 130, our Fig. 193)
presents another difficult problem, which has been dealt with by R.
Wittkower, "Titian's Allegory of 'Religion Succoured by Spain'," *Journal
of the Warburg and Courtauld Institutes*, III, 1939, pp. 138ff.; Wind, *Bellini's
Feast of the Gods*, p. 38; E. Tietze-Conrat, "Titian's Allegory of 'Religion',"
Journal of the Warburg and Courtauld Institutes, XIV, 1951, pp. 128ff.; eadem
in her review of Berenson's *Italian Pictures of the Renaissance... Venetian
School*, *Art Bulletin*, XL, 1958, pp. 347ff., particularly p. 349. Recently,
however, an excellent article by C. Bertelli, "Il restauro di un quadro

di Tiziano," *Bollettino dell'Istituto Centrale del Restauro*, Nos. 31-32, 1957, pp. 129 ff., has established some crucial facts on the basis of which the question may be briefly reviewed.

We know from Vasari (VII, p. 458) that Titian had begun for Alfonso d'Este — and *a suo capriccio* — an Allegory showing a "nude young woman bowing before Minerva with another figure beside her, and a seascape where, in the center at a distance, Neptune appears on a chariot." Vasari also reports that this picture, unfinished when Alfonso died in 1534, was still in Titian's studio when Vasari visited it in the Spring of 1566. I agree with E. Tietze-Conrat in feeling that the original version of this composition can be inferred from an engraving by Giulio Fontana which she was the first to introduce into the discussion in 1951 (Fig. 194); that it was a purely secular Allegory; and that its suppliant heroine may be described as "Ferrara in Distress" — *infelice Ferrara*, as she is called in a poem discovered by E. Tietze-Conrat and datable in the early years of Leo X's papacy. The original significance of the other elements may be interpreted as follows. The snakes behind the personification of Ferrara symbolized the evil forces menacing the little duchy and its ruler from within. Neptune — in my opinion conceived as a force hostile to Ferrara from the outset — personified the formidable sea power of Venice which constituted a permanent and serious threat to Ferrara; suffice it to mention the battle of Polesella on December 22, 1509, when a Venetian fleet had penetrated the Po to within a few miles from Ferrara but was defeated by Alfonso's famous artillery (cf. the correspondence between E. Wind and C. Dionisotti in *Art Bulletin*, XXXIII, 1951, p. 70f.). Minerva, as she habitually does in Renaissance iconography (including the inscription on Giulio Fontana's engraving), stood for Virtue. And the *altra figura accanto* — presumably carrying, as in Fontana's print, an olive branch — denoted Peace.

Shortly after Vasari's visit this political manifesto was converted into a religious allegory which has come down to us in three versions.

Version A: a picture acquired by Emperor Maximilian II some time before November 25, 1568, when it is referred to, under the title *La Religion*, in the list of paintings accompanying a letter from the imperial envoy, Veit von Dornberg (see above, p. 161, Note 59, and E. Tietze-Conrat, 1951, p. 131). It is known to us through the engraving by Giulio Fontana just mentioned which explicitly defines the suppliant figure as *Caesaris invicti pia relligionis imago/Christigenûm*, that is to say, "the pious image of the religion of the unvanquished Emperor of the Christians"

(Mauroner, *Le Incisioni di Tiziano*, p. 57, No. 2; Tietze-Conrat, Pl. 27b; Bertelli, Fig. 116; our Fig. 194). In conjunction with the entry in Veit von Dornberg's list, this far-from-triumphant inscription proves that the completion and transformation of the unfinished composition described by Vasari took place not, as had been thought, "in allusion to the sea battle of Lepanto" in 1571, but, much more fittingly, in allusion to the terrifying recrudescence of the "Turkish Peril" just about the time of Vasari's visit to Venice. It was on March 9, 1566, that Pius V signed the Bull *Cum gravissima*, exhorting all Christian powers to unite against the infidels; it was in the autumn of that year that the Western world was shocked by the fall of Szigatvar on September 7; and it is this perilous situation to which the inscription on Fontana's engraving (E. Tietze-Conrat, 1951, p. 131) refers. It should be noted, however, that the four hexameters — involved but not in need of any emendation — make sense and construe only if read across the page, and not in two columns:

> Caesaris invicti pia relligionis imago
> Christigenûm passura dolos (ut cernis), utrinque
> Haeresis anguicoma et saevus quam territat hostis,
> Virtuti et Paci sese commendat amicae.

"The pious image of the religion of the unvanquished Emperor of the Christians, destined, as you see, to suffer malicious persecution in that she is threatened on either side by snake-haired Heresy and a fierce foe, entrusts herself to Virtue and friendly (or: "her friend") Peace."

Version B: a picture, referred to as *La Religión*, which had been shipped to Philip II, together with the *Allegory of the Battle of Lepanto* (our Fig. 80), shortly before September 24, 1575 (see Guzman de Silva's report to the King, published by Zarco del Valle, "Unveröffentlichte Beiträge zur Geschichte der Kunstbestrebungen Karl V. und Philipp II.," 1888 [quoted above p. 173], p. 235; cf. Tietze-Conrat, 1951, p. 128, Note 4); it is still in the Prado (*V.*, II, Pl. 130; Bertelli, Fig. 117, our Fig. 193).

Version C: a picture originally belonging, as we know from Ridolfi, to Pietro Cardinal Aldobrandini; it is now in the Galleria Doria-Pamphili (*V.*, II, p. 74, Pl. 185; Tietze-Conrat, 1951, Pl. 27a, where in the caption the picture is mistakenly located in the Prado; Bertelli, Figs. 108-115, 118, 119; our Fig. 195).

In A — which may be called the "Imperial Version" — the transformation of the original, secular composition goes much less far than in B (Prado) and C (Galleria Doria-Pamphili); a cross has been added in the lower right-hand corner beneath the snakes, which now, as we learn

from the phrase "Haeresis anguicoma," have acquired the specific connotation of Heresy. The "Neptune," representing the *saevus hostis*, has been transformed into a Turk by the simple device of covering the head of the still naked figure with a turban. And in order to please the Emperor, Titian (or the engraver?) has embellished the banner of Minerva-*Virtus* with the Austrian eagle. But Minerva-*Virtus* herself has retained her mythological identity in that she still wears the gorgoneion on her breast; and her companion, whom she leads by the hand, still wears an olive branch which, like the inscription, uniquely determines her as a personification of Peace.

In B and C — practically identical with each other except for a few unimportant details — the Austrian eagle is absent. A chalice (in C supplemented by a host) has been added to the cross. Virtue, her gorgoneion changed into an angel's head and her right hand resting on a shield instead of guiding her companion, has shed the iconographical characteristics of Minerva and is transformed into what I propose to call a personification of *Ecclesia militans*. Her companion, now carrying a sword instead of the olive branch, no longer embodies Peace but Fortitude. These two leaders are followed by a throng of warlike men and women apparently representing the host of the faithful. And the erstwhile Neptune, beturbaned but still nude in Fontana's engraving, has become a Turk in full battle dress. In this final state, the subject of the composition can thus be described as "The Christian Religion, Threatened by Internal Subversion (the snakes of Heresy) and External Enemies (the Turk), Seeking the Protection of the Church Militant and Fortitude."

It is obvious from the changes in content as well as from the documentary evidence that A antedates both B and C by several years, no matter whether C precedes B (as assumed by Bertelli, p. 140) or the other way around. Whichever may be the case, C can be regarded only as the work of an assistant, except for the more extensive and very beautifully painted drapery of the principal figure which in A and B conceals only her middle but also covers her breast and shoulders in C.

What remains in doubt is what became of A, viz., the original, secular composition started for Alfonso d'Este, inspected by Vasari in 1566, transformed into a religious Allegory between 1566 and 1568, and — ultimately — acquired by Maximilian II. It cannot be identical with C, as tentatively suggested by E. Tietze-Conrat, since a thorough radiographic examination of the Doria-Pamphili painting, conducted by Bertelli, has failed to disclose any change in the critical places, that is to

say, in the figure of Neptune and in the gorgoneion on the breast of Minerva-*Virtus*. Nor can it be presumed to be identical with B because the Prado picture does not seem to show these technical changes either. Moreover, the latter was produced at a time — shortly before 1575 — when the "Imperial Version," representing the "second state" of the composition, had long been in the hands of Maximilian II. We must resign ourselves to the fact that the "Imperial Version," i.e. the reworked original, is lost; and there is no good reason not to identify it with the picture engraved by Fontana — unless, regardless of William Ockham, we wish to postulate an archetype X looking exactly like A and also lost.

By way of postscript, it may be noted that a few further changes in attributes (addition of a helmet, elimination of the breast ornament and substitution of a torch for the shield) sufficed to transform the erstwhile Minerva into Bellona. This was done in the charming little engraving by or after François Boitard in L. G. Gyraldus, *Opera omnia*, Leyden, 1696, I, Pl. following cols. 75-76 (Fig. 196).

Excursus 7

The "Pardo Venus" in the Louvre

The notion of Adonis relinquishing Venus may have influenced the final version of that enigmatical composition, the *"Pardo Venus"* in the Louvre (*V.*, I, Pls. 153-154, our Fig. 197).

The picture, for which see P. Hofer, "Die Pardo-Venus Tizians," *Festschrift Hans R. Hahnloser*, Basel und Stuttgart, 1961, pp. 341 ff. (cf. also M. Kahr, "Titian, the '*Hypnerotomachia Poliphili*' Woodcuts and Antiquity," *Gazette des Beaux-Arts*, ser. 6, LXVII, 1966, pp. 119 ff., particularly p. 123, and M. Meiss, "Sleep in Venice. Ancient Myths and Renaissance Proclivities," *Proceedings of the American Philosophical Society*, CX, 1966, pp. 348 ff.), was sent to Philip II in 1567 and removed from the Pardo (a kind of glorified hunting lodge about six miles from Madrid) in 1623 when Philip IV of Spain presented it to the then Prince of Wales, later King Charles I of England; after the latter's execution it went, like the *Young Woman Doing Her Hair* (cf. above, pp. 91 ff.), to the collection of Everhard Jabach from which it passed, via the collection of Cardinal

Mazarin, to that of Louis XIV. Pending further investigation, the following statements may be made with some confidence.

1. As reported by Hofer, the picture was enlarged by a strip of c. 24 inches on the left side. In a letter of November 21, 1963 (supported by infra-red photographs since recanvasing makes an X-ray photograph impossible) Mme. Madeleine Hours of the Louvre kindly confirmed me that such a strip was added, but that, however, nothing prevents us from ascribing this one-sided addition to Titian's own workshop — an assumption concordant with the fact that the hornblower, who appears therein and seems so objectionable to Mr. Hofer, comes from the same Actaeon woodcut in the early Venetian Ovid editions (cf. our Fig. 166) which, as observed by Mrs. Kennedy (*Novelty and Tradition in Titian's Art*, p. 26, Note 79), furnished the model for the bathing nymphs and the hunting scene in the background of the *"Pardo Venus."*

2. Nothing justifies the modern interpretation of the subject as "Antiope Approached by Zeus in the Guise of a Satyr." The objections raised against this interpretation with regard to Correggio's *Sleeping Venus* by L. Soth, "Two Paintings by Correggio," *Art Bulletin*, XLVI, 1964, pp. 539 ff., and E. Verheyen, "Eros and Anteros" (referred to above, p. 131, Note 53) apply *a fortiori* to Titian's *"Pardo Venus"*; I say *a fortiori* because the conspicuous presence of huntsmen, absent from Correggio's painting, would be entirely inexplicable in the context of the Antiope story. In the list subjoined to the letter of December 22, 1574 (*C.-C.*, II, p. 539 f., for which see above, p. 162, Note 61) Titian himself calls the picture "La nuda con il paese con el satiro"; but Giovanni Paolo Lomazzo describes an apparently quite similar composition, said to have been found in Titian's house after his death, as "una Venere che dorme, con satiri che gli scoprono le parti più occulte, ed altri satiri intorno che mangiano uva e ridono come imbriachi, e lontano Adone in un paese che segue la caccia" (*Idea del Tempio della Pittura*, p. 133, quoted in *T.*, p. 289). Lomazzo, then, interpreted the sleeping nude in this second picture — similar to, but obviously not identical with, the Louvre painting — as Venus abandoned by Adonis to the tender mercies of satyrs (several rather than one) who "uncover her most secret parts"; and an analogous interpretation might be applied to the *"Pardo Venus"* if we assume that the huntsman in the left-hand foreground is Adonis who, excited by the call of the hornblower (a figure also occurring in the Venus and Adonis etching by or after Hans Bol, reproduced in our Fig. 162) and the impatience of his dogs, cannot resist the temptation of the chase.

3. What remains difficult to account for, however, is the second couple: another satyr, seen from the back, who faces a quiet girl with flowers on her lap. But instead of paying attention to his companion, he glances upward (Fig. 198).

It is generally — and, I believe, correctly — assumed that the *"Pardo Venus"* remained in Titian's hands for almost half a century and that at least three stages of execution can be distinguished. The picture would seem to have been started as early as c. 1515, resumed about 1540 (the landscape in the middle distance is closely akin to that in the *St. John the Baptist* in the Accademia at Venice, *V.*, i, Pls. 172, 173), and not completed until some time before 1567, when it was sent to Philip II. While the reclining nude duplicates Giorgione's Dresden *Venus* in pose and outline even more literally than does the *Venus of Urbino* completed in 1538, her face resembles that of such later figures as the Eve in the *Fall of Man* in the Prado (Fig. 29), the Prado *Danaë* (Fig. 158) and the heroine of the *Perseus and Andromeda* in the Wallace collection (Fig. 176).

We may venture the hypothesis that this long process of remodeling affected not only the style but also the iconography of the Louvre picture. When it was conceived Titian was more interested in allegorical subjects than ever after (witness the *Three Ages of Man* and the *"Sacred and Profane Love"*), and we may consider the possibility that the three chief components of the *"Pardo Venus"* — the eager huntsman (now perhaps Adonis), the lecherous satyr uncovering what was perhaps not as yet intended to be a goddess but (as in classical art, where the motif of Venus uncovered by a satyr or satyrs does not seem to occur) a mere nymph or, to quote Titian's own words, an anonymous "nude," and the calm, thoughtful group so emphatically separated from the latter — were originally meant to indicate the three forms of human life which the mythographers found symbolized in the three goddesses in the Judgment of Paris (for the importance of this notion in Neoplatonic thought, see above, p. 133f., Note 60, and Kristeller, *The Philosophy of Marsilio Ficino*, pp. 357 ff.): the active life (*vita activa*), represented by the huntsman; the life of sensual pleasure (*vita voluptaria*), represented by Venus and the indiscreet satyr; and the contemplative life (*vita contemplativa* or *speculativa*), represented by the tranquil couple in front of the huntsman.

There is, in fact, some indication that the original plan of the composition called for a reference to the "contemplative life" more explicit than can be found in the final version. A drawing in the collection of Mr. Curtis O. Baer at New Rochelle, N. Y. — *T.*, Fig. 7; H. and E. Tietze, *The*

Drawings of the Venetian Painters, New York, 1944, p. 322 f., No. 1948, Pl. LIX; Bean and Stampfle, eds., *Drawings from New York Collections*, I (see, p. 65, Note 20), p. 45 f., No. 59; our Fig. 199 — shows two "satyrs" seated in a landscape, one of them holding a celestial sphere; he is most probably none other than Pan, the image of the universe (τὸ πᾶν) and according to Plato's *Cratylus* (408 C, D) the "discloser and mover of all things" (ὁ Πᾶν μηνύων καὶ ἀεὶ πολῶν). Allegedly a son of Mercury, he symbolizes speech or reason (λόγος), which can be both true and false even as Pan is composed of man and beast (see, with explicit reference to the *Cratylus* passage, Natale Conti [Natalis Comes], *Mythologiae*, V, 6, and Vincenzo Cartari, *Le Imagini dei Dei degli antichi*, first illustrated edition of 1571, p. 139).

The Baer drawing — where the second figure has been inadvertently deprived of its legs and where, as I am assured by the most competent expert I know, the astronomical or astrological symbols on the celestial sphere make no sense whatever — is too weak, even from a purely technical point of view, to be attributable to Titian himself (I regret to disagree on this point with H. Tietze and E. Tietze-Conrat as well as with Bauch, "Zu Tizian als Zeichner," referred to above, p. 37 f., Note 26). But the figure holding the celestial sphere and looking heavenward is nearly identical with the tranquil "satyr" in the "*Pardo Venus*." And since the drawing is obviously not copied from the picture, we may infer that it reflects an original study made in preparation thereof, datable about 1515 and bearing witness to a "first state" of the composition in which the group in front of the huntsman was intended to consist of Pan "disclosing" (just as it says in Plato's *Cratylus*) the movements of the universe to another sylvan divinity — perhaps Silvanus. This group would have represented the "contemplative life" more unequivocally than does the bucolic couple in the "*Pardo Venus*" itself.

Index

Abel, prefiguration of Christ: 34, Figs. 35, 36

Actaeon: surprising Diana 154 ff., Figs. 163, 166-168, 171; death of 161 ff., Figs. 173, 174

Adlocutio: 74 ff., Figs. 83, 85-88

Adonis: sarcophagus 25, Fig. 24; and Venus 150 ff., 190 ff., Figs. 159, 162, 197

Aegisthus: sarcophagus 35, Fig. 57

Ages of Man: 94 ff., 99 ff., 103, Figs. 110, 114, 117, 118, 120

Agostino Veneziano: engraving, "*Academy of the Belvedere*" (*B*. 418) 81

Alberti, Leone Battista: four color system 18 n.; beauty and ornament 113; on rustication 158

Alciati, Andrea, *Emblemata:* Eros and Anteros 130 ff., Fig. 145; *Illicitum non sperandum* 94 n.; *Justa Vindicta* 118 n.

Aldegrever, Heinrich: engraving of Luxury (*B*. 127) 28 n.

Aldobrandini: Ippolito (Pope Clement VIII) 97; Pietro, Cardinal 97, 99 n., 188

Alexander III, Pope: 181

Alexander VI, Pope: 178 f.

Alexander the Great: *see* Apelles

Alfonso d'Avalos: *see* Avalos

Allori, Alessandro: *Christ's Appearance to His Mother* 41 n.

Allori, Cristofano: *Judith* 43

All Saints-picture (*La Cour Céleste*): 64 ff., Figs. 73, 74, 77, 78

Altichiero: fresco, *Martyrdom of St. George* 35, Fig. 39

Amberger, Emanuel: assistant of Titian 80 n., 81

Amor: *see* Eros, *also* Venus

Amsterdam, Royal Palace (former Town Hall): 107, Fig. 127

Andros: 100 f.

Antiquity: *see* Classical influence

Andromeda: 154, 163 ff., 166 ff., Figs. 176, 179-181

Annunciation: 25, 29 f., 40, Figs. 21, 22, 33, 34

Anteros: *see* Eros

Apelles: and Alexander the Great 8; his four color system 17

Aphrodite: *see* Venus

Apollo: Belvedere statue 25; as sun god 106, Figs. 123, 124

Apollodorus: on Oenone 170 n.

Apuleius, *Apologia*: 49

Aquinas, Thomas: on sensory perception 13; distinction between the good and the beautiful 109

Arcas: 158 f., Fig. 170

Aretino, Pietro: friendship with Titian 9 ff.; his portraits 9, Figs. 9, 11; his letters 173, 185; on Titian's paintings (*Allocution*) 75, 77, ("*La Gloria*") 67, (*Equestrian Portrait of Charles V*) 86 f.

Ariadne: 141 ff., Fig. 115

Ariosto, *Orlando Furioso*: illustration by Titian 122

Aristotle: effect of wine 101; sense of hearing 120; miniature of Prudence 102 n.

Aristoxenus: division of octave 101 n.

Assonica, Francesco: 123 n.

Augsburg: *see* Titian

Augustine, St.: *nova Eva* 29; Abel as prefiguration of Christ 34; *Civitas Dei* 64 f., 68 ff., Fig. 77

Augustus: statue from Primaporta 48 n.; relief with his family *ibid*.

Aurelio, Niccolò: 110, 117, 125 f.

Ausonius, *Cupido cruciatur:* 119

Avalos, Alfonso, Marchese del Vasto: Allocution 74 ff., 85, Fig. 83; "*Allegory*" 126 ff., Figs. 140, 140a; his portrait 74, 126, Fig. 82

Avalos, Francesco Ferrante, son of Alfonso: 74 n., 75, Fig. 83

Averoldi, Altobello, Bishop of Brescia: 13

Bacchus: relief with Birth 79, Fig. 91; and Ariadne 50, 97, 141 ff., Fig. 115; Island of Andros 100 f.

Balzac, Honoré de: Titian's *"Assunta"* 20; Allori's *Judith* 43 n.; *nova Eva* 29; proverb on drinking 100; copy and original 183

Bandinelli, Baccio: drawing, *Three Forms of Time* 104, 108, Fig. 120; engraving after, *Martyrdom of St. Lawrence* 53, Fig. 61

Bartolomeo Veneto: *Bridal portrait* 137f., Fig. 149

Bartolommeo, Fra: drawing, *"Feast of Venus"* 97f., Fig. 111

Bassano, Francesco: *Battle of Cadore* 181

Bassano, Jacopo: portraying Titian as a Money-Lender 6, Fig. 3

Beardsley, Aubrey: Salome 43

Beccafumi, Domenico: drawing, *Two Nudes* 20, 101 n., Fig. 116

Bede: on Cain and Abel 34 n.

Bellini, Gentile: his workshop 3, 178

Bellini, Giovanni: his workshop 3; broker's patent 4f.; influence on Titian 19; *The Feast of the Gods* 4f., 97, 99 n., Fig. 2; *"Vana Gloria"* 94; Cornaro's gazelle 144

Bembo, Pietro: friendship with Titian 4, 110; three stages of love 99 n., 117 n.; on sense of hearing 121; Bellini's *Feast of the Gods* 4 n.

Benivieni, Girolamo, *Canzone d'amore* 136 n.

Berchorius, Petrus, *Moralized Ovid:* 140f. n.

Bernini, Gian Lorenzo: mirror for Queen Christina 93

Berry, Duc de: Medal of Constantine 112, Fig. 131

Betussi, Giuseppe, *Il Raverta:* on sense of hearing 121

Binche, Palace at: 147f.

Bion of Smyrna, *Dirge on Adonis:* 152

Bocchi, Achille: Dea Roma 55 n.; unbridled horses 118 n.

Boëthius: division of octave 101 n.

Boitard, François: engraving, *Bellona* 190, Fig. 196

Bol, Hans: etching, *Venus and Adonis* 152, 191, Fig. 162

Bonasone, Giulio: engravings for Achille Bocchi 55 n., 118 n.

Bonifazio Veronese: *Callisto* 160 n.

Bordone, Paris: *Mars and Venus* 127, 138 n., Fig. 143

Borghini, Raffaello: Titian's *Venus and Adonis* 151; Titian's birthdate 176f.

Boschetti, Isabella: 92

Boschini, Marco: Titian's manner of painting 16, 17 n.; Titian's *"Tobiolo"* 31 n.; ceiling in S. Spirito in Isola 32 n., 33; bibliography 175

Botticelli, Sandro: celestial and terrestrial Venus 114, 116; *Mars and Venus* 126f.

Bramante, Donato: on Gothic style 158 n.

Brescia, City Hall: lost ceiling decoration by Titian 32, 139 n.

Breugel, Abram: on Guercino's *Salome* 47 n.

Breugel, Peter: table clock as symbol of temperance 89

Bronzino: *Allegory* 130

Bryaxis: cult image of Serapis 105

Bulla Sabbatina: 41

Bulwer, John, *Chirologia:* gesture of marital faith 127 n.

Burgkmair, Hans: woodcut for *Weiss-Kunig* 184, Fig. 191

Cadore: battle of 4ff., 179ff., Figs. 187-189; Titian's birthplace 1f., 12

Caesar, Julius: legend of parrot 29

Calcagnini, Celio: Eros and Anteros 131

Calcar, Jan Stevensz. of: woodcut, *muscleman* 75, Fig. 84

Calderón de la Barca: Queen Zenobia of Palmyra 77

Callisto: 154f., 158ff., Figs. 164, 169-172

Calvete, Juan C.: description of Binche 148 n.

Campagnola, Giulio: engraving, *Reclining Nude* 168, Fig. 183

Caravaggio: *David* 43

Carducho, Vicente: restoration of Titian's *"Allegory of Lepanto"* 72 n.

Carpaccio, Vittore: *Portrait of a Knight* 183

Carpi, Ugo da: chiaroscuro woodcut, *The Bath of Diana* 156, Fig. 165

Carracci, Annibale: *Danaë* 145

Carracci, Lodovico: *Christ's Appearance to His Mother* 41 n.

Cartari, Vincenzo: on Anteros 131; on Pan 193

Castiglione, Baldassare, *Cortigiano*: Pietro Bembo 110; on senses of sight and hearing 120f.

Catullus, *Carmina*: Bacchus and Ariadne 99, 102 n., 142

Cavalca, Domenico: Salome 44 n.

Cellini, Benvenuto: influence on Titian 24; *Perseus and Andromeda* 167, 168 n.

Chantilly, Très Riches Heures de: 28 n., 163

Chariot: of Aminadab 61f.; of Triumph 59ff., Figs. 67a, 69, 70, 72

Charles I of England: his collection of paintings by Titian (*Pardo Venus*) 190; (*Venus and Organ Player*) 123 n.; (*Young Woman Doing Her Hair*) 92 n.

Charles V, Emperor: as patron of Titian 7ff.; his portraits by Titian 7f., 82ff., 90, 186, Figs. 6, 73, 96-98, 106; by Jan Cornelisz. Vermeyen 85 n.; by Seisenegger 182ff., Fig.190; Marchese del Vasto, his general 74ff.; "*La Gloria*", 63ff.; *Venus*, Uffizi 121

Cheetahs: 143f.

Chiaradadda, battle of: 180f.

Christina, Queen of Sweden: her collection of paintings by Titian (*Death of Actaeon*) 162; ("*Lavinia*") 80 n.; (*Three Ages of Man*) 94 n.; (*Venus with Luteplayer*) 124; mirror by Bernini 93

Christine de Pisan: clock as symbol of temperance 89; miniature of Actaeon 157 n.

Christus, Petrus: portrait 81

Cicero: three personifications of Venus 117 n.

Cima da Conegliano: *Presentation of the Virgin* 37f., Fig. 43

Classical influence on Titian: 19ff., 23, 25, 29, 53f., 110f., 159, 163, 168f. n.; esp. on portraiture 74f., 76, 86, 127; *see also* the following entries

Classical coins: *Adlocutio Augusti* 76, Fig.85; *Profectio Augusti* 86, Figs. 100, 101; Serapis 105, Fig. 121

Classical reliefs: Adonis sarcophagus 25, Fig. 24; Attic Stele 81, Fig. 95; Bacchus, birth of 79, Fig. 91, triumph of 141 n.; "Bed of Polyclitus" 151, Fig. 160; Eros and Anteros 131, 138 n.; Leda 147, Fig. 154; Maenads 142 n., 167; Mars and Sylvia sarcophagus 156 n.; Nereid sarcophagi 110f., 159, 167, Fig. 129; Orestes sarcophagus 35, 50, 143f., Fig. 57; Paris, and Oenone 159 n., sarcophagus 169f., Fig. 184; Venus and Helen 159 n.; Tomb of M. Vergilius Eurysaces 149 n.; Pseudo-classical reliefs in Titian's paintings: *Amor ferinus*-castigation of Cupid 111, 117ff., Fig. 133; Venus-Minerva 19, 178, Fig. 16

Classical statues: *Apollo Belvedere* 25; *Eros* by Lysippus 23, 147; *Fallen Gaul* 54, 65, 148f., Fig. 63; *Laocoön* 20, 23, 33, 65, 141; *Niobe Group* 65; *Signum triceps* 105f., Fig. 122; Pseudo-classical statues in Titian's paintings: Roman Emperor 48f., Fig. 53; Roman torso 21 n., 37ff., Fig. 41; Bust of Tiberius 49, Fig. 20; Vesta 54ff., Figs. 64, 65

Clement VII, Pope: *see* Medici

Clement VIII, Pope: 97

Clock: *see* table clock

Cochlaeus, Johannes: on Trinity 64 n.

Codex Coburgensis: Leda 147, Fig. 154; *Paris* 169f., Fig. 184

Coins: *see* Classical coins

Collaert, Jan: engraving, *Sol-Apollo* 106, Fig. 124

Colonna, Francesco, *Hypnerotomachia Polyphili:* signum triceps 106, Fig. 125; unbridled horse 118; on love opposed to intellect 133f.

Colonna, Vittoria: 74

Consiglio ("Wise Counsel"): 107, Figs. 126, 127

Constantine: medal of 112, Fig. 131

Constellations: Arctophylax or Boötes 159; Corona ("Gnossian Crown"), 142, Fig. 115; Ursa Maior ("Great Bear") 159

Conti, Natale: on Pan 193

Cornaro, Venetian family: battle of Cadore 181f.; gazelle 144

Cornelisz. van Oostsanen, Jacob: *All Saints Altarpiece* 70, Fig. 78

Cornelisz. van Rijck, Pieter: *Salome* 47, Fig. 51

Cornoça, Thomas de: 179

Correggio: contrast to Titian 15; frescoes, S. Giovanni Evangelista, Parma 22, 32, 35; *Danaë* 145; *Venus* 131 n., 191

Cort, Cornelis, engravings after Titian: Ariosto illustration 122 n.; *Diana and Callisto* 160 n.; *"La Gloria"* 63 n., 64, 66 n., 68, 71; *Martyrdom of St. Lawrence* 53 n., 56, 57 n., Fig. 65; *Tarquinius and Lucretia* 139 n.; *Tityus* 148 n.

Cortona, Amelio: 29 n.

Cosimo, Piero di: *Mars and Venus* 127

Costa, Lorenzo: *Gate of Comus* 114

Cranach, Lucas: *Fall of Man* 28 n.; *Unblinding Cupid* 135 n.

Cupid: *see* Eros

D'Alviano, Bartolommeo: 181 f.

Danaë: 144 ff., 149 f., Figs. 150-152, 158

Dante, *Divina Commedia:* Triumph of Faith 61 f.; Last Judgment 69

David: and Goliath 31 ff., Figs. 35, 38; Last Judgment 65, 68, Fig. 73

Dea Roma: 55 f.

Degli Organi, Alessandro: 6

Dentone, Giovanni: *Venus Urania* 115, Fig. 132

Diana: and Actaeon 154 ff., 163, Figs. 163, 166-168, 171, 173; and Callisto 154 f., 158 ff., Figs. 164, 169-172; and Endymion 161 f. n., 169; drawing by Parmigianino 156, 167, Fig. 165

Dianti, Laura: 92

Diodorus: on Actaeon 154 f. n.

Dioscurides: on hollyhock 28

Dolce, Lodovico, *Dialogo della Pittura:* 174; (on Titian's birthdate) 177 f.; (*Battle of Cadore*) 180; (*Perseus and Andromeda*) 164 n.; *Le Trasformationi:* 141 n., 157, 160, Figs. 167, 170

Donatello: *Abraham* 26, Fig. 26; *Miracle of St. Anthony* 48, Fig. 54

Dornberg, Veit von: paintings offered to Maximilian II 161, 162 n., 187 f.

Dossi, Dosso: *Feast of Cybele* 97, 99 n.; *Stories of Aeneas* 99 n.

Dürer, Albrecht: influence on Titian 19, 58; drawing, *Abduction of Europa* 165, Fig. 177; *Apocalypse* 36; engraving, *Christian Knight* (B. 98) 86, Fig. 99; engraving, *Fall of Man* (B. 1) 28 f., Fig. 31; engraving, *Four Witches* (B. 75) 137 n.; *Fürlegerin, Katharina* 137; *Heller Altarpiece* 71 n.; *Landauer Altarpiece* 66 f., Fig. 74; woodcut, *Presentation of the Virgin* (B. 81) 38, Fig. 45; St. Margaret in Antwerp procession 52; on sense of sight 120

Endymion: *see* Diana

Equicola, Mario: on Anteros 131

Erasmus of Rotterdam: on *Miles Christianus* 86

Eros: and Anteros 129 ff., Figs. 144-146; castigation of 119, Fig. 133; by Lysippus 23, 147

Erythrean Sibyl: in Last Judgment 65, 68, Fig. 73

Escorial: 53, 64

Este, Alfonso, brother of Isabella: studio at Ferrara 5 n., 7, 97 ff., 141; paintings by Titian (*Allegory of Religion*) 187 ff.; (Brescia polyptych) 20 f. n.; (*Judith*) 30; (Portrait of gazelle) 144; (*Young Woman Doing Her Hair*) 92; Michelangelo's *Leda* 146 n.

Este, Isabella: 4 f. n.

Esteve, Miguel: *Christ's Appearance to His Mother* 40, Fig. 48

Euripides: on Actaeon 154 n.

Europa: 163 ff., Figs. 175, 177, 178

Evangelists: in Triumph of Faith 59 ff., Figs. 67a, 69-71

Ezekiel: in Last Judgment 65, 68, Fig. 73

Fall of Man: 27 ff., Figs. 29-32

Fallen Gaul: see Classical statues

Fantuzzi, Antonio: engraving after Parmigianino 156

Farnese: Alessandro (Pope Paul III) 7, 78 f., Fig. 89; Alessandro, Cardinal 78 f., Fig. 89; Orazio, husband of Diane de France 79 n.; Ottavio 78 f., 144, Fig. 89; Pier Luigi 79 n.

Fernando, Infante, son of Philip II of Spain 72 f., Fig. 80

Ferrara: 92, 100; Allegory by Titian 187; studio of Alfonso d'Este 5 n., 7, 97 ff., 141

Feuerbach, Anselm: *Death of Aretino* 10 n., 11

Ficino, Marsilio: 109; celestial and terrestrial Venus 114 ff.; on senses of sight and hearing 120 f.; on love opposed to intellect 133 f.; three forms of life 134 n., 192 f.

Flacco (Fiacco), Orlando: portrait of Titian 6 n., Fig. 4

Flora: bridal portraits in the guise of 137 f.

Fontana, Giulio, engravings after Titian: *Battle of Cadore* 179 ff., Fig. 187; *Allegory of Religion* 139 f. n., 187 ff., Fig. 194

Fontane, Theodor, *Briefe*: 177

Fouquet, Jean: representation of Trinity 71 n.

Fragonard, Honoré: Ariosto illustrations 74 n., 77

Franciscus de Retza: on parrot 29; on Danaë 145

Francucci, Scipione: on Titian's *"Sacred and Profane Love"* 113 f.; on Titian's *"Education of Cupid"* 135 f.

Fregoso (Fulgosus), Giovanni Battista: on Anteros 131 n.

Fugger, Jacob: 80 n.

Fulgentius metaforalis: Danaë as Chastity 145

Garofalo: *Eros and Anteros* 132 n.; *Allegory of Love* 137 n.

Ghirlandaio, Domenico: *Presentation of the Virgin Mary* 38 n.; fresco, *Adlocutio* 76 f., Fig. 86

Gibbon, Edward: on Zenobia of Palmyra 77

Giorgione: influence on Titian 19, 42, 177; Callisto 159; frescoes, Fondaco dei Tedeschi 3, 177; *Venus* (Dresden) 21, 110, 192; wrong ascription of *"La Vecchia"* 90 f.; engraving by Giulio Campagnola 168, Fig. 183

Giotto: frescoes, Arena Chapel 47 n., 48

Giovanni da Castel Bolognese: 94 n.

Giraldi, Giglio Gregorio: on Anteros 131

Goethe, Johann Wolfgang von: Titian's colorism 16 f.; *Marienbader Elegie* 23

Gonzaga: Eleonora, Duchess of Urbino, her portrait 88, Fig. 104
Federico, Duke of Mantua: his portrait 7, 92, Fig. 5; portrait of Aretino 10 n.; other paintings by Titian (*Roman Caesars*)

21 n.; (*"Le Donne del Bagno"*) 97 n.; (*Rape of Proserpina*) 140 n.; canonry at Medole 39 n.
Ferrante: 79 n., 140 n.
Guglielmo, son of Federico 39 n.

Gossart, Jan: *Danaë* 145

Grace: personification of 112, Fig. 131

Graces, the Three: 136 f., Figs. 147, 148

Granada, Capilla Real: 64

Granvelle, François de, Count of Cantecroy: 123 n.

Granvelle, Nicholas, Chancellor of Charles V: 121 n., 186

Gregory, St., Commentary on *Song of Songs*: 62 n.

Grimm, Jacob: Salome 44 ff.

Gritti, Andrea, Doge: 182

Guercino: *Salome* 47, Fig. 52

Haedus (Hedo), Petrus: on Anteros 131 n.

Harmony: daughter of Mars and Venus 127; symbolized by sphere 128, Fig. 140

Heine, Heinrich: Salome 43, 46

Helle (Helde, Hulda), Fru: 44 f.

Heraclitus: on sense of sight 120

Hernández, Garcia: Titian's Diana paintings 154 n.; on Titian's age 176 f.

Herodias: *see* Salome

Herrade of Landsberg, *Hortus Deliciarum:* 62, Fig. 71

Hesiod: on Actaeon 154 n.

Hildesheim: Cathedral, pavement 104 n.; St. Godehard, St. Albans Psalter 27 f. n.

Holbein the Younger, Hans: *Portrait of Georg Gisze* 81, Fig. 93

Hollyhock: meaning of 28

Homer: quoted by Valeriano 118; description of Hades 148

Honorius of Autun, Commentary on *Song of Songs:* 61 f.

Honthorst, Gerard: *Vanitas* 93 n.

Horace, *Carmina:* on hollyhock 28

Horapollon, *Hieroglyphica:* 106

Hurtado de Mendoza, Diego: copies after Michelangelo 122 n., 146; portraits of Isabella of Portugal 184 f.

Hyginus, *Fabulae:* on Actaeon 154 f. n.

Hypnerotomachia Polyphili: see Colonna, Francesco

Intercession: *see* Virgin Mary as *Maria Mediatrix*

Isaac, prefiguration of Christ: 34, Figs. 35, 37

Isabella of Portugal, wife of Emperor Charles V: 9, 66 f., 90, 184 ff., Figs. 8, 106, 192

Isidore of Pelusium: on Salome 44

Isidore of Seville, *Etymologiae*: division of human life 94

Ixion: 140 n., 147 ff.

Jabach, Everhard: his collection 92 n., 190

Jacquard, Antoine: engraving, *Triumph of Henri de Bourbon-Verneuil* 63 n.

Jode, Pieter de: engraving, *Portrait of Isabella of Portugal* 9, 186, Fig. 192

Josephus, Flavius, *Antiquitates Judaeorum*: on Salome 44

Jossius, Nicander: death of Aretino 11 n.

Juan de Austria, half brother of Philip II: 72

Judaism, representation of: 38 f., Figs. 42, 43, 45, 46

Justinian, *Corpus iuris:* 82

Keats, John, *Sleep and Poetry:* description of Bacchus 50, 143

Küsel, Melchior: engraving, *Golden Calf* 100

Landi, Pietro, Doge: 75

Landino, Cristoforo: panther's skin symbolizing *libido* 169

Laocoön: influence of 20, 23, 33, 65, 141; caricature by Titian 75 n.

Last Judgment: 65 ff.

Leda: 19, 122 n., 146 f., Figs. 153, 154

Lefèbre, Valentin: etching after Titian's *Three Ages of Man* 96 n.

Leo X, Pope: *see* Medici

Leonardo da Vinci: light and shade in contrast to Titian 15; influence on Titian 19, 42; on sense of sight 120; settings for *Danaë*-play 144 n.; *Leda* 19; drawing by Bandinelli 104

Leone Ebreo: on senses of sight and hearing 120 f.

Leopold William, Archduke of Austria: his collection 162

Lepanto, battle of: 72 f., Fig. 80

Le Pautre, Jean: engraving, *Danaë* 145

Lomazzo, Giovanni Paolo: on Titian's *Bacchus and Ariadne* 142; on Titian's *Sleeping Venus* 191; bibliography 174

Lorenzini, Antonio (called Politianus): death of Aretino 10 f. n.

Lotto, Lorenzo: *Portrait of Andrea Odoni* 81, Fig. 94

Louis XIV: his collection 92 n., 191

Lucian, *De imaginibus:* on Praxiteles' two statues of Venus 114

Lucretius: on Venus and Mars 127

Ludolf of Saxony, *Vita Christi:* on Christ's appearance to His mother 40

Lysippus: *Eros* 23, 147

Macrobius: on Serapis 105 f.

Madrid, Royal Palace: 147 f.

Malatesta, Giacomo: 97 n.

Manilli, Jacopo: on Titian's "*Education of Cupid*" 135 f.

Mantegna, Andrea: in contrast to Titian 15; celestial and terrestrial Venus 114; frescoes, Eremitani Chapel 48; *Parnassus* 58; *Triumph of Caesar* 48, 54, 58

Mantua: Castello di Corte, "*studiolo*" of Isabella d'Este 4 n.; Palazzo del Tè 159 n., 171 n.; *see also* Titian

Marcolini, Francesco: Titian's portrait of Aretino 10 n.

Margaret of Parma, daughter of Emperor Charles V: 79 n.

Mariette, P.-J.: print after Parmigianino 156 n.

Marriage-portraits: 126 ff., 137 f., Figs. 140-143

Mars: *see* Venus

Martinez, Jusepe: on Titian's "*Allegory of Lepanto*" 72 n., 73

Martinioni, Giustiniano: edition of Sansovino 33 n., 174

Mary of Aragon, wife of Alfonso d'Avalos: 126

Mary of Hungary, sister of Emperor Charles V: 65 n., 66 f., 147

Massolo, Lorenzo: 53

Maupassant, Guy de: 100

Maximilian I, Emperor: battle of Cadore 181f.; woodcut by Burgkmair 184, Fig. 191

Maximilian II, Emperor: his antiquarian, Jacopo Strada 80; replicas of Titian's mythologies 161f., 164; Titian's *Allegory of Religion* 187ff.

Medici: Cosimo I, Duke of Tuscany 10 n.; Cosimo II, Grand Duke of Tuscany 121 n.; Giovanni (Pope Leo X) 78, Fig. 90; Giulio, Cardinal (Pope Clement VII) 78, 183, Fig. 90; Ippolito, Cardinal 10 n., 103 n.; Lorenzo Magnifico 133f.

Meldolla, Andrea (called Schiavone): print after Parmigianino 156 n.

Michelangelo: influence of 13, 19, 22f., 25f., 64f.; *Annunciation* 25, Fig. 22; *Battle of Cascina* 20, 53 n., 59, 65, 101 n.; *Leda* 121f. n., 146f., Fig. 153; *Moses* 10 n., 26, Fig. 25; *Pietà* (Rome, St. Peter's) 26, Fig. 28; "*Rebellious Slave*" 20; *Risen Christ* 26, 39, 147, Fig. 27; frescoes, Sistine Chapel 28 n., 53f., 65, Fig. 75; *Tityus* 148; *Venus* 121f. n., 146

Michiel, Marcantonio: bibliography 173f.

Mignon, Jean: engraving after Luca Penni 155 n.

Miles Christianus: 86f., Figs. 97-99

Mini, Antonio: Michelangelo's *Leda* 146 n.

Miranda, Juan de: restoration of Titian's *Fall of Man* 27

Mirror: as symbol of Vanity 92ff.

Mörike, Eduard: epitaph on Aretino 11; *Besuch in der Kartause* 90 n.

Molinari, Antonio: drawing, *Venus and Adonis* 152

Montagnac, Jean de: 71

Montese, Ferrante: 185

Moretto da Brescia: *Prophet* 64 n.; *Portrait of a Gentleman* 183

Moschus: on Europa 165

Mühlberg, battle of: 84ff.

Musical Instruments: bass viol played by Titian 6; flute 95, 96 n., 125, 169, Figs. 110, 138, 139, 182; lute 122, 124f. Figs. 138, 139; organ, acquired by Titian 6; played before Venus 122f., Figs. 135-137; viola da gamba 125, Figs. 138, 139

Mythographers: origin of Venus 117 n.; three forms of life 192f.

Nardini, Girolamo: allegory with unbridled horses 118 n.

Nature, personification of: egg woman in *Presentation of the Virgin* 37, Fig. 42; as a nude figure 112, Figs. 130, 131

Niccolò Fiorentino: medals with *Three Graces* 136, Figs. 147, 148

Niobe Group: 65

Nivardus of Ghent: legend of Salome 45f.

Nonnus: on Actaeon 154f. n.; on Venus and Mars 127

Odoni, Andrea: 81, Fig. 94

Oenone: 169ff., Fig. 182

Opicinus de Canistris: 52, Fig. 58

Oresme, Nicole: miniature of Prudence 102 n.

Orestes: sarcophagus 50, 143f., Fig. 57

Origen: on Salome 44

Orsini, Paolo Giordano: 121 n.

Ovid: *Amores*, Danaë 145; *Ars amatoria*, Bacchus and Ariadne 99, 141 n., 142f.; Danaë 145; *Epistolae* or *Heroides*, Paris and Oenone 170f. *Fasti*, Bacchus and Ariadne 141 n., 142, 143 n.; Callisto 158ff.; Europa 165f.; Flora 138 n. *Metamorphoses*, Actaeon 154f. n., 156ff., 163; Adonis 152f.; Andromeda 166ff.; Ariadne 99, 142f.; Bacchus *ibid.*; Callisto 158ff.; Danaë 145; Diana 154f. n., 156ff.; Europa 165f.; Hecuba 140 n.; Ixion *ibid.*, 147ff.; Jason 140 n., 150, 154; Medea *ibid.*; Perseus 166ff.; Polydorus 140 n.; Pomona *ibid.*; Proserpina *ibid.*; Sisyphus 147ff.; Tantalus *ibid.*; Tityus *ibid.*; Venus 152f.

Editions of *Metamorphoses*: Venice (1497/1513) 157, 159f., 191, Figs. 166, 169; Venice (1508) 167, Fig. 181; Mayence (1545, 1551) 167 n.; *see also* Petrus Berchorius, Lodovico Dolce and Bernard Salomon

Pacino di Bonaguida (follower of): miniature of *Trinity* 70 n.

Pacioli, Fra Luca, *Divina proportione:* on sense of sight 120 n.

Padua: Scuola del Santo, frescoes by Titian 3, 47 ff., Fig. 53; Arena Chapel, frescoes by Giotto 48; Eremitani Chapel, frescoes by Mantegna, *ibid.*; Oratorio di S. Giorgio, frescoes by Altichiero 35, Fig. 39; Titian's house, lost frescoes 58; *see also* Titian

Palma Giovane: Titian's pupil 16; *Pietà* 25; *Flaying of Marsyas* 171 n.

Palma Vecchio: friendship with Titian 3; *Fall of Man* 28

Pan: 192 f., Fig. 199

Paolo Veronese: portrait of Titian in *Wedding of Cana* 6; drawing after Titian's *"Gloria"* 65 f. n.; *Actaeon* 157; *Cupid with Dogs* 171 n.; *Venus and Adonis* 154 n.

Paradise: *"La Gloria"* as 64, 68 ff., Fig. 73

Paris: sarcophagus 169 f., Fig. 184; and Oenone 169 f., Fig. 182; judgment of 192

Parmigianino: *Bath of Diana* 24, 156, 167, Fig. 165

Parrot: meaning of 28 f.

Partridge: meaning of 30, Fig. 34

Paul III, Pope: *see* Farnese

Paulinus de Nola, *Epistolae:* on prefigurations of Christ 34

Pausanias, speech in Plato's *Symposium:* on celestial and terrestrial Venus 114

Penni, Francesco: fresco, *The Marriage Feast of Psyche* 151, Fig. 161

Penni, Luca: engraving, *Callisto* 155 n.

Perez, Antonio: 162 n.

Perrière, Guillaume de la: table clock as symbol of time 90 n.

Perseus: 154, 163 ff., 166 ff., Figs. 176, 179-181

Peruzzi, Baldassare: frescoes, *Presentation of the Virgin* 37; *Danaë* 145

Pesaro, Jacopo: 19, 178 f., Figs. 16, 185, 186

Petrarch, *Trionfi:* 60 ff., 71, 90, Figs. 69, 72; Apollo with *signum triceps* 106

Phidias: statuette of Victory 54 f.

Philip II of Spain: battle of Saint-Quentin 53, 56 f.; mythological subjects 23; his portraits by Titian 66 f., 72 f., 82 f.,

122, Figs. 73, 80, 135; other paintings by Titian (*Allegory of the Battle of Lepanto*) 72 f.; (*Allegory of Religion*) 188; (*Danaë*) 23, 149 f.; (*Europa*) 163 f.; (*Jason and Medea*) 150, 154; (*Pardo Venus*) 190 ff.; (*Perseus and Andromeda*) 150, 154, 163 f.; (*St. Margaret*) 49 f.; (*Venus and Adonis*) 150; (*Venus with Organ Player*) 122

Philip III of Spain: Titian's *Venus with Organ Player* 123 n.

Philip IV of Spain: his equestrian portraits 87, Figs. 102, 103; Titian's *Venus with Organ Player* 123 n.; Titian's *Pardo Venus* 190

Philostratus: *Imagines*, Andrians 20, 99 f.; panther 143 n.; *Erotes*, Feast of Venus 98

Physiologus latinus: fox as symbol of the devil 28 n.

Picasso, Pablo: 25, 128

Piccini, Giacomo: engravings after Fondaco frescoes 3 n.; after Pordenone 32

Picinelli, Filippo, *Mundus Symbolicus:* Titian's *impresa* 14 n.; emblems with partridge 30 n.

Pico della Mirandola: on *amor ferinus* 117; on love opposed to intellect 133 f.; on blind and seeing love 135 n.; Three Graces 136

Pieve di Cadore: *see* Cadore

Pino, Paolo, *Dialogo:* on Michelangelo and Titian 13

Pio, Prince of Savoy: his collection 122 n., 124

Pisano, Giovanni: representation of nude figures 112 n.

Plato: meaning of prudence 103; celestial and terrestrial Venus 114, 117 n.; sense of sight 120, 123 f. n.; blind and seeing love 135; quoting Homer on Hades 148 n.; on Pan 193

Pliny: Apelles' four-color system 17 n.; Praxiteles' two statues of Venus 114

Politian, *Giostra:* stanzas on Europa 165

Polybius, *Historiae:* quoting Heraclitus on sense of sight 120 n.

Pordenone, Giovanni Antonio: competition for *Martyrdom of St. Peter Martyr* 12; influence on Titian 20, 22, esp.

through lost frescoes in S. Stefano, Venice 32; wrong attribution of *Salome* 42 n.

Porta, Giuseppe: transforming Titian's *Venus and Adonis* 154 n.

Poussin, Nicolas: *Bacchanal of the Andrians* 21, 96; *Eros and Anteros* 132; Roman relief with *Birth of Bacchus* 79

Praxiteles: statues of celestial and terrestrial Venus 114; statuette of Aphrodite in portrait of Jacopo Strada 81, Fig. 92

Presentation of the Virgin: 36 ff., Figs. 41, 43, 45

Primaticcio: *Danaë* 146 f., Fig. 152

Proclus: visual experience of beauty 124 n.

Profectio Augusti: 85 ff., Figs. 100, 101

Prudence, Allegory of: 102 ff., Figs. 117-120

Prudentius, *Passio sancti Laurentii:* 55 ff.

Psalm: *Ad te levavi* . . 73, Fig. 81

Pseudo-Bonaventure, *Meditations:* Christ's appearance to His mother 40

Pseudo-Callisthenes, *Romance of Alexander:* on *signum triceps* 105

Publilius Syrus: fragility of fortune and glass 128 n.

Quadriga Christi: *see* Chariot of Triumph

Quarton, Enguerrand: *Coronotion of the Virgin* 71, Fig. 79

Quellinus the Elder, Artus: frieze with allegory of "Wise Counsel" 107, Fig. 127

Quintana, Juan, confessor of Charles V: 64 n.

Raimondi, Marcantonio, engravings: after Bandinelli (*B.* 104) 53, Fig. 61; after Dürer (*B.* 81) 38; after Raphael (*B.* 481) 53, 58 f., Fig. 62; (*B.* 245) 156

Raphael: general influence of 19; *Entombment* 54; fresco, *Fall of Man* 27, Fig. 30; fresco, *Marriage Feast of Psyche* 151, Fig. 161; *Portrait of Pope Leo X* 78, 89, Fig. 90; *St. Margaret* 50; *Sistine Madonna* 25, Fig. 19; *Standard Bearer* 53, 58 f., Fig. 62; frescoes, Stanze, Vatican 54; *Three Graces* 137; *Transfiguration* 25; *Triumph of Bacchus and Ariadne* 97; on Gothic

style 158 n.; *see also* Marcantonio Raimondi

Rather of Verona, *Praeloquia:* on Salome 45 n.

Recueil des histoires de Troie: Danaë 145

Rembrandt: *Danaë* 145, Fig. 151; *Diana* 160, Fig. 171; *Saskia* in the guise of Flora 138

Reni, Guido: *Eros and Anteros* 132, 134 f., Fig. 146; *Harrowing of Hell* 41, Fig. 49

Ridolfi, Carlo, *Le Maraviglie* . .: on Titian's colorism (red and blue) 17; Titian's age 176 f.; paintings by Titian (*Allegory of Religion*) 188; (*Bacchus and Ariadne*) 142, 143 n.; (*Battle of Cadore*) 180, 182; ("*Education of Cupid*") 136; ("*La Gloria*") 65; (*Judgment of Solomon*) 31 n.; (S. Spirito in Isola, ceiling) 33; (*Triumph of Faith*, frescoes) 58; (*Venus with Organ Player*) 123 n.; Giorgione's Diana and Callisto 159; bibliography 175

Ripa, Cesare, *Iconologia: Amor di Virtù* as Anteros 131 n.; *Carro* after Petrarch's *Trionfi* 60; *Consiglio* with *signum triceps* 106 f., Fig. 126; *Fede Cattolica*, gesture of marital faith 127; *Felicità Eterna e Breve* 112 f.; *Fortezza*, conquering uncontrolled passion 118 n.; *Libidine*, symbolized by panther's skin 169; *Meditatione della Morte* 95; *Miseria Mondana*, sphere of glass symbolizing vanity 128

Romano, Giulio: in Mantua 7; in contrast to Titian 15; fresco, *Allocution of Constantine* 77, Fig. 87; fresco, *Fall of Man* 27, Fig. 30; drawing, "*Feast of Venus*" 98, Fig. 112; frescoes, Palazzo del Tè, Mantua 159 n., 171 n.; *St. Margaret* after Raphael 50

Rome: Arch of Constantine 76; Temples of Antoninus and Faustina, of Mars Ultor 54; Tomb of M. Vergilius Eurysaces 149 n.; Villa Farnesina, 151, Fig. 161 *see also* Titian

Roncagli, Annibale: studio of Alfonso d'Este, Ferrara 99 n.; description of *Bacchus and Ariadne* 141

Rossellino, Antonio (School): relief, *Personification of Prudence* 104, Fig. 119

Rossi, Lodovico Cardinal: 78, Fig. 90

Rosso Fiorentino: *Death of Adonis* 152; *Leda* after Michelangelo 146, Fig. 153

Rota, Martino: engraving after Titian's *Venus and Adonis* 153

Rovere: Francesco Maria, Duke of Urbino 7, 88 f. n.; Guidobaldo II, Duke of Urbino 7

Rubens, Peter Paul: *Allocution of Decius Mus* 77; Antwerp, decoration of Jesuit's Church 35 n.; *Bacchanal of the Andrians* 21, 96; *Battle of Cadore* 180 f.; *Diana and Actaeon — Callisto* 155; *Fall of Man* 29, Fig. 32; *Portrait of Charles V and Isabella of Portugal* 90, Fig. 106; *Equestrian Portrait of Philip IV of Spain* 87, Fig. 103; *St. Theresa* 41 n.; *Venus and Adonis* 154 n.

Rudolf II, Emperor: Titian's *Venus and a Musician* 123 n., 124

Saint: Catherine 69 f. n.; George 35, 51 f., 86, Fig. 39; John the Baptist 43 ff., Figs. 50-52; John Evangelist 35 f., Fig. 40; Lawrence 53 ff., Figs. 59-61, 65; Margaret 49 ff., Figs. 55, 56, 58; Martha 51 f., Fig. 58; Peter Martyr 12, 18, 64; Pharaïldis (Verelde) 45 f.

Saint-Quentin, battle of: 53, 56 f.

Salome: 42 ff., Figs. 50-52

Salomon, Bernard, *Métamorphose d'Ovide figurée:* Actaeon 157, 163, Figs. 168, 174; Andromeda 167 f., Fig. 179; Callisto 159; Europa 165, Fig. 178; Venus and Adonis 152

Sánchez Coello, Alonso: *bozzetto* for Titian's *"Allegory of the Battle of Lepanto"* 72; *Portrait of Isabella of Portugal* 185 f.

Sandrart, Joachim: description of Titian's *Three Ages of Man* 96 n.

Sansovino, Francesco, *Venetia:* Titian's *Battle of Cadore* 182; S. Spirito in Isola 33 n.; bibliography 174

Sansovino, Jacopo: *see* Tatti, Jacopo

Sanudo (Sanuto), Marino, *Diarii:* 173

Sanuto, Giulio: engraving after Titian's *Tantalus* 147 ff., Fig. 156; after Titian's *Venus and Adonis* 153

San Yuste, Monastery of S. Jeronimo: refuge of Charles V 7 f.; paintings by Titian ("*La Gloria*") 64; (*Portrait of Charles V and Isabella of Portugal*) 90, 186

Sarcinelli, Cornelio, husband of Titian's daughter: 12

Sarcophagi: 20; *see* Classical reliefs

Sarrazin, Jacques: reliefs with *Trionfi* 61 n.

Savonarola, *Triumphus Crucis:* 59 ff.

Schiavone, Andrea: *see* Meldolla, Andrea

Schopenhauer, Arthur: division of human life 94 f.

Seisenegger, Jakob: *Portrait of Charles V* 182 ff., Fig. 190; *of Isabella of Portugal* 186

Sellaio, Jacopo del (School): *cassone* 60 f. n.

Senses of sight and hearing, their rivalry: 119 ff., 135, 169

Serapis: 105 f., Figs. 121, 122, 125

Serlio, Sebastiano: stage designs 37, Fig. 44; on rustication 158

Servetus, Michael: 64 n.

Servius, *Commentary on Virgil:* on Anteros 131

Severianus, *De creatione mundi:* 49

Shahn, Ben: 102 n.

Shakespeare, William: Shylock looking like Titian 6 n.; sonnets on vanity 93; *As You Like It*, speech on ages of man 94; *Hamlet* contemplating death's-head 95; *Venus and Adonis* 118, 153

Siena, Cathedral: representation of *Prudence* 104, Fig. 118

Signorelli, Luca: fresco, Sistine Chapel 38 n.

Signum triceps: 103 ff., Figs. 117, 121-127

Silva, Guzman de: 188

Silvanus: 192 f., Fig. 199

Simenon, Georges, *Antoine et Julie:* 100

Sisyphus: 147 ff., Fig. 157

Song of Songs: 61 f.

Spear: as symbol of Imperial power 85 ff.

Spoleto, conquest of: 181 f.

Statius: on Venus and Mars 127

Stesichorus: on Actaeon 154 n.

Stoppio, Niccolò: 80 f.

Strada, Jacopo: his portrait by Titian 80 f., Fig. 92

Stradano, Giovanni: engraving, *Sol-Apollo* 106, Fig. 124

Strauß, Richard: *Salome* 43

Suso, Henry, *Horologium Sapientiae:* 70 n., 89

Sustris, Lambert: *Portrait of Charles V* 82 n.; *Portrait of Erhard Vöhlin* 84 n.

Synagogue: as Shulamite woman 61 f., Fig. 70; her conversion at Last Judgment 65

Table Clock: as symbol of temperance 89, Fig. 105; of time and death 88 ff., Figs. 89, 104, 106

Taccone, Baldassare: *Danaë* play 144 n.

Tantalus: 65 n., 147 ff., Fig. 156

Tarasca (Tarasque): 51 f., Fig. 58

Targumim: upon *Genesis* 17 n.

Tatti, Jacopo (called Sansovino): friendship with Titian 9, 12; S. Spirito in Isola 31 n.

Tebaldi, Jacopo, envoy of Alfonso d'Este: 21

Teniers, David, the Younger: gallery of Archduke Leopold William 162 n.

Thiry, Léonard: engraving, *Leda* 146; *Callisto* 160

Tiepolo, Giovanni Battista: *Allocution of Queen Zenobia* 77, Fig. 88

Tiepolo, Giovanni Domenico: etching, *Flight into Egypt* 38 n., Fig. 46

Tintoretto, Domenico Robusti: 124 n.

Tintoretto, Jacopo Robusti: Titian's colorism 13; in contrast to Titian 15

TITIAN:

in Augsburg 8 f., 12, 18, 53, 64, 82, 121 n., 147, 186; his birth 2, 176 ff.; in Bologna 7 f.; in Brescia 32, 139 n.; the broker's patent 4 f.; his colorism 13 ff., 17, 24 f. (white, black and red 17, 78, 84; green 17, 50, 52, 110); his death 2, 176 f.; his family 2, 12, *see also* Vecelli; in Ferrara 5 n., 92; his *impresa* 14; his letters: 172 f.; to Giovanni Benevides 68 n.; to Charles V 9, 66, 68, 121 n., 177, 184 ff.; to Alfonso d'Este 97 n., 98; to Cardinal Farnese 31 n.; to Nicholas Granvelle 90 n., 121 n., 186; to Antonio Perez

162 n., 191; to Philip II 8 n., 50 n., 52, 149 f., 154, 162, 164, 176; to Vecello Vecelli 151 n.; in Mantua 7, 50, 92; in Milan 83 n.; as musician 6, 125; in Padua 3, 35, 47 ff., 58; painting as God created Adam 16 n., 17 f. n.; his portraits: 43, 66, 92, 107 f., 126; by Jacopo Bassano 6, Fig. 3; by Orlando Flacco (Fiacco) 6 n., Fig. 4; by Paolo Veronese 6; by Jacopo Tatti (Sansovino) 9; by Jacques Sarrazin 61 n.; self-portraits 8, 43, Frontispiece, Fig. 7; rabbinical sources 17 f. n.; in Rome 4, 7, 22, 53 f., 78 f., 121 n., 144, 146, 174, 185; motif of space-traversing glance 19 f., 42 f.; in Urbino 7; in Vicenza 4, 30 f.

WORKS:

Actaeon, Death of (London, Earl of Harewood) 161 ff., Fig. 173, *see also* Diana; *Adonis Taking Leave from Venus* (Madrid, Prado) 150 ff., Fig. 159; *"Allegory of Alfonso d'Avalos"* (Paris, Louvre) 126 ff., 149 n., Figs. 140, 140 a, 141; *"Allegory of the Battle of Lepanto"* (Madrid, Prado) 72 f., 188, Fig. 80; *Allegory of Prudence* (London, National Gallery) 102 ff., Fig. 117; *Allegory of Religion* (Madrid, Prado) 98 n., 139 f. n., 186 ff., Fig. 193; (Rome, Galleria Doria-Pamphili) 139 f. n., 186 ff., Fig. 195; *Allegory of Wisdom* (Venice, Biblioteca Marciana) 32; *Allocution of Alfonso d'Avalos* (Madrid, Prado) 22, 74 ff., 85, Fig. 83; *Altarpiece of Jacopo Pesaro* (Antwerp, Musée Royal des Beaux-Arts) 19, 110, 178 f., Figs. 16, 185; *Andromeda, see* Perseus; *Angelica Saved by Ruggiero*, drawing (Bayonne, Musée Bonnat) 122; *Annunciation* (Venice, S. Salvatore) 25, Fig. 21; (Venice, Scuola di S. Rocco) 29 f., 36, Figs. 33, 34; *Assumption of the Virgin,* "*Assunta*" (Venice, S. Maria Gloriosa de' Frari) 19 f., 39, Fig. 14; *Bacchanal of the Andrians* (Madrid, Prado) 5 n., 7, 20 f., 39, 96 f., 99 ff., Fig. 114; *Bacchus and Ariadne* (London, National Gallery) 5 n., 7, 50, 97 n., 99 f., 141 ff., Fig. 115; *Baptism*

of Christ (Rome, Museo Capitolino) 31 n.; *"The Bath"* (lost) 97; *Battle of Cadore* (destroyed, formerly Venice, Palazzo Ducale) 4 ff., 21, 179 ff., Figs. 187-189; *Boy with Dogs* (Rotterdam, Boymans Museum) 171 n.; *Cain Slaying Abel* (Venice, S. Maria della Salute) 22 f., 31 ff., Figs. 35, 36; *Christ's Appearance to His Mother*, see Perpetual Intercession of the Virgin Mary; *"Compagno della Calza"*, fresco (Venice, Palazzo Ducale, formerly Fondaco dei Tedeschi) 3, 19, 177; *Crowning with Thorns* (Munich, Alte Pinakothek) 15 f., 24 f., 139 n., Figs. 12, 13; (Paris, Louvre) 23 f., 33, 49, 139 n., 161 n., Fig. 20; *Danaë* (Leningrad, Hermitage) 149 n.; (Madrid, Prado) 20, 23, 91, 149 f., 166, 192, Fig. 158; (Naples, Galleria Nazionale di Capodimonte) 23, 144 ff., Fig. 150; (formerly New York) 144 n.; (Vienna, Kunsthistorisches Museum) 149 n.; *David's Triumph over Goliath* (Venice, S. Maria della Salute) 22 f., 31 ff., Fig. 35, 38; *Diana Surprised by Actaeon* (Edinburgh, National Gallery of Scotland) 24, 154 ff., Fig. 163; *Diana Discovering the Pregnancy of Callisto* (Edinburgh, National Gallery of Scotland) 24, 139 n., 154 f., 158 ff., Fig. 164; (Vienna, Kunsthistorisches Museum) 139 n., 160 f., 162 n., Fig. 172; *Diana and Endymion* (lost) 161 f. n.; *"Le Donne del Bagno"*, see "The Bath"; *Drowning of Pharaoh's Host*, woodcut 30; *"Education of Cupid"* (Rome, Galleria Borghese) 126 n., 129 ff., Fig. 144; *Europa, Abduction of* (Boston, Isabella Stewart Gardner Museum) 163 ff., Fig. 175; *Fall of Man* (Madrid, Prado) 27 ff., 192, Fig. 29; *The Feast of the Gods* (Washington, National Gallery of Art) 4 f., 97, 99 n., Fig. 2; *"The Feast of Venus"* (Madrid, Prado) 5 n., 7, 97 ff., Fig. 113; *Flaying of Marsyas* (Kroměříž, Archiepiscopal Palace) 171 n.; *Gazelle, portrait of* (lost) 144; *"La Gloria"* (Madrid, Prado) 13, 63 ff., Fig. 73; *Holy Family with St. John the Baptist and St. Catherine* (London, National Gallery) 81; *Ixion* (lost) 140 n., 147 ff.; *Jason and Medea* (lost) 140 n., 150, 154; *Judgment of Solomon*, fresco (lost) 4, 30 f.; *Judith* (lost) 30 f.; *Laocoön Caricature*, woodcut 75 n.; *"Lavinia"* (Berlin, Staatliche Museen) 80 n.; *Lucretia, Suicide of* (Hampton Court) 139 n.; (formerly Munich) *ibid.*; (Vienna, Kunsthistorisches Museum) *ibid.*; see also Tarquinius and Lucretia; *Madonna della Misericordia* (Florence, Palazzo Pitti) 108 n.; *Milo of Crotona, Death of*, woodcut 140 n.; *Miracles of St. Anthony*, frescoes (Padua, Scuola del Santo) 3, 47 ff., 110, Fig. 53; *Noli me tangere* (London, National Gallery) 110; *"Nymph and Shepherd"*, see Paris and Oenone; *Ostentatio Christi* (Vienna, Kunsthistorisches Museum) 10 n., 161 n.; *"Pala Pesaro"* (Venice, S. Maria Gloriosa de' Frari) 178 f., Fig. 186; *Pan and Silvanus* (?), drawing (New York, Coll. Curtis O. Baer) 192 f., Fig. 199; *"Pardo Venus"* (Paris, Louvre) 153 n., 190 ff., Figs. 197, 198; *Paris and Oenone* (Vienna, Kunsthistorisches Museum) 17, 25, 168 ff., Fig. 182; *Perpetual Intercession of the Virgin Mary* (Medole, Collegiata) 39 ff., 64, Fig. 47; *Perseus Liberating Andromeda* (London, Wallace Collection) 150, 154, 163 ff., 166 ff., 192, Figs. 176, 180; *Pietà* (Venice, Galleria dell'Accademia) 25, 168, 171 n., Fig. 23; *Polyptych* (Brescia, SS. Nazzaro e Celso) 13, 20, 141 n., Fig. 15; *Pomona* (lost?) 80 n., 140 n.;

Portrait of: Pietro Aretino (Florence, Pal. Pitti) 9, 10 n., Fig. 9; (New York, Frick Coll.) *ibid.*, Fig. 11; (lost) *ibid.*; *Georges d'Armagnac and Guillaume Philandrier* (Alnwick Castle) 20 n.; *Alfonso d'Avalos, Marchese del Vasto* (Paris, Marquis de Ganay) 74, Fig. 82; *Charles V, Emperor* (Madrid, Prado) 7 f., 20 n., 182 ff., Fig. 6; *on horseback* (Madrid, Prado) 72, 82, 84 ff., Figs. 97, 98; (Munich, Alte Pinakothek) 15 f., 82 ff., Fig. 96; *in armor* (lost) 7; *with Isabella of Portugal* (Madrid, Duchess of Alba) 90, 186, Fig. 106; *Degli*

Organi, Alessandro (lost) 6; *Farnese, see* Pope Paul III; *Titian's Father* (Milan, Pinacoteca Ambrosiana) 2, Fig. 1; *Girl in Yellow* (lost) 23f.; *Girl "Violante"* (Vienna, Kunsthistorisches Museum) 15, Fig. 10; *Eleonora Gonzaga, Duchess of Urbino* (Florence, Uffizi) 88, Fig. 104; *Federico Gonzaga, Duke of Mantua* (Madrid, Prado) 7, Fig. 5; *Hurtado de Mendoza, Diego* (Florence, Palazzo Pitti) 122 n.; *Isabella of Portugal, wife of Charles V* (Madrid, Prado) 9, 184ff., Fig. 8; (lost) *ibid.*; see Fig. 192; with Charles V (Madrid, Duchess of Alba) 90, 186, Fig. 106; *Pope Paul III and His Grandsons* (Naples, Galleria Nazionale di Capodimonte) 78f., 84, 88, Fig. 89; *Guillaume Philandrier, see* Georges d'Armagnac; *Philip II of Spain* (Cincinnati, Art Museum) 82f.; (Madrid, Prado) *ibid.*; (Naples, Galleria Nazionale di Capodimonte) *ibid.*; (formerly Stockholm) *ibid.*; *Francesco Maria della Rovere* (Florence, Uffizi) 88f. n., 128 n.; *Jacopo Strada* (Vienna, Kunsthistorisches Museum) 80f., 162 n., Fig. 92; see also Self-Portrait
Presentation of the Virgin (Venice, Galleria dell'Accademia) 21 n., 22, 29, 36ff., 91, Figs. 41, 42; *Rape of Proserpina* (lost) 140 n.; *Resurrection* (Urbino, Galleria Nazionale) 161 n.; *Roman Caesars* (lost) 21 n.; *"Sacred and Profane Love"* (Rome, Galleria Borghese) 19f., 110ff., 125f., 134f., 192, Figs. 128, 133; *Sacrifice of Isaac* (Venice, S. Maria della Salute) 22f., 31ff., Figs. 35, 37; woodcut 30; *Salome* (Los Angeles, Norton Simon) 42 n.; (Rome, Galleria Doria-Pamphili) 19, 20 n., 42ff., 75, 110, Fig. 50; *St. Catherine* (Boston, Museum of Fine Arts) 69f. n.; *St. James* (Venice, S.Lio) 31 n.; *St. John the Baptist* (Venice, Galleria dell'Accademia) 48 n., 192; *St. John on Patmos* (Washington, National Gallery of Art) 35f., Fig. 40; *St. Lawrence, Martyrdom of* (Escorial) 53ff., 65, Fig. 60; (Venice, Gesuiti Church) *ibid.*, Figs. 59, 64; *St. Margaret* (Escorial) 49ff., Fig. 55; (Madrid, Pra-

do) 50ff., Fig. 56; *St. Peter Martyr, Martyrdom of* (lost) 12, 18; *St. Sebastian* (Leningrad, Hermitage) 17; *Samson and Delilah*, woodcut 30; *Self-Portrait* (Berlin, Staatliche Museen) 8, 43, Fig. 7; (Madrid, Prado) *ibid.*, Frontispiece; *Sisyphus* (Madrid, Prado) 147ff., Fig. 157; *Tantalus* (lost) 65 n., 147ff., see Fig. 156; *Tarquinius and Lucretia* (Cambridge, Fitzwilliam Museum) 139 n.; (Vienna, Kunstakademie) *ibid.*; *The Three Ages of Man* (Edinburgh, National Gallery of Scotland) 94ff., 110, 192, Fig. 110; *Tityus* (Madrid, Prado) 147ff., Fig. 155; *"Tobiolo"* (Venice, Galleria dell'Accademia) 30f.; (Venice, S. Marziale) *ibid.*; *Transfiguration* (Venice, S. Salvatore) 25, Fig. 18; *Tribute Money* (Dresden, Gemäldegalerie) 7; *Triumph of Faith*, woodcut 53 n., 58ff., Figs. 66-68; lost frescoes 58; *Vanitas* (Munich, Alte Pinakothek) 93f., Fig. 109; *"La Vecchia"* (Venice, Galleria dell'Accademia) 90f., Fig. 107; *Venus* (Florence, Uffizi) 121f., Fig. 134; *Venus of Urbino* (Florence, Uffizi) 21, 29, 36, 192, Fig. 17; *Venus and Adonis* (London, National Gallery) 150f. n.; (Madrid, Prado) 150ff., Fig. 159; (New York, Metropolitan Museum) 150f. n.; (Paris, M. de Marignac) *ibid.*; (Rome, Galleria Nazionale) *ibid.*; (Washington, National Gallery of Art) *ibid.*; *Venus with a Lute Player* (Cambridge, Fitzwilliam Museum) 15f., 124f., Fig. 138; *"Holkham Hall Venus"* (New York, Metropolitan Museum) *ibid.*, Fig. 139; *Venus with an Organ Player* (Berlin, Staatliche Museen) 15f., 122f., Fig. 135; (Madrid, Prado) *ibid.*, Figs. 136, 137; *Woods of Polydorus* (Padua, Museo Civico) 140 n.; *Young Woman Doing Her Hair* (Paris, Louvre) 91ff., 190, Fig. 108; (Prague, Castle) 91f. n.; *Young Woman Holding a Bowl with Fruit, see "Lavinia"*

Tityus: 147ff., Fig. 155
Tricipitium: see signum triceps

Trinity: God the Father and Christ Enthroned 64ff., 70f., Figs. 73, 76-79; as "Throne of Mercy" (*Gnadenstuhl*) 67, 70 n., Figs. 69, 74; in Triumph of Faith 59ff.

Trionfi: see Petrarch

Tudor, Mary, wife of Philip II: 149 n., 150

Vanitas: 93f., Figs. 108, 109

Valeriano, Pierio, *Hieroglyphica: meretricia procacitas* 118; *signum triceps* 106

Vargas, Francisco, Imperial envoy to Venice: 66f., 68 n., Fig. 73

Vasari, Giorgio, *Vite*: on Titian's birth 177f.; Titian's manner of painting 16, 22, 54; Titian's *Vita* 174; Titian's paintings (*Allegory of Religion*) 187ff.; (*Allocution of Alfonso d'Avalos*) 74f.; (*Battle of Cadore*) 180; (*Feast of the Gods*) 5 n.; ("*La Gloria*") 67f.; (*Judgment of Solomon*) 31 n.; (*Perseus and Andromeda*) 164 n.; (*Portrait of Aretino*) 10 n.; (*Portrait of Hurtado de Mendoza*) 122 n.; (*Three Ages of Man*) 94 n., 95; (*Tityus*) 148 n.; ("*Tobiolo*") 31 n.; (*Triumph of Faith*) 58; on Baccio Bandinelli 104f. n.; copies after Michelangelo 121f. n., 146; ceiling decoration in S. Spirito in Isola 31ff.; Studio of Alfonso d'Este 97

Vecelli: Cecilia, wife of Titian 12, 126; Cesare 12; Francesco, Titian's brother 2, 12; Gregorio di Conte, Titian's father 2, Fig. 1; Lavinia, Titian's daughter 12, 80 n., 177; Marco 12, 107f., 174; Orazio, son of Titian 12, 107f.; Pomponio, son of Titian 12f., 39 n.; Tiziano di Marco (called Tizianello) 174f., 176f.; Vincenzo 2 n.; other members of the family 182

Vegio, Maffeo, *Philalethes*: woodcuts 112 n.

Velázquez, Diego: *Equestrian Portrait of Philip IV* 87, Fig. 102

Venice: Fondaco de' Tedeschi 3f., 19, 177; Palazzo Ducale, Sala del Maggior Consiglio 4, 179ff.; S. Canciano, Parish Register 177; S. Maria Gloriosa dei Frari, burial of Titian 2

Venus: and Adonis, sarcophagus 25, Fig. 24; etching by Hans Bol 152, 191, Fig. 162; by Titian 150ff., 190ff., Figs. 159, 197; and Bacchus 101; and Mars, as marriage portraits 126ff., Figs. 140, 142, 143; and Minerva 19, 178, Fig. 16; Feast of 97ff., Figs. 111-113; dual nature of 110ff., 114ff., 131 n., 135, 137, *see also* Eros and Anteros; celestial and terrestrial love in contrast to *amor ferinus* 117ff.; with musician 121ff., 135, Figs. 135-139; displayed as statuette 81, Fig. 92

Venusti, Marcello: *Annunciation* after Michelangelo 25, Fig. 22

Verdizotti, Giovanni Mario: biography of Titian 174

Vermeyen, Jan Cornelisz: *Equestrian Portrait of Charles V* 85 n.

Verrocchio, Andrea del: copy of Ovid 170 n.

Vesalius, Andreas, *Fabrica*: 75, Fig. 84

Vesta: 55ff., Figs. 59, 60, 64, 65

Vicenza, Palazzo della Ragione: 4, 30f.

Vico, Enea: engraving, *Tarquinius and Lucretia* 139 n.

Victory: 73, Fig. 80; statuette of 54ff., Figs. 59, 60, 64, 65

Vincent of Beauvais: on hollyhock 28

Virgil: quoted by Valeriano 118; myth of Polydorus 140 n.; description of Hades 148 n.

Virgin Mary: as "*nova Eva*" 29f.; as *Maria Mediatrix* 39ff., 66ff., Figs. 47, 49, 73; *see also* Annunciation, Presentation

Virtues: chastity 136f., 145; love, faith, hope 127ff., Figs. 140, 141; temperance 89, Fig. 105; Anteros as love of virtue 131ff.

Vouet, Simon: *St. Margaret* 51 n.

Wallbaum, Mathaeus: silver relief 57 n.

Watteau, Antoine: his *trois-crayons* 17; Titian's *Bacchanal of the Andrians* 21, 96

Wilde, Oscar: Salome 43

Willaert, Adriaan: 100, 125 n.

Zago, Sante: "*Tobiolo*" after Titian 31 n.

Zanetti, Antonio Maria: engravings after Fondaco frescoes 3 n.

Ziano, Sebastiano, Doge, 181

Zoan Andrea: engraving after Mantegna 58

Zuccato, Sebastiano: Titian's first teacher 3, 178

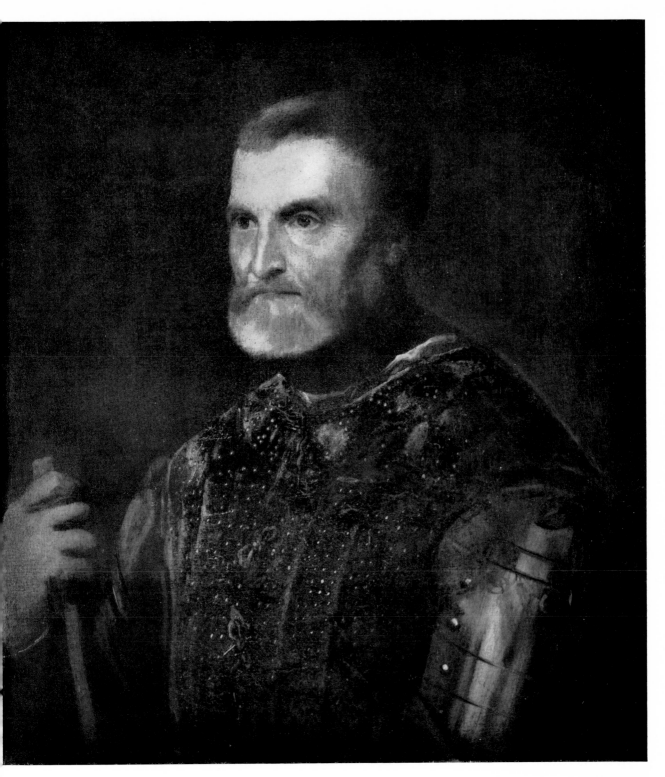

1. Titian, *Portrait of His Father* (?). Milan, Courtesy Pinacoteca Ambrosiana

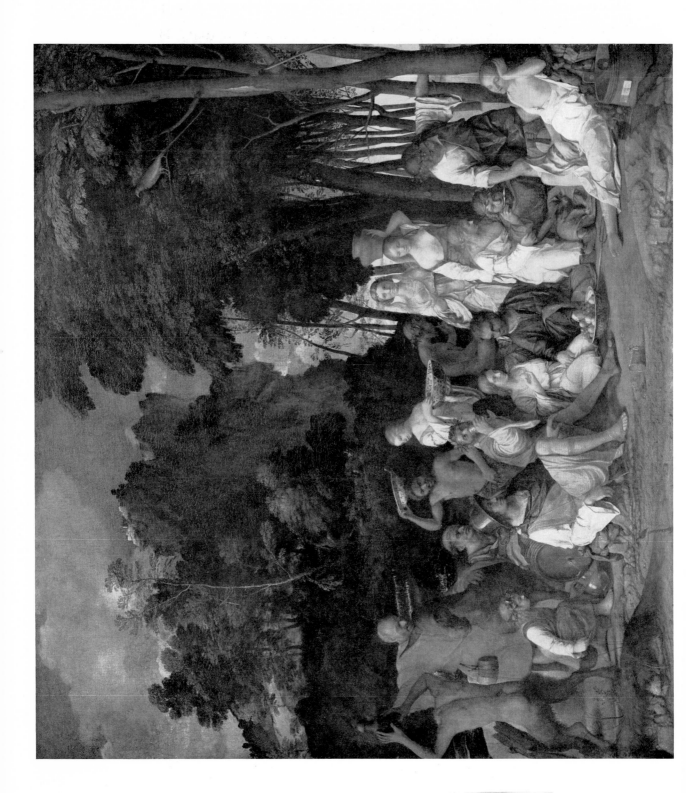

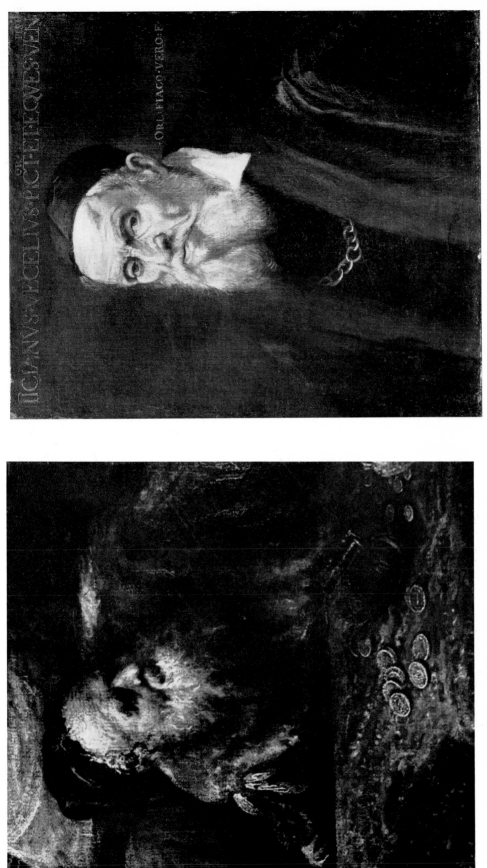

3. Jacopo Bassano, *The Purification of the Temple*, detail showing Titian as a Money-Lender. London, National Gallery (reproduced by courtesy of the Trustees)

4. Orlando Flacco (Fiacco), *Portrait of Titian.* Stockholm, Nationalmuseum

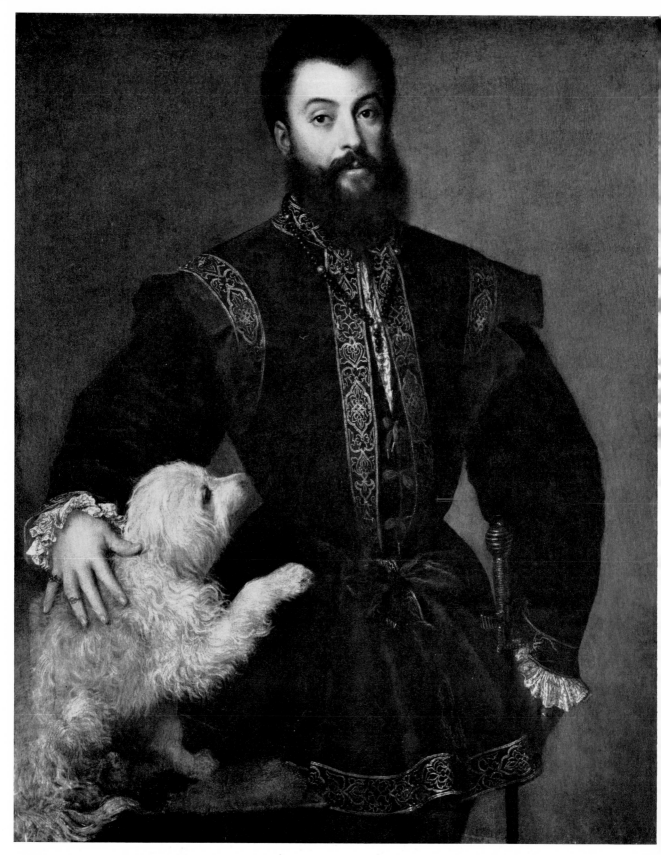

5. Titian, *Portrait of Federico Gonzaga, Duke of Mantua*. Madrid, Prado

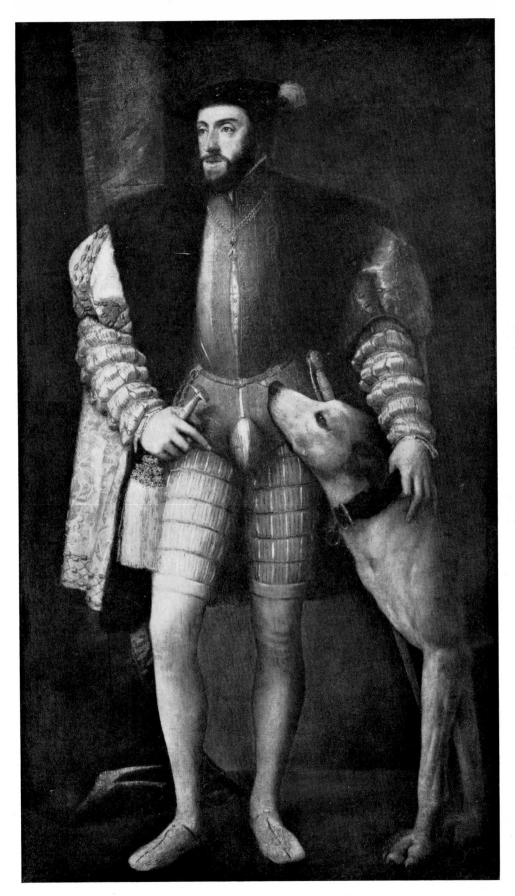

6. Titian, *Portrait of Charles V*. Madrid, Prado

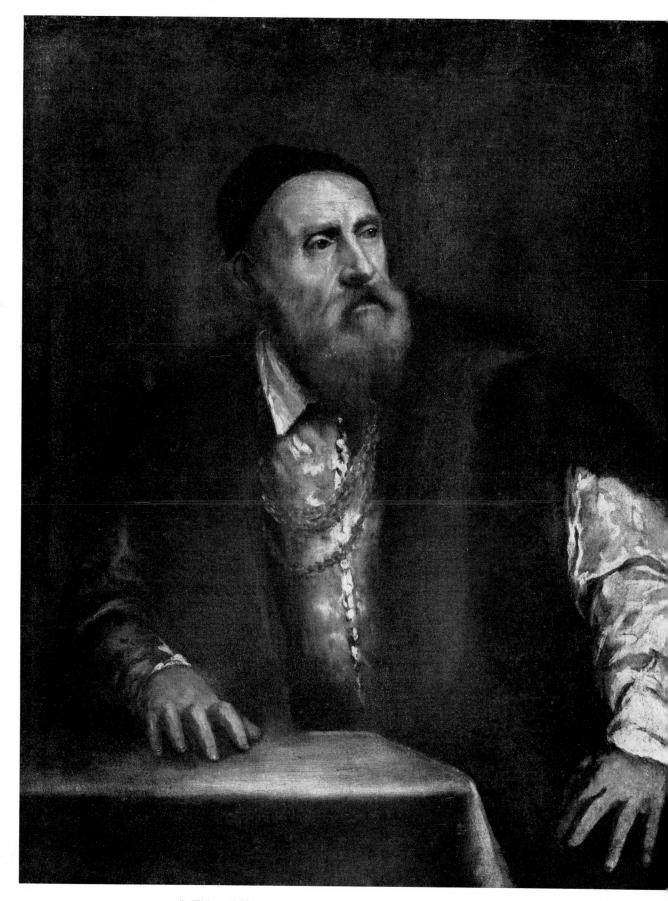

7. Titian, *Self-Portrait*. Berlin, Staatliche Museen, Gemäldegalerie

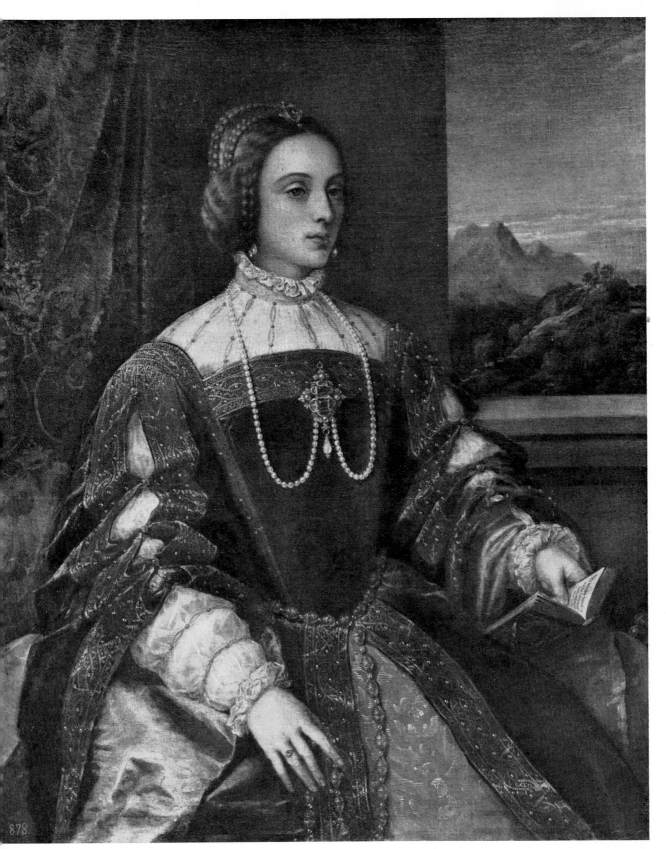

8. Titian, *Portrait of Isabella of Portugal, Wife of Charles V*. Madrid, Prado

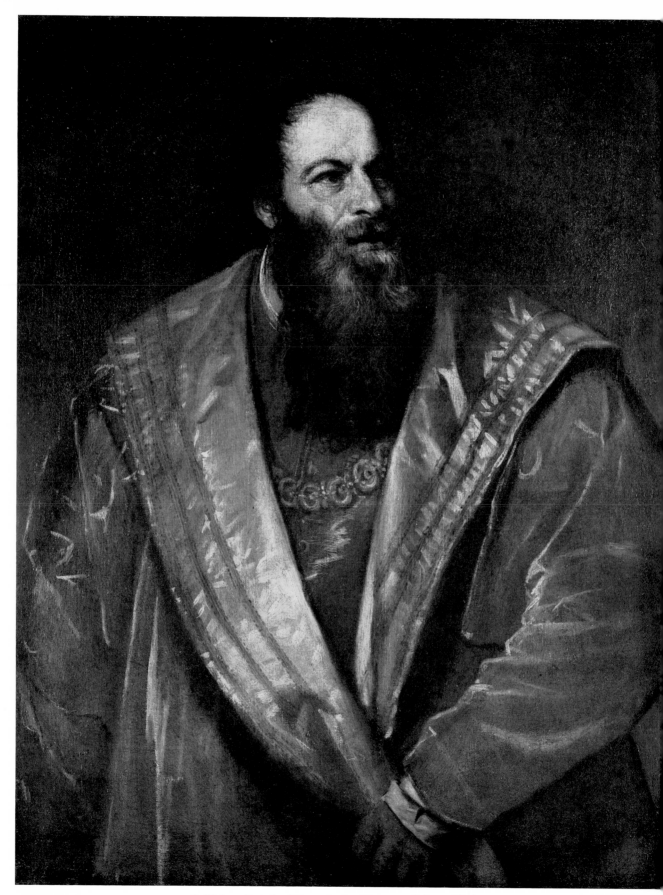

9. Titian, *Portrait of Pietro Aretino*. Florence, Palazzo Pitti

10. Wrongly ascribed to Titian, *Portrait of a Girl* ("*Violante*").
Vienna, Kunsthistorisches Museum

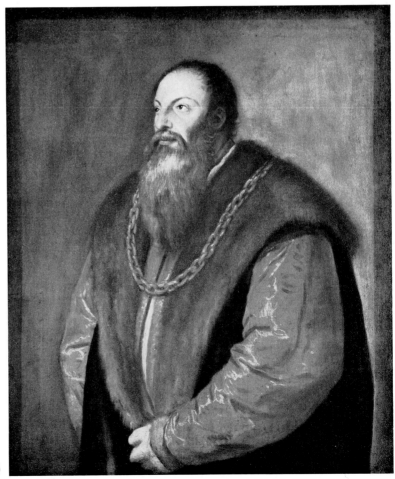

11. Titian, *Portrait of Pietro Aretino*.
New York, Frick Collection (Copyright)

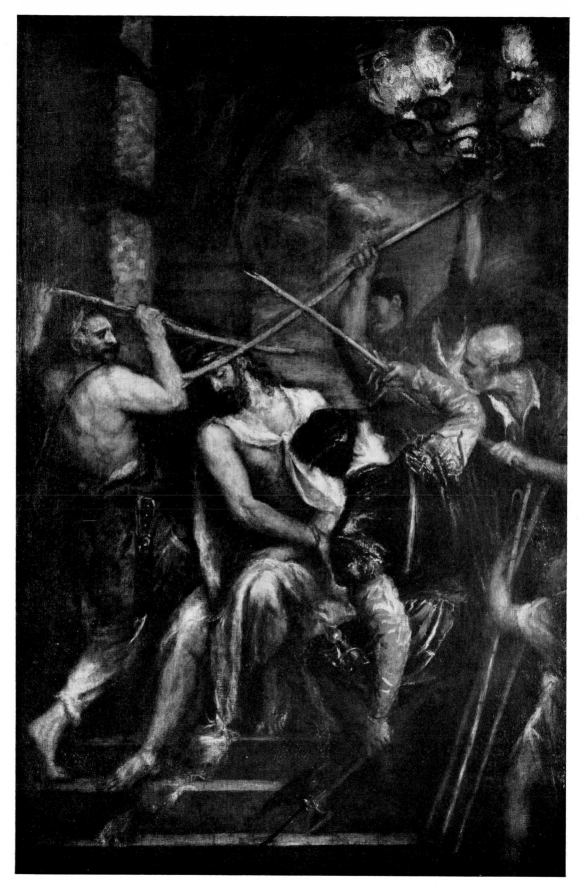

12. Titian, *Crowning with Thorns*. Munich, Alte Pinakothek

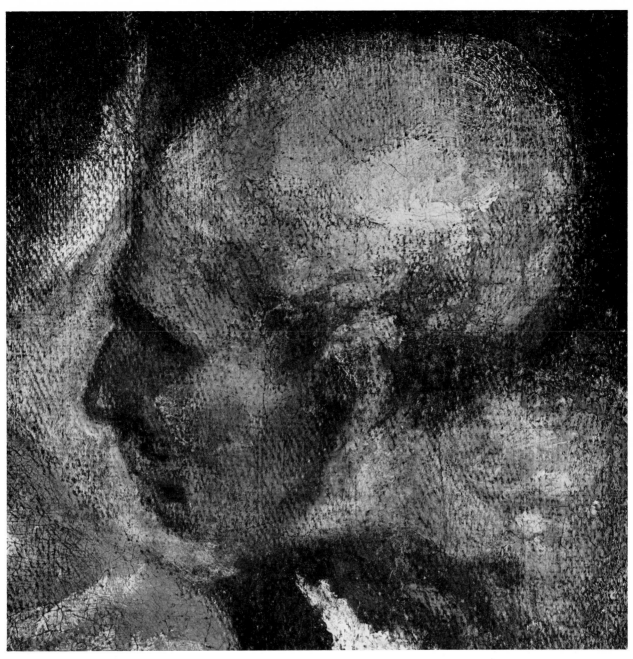

13. Detail of Figure 12

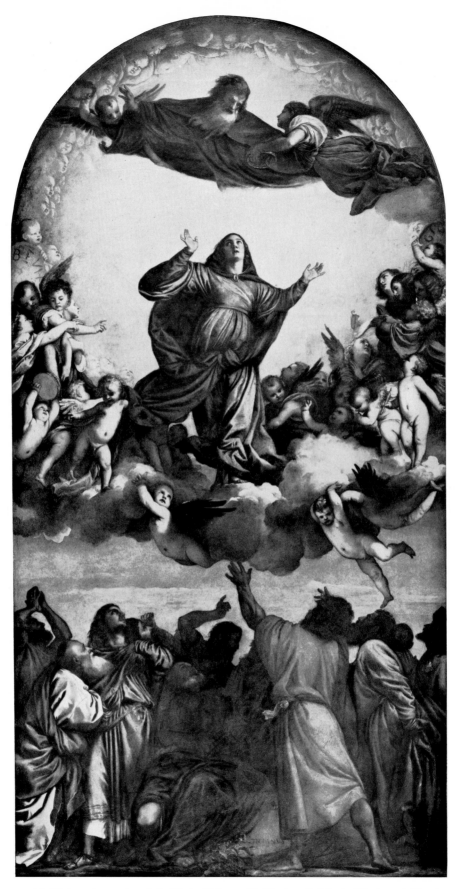

14. Titian, *Assumption of the Virgin* ("*Assunta*"). Venice, S. Maria Gloriosa de'Frari

15. Titian, *Polyptych*. Brescia, SS. Nazzaro e Celso

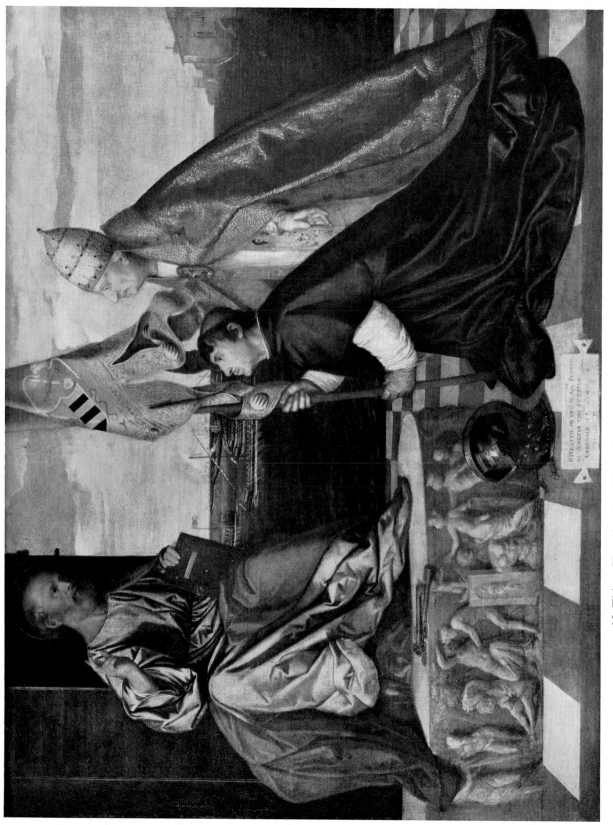

16. Titian, *First Altarpiece of Jacopo Pesaro*. Antwerp, Musée Royal des Beaux-Arts

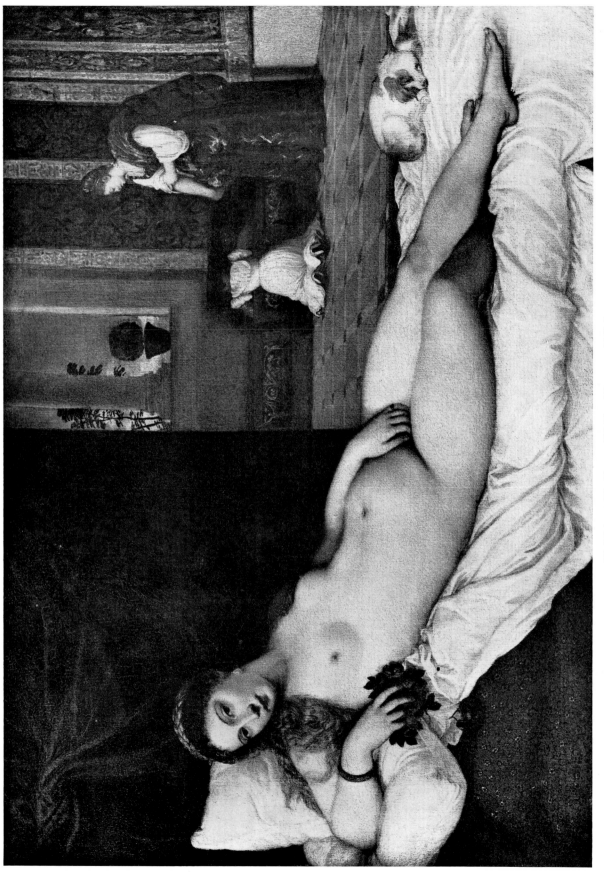

17. Titian, *The Venus of Urbino*. Florence, Uffizi

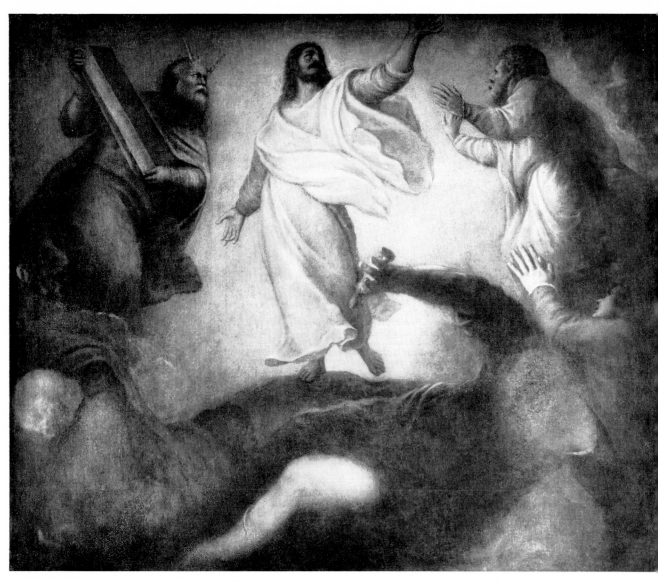

18. Titian, *Transfiguration*. Venice, S. Salvatore

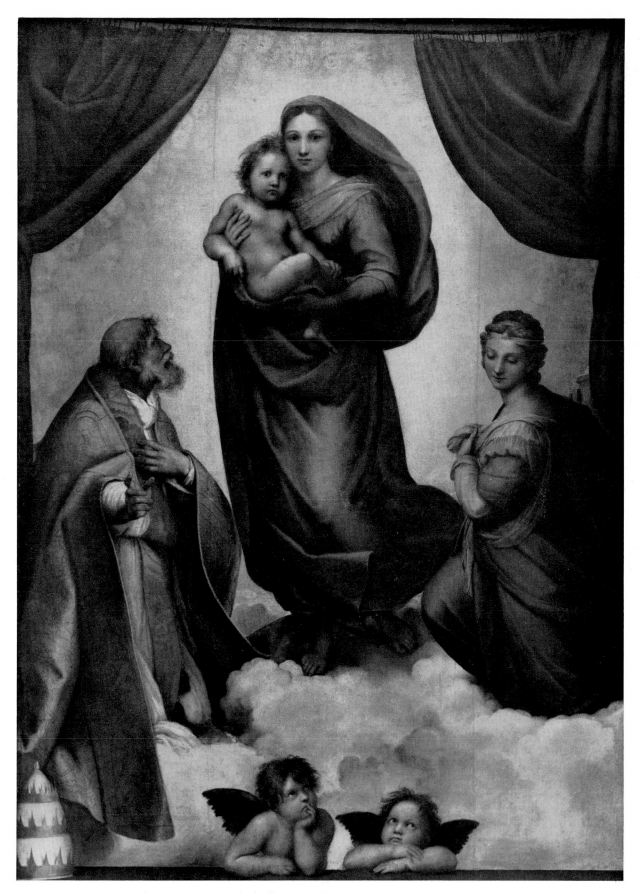

19. Raphael, *Sistine Madonna*. Dresden, Gemäldegalerie

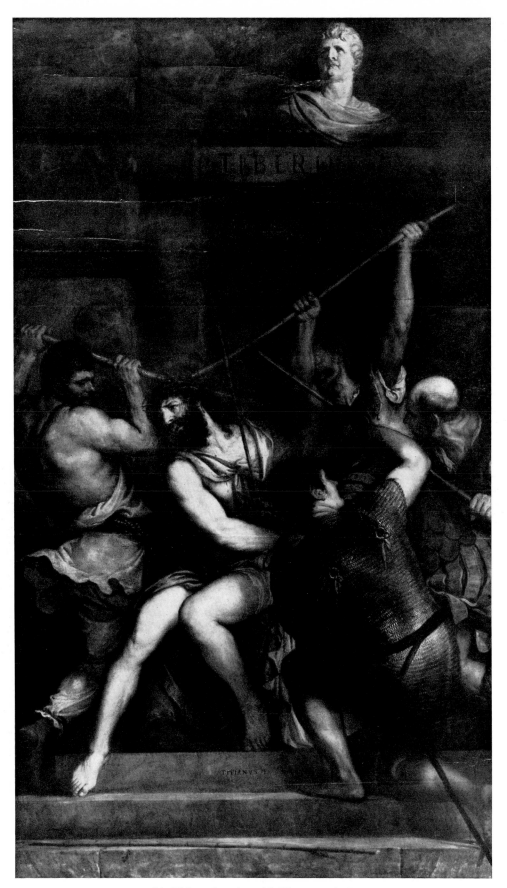

20. Titian, *Crowning with Thorns*. Paris, Louvre

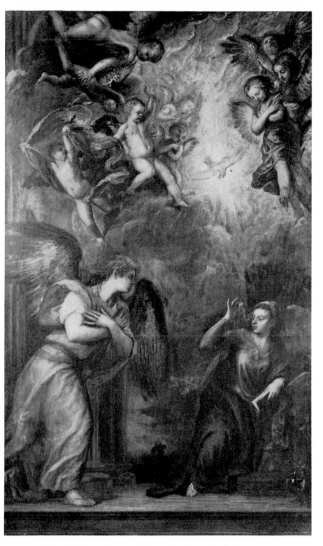

21. Titian, *Annunciation*. Venice, S. Salvatore

22. Marcello Venusti after Michelangelo, *Annunciation*.
Rome, Galleria Nazionale d'Arte Antica

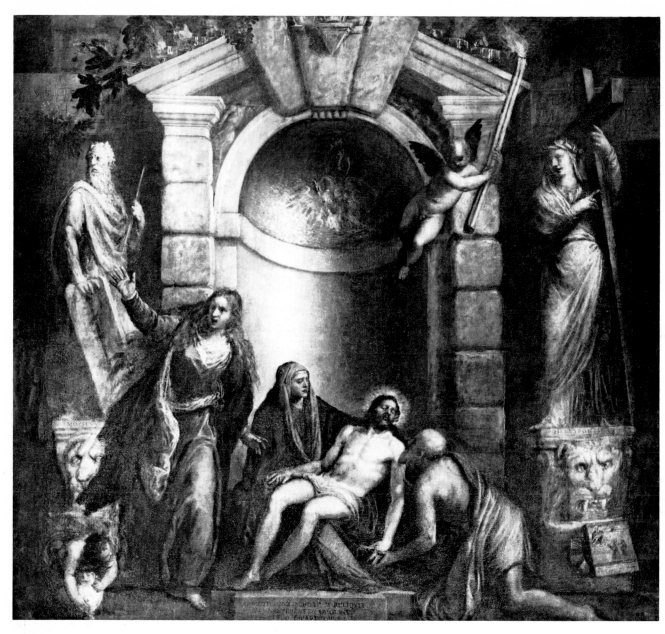

23. Titian, *Pietà*. Venice, Galleria dell'Accademia

24. *Adonis Sarcophagus* (detail). Matua, Palazzo Ducale

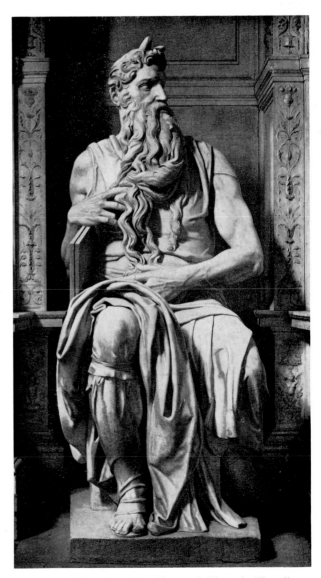

25. Michelangelo, *Moses*. Rome, S. Pietro in Vincoli

26. Donatello, *Abraham*.
Florence, formerly Campanile (as shown here),
now Museo dell'Opera di S. Maria del Fiore

27. Michelangelo, *The Risen Christ*.
Rome, S. Maria sopra Minerva

28. Michelangelo, *Pietà*. Rome, St. Peter's

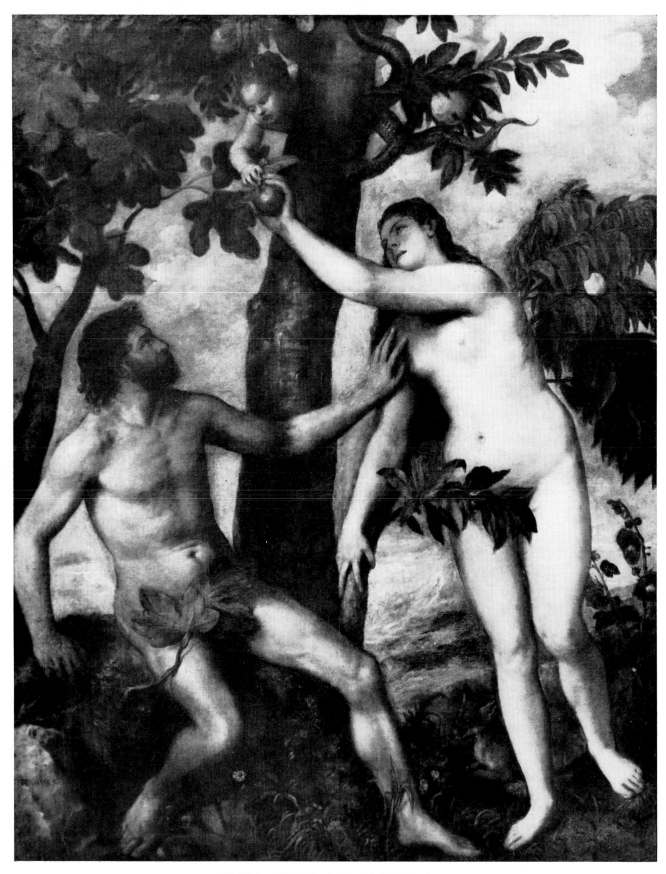

29. Titian, *The Fall of Man*. Madrid, Prado

30. Raphael (School), *The Fall of Man*. Fresco. Rome, Vatican, Loggie

31. Dürer, *The Fall of Man*. Engraving B. 1 (first state).
New York, Metropolitan Museum of Art (Fletcher Fund, 1919)

32. Rubens after Titian, *The Fall of Man*. Madrid, Prado

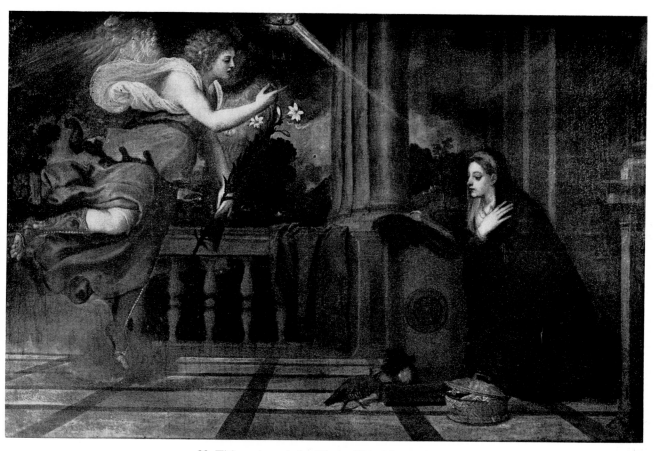

33. Titian, *Annunciation*. Venice, Scuola di S. Rocco

34. Detail of Figure 33

35. Titian, Three Ceiling Paintings, proposed original arrangement. Venice, S. Maria della Salute

36. Titian, *Cain Slaying Abel*. Venice, S. Maria della Salute

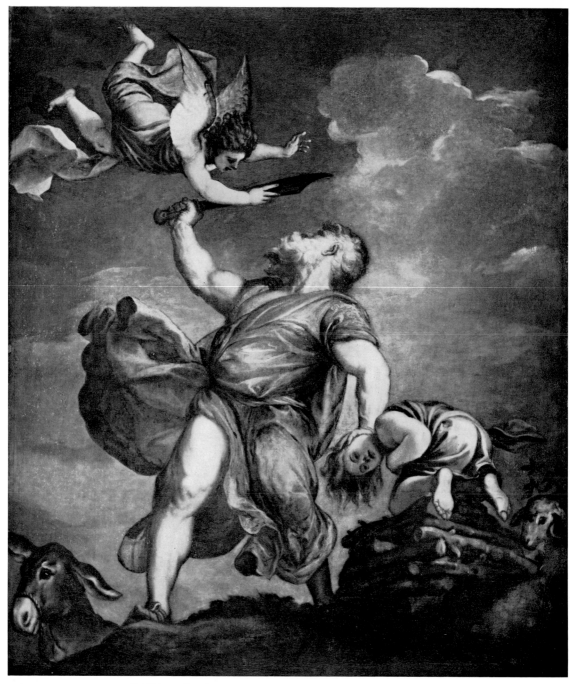

37. Titian, *Sacrifice of Isaac*. Venice, S. Maria della Salute

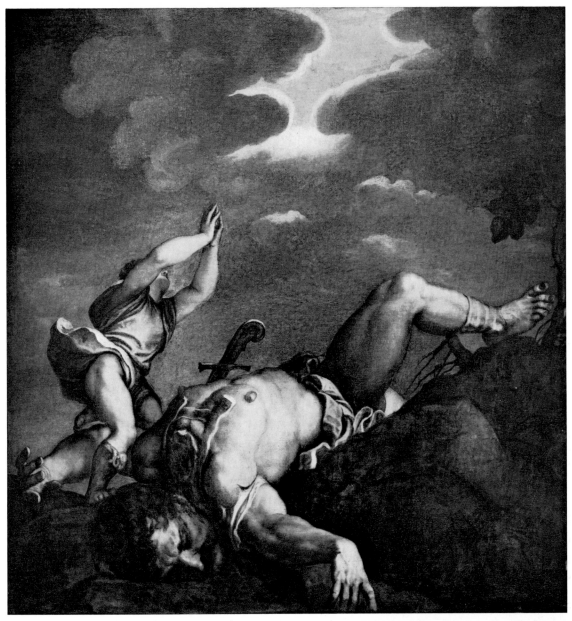

38. Titian, *David's Triumph over Goliath*. Venice, S. Maria della Salute

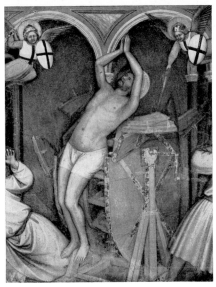

39. Altichiero, *Martyrdom of St. George*.
Fresco (detail). Padua, Oratorio di S. Giorgio

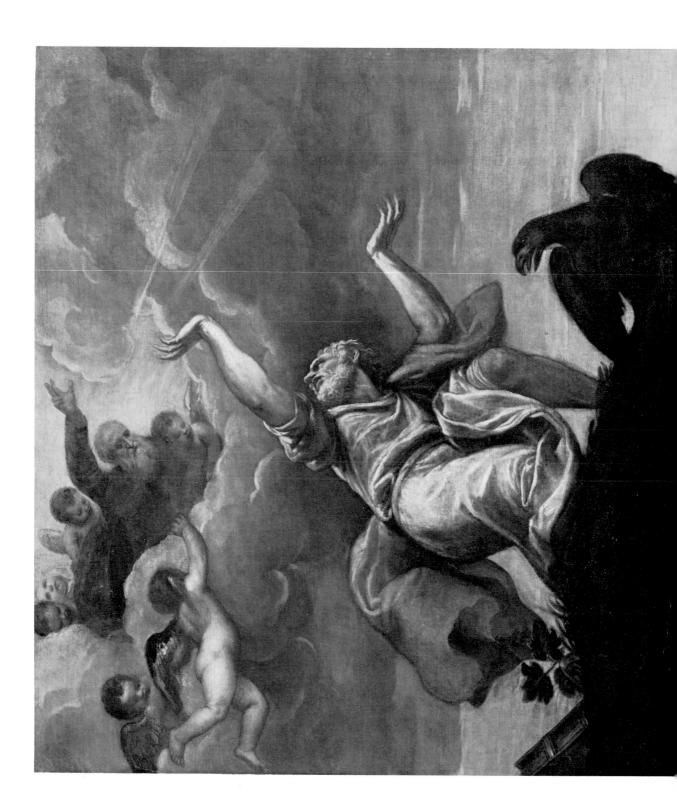

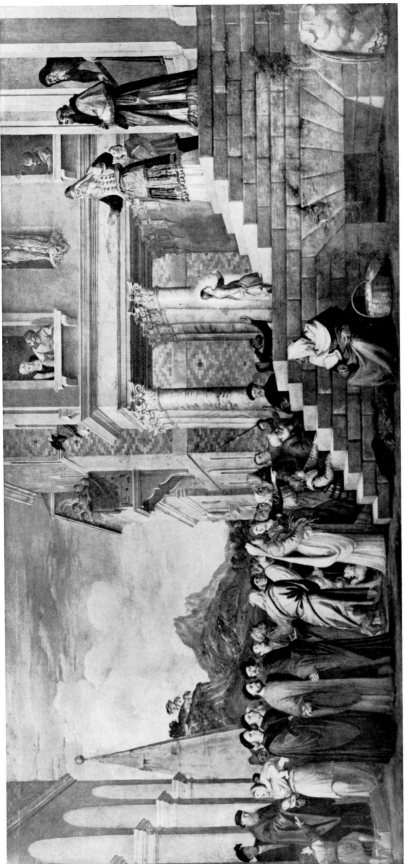

41. Titian, *Presentation of the Virgin*. Venice, Galleria dell'Accademia

42. Detail of Figure 41

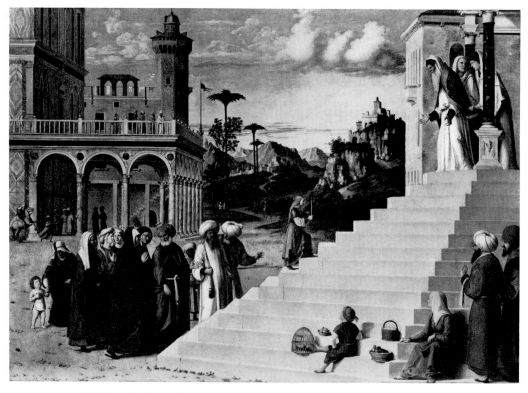

43. Cima da Conegliano, *Presentation of the Virgin*. Dresden, Gemäldegalerie

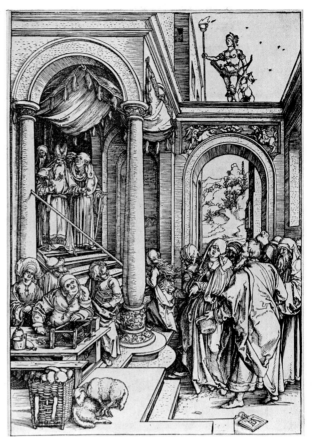

44. Sebastiano Serlio, *Tragic Scene*.
Woodcut from *Il Libro primo dell' architettura*, Venice, 1551, fol. 29v

45. Dürer, *Presentation of the Virgin*.
Woodcut B. 81. New York, Metropolitan Museum of Art
(Rogers Fund, 1918)

46. Giovanni Domenico Tiepolo, *Flight into Egypt*. Etching from *Idee pittoresche sopra la Fugga in Egitto*.
Washington, National Gallery of Art (Rosenwald Collection)

47. Titian, *The Perpetual Intercession of the Virgin Mary*. Medole, Collegiata

48. Miguel Esteve (?), *Christ and the Redeemed Patriarchs Appearing to the Virgin Mary.*
Williamstown, Williams College Museum of Art

49. Guido Reni, *Intercession of the Virgin Mary in Limbo*. Dresden, Gemäldegalerie (destroyed?)

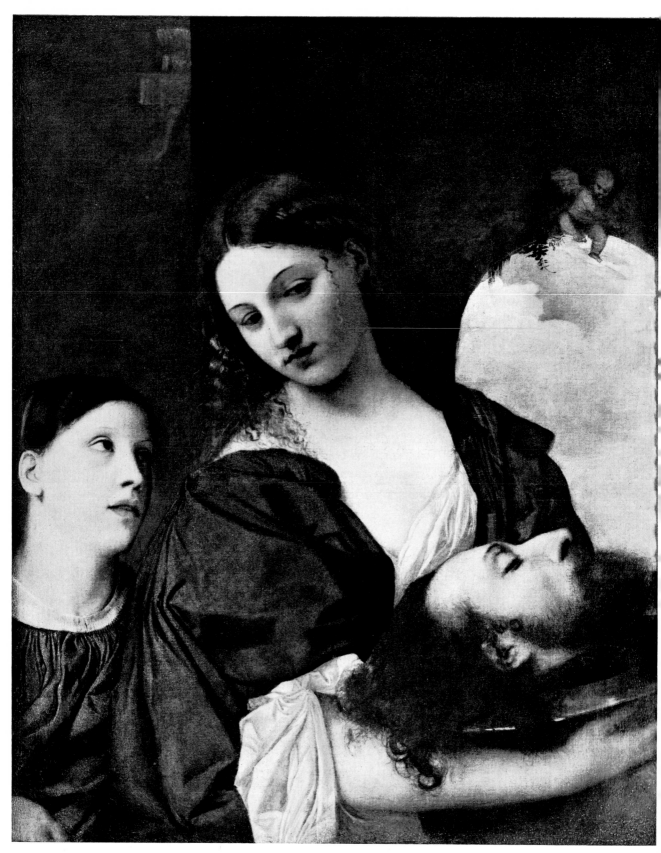

50. Titian, *Salome*. Rome, Galleria Doria-Pamphili

51. Pieter Cornelisz van Rijck, *Salome*.
New York, art market

52. Guercino, *Salome Visiting John the Baptist
in Prison*. London, Collection Denis Mahon

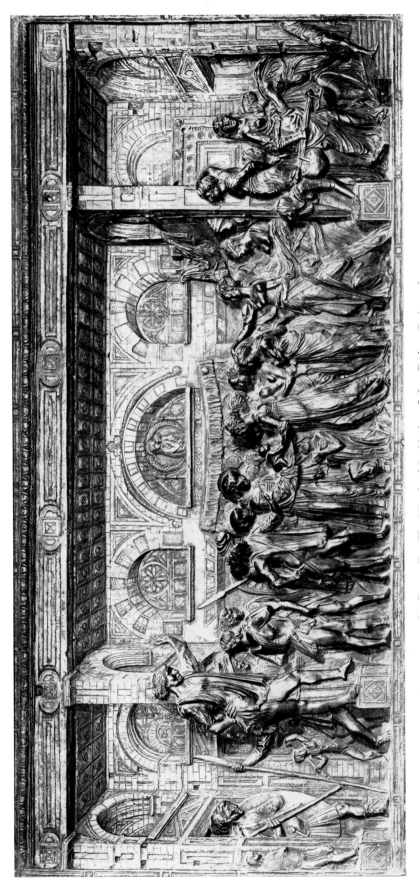

54. Donatello, *The Miracle of the Newborn Infant*. Padua, S. Antonio

55. Titian, *St. Margaret*. Escorial (by permission of Patrimonio Nacional)

56. Titian, *St. Margaret*. Madrid, Prado

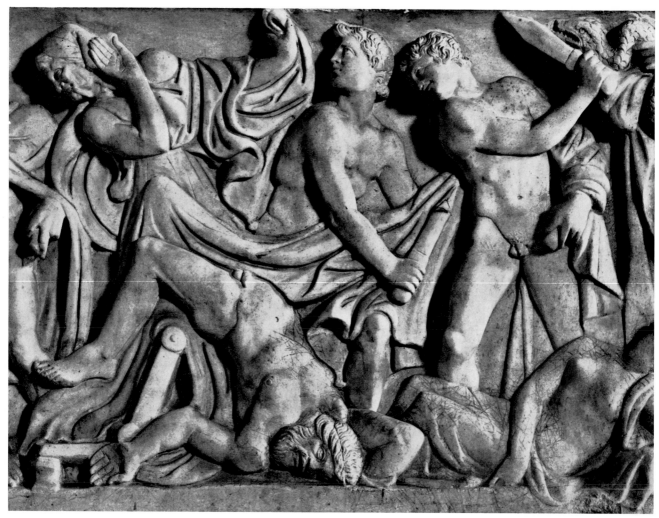

57. *Orestes Sarcophagus* (detail). Rome, Lateran

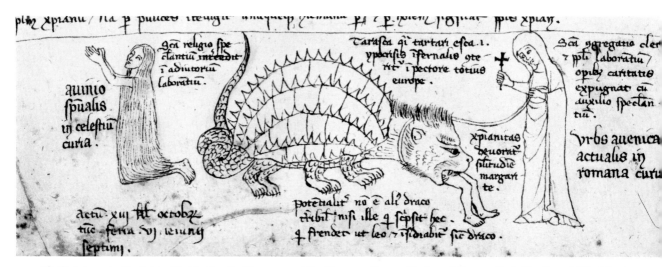

58. Opicinus de Canistris, *St. Martha, the Tarasque and St. Margaret*. Rome, Vatican Library, Cod. Vat.Lat. 6435, fol. 52v

59. Titian, *Martyrdom of St. Lawrence*. Venice, Gesuiti Church

60. Titian, *Martyrdom of St. Lawrence*. Escorial (by permission of Patrimonio Nacional)

61. Marcantonio Raimondi after Bandinelli, *Martyrdom of St. Lawrence*. Engraving B. 104.
New York, Metropolitan Museum of Art (Dick Fund, 1917)

62. Marcantonio Raimondi after Raphael (?), *The Standard Bearer*. Engraving B. 481.
New York, Metropolitan Museum of Art (Dick Fund, 1944)

63. *Fallen Gaul*. Venice, Museo Archeologico

64. Detail of Figure 59

65. Cornelis Cort after Titian, *Martyrdom of St. Lawrence*. Engraving.
Rome, Gabinetto Nazionale delle Stampe

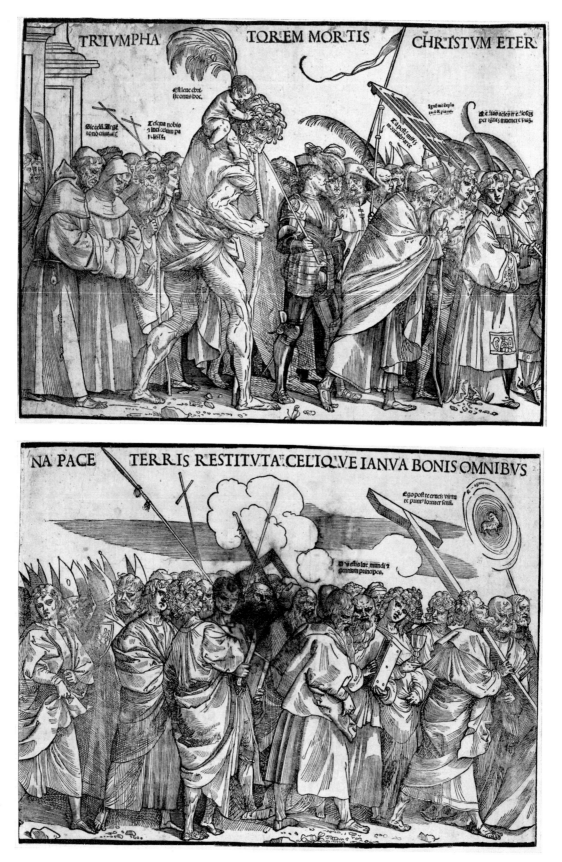

66. Titian, *Triumph of Faith*. Woodcut (details).
New York, Metropolitan Museum of Art (Whittelsey Fund, 1949)

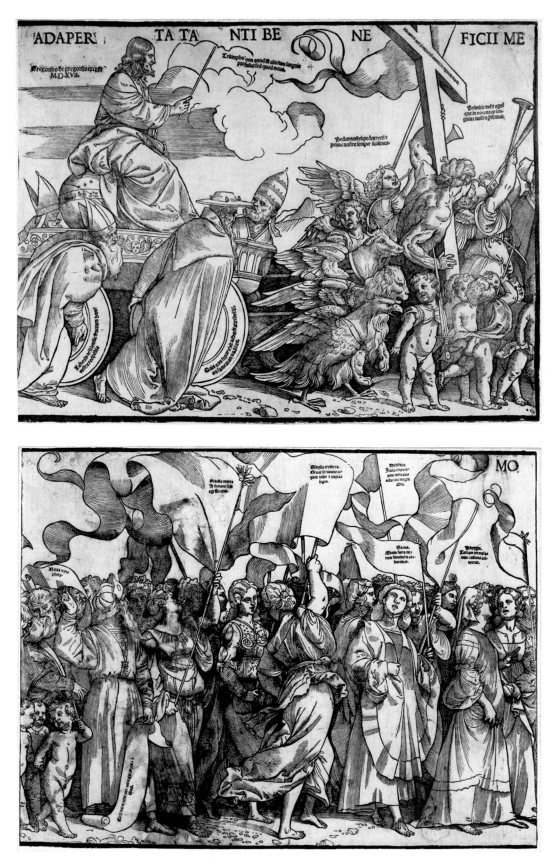

67. Titian, *Triumph of Faith*. Woodcut (details).
New York, Metropolitan Museum of Art (Whittelsey Fund, 1949)

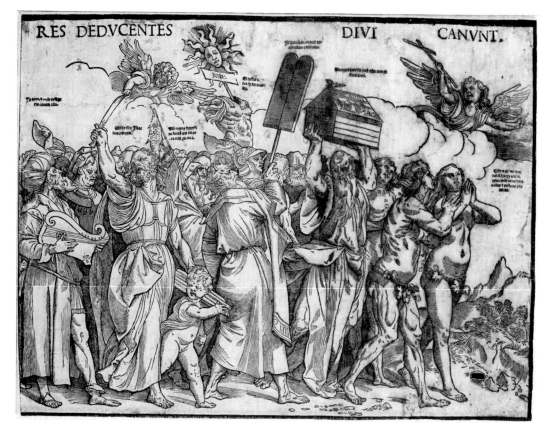

68. Titian, *Triumph of Faith*. Woodcut (detail).
New York, Metropolitan Museum of Art (Whittelsey Fund, 1949)

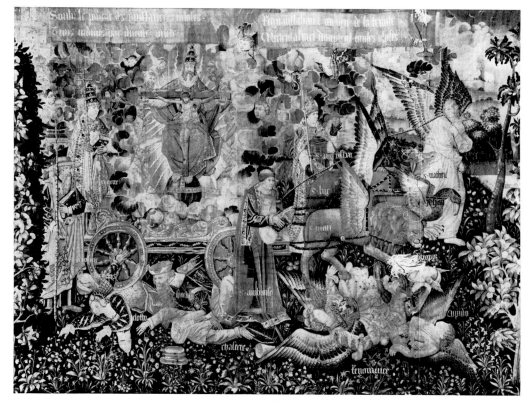

69. *Triumph of Divinity* (originally *Eternity*). North French tapestry. Vienna, Kunsthistorisches Museum

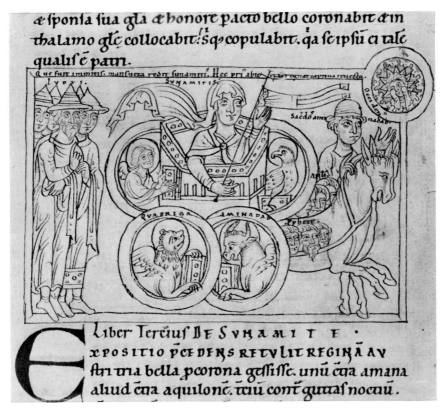

70. *The Shulamite Woman on the "Quadriga Christi"*. Vienna, Nationalbibliothek, Cod. 942, fol. 79v

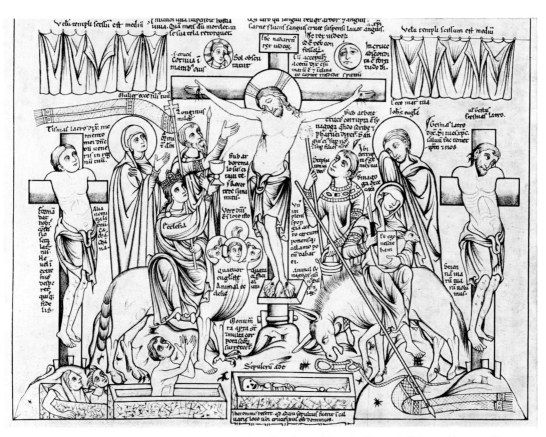

71. *Crucifixion*. Copy after a miniature in Herrade of Landsberg's *Hortus Deliciarum* (destroyed)

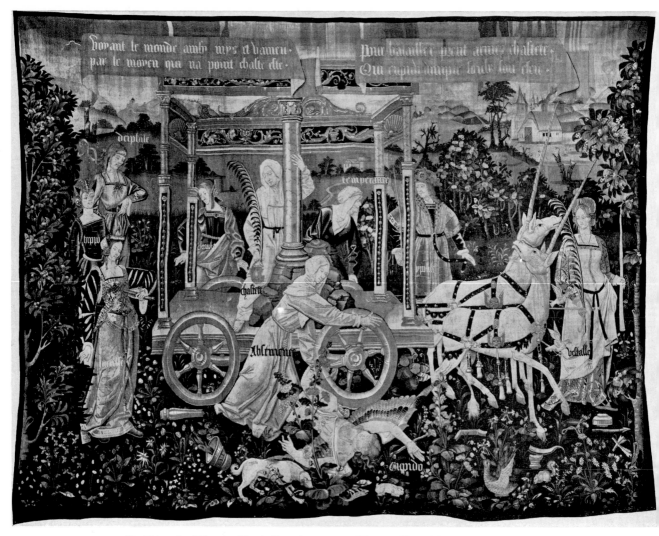

72. *Triumph of Chastity*. North French tapestry. Vienna, Kunsthistorisches Museum

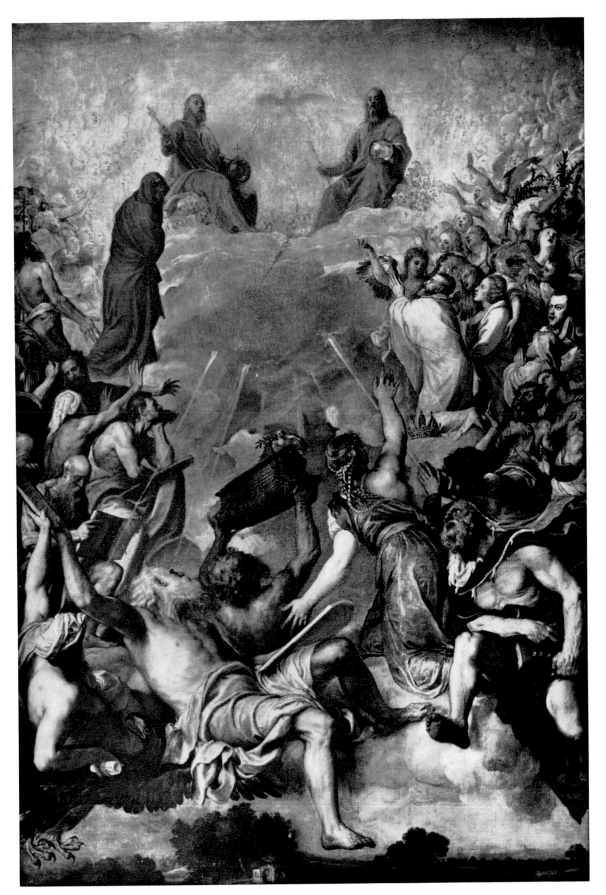

73. Titian, "*La Gloria*". Madrid, Prado

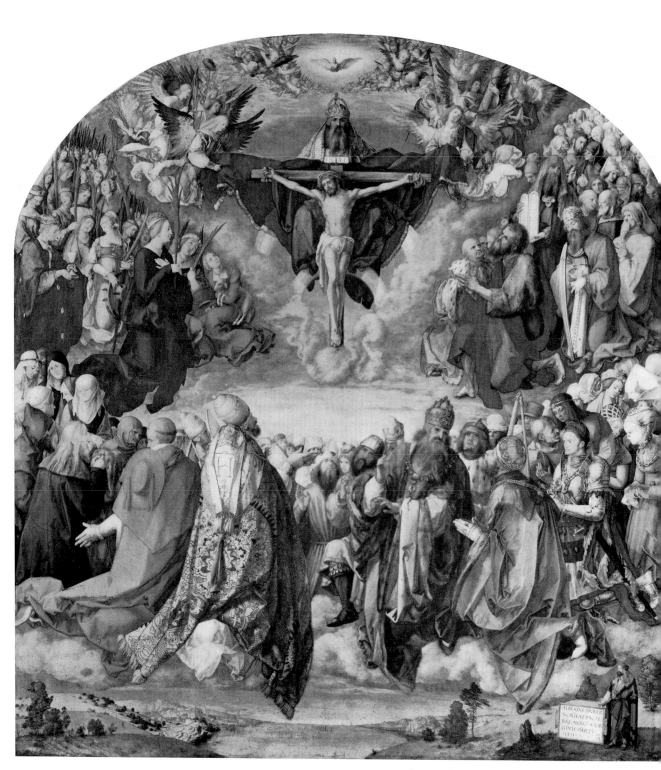

74. Dürer, *All Saints Altarpiece* (the "*Landauer Altarpiece*"). Vienna, Kunsthistorisches Museum

75. Michelangelo. *Last Judgment*. Fresco (detail). Rome, Sistine Chapel

77. "*La Cour Céleste*". Paris, Bibliothèque Ste.-Geneviève, MS. 246, fol. 406

76. *The Trinity*. Paris, Bibliothèque Nationale, MS. Lat. 18014, fol. 137 v

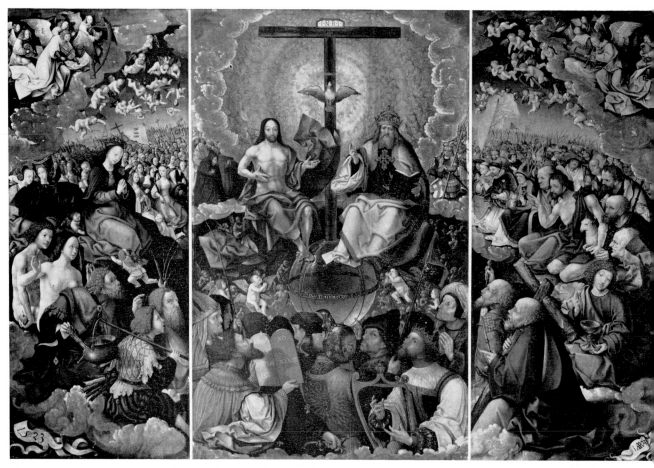

78. Jacob Cornelisz van Oostsanen, *All Saints Altarpiece*. Kassel, Gemäldegalerie

79. Enguerrand Quarton, *Coronation of the Virgin* (detail). Villeneuve-lès-Avignon, Carthusian Church

80. Titian, *Allegory of the Battle of Lepanto*. Madrid, Prado

81. *"Ad te levavi"* Initial. Paris,
Bibliothèque Nationale, MS. Lat. 17318, fol. 18

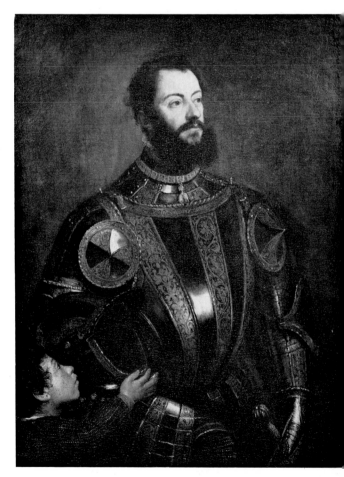

82. Titian *Portrait of Alfonso d'Avalos, Marchese del Vasto.*
Paris, Collection Marquis de Ganay

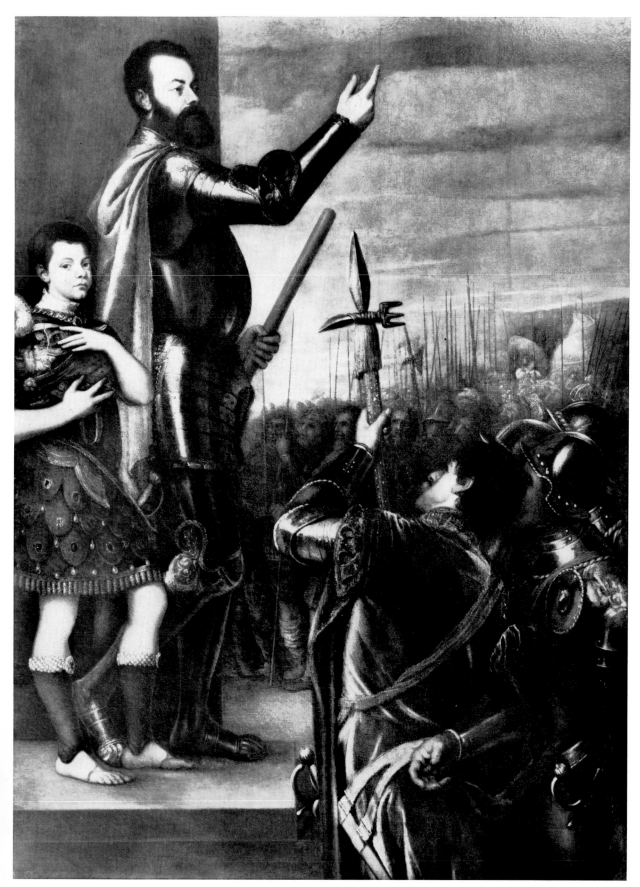

83. Titian, *Allocution of Alfonso d'Avalos, Marchese del Vasto*. Madrid, Prado

85. "*Adlocutio Augusti*". Coin of Gordian III

84. Jan Stevensz of Calcar, "*Secunda Musculorum Tabula*".
Woodcut from Andreas Vesalius,
Fabrica Corporis Humani

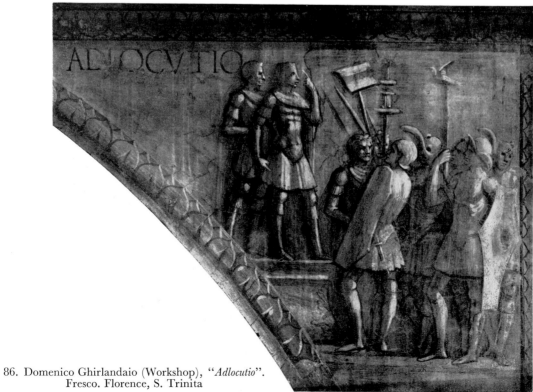

86. Domenico Ghirlandaio (Workshop), "*Adlocutio*".
Fresco. Florence, S. Trinita

87. Giulio Romano, *Allocution of Constantine*. Fresco. Rome, Vatican

88. Giovanni Battista Tiepolo, *Allocution of Queen Zenobia*. Washington, National Gallery of Art (Samuel H. Kress Collection)

89. Titian, *Portrait of Pope Paul III and His Grandsons, Alessandro Cardinal Farnese and Ottavio Farnese*.
Naples, Galleria Nazionale di Capodimonte

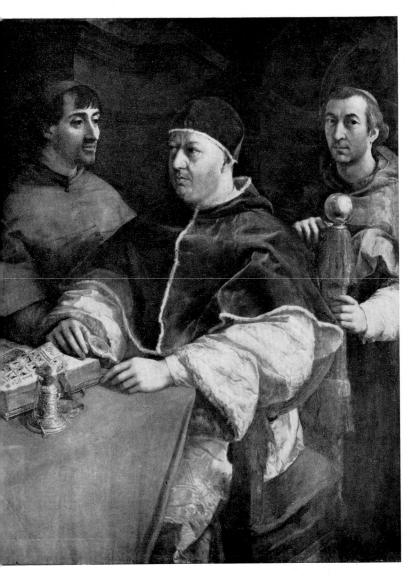

90. Raphael, *Portrait of Pope Leo X and His Nephews, Giulio Cardinal de' Medici and Lodovico Cardinal de' Rossi.* Florence, Uffizi

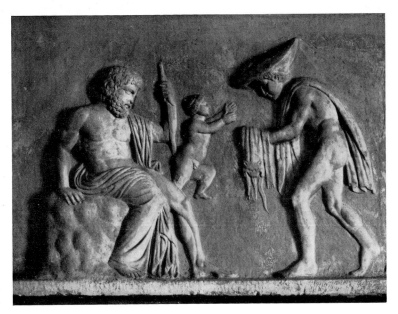

91. *Mercury Receiving the Newborn Bacchus.* Roman relief (left-hand section). Rome, Musei Vaticani

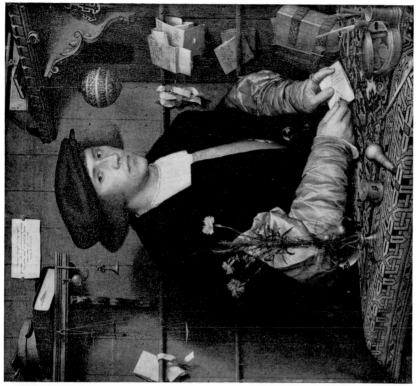

93. Hans Holbein the Younger, *Portrait of Georg Gisze.*
Berlin, Staatliche Museen, Gemäldegalerie

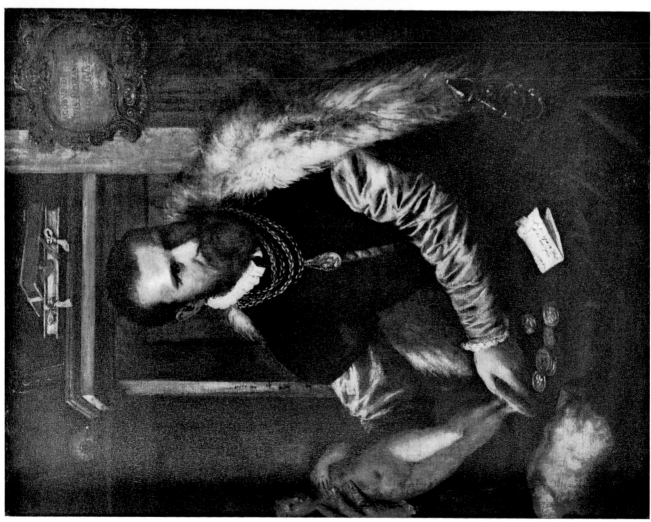

95. *Mother and Child.* Attic Stele. Avignon, Musée Calvet

94. Lorenzo Lotto, *Portrait of Andrea Odoni.* London, Hampton Court
(reproduced by gracious permission of H. M. the Queen)

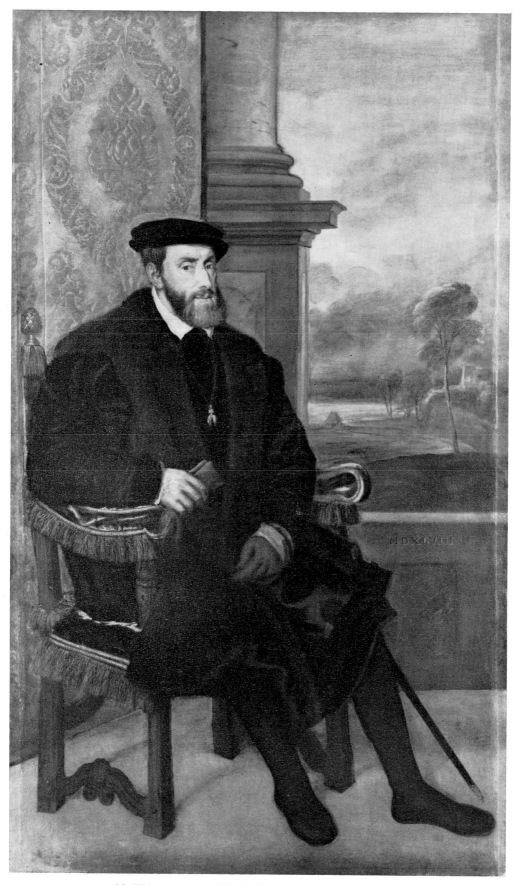

96. Titian, *Portrait of Charles V*. Munich, Alte Pinakothek

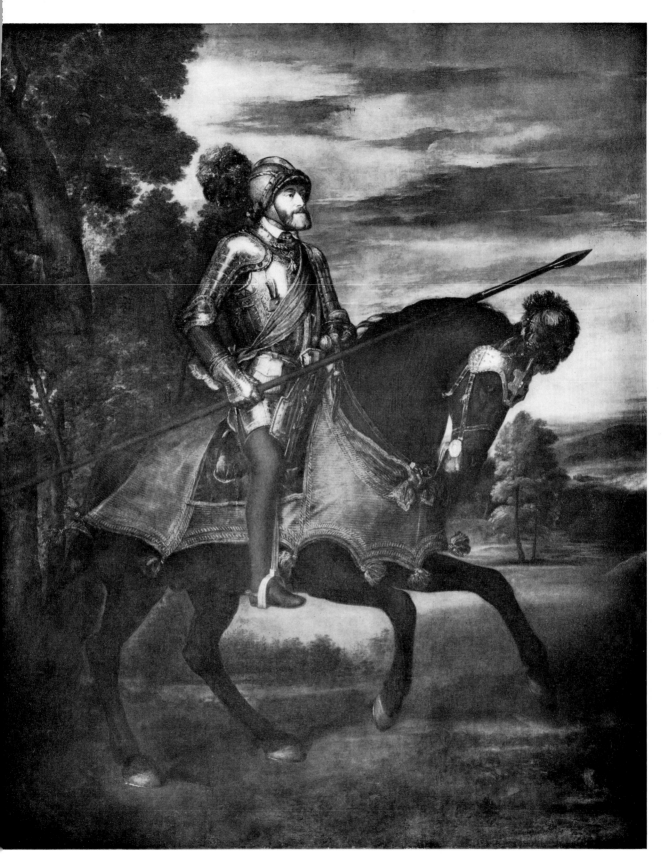

97. Titian, *Portrait of Charles V on Horseback*. Madrid, Prado

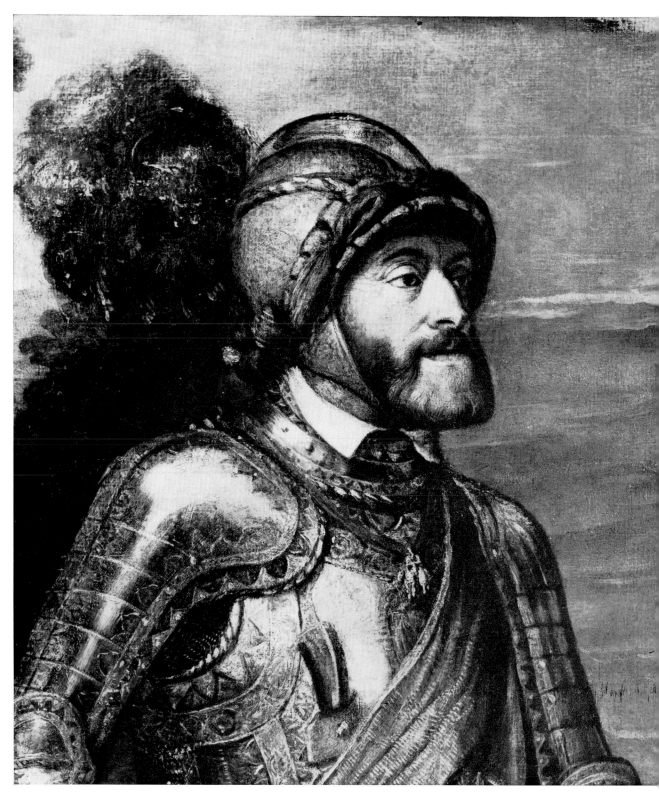

98. Detail of Figure 97

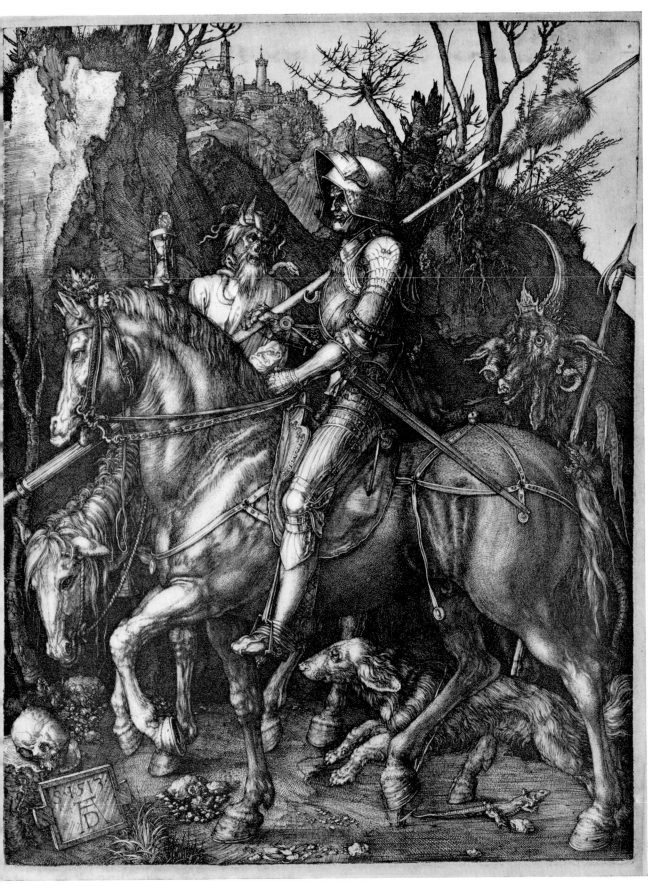

99. Dürer, *The Christian Knight*. Engraving B. 98. New York, Metropolitan Museum of Art (Dick Fund, 1943)

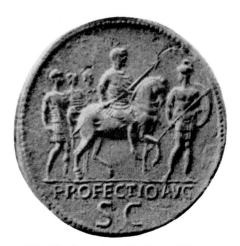

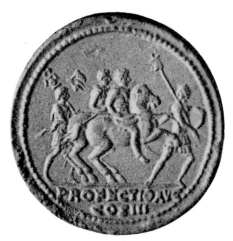

100. "*Profectio Augusti*". Coin of Trajan

101. "*Profectio Augusti*". Coin of Marcus Aurelius

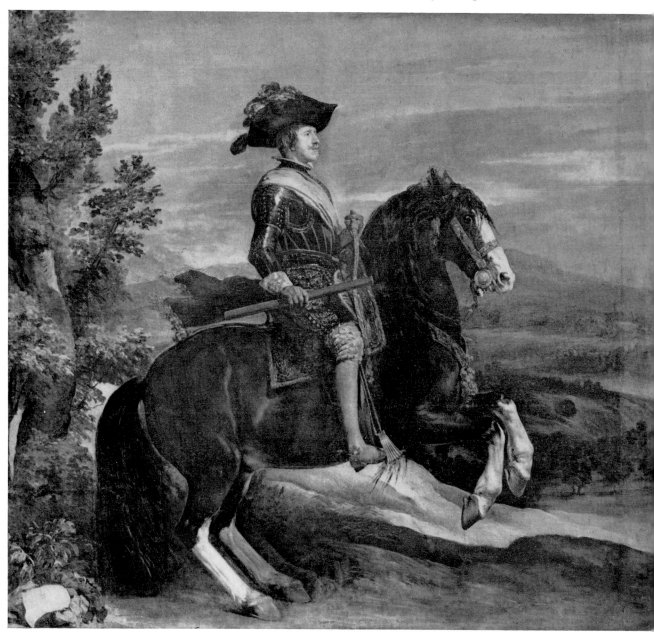

102. Velázquez, *Portrait of Philip IV of Spain on Horseback*. Madrid, Prado

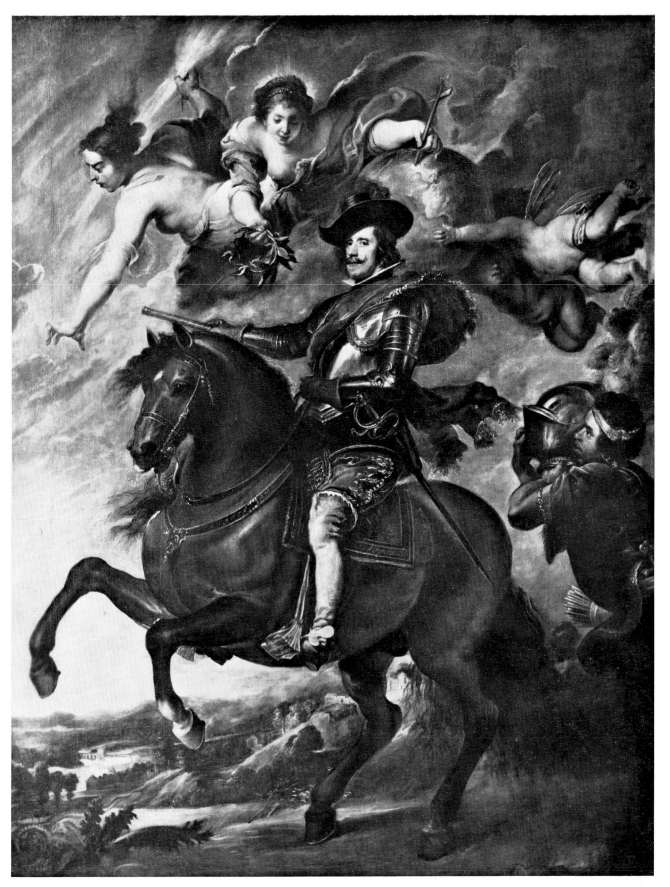

103. Rubens (copy), *Portrait of Philip IV of Spain on Horseback*. Florence, Uffizi

104. Titian, *Portrait of Eleonora, Duchess of Urbino*. Florence, Uffizi

105. Michel Colombe and Girolamo da Fiesole, *Tomb of Francis II of Brittany and Marguérite de Foix*. Nantes, Cathedral

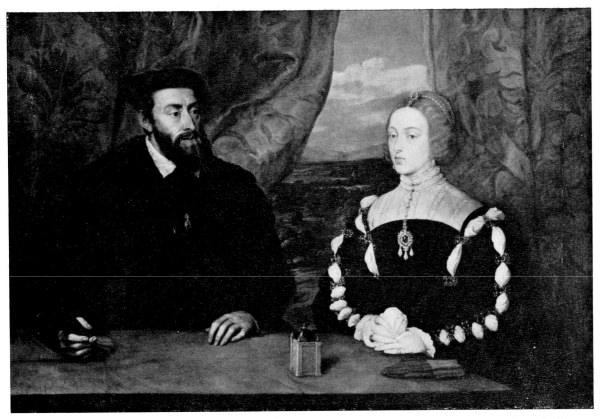

106. Rubens (?) after Titian, *Double Portrait of Charles V and Isabella of Portugal*. Madrid, The Duchess of Alba

107. Titian, "*La Vecchia*".
Venice, Galleria dell'Accademia

109. Titian, *Vanitas*. Munich, Alte Pinakothek

108. Titian, *Young Woman Doing Her Hair*. Paris, Louvre

110. Titian, *The Three Ages of Man*. Edinburgh, National Gallery of Scotland (on loan from the Duke of Sutherland Collection)

111. Fra Bartolommeo, "*The Feast of Venus*". Drawing. Florence, Uffizi

112. Giulio Romano, "*The Feast of Venus*". Drawing. Chatsworth. Devonshire Collection
(reproduced by permission of the Trustees of the Chatsworth Settlement)

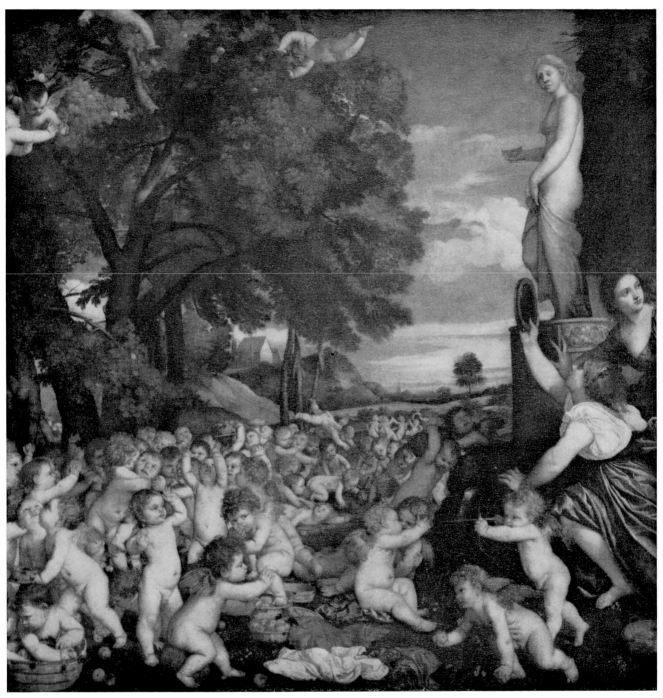

113. Titian, "*The Feast of Venus*". Madrid, Prado

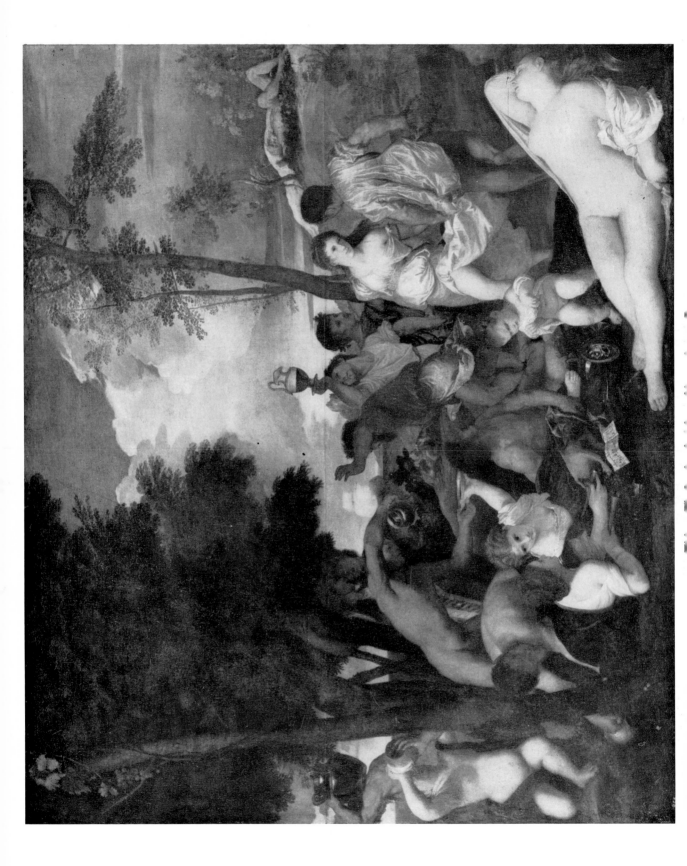

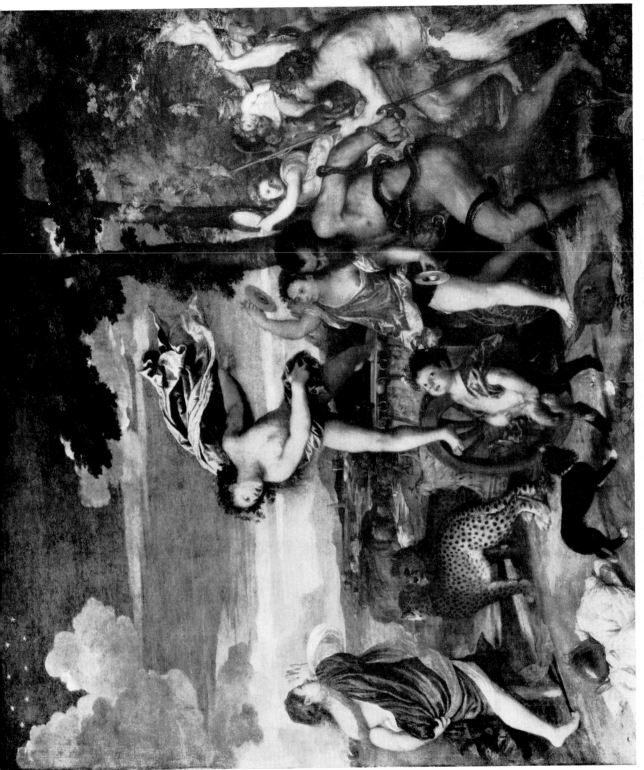

115. Titian, *Bacchus and Ariadne*. London, National Gallery (reproduced by courtesy of the Trustees)

117. Titian, *Allegory of Prudence*. London, National Gallery
(reproduced by courtesy of the Trustees)

116. Domenico Beccafumi, *Two Nudes*. Drawing.
Private Collection

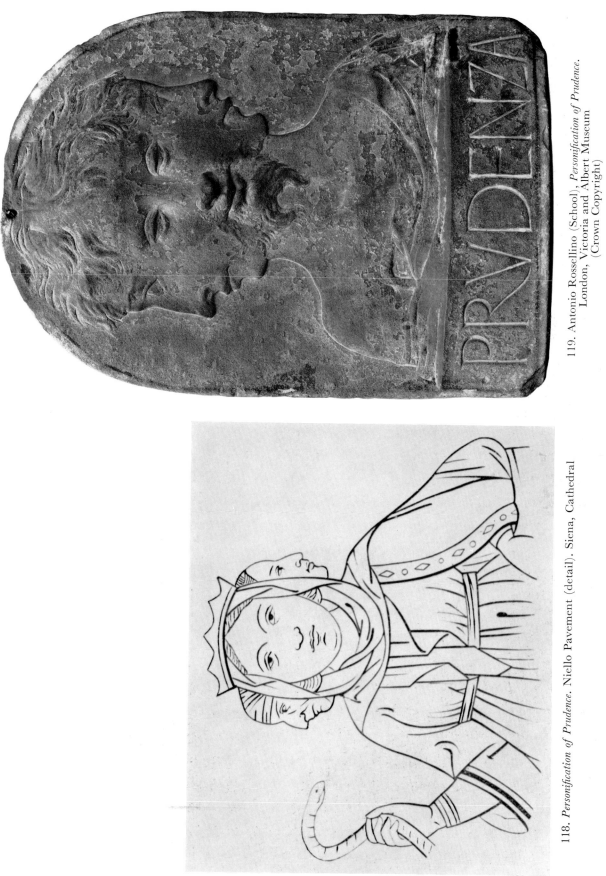

119. Antonio Rossellino (School), *Personification of Prudence*.
London, Victoria and Albert Museum
(Crown Copyright)

118. *Personification of Prudence*. Niello Pavement (detail). Siena, Cathedral

120. Baccio Bandinelli, *The Three Forms of Time*. Drawing.
New York, Metropolitan Museum of Art
(Rogers Fund, 1963)

122. *The Companion of Serapis* ("*Signum triceps*"
or "*Tricipitium*"). Graeco-Egyptian
statuette. Engraving from L. Begerus,
Lucernae . . . iconicae, Berlin, 1702

121. *Serapis*. Coin of Caracalla

Et erat apollo mé duo Juga moñs parnaſi ſedy de quo ⁊ fors Castalius ſcaturicibat ·

123. *Apollo Enthroned on the "Signum Triceps"*. Rome, Vatican Library, Cod. Reg. Lat. 1290, fol. 1 v

124. Jan Collaert after Giovanni Stradano,
Sol-Apollo Accompanied by the "Signum Triceps". Engraving

125. *"Simulachro di Serapi"*.
Woodcut from Francesco
Colonna, *Hypnerotomachia Polyphili*, Venice, 1499,
fol. Y 1

126. *Wise Counsel ("Consiglio")*.
Woodcut from Cesare Ripa, *Iconologia*,
Venice, 1643

127. Artus Quellinus the Elder, *Allegory of Wise Counsel*. Amsterdam, Paleis. Engraving from J. van Campen, *Afbeelding van't Stad-Huys van Amsterdam*, 1664-68, Pl. Q

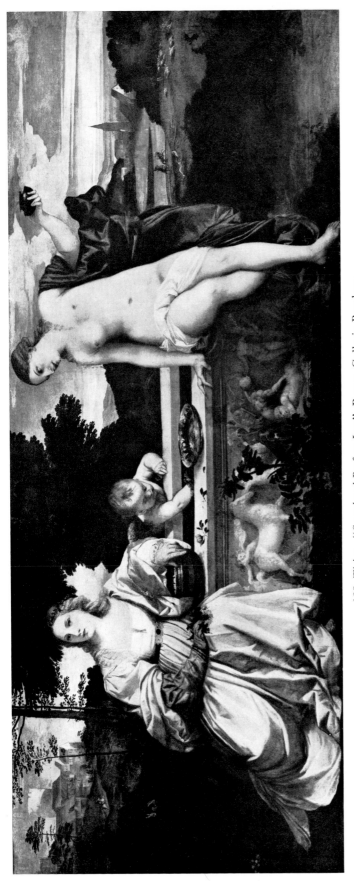

128. Titian, "*Sacred and Profane Love*". Rome, Galleria Borghese

129. *Nereid Sarcophagus*. Pisa, Camposanto

130. *St. Basil between "Worldly Happiness" and "Heavenly Life"*. Paris, Bibliothèque Nationale, MS. Grec 923, fol. 272

131. *Nature and Divine Grace (?) at the Fountain of Life*. Medal of Constantine the Great, formerly in the collection of Jean Duc de Berry (from plaster cast). Paris, Bibliothèque Nationale. Courtesy Stephen K. Scher, Brown University

133. Detail of Figure 128

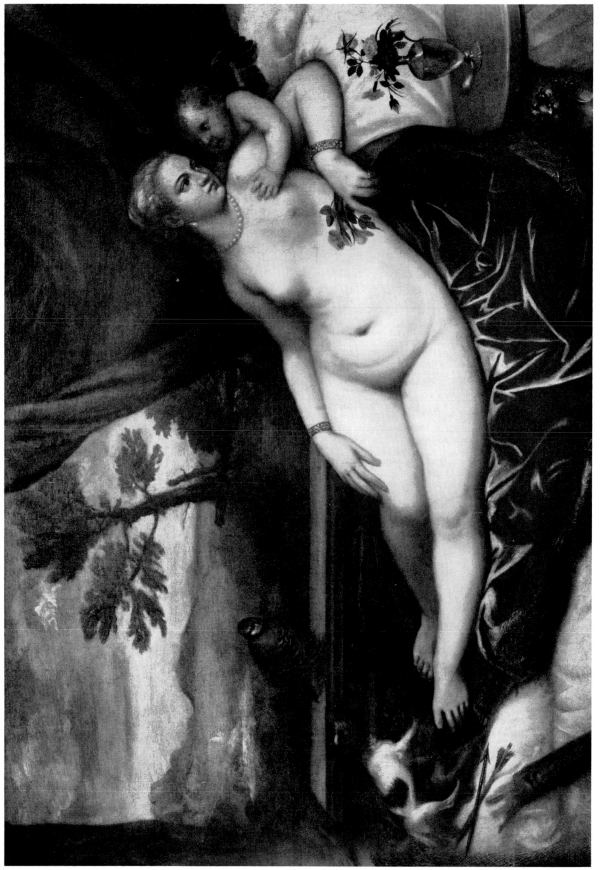

134. Titian, *Venus.* Florence, Uffizi

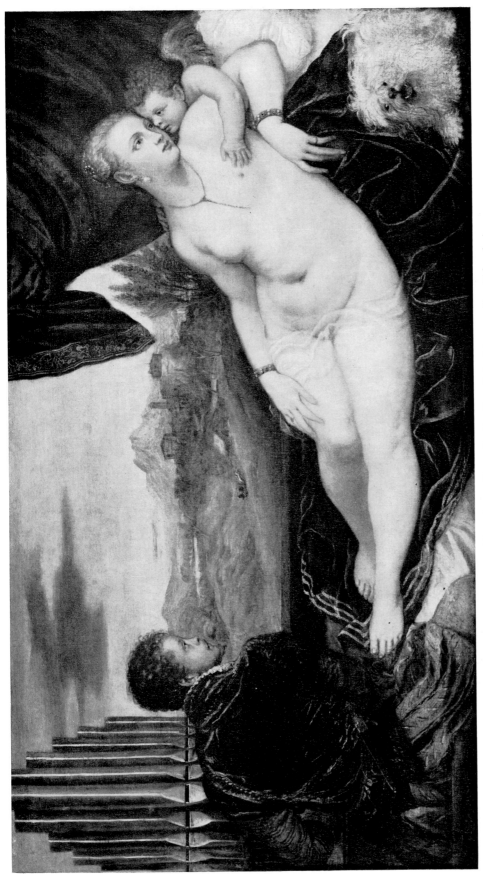

135. Titian, *Venus with an Organ Player*. Berlin, Staatliche Museen, Gemäldezalerie

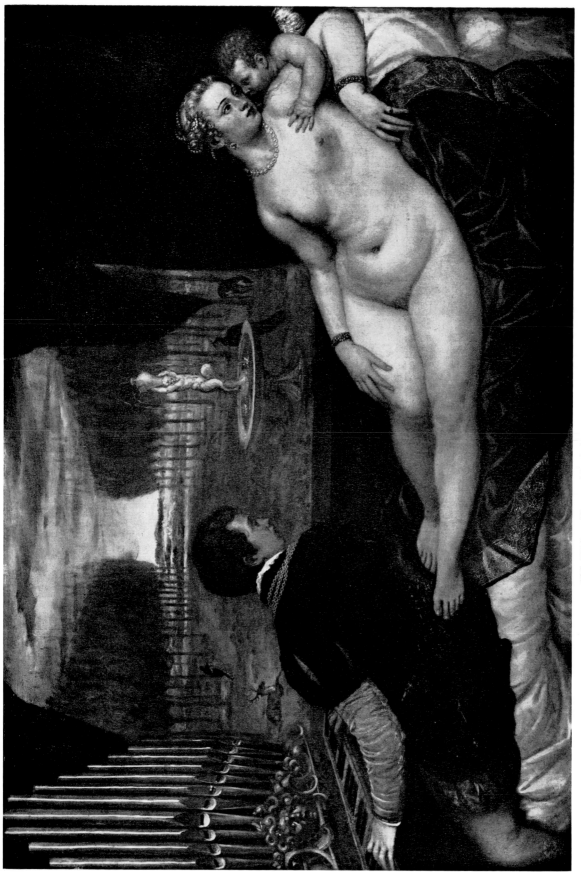

136. Titian, *Venus with an Organ Player*. Madrid, Prado

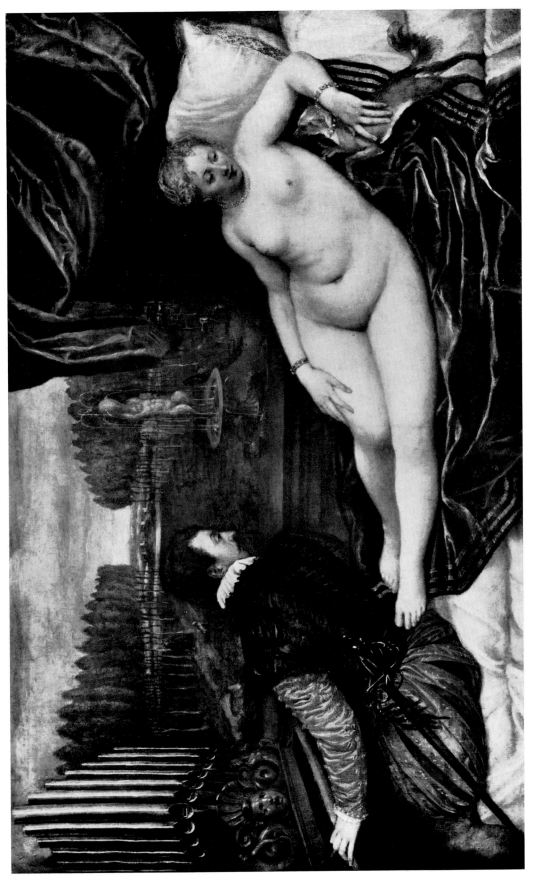

137. Titian, *Venus (?) with an Organ Player*. Madrid, Prado

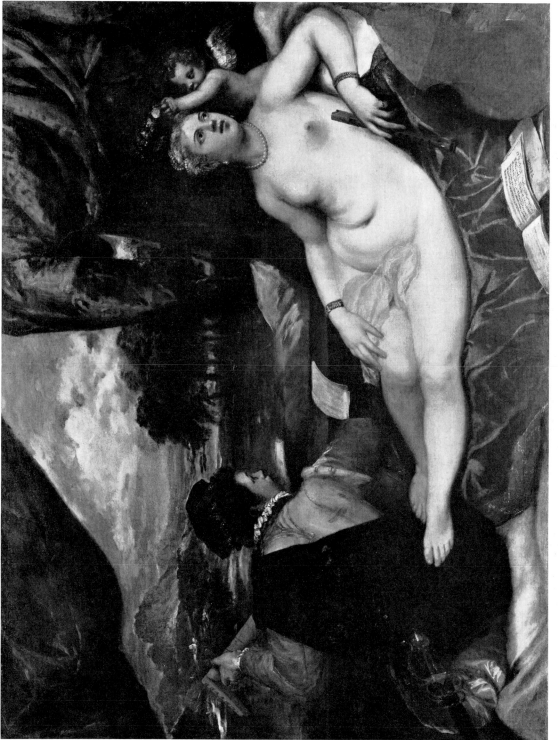

138. Titian, *Venus with a Lute Player*, Cambridge, Fitzwilliam Museum
(reproduced by permission of the Syndics)

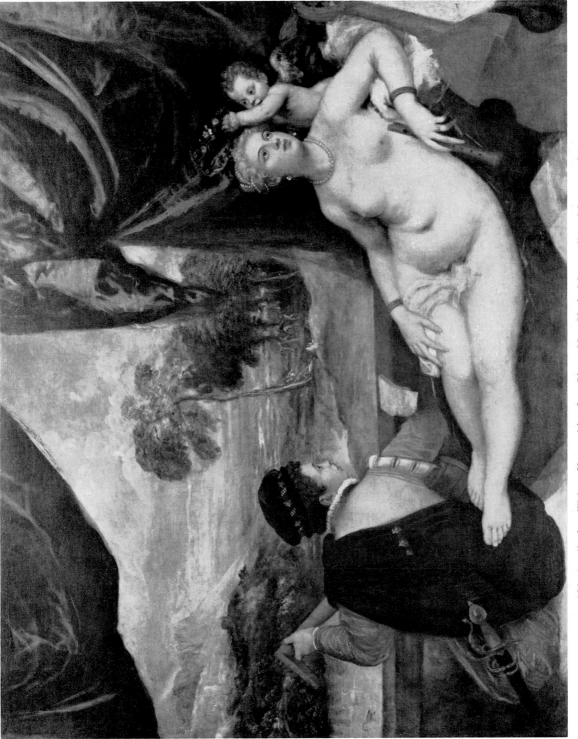

139. Ascribed to Titian, *Venus with a Lute Player*. New York, Metropolitan Museum of Art
(Munsey Fund, 1936)

140. Titian, "*Allegory of Alfonso d'Avalos, Marchese del Vasto*". Paris, Louvre

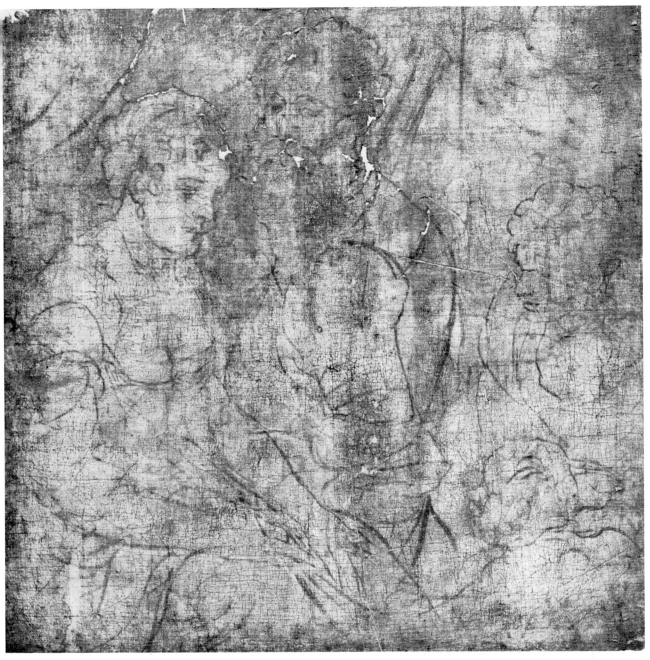

140a. Titian, "*Allegory of Alfonso d'Avalos, Marchese del Vasto*". Underdrawing
discovered and salvaged when the picture was recanvased. Paris, Louvre

141. Detail of Figure 140

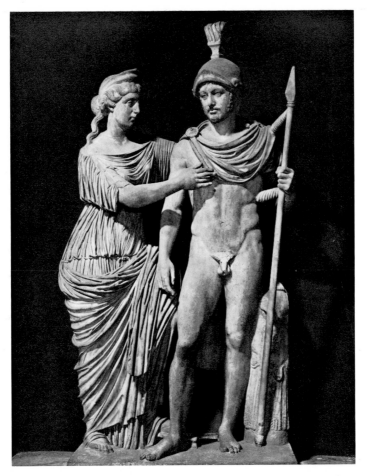

142. *Roman Couple (Commodus and Crispina?) in the Guise of Mars and Venus.* Rome, Museo Capitolino

143. Paris Bordone, *Married Couple in the Guise of Mars and Venus.* Vienna, Kunsthistorisches Museum

144. Titian, *"Education of Cupid"*. Rome, Galleria Borghese

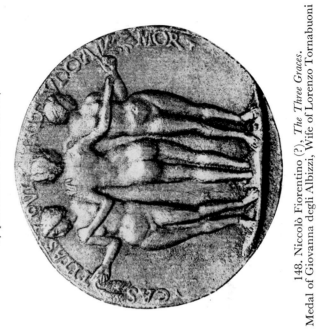

147. Niccolò Fiorentino (?), *The Three Graces.*
Medal of Pico della Mirandola.
London, British Museum (reproduced
by permission of the Trustees)

148. Niccolò Fiorentino (?), *The Three Graces.*
Medal of Giovanna degli Albizzi, Wife of Lorenzo Tornabuoni

145. *Eros and Anteros.* Woodcut from Andrea Alciati, *Emblemata,*
Paris (Wechel), 1534, p. 76

146. Guido Reni, *Eros and Anteros.* Pisa, Museo Nazionale di S. Matteo

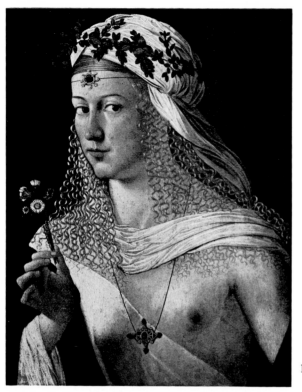

149. Bartolomeo Veneto, *Bridal Portrait of a Lady*.
Frankfurt, Städelsches Kunstinstitut

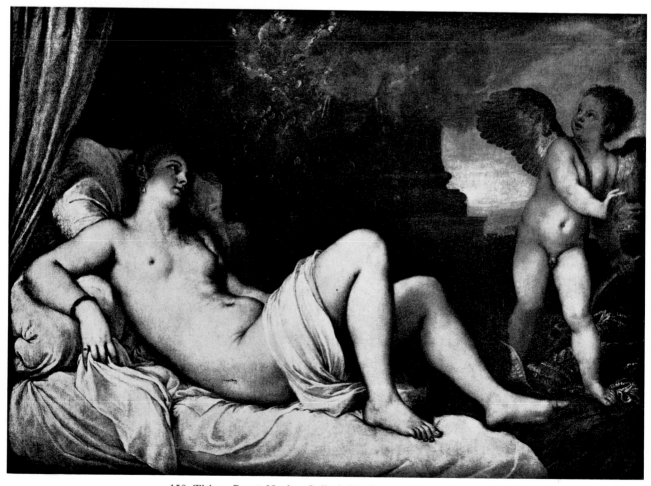

150. Titian, *Danaë*. Naples, Galleria Nazionale di Capodimonte

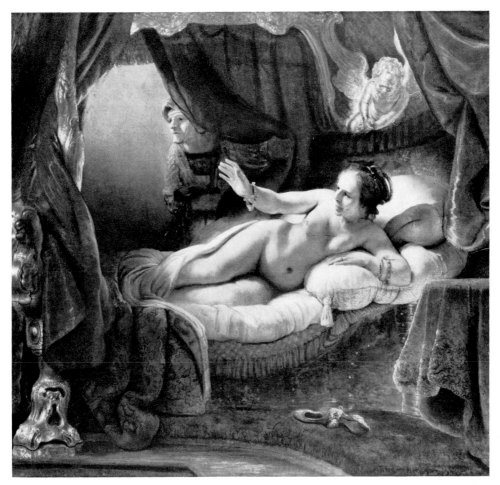

151. Rembrandt, *Danaë*. Leningrad, Hermitage

152. After Primaticcio, *Danaë*. Tapestry. Vienna, Kunsthistorisches Museum

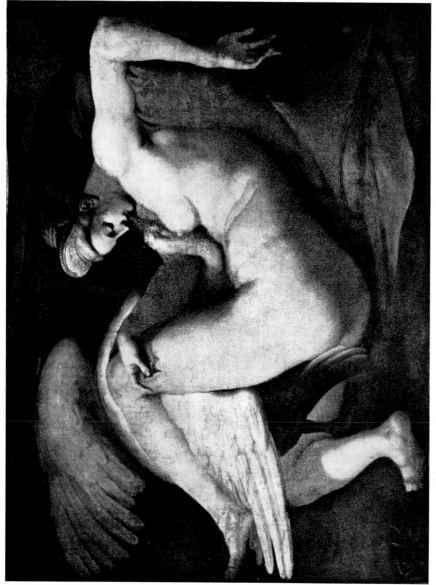

153. Rosso Fiorentino after Michelangelo, *Leda*. London, National Gallery (reproduced by courtesy of the Trustees)

154. *Leda*. Drawing after a classical relief. Veste Coburg, Kunstsammlungen. MS. HZ II (*"Codex Coburgensis"*)

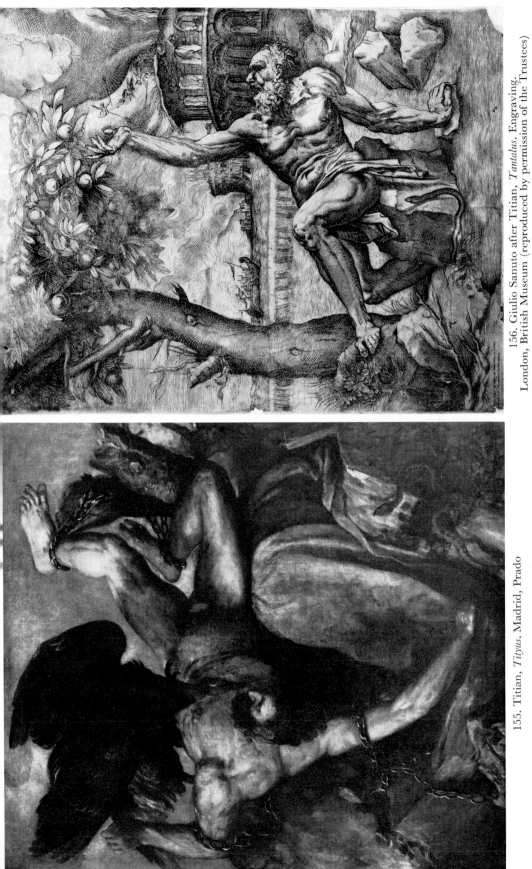

156. Giulio Sanuto after Titian, *Tantalus*. Engraving.
London, British Museum (reproduced by permission of the Trustees)

155. Titian, *Tityus*. Madrid, Prado

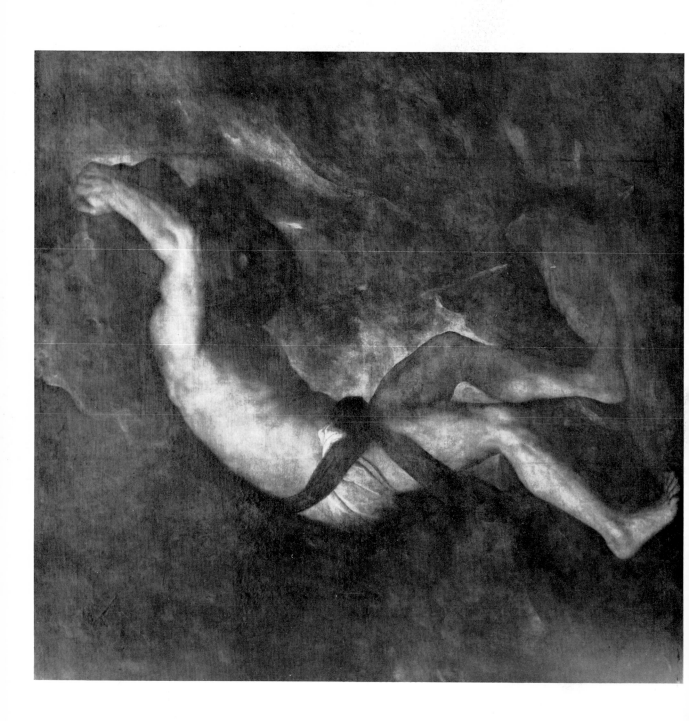

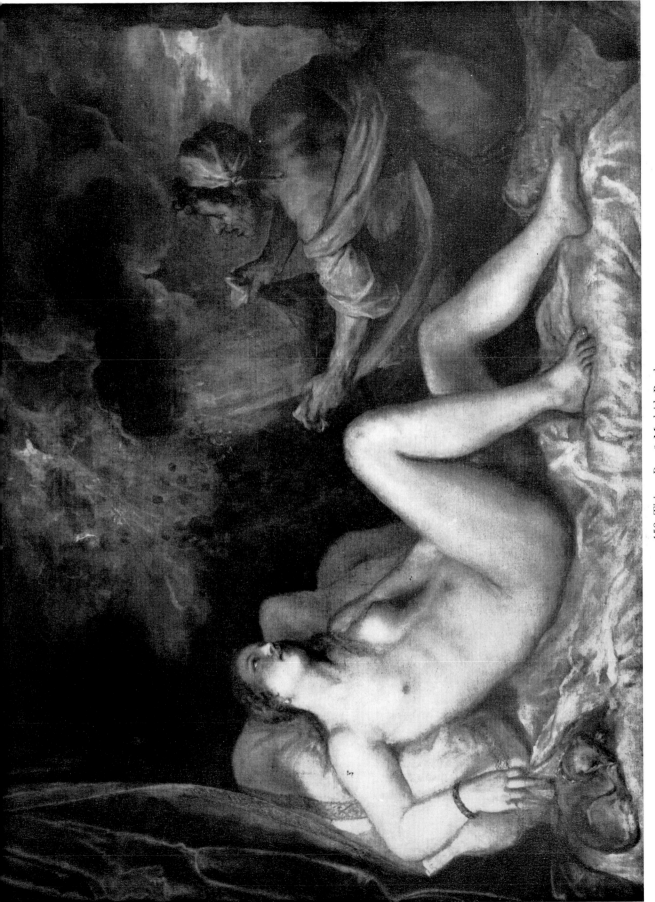

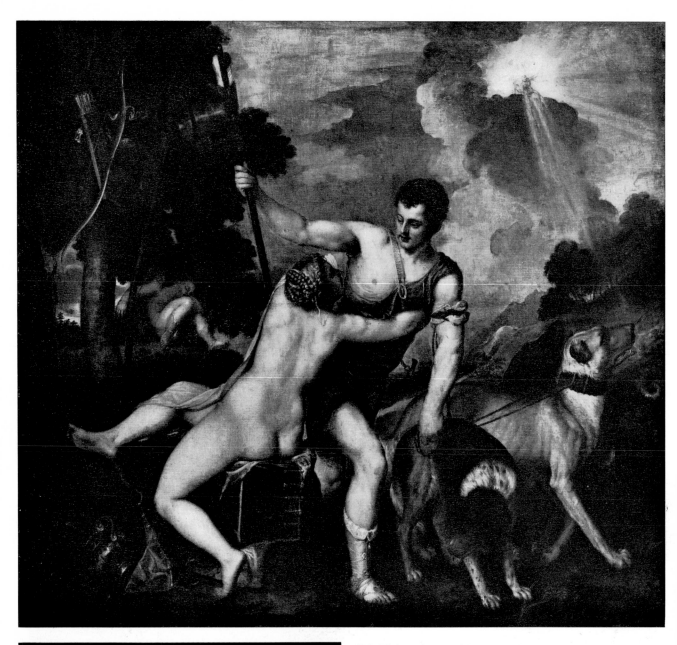

159. Titian, *Adonis Taking Leave from Venus*. Madrid, Prado

160. *"Bed of Polyclitus"*. Ashford, Kent, Collection K. J. Hewett

161. Raphael (School), *The Marriage Feast of Psyche*, Fresco (detail). Rome, Villa Farnesina

162. Hans Bol (or after Hans Bol), *Venus Taking Leave from Adonis*. Etching.
Amsterdam, Rijksmuseum (Copyright)

163. Titian, *Diana Surprised by Actaeon*.
Edinburgh, National Gallery of Scotland (on loan from the Duke of Sutherland Collection)

164. Titian, *Diana Discovering the Pregnancy of Callisto*.
Edinburgh, National Gallery of Scotland (on loan from the Duke of Sutherland Collection)

165. Ugo da Carpi(?) after Parmigianino, *The Bath of Diana*.
Chiaroscuro Woodcut. London, British Museum (reproduced by permission of the Trustees)

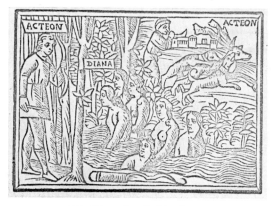

166. *Diana Surprised by Actaeon*.
Woodcut in *P. Ovidii Metamorphosis*, Venice (J. Thacuinus),
1513. p. xix, reversed copy after the corresponding wood-
cut in the first illustrated edition, Venice (Z. Rosso), 1497

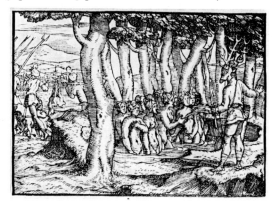

167. *Diana Surprised by Actaeon*.
Woodcut in Lodovico Dolce, *Le Trasformationi*,
Venice (G. Giolito), 1553, p. 63

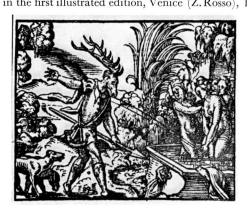

168. Bernard Salomon, *Diana Surprised by Actaeon*.
Woodcut in *La Métamorphose d'Ovide figurée*, Lyons
(J. de Tournes), 1557, No. 42

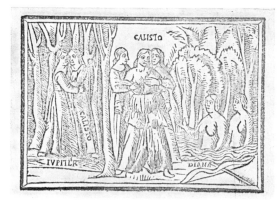

169. *The Story of Callisto*.
Woodcut in *P. Ovidii Metamorphosis*, Venice (J. Thacuinus),
1513, p. xxii, reversed copy after the corresponding wood-
cut in the first illustrated edition, Venice (Z. Rosso),1497

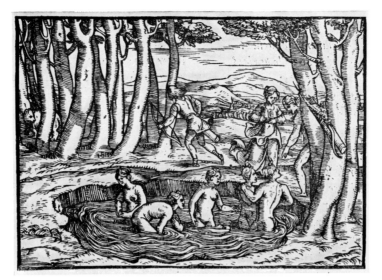

170. *The Story of Callisto.*
Woodcut in Lodovico Dolce, *Le Trasformationi*, Venice (G. Giolito), 1553, p. 44

171. Rembrandt, *Diana Surprised by Actaeon; Diana Discovering the Pregnancy of Callisto.*
Anholt, Wasserburg, Prince Salm-Salm Collection

172. Titian, *Diana Discovering the Pregnancy of Callisto*. Vienna, Kunsthistorisches Museum

173. Titian, *Death of Actaeon*. London, Earl of Harewood (on deposit in the National Gallery, London; reproduced by courtesy of the Trustees)

174. Bernard Salomon, *Death of Actaeon*.
Woodcut from *La Métamorphose d'Ovide figurée*, Lyons (J. de Tournes), 1557, No. 43

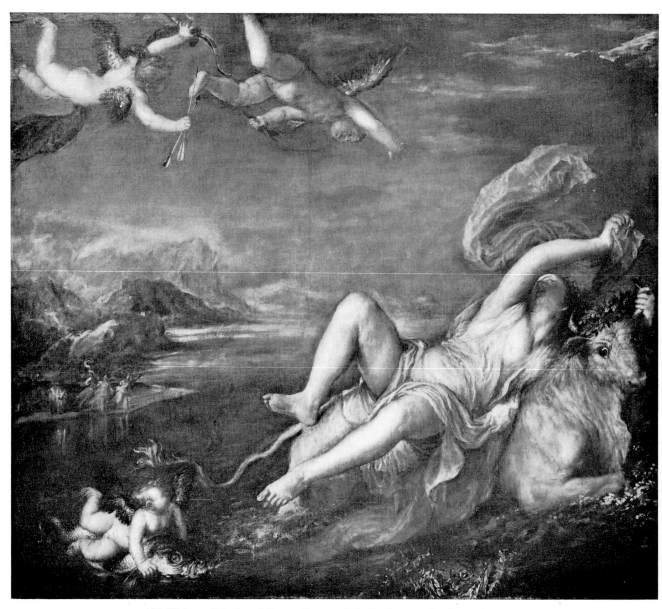

175. Titian, *Abduction of Europa*. Boston, Isabella Stewart Gardner Museum

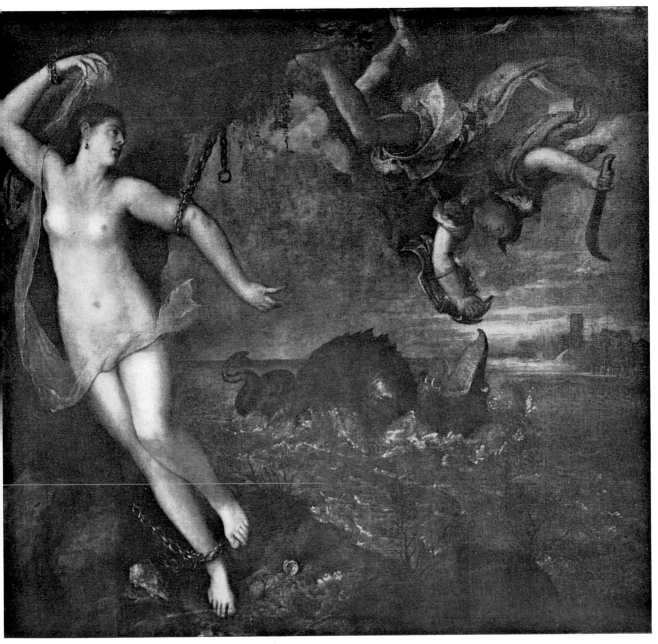

176. Titian, *Perseus Liberating Andromeda*. London, Wallace Collection
(reproduced by permission of the Trustees)

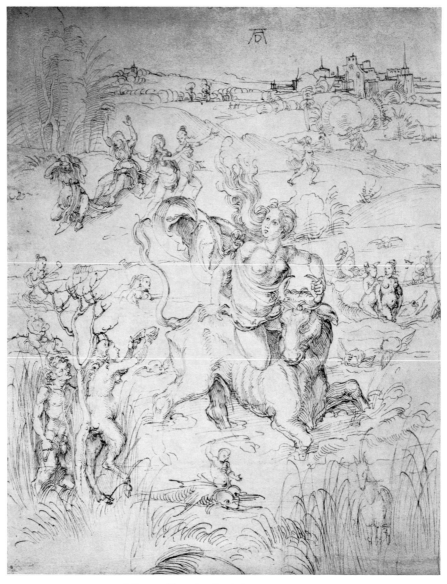

177. Dürer, *Abduction of Europa*. Drawing L. 456 (left-hand section). Vienna, Albertina

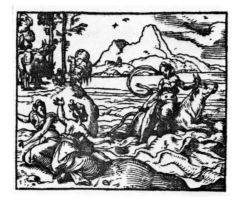

178. Bernard Salomon, *Abduction of Europa*. Woodcut
from *La Métamorphose d'Ovide figurée*, Lyons
(J. de Tournes), 1557, No. 38

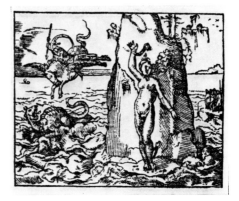

179. Bernard Salomon, *Perseus Liberating Andromeda*.
Woodcut from *La Métamorphose d'Ovide figurée*, Lyons
(J. de Tournes), 1557, No. 6

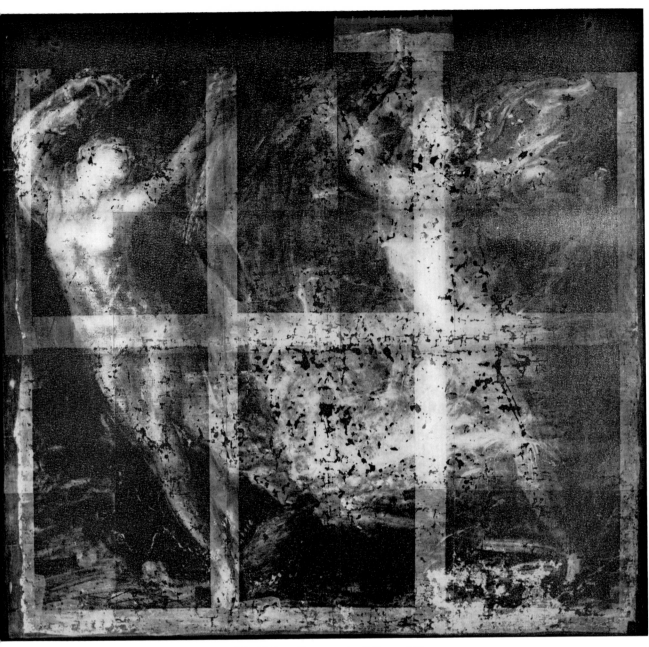

180. X-Ray Photograph of Figure 176

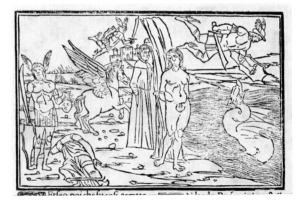

181. *Perseus Liberating Andromeda*.
Woodcut from *Ovidio Metamorphoseos vulgare*, Venice (A. di Bandoni), 1508, IV, 48, printed from the same block as the corresponding woodcut in the first illustrated edition, Venice (Z. Rosso), 1497

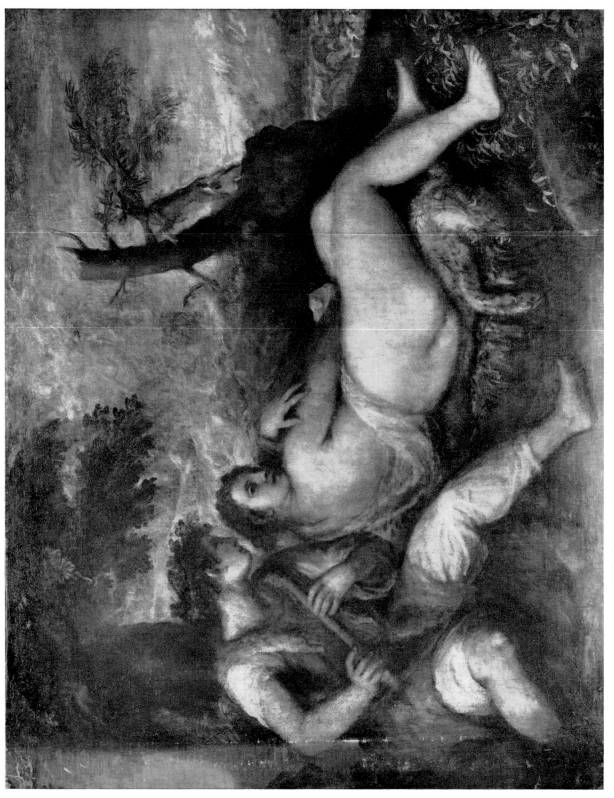

182. Titian, *"Nymph and Shepherd"*. Vienna, Kunsthistorisches Museum

184. *Paris as a Shepherd.* Drawing after the end of a Roman sarcophagus at Ince Hall. Veste Coburg, Kunstsammlungen, MS. HZ II (*Codex Coburgensis*)

IVLIVS
CAPAGNOLA.

183. Giulio Campagnola after Giorgione, *Reclining Nude.* Engraving. Cleveland Museum of Art (gift of the Print Club of Cleveland)

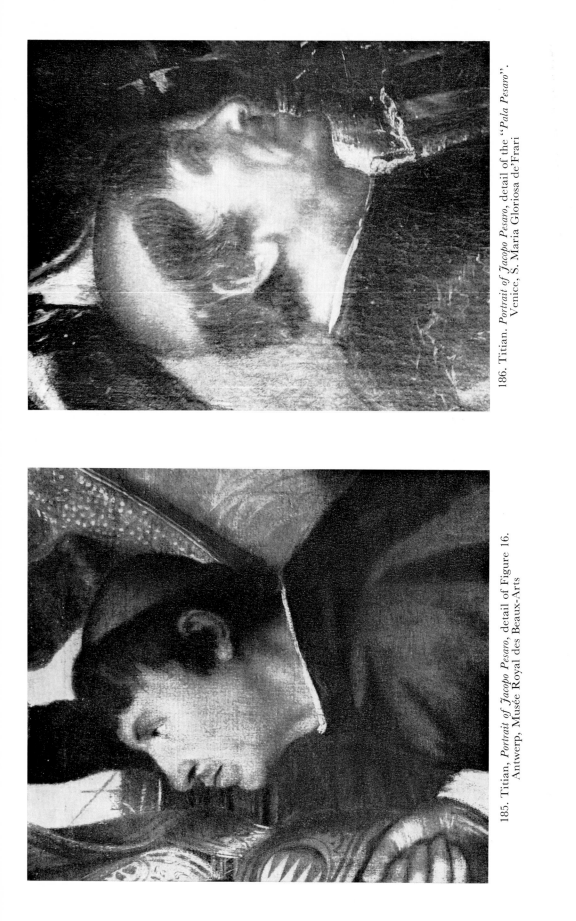

185. Titian, *Portrait of Jacopo Pesaro*, detail of Figure 16.
Antwerp, Musée Royal des Beaux-Arts

186. Titian. *Portrait of Jacopo Pesaro*, detail of the "*Pala Pesaro*".
Venice, S. Maria Gloriosa de'Frari

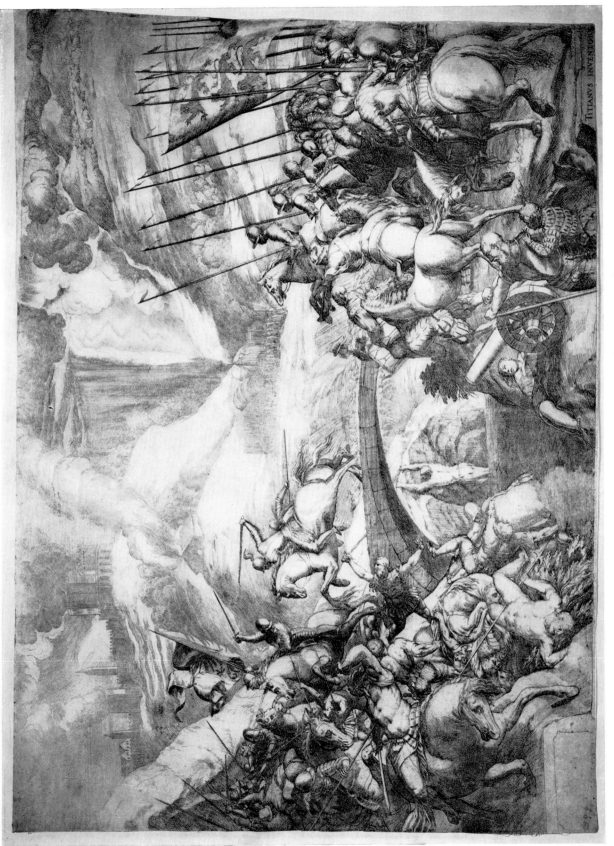

187. Giulio Fontana after Titian, *The Battle of Cadore*. Engraving.
London, British Museum (reproduced by permission of the Trustees)

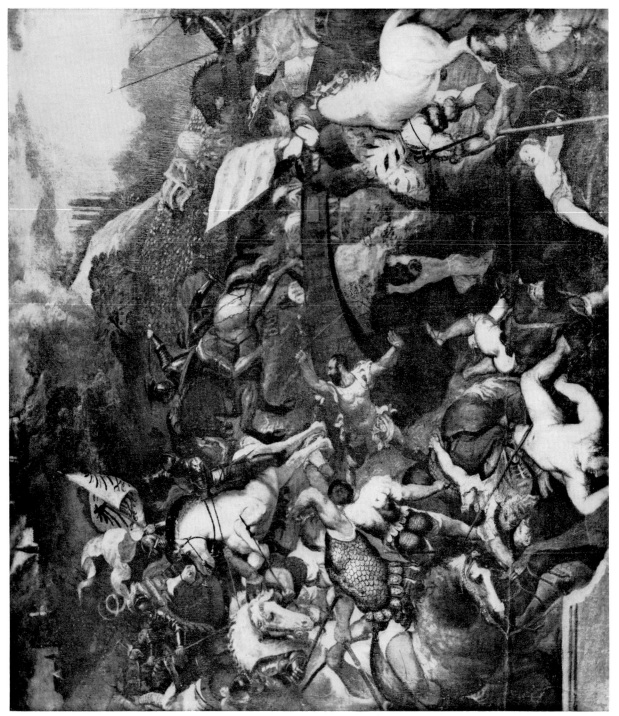

188. Titian (copy), *The Battle of Cadore*. Florence, Uffizi

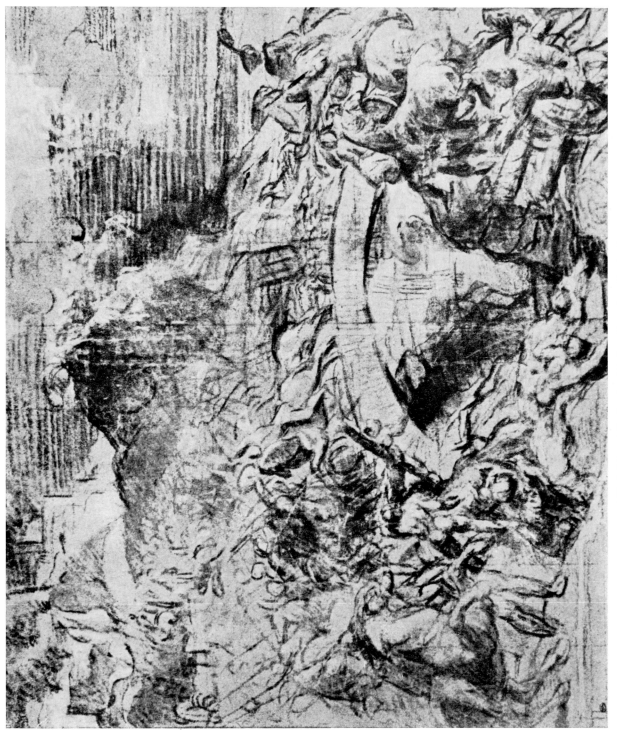

189. Titian, *The Battle of Cadore*. Drawing. Paris, Louvre

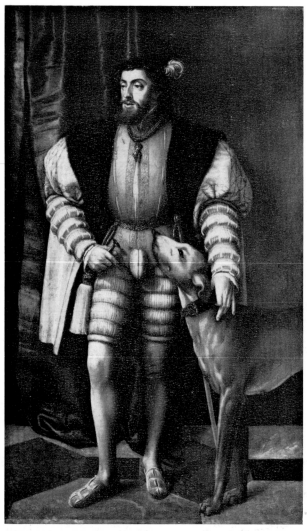

190. Jakob Seisenegger, *Portrait of Charles V*.
Vienna, Kunsthistorisches Museum

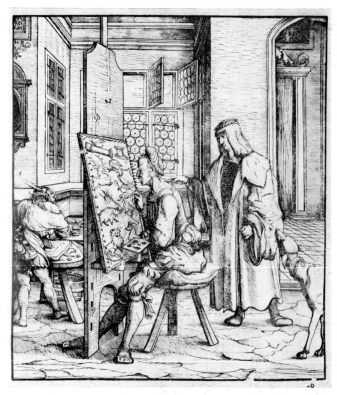

191. Hans Burgkmair, *Maximilian I Visiting Hans Burgkmair in His Studio*. Woodcut destined for the *Weiss-Kunig*

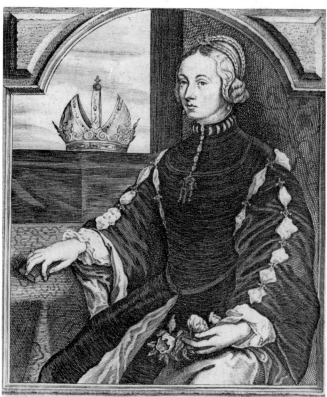

192. Pieter de Jode after Titian, *Portrait of Isabella of Portugal, Wife of Charles V*. Engraving.
Rome, Gabinetto Nazionale delle Stampe

193. Titian "*La Religione*". Madrid, Prado

194. Guilio Fontana after Titian, "*La Religione*". Engraving.
London, British Museum (reproduced by permission of the Trustees)

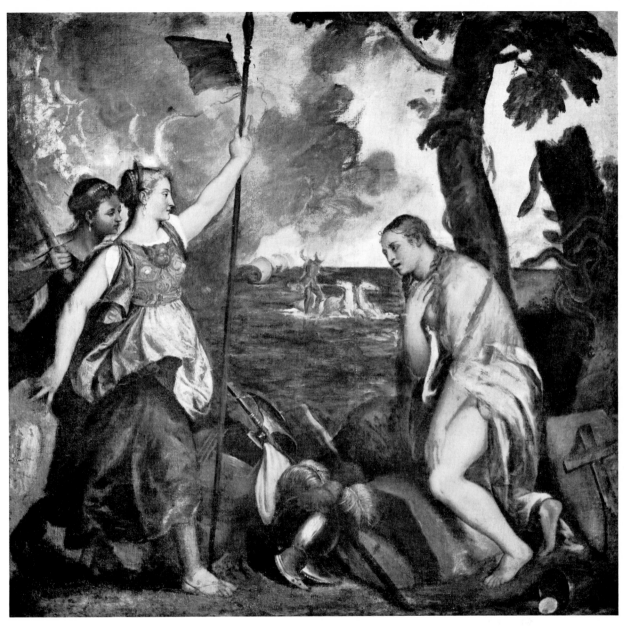

195. Titian and Assistants, "*La Religione*". Rome, Galleria Doria-Pamphili

196. François Boitard, *Bellona*. Engraving
from L. G. Gyraldus, *Opera omnia*, Leyden,
1696, I, Plate following cols. 75, 76

197. Titian, *Pardo Venus*, Paris, Louvre. Infra-red Photograph
(courtesy Laboratoire du Musée du Louvre)

199. After Titian, *Pan and Silvanus* (?).
Drawing, New York, Collection Curtis O. Baer

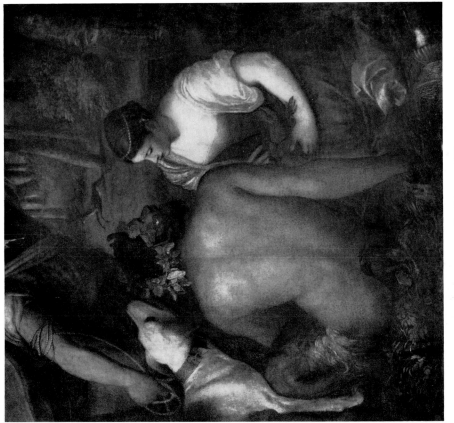

198. Detail of Figure 197